BETTY WHITE

To my loving wife, Jill Holden, and
supportive son, Dylan, who both patiently
and graciously endured my sudden
Betty White obsession.

Inspiring | Educating | Creating | Entertaining

Brimming with creative inspiration, how-to
projects, and useful information to enrich your
everyday life, quarto.com is a favorite destination
for those pursuing their interests and passions.

© 2022 Quarto Publishing Group USA Inc.

Published in 2022 by Epic Ink an imprint of The Quarto Group,
142 West 36th Street, Fourth Floor, New York, NY 10018 USA.
www.Quarto.com

becker&mayer! books titles are also available at discount for retail, wholesale,
promotional, and bulk purchase. For details, contact the Special Sales Manager
by email at specialsales@quarto.com or by mail at The Quarto Group, Attn: Special
Sales Manager, 142 West 36th Street, Fourth Floor, New York, NY 10018 USA.

1 2 3 4 5 6 7 8 9 10

ISBN: 978-0-7603-7946-2

Digital edition published in 2022
eISBN: 978-0-7603-7947-9

Library of Congress Control Number: 2022933767

Author: Ray Richmond

Printed, manufactured, and assembled in Guangdong, China, 5/22.

Front cover photo: © Kwaku Alston/Getty Images
Back cover photo: © Angela Weiss/Getty Images
Interior image credits: See page 259

BETTY WHITE

100 REMARKABLE MOMENTS IN AN EXTRAORDINARY LIFE

Foreword by Gavin MacLeod

Ray Richmond

EPIC INK

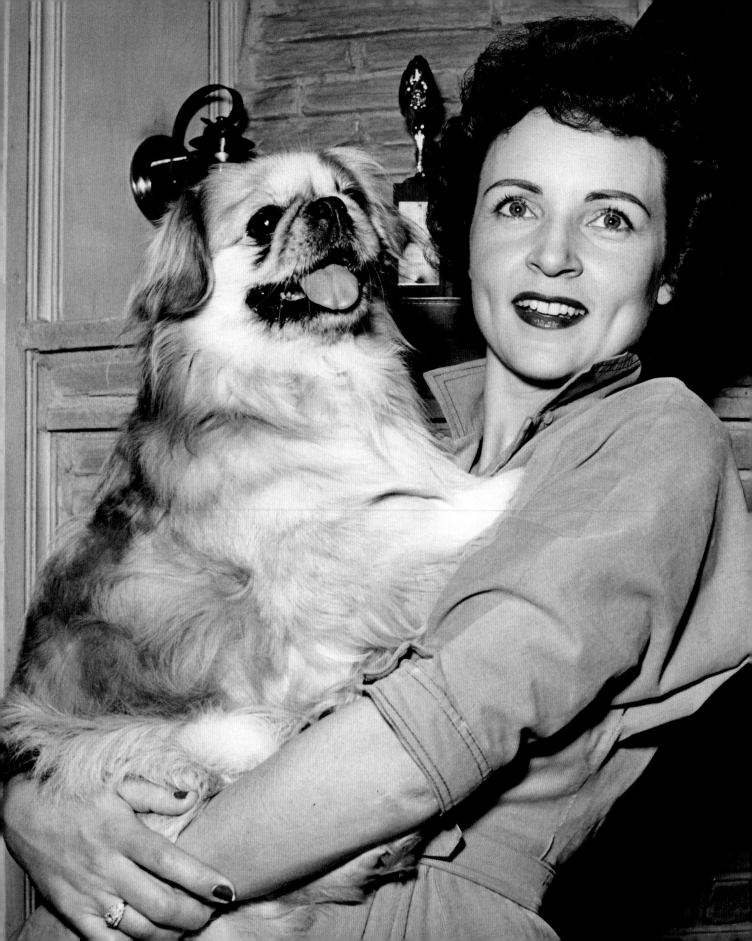

CONTENTS

OPPOSITE: Betty White and her Pekingese dog Bandy at home together in 1954.

Foreword

Writing a few words about Betty White is not a difficult task. I've always thought the woman should be declared a national treasure. As far as I'm concerned, she belongs up on Mount Rushmore right alongside the presidents. There is just nobody like Betty. When they invented her, they broke the mold. She's such a special combination of marvelous attributes. As you go through life, you don't find many people who blend great talent and great humanity in so perfect a fashion. Everyone wants to be around her because she has such a positive nature, such a cheerful vibe. It's like she emits an electric current that draws people to her.

Betty and her husband, Allen Ludden, were such a wonderful couple back in the '70s, in the earliest years of *The Mary Tyler Moore Show* before she was hired for the show herself. They would come to watch our shoot every Friday night, because Allen was great friends with Grant Tinker, who was Mary's husband and our show's executive producer. Then when Valerie Harper left the cast in 1973 to go do *Rhoda*, we suddenly had a big vacancy and needed another character.

We were all a little worried to lose someone who was so important to the show. It was kind of uncharted waters. No one expected that when Betty did her first episode as Sue Ann Nivens, she would become a regular presence on the show. She was just coming on as a one-time guest, but as soon as she stepped in, she was so magnificent. It was like God intended it to be that way. Only Betty could get away with some of the stuff she had to do. Her choices as an actor were superb.

Sue Ann and Mary Richards played so well off each other. She was just the antithesis of Rhoda and brought a whole new color to the show, a whole new personality for the comedy to bounce off. From the first moment she stepped onto our set, Betty *was* Sue Ann. And talk about a professional. As soon as we were handed new scripts, she'd have her dialogue down immediately. Betty had a photographic memory, and it was astounding to see how perfectly she'd have the script memorized in no time at all. She was really the best I've ever seen that way. As soon as she read it through once, she had it cold.

There are so many reasons why I love Betty. She's an incredible lady in many, many ways. There's her sense of humor. The way she loves animals. The care she shows for people. She's one of the most caring and loving human beings I've ever known.

We all have our favorite *Mary Tyler Moore* episodes, and so many of mine are ones that have a lot of Sue Ann. There's one where my Murray got hired to be her assistant. She was getting ready to do a big wedding and used Murray as the model for the wedding gown, emasculating the poor fellow. Finally, he'd had enough and snapped, lifting Sue Ann up and plopping her butt down on the cake. The idea was that Betty was going to slowly slide down this cake. But we never had a cake to practice with. I guess the budget only allowed for a single cake to be used during the actual filming. There was no rehearsal cake.

So come filming night in front of the live audience, I'm in the wedding gown. I pick Sue Ann up and put her down on that cake. The cake gets between her legs and she slides down to the floor. It was riotous. The audience went crazy. But when it was all over, Betty comes up to me and says, "I really hurt my back." See, when I lifted her up and slapped her down, crack went her back. Nobody knew the pain she was

in, least of all me. But she never flinched. She was such a pro that she never betrayed any discomfort. She knew we had only the one cake and understood we couldn't do a second take. That's Betty.

Another part of what makes Betty so extraordinary is how natural a performer she is. I think that goes back to her being part of the earliest days of live television and doing so much improvisation. She's really a guiding light, a towering symbol of the industry who goes back to the very beginning. She is like TV royalty.

When we stopped working together after *Mary Tyler Moore* left the air in 1977, I missed being around Betty so much. But we were able to get her onto *The Love Boat* several times, with both Allen and Carol Channing. Whenever she was there, it was magical. There was also the time, maybe six or seven years ago, when I got a call from Air New Zealand. They wanted me to be in the safety video that they show on their jets before flights—and Betty would be a part of it, too. Well, as soon as I found out Betty was involved, of course I said yes. The whole thing is purportedly shot in a retirement home. It was just delightful.

Betty and I had a great time working on it, and I found out something interesting about her that day. She steered clear of eating the chicken once we broke for lunch because she needed to eat a hot dog. I came to discover that's what she has for lunch *every day of her life*! And here she's going to be 100 years old. She's refuted the whole idea that if you eat too much of that stuff, you aren't going to live very long. Maybe the preservatives in hot dogs preserve the human body, too!

But in all seriousness, I think what's kept Betty going strong to such a ripe old age is her attitude. It's such an important factor in everything. She's an upbeat, optimistic, loving person, and that can keep you healthy, strong, and vibrant. Betty lights up everything. Anyplace she ever went, even if it was dark out, she was this human flashlight who could show everyone the way. No matter the situation, she made it better. Her comedy mind is so brilliant, so fertile.

I know people worry as Betty gets older that there will come a day when she isn't with us anymore, and they have a hard time dealing with the thought. But the truth is that she will never leave us because she's embedded in our memories. She's a part of our lives and a part of us. She'll always be alive in us. That's the ultimate blessing.

—Gavin MacLeod

Gavin MacLeod starred as the balding, wisecracking Murray Slaughter throughout the seven-season run of *The Mary Tyler Moore Show* (1970–1977) and as the esteemed Captain Merrill Stubing during the nine seasons of *The Love Boat* (1977–1986). He was also the author, with Mark Dagostino, of the 2013 memoir *This Is Your Captain Speaking: My Fantastic Voyage Through Hollywood, Faith & Life*. He died on May 29, 2021. He was 90 years old.

Introducing Betty White!

Her birth certificate indicates that she was born in Oak Park, Illinois, on January 17, 1922, but in fact Betty Marion White seems forever to have been a part of the American psyche. She is the embodiment of the nation's can-do spirit, a paragon of optimism, the very model of hard work, decency, elegance, positive energy, and vitality.

In the lead-up to her landmark 100th birthday, Betty's exuberance and ubiquity have transformed her into an almost mythic figure, rather like the love child of Mister Rogers, the Energizer Bunny, and a vintage chardonnay. She is a metaphor for a life lived with uncompromising character and integrity and simultaneously leavened with sugar and spice. If Betty White had never been born, Dr. Seuss would have had to create her with an assist from Steven Spielberg. She never had children herself because she was too busy being the nation's mother, then grandmother, then great-grandmother, then naughty senior pal.

Everyone fortunate enough to have been graced by Betty's presence, whether for a single meeting, years on a show, or a lifetime of friendship is left captivated by her loveliness and powerless not to adore her. At the same time, she's no Goody Two-Shoes. She knows how to get down and dirty and is as comfortable with sailors on shore leave as she is with members of her ever-expanding fan base. She has a sixth sense for supplying whatever Betty the situation calls for.

Give her a hot dog (plain, thank you), a few pieces of red licorice, and a tumbler of vodka and Betty is good to go. But those simple tastes mask a woman of deceptive complexity, who is nobody's guileless and sickly sweet chew toy. From the moment she set foot in a recording booth for a radio drama at age eight, Bets has given workaholism a good name. She understands that it isn't the fame or the adulation that's so fulfilling, but the job itself. She appreciates the outrageous number of plaudits that have come her way, but those aren't what starts her engine in the morning.

Betty is still the midwestern gal who was taught by her beloved folks to take care of herself, show up ready to go, never cop an attitude, and always treat the people you meet with courtesy and respect no matter where they come from. These values have served her magnificently in a show business career that's exceeded 75 years, and a life that's closing in on a century. Indeed, few who have ever worked in entertainment can match White's biography for sheer variety and longevity. She's a blue-collar performer to her core, her photographic memorization of scripts is the stuff of legend, and she insists on no special treatment owing to age or eminence. In point of fact, she fully lacks the snob gene, which explains her proud status as Queen of the Game Show (the humble underclass genre of daytime TV).

But Betty has accrued quite a few handles as the years have piled up. She's also the First Lady of Television and an Auntie Dolittle with animals. As the latter, she scratches behind the ears of dogs and cats, slaps the tongues of elephants, shares special time with literate gorillas, allows bears to extract marshmallows from between her teeth, and—if given sufficient time—could charm a snake with her whisper. The L.A. Zoo is her home away from home for a reason.

A throwback to a time (real or imagined) when manners genuinely mattered, White is also a walking time machine. Already in her mid-20s when television first appeared on the scene, she has performed live before the cameras practically since they started rolling. She even produced shows before that role became part of the boys' club that would eventually run Hollywood.

When it came to race, she was color-blind as a matter of course, and not because it was trendy. She was accepting and inclusive of the LGBTQ community before that became fashionable, too. It is just the way the woman is wired. She could have allowed discriminatory practices or discriminated herself and blamed it on age and naïveté, but instead, she quietly led with the modest eloquence of her example. This has been a hallmark of the Betty White brand dating to her first dance with fame in the late 1940s. She was effortlessly classy and charming without calling attention to it. The same went for her social awareness. It just flowed out from her naturally.

The book you're about to read takes all of the above into account while guiding you on a chronological journey through 100 of the most remarkable moments and accomplishments in Betty's extraordinary life and career. It is by no means definitive or complete—that would require a 12-volume encyclopedia—but it's certainly a more than representative selection. What I found as an author while researching White's life was something almost miraculous. The deeper you dig into her past, the more impressive she becomes. There are no hidden agendas, no buried issues, no nasty outbursts, no ugly skeletons in her closet. About the worst thing one can say about her is that she didn't give herself enough time to enjoy the fruits of her substantial labor. But the bottom line is, Betty is everything she appears to be—and more. That made chronicling her existence a singular pleasure.

Meanwhile, Betty's career highlights are astonishing when taken as a whole. She starred in TV early on, when everything was live and before the medium considered itself important enough to commit its product to film. Her game show history extends back to *What's My Line?* in 1955 and spans hundreds of appearances. She was Sue Ann Nivens on *The Mary Tyler Moore Show*. She was Rose Nylund on *The Golden Girls*. She was Elka Ostrovsky on *Hot in Cleveland*. She hosted *Saturday Night Live*—at 88!

Regrets? Sure, Betty has a few, but only one major one: wasting a year playing hard to get while being courted by the one true (human) love of her life, husband Allen Ludden. They were married for just 18 years before he passed in 1981. But she refused to let her grief drag her down. It isn't her way. For Betty, loss is a dish that can't be lingered over. After starring in hit series after hit series in the 1970s and '80s, she enjoyed a professional renaissance that's lasted from her mid-80s to her late 90s, a run that simply never happens. She mocked the very idea of retirement by significantly ratcheting up her workload rather than scaling back. Betty would depart showbiz on her own terms, which is to say never.

What was perhaps most impressive about her late-life rebirth was how game she was to turn her image on its head and become a mischievous granny with a potty mouth and an eccentric streak, never hesitating to revel in a measure of lude 'n' crude when the script or the moment demanded it. That eagerness to play counter to her wholesome image has earned her the love and loyalty of an entire new group of younger fans who can't get enough of her irreverent antics.

Evolving into such a multigenerational icon had kept Betty working steadily until the COVID-19 pandemic shut down nearly all production in 2020. She has lived to work considerably more than she has worked to live. It's slowing down that she's feared. As long as she was performing and in demand, she was alive. It is in this spirit that the following pages celebrate a woman of uncommon humanity and generosity. A performer of effervescent joy. A pioneer. An artist. A jokester. A life force. A loyal friend. And every once in a while, when called for, a cheeky, sassy babe.

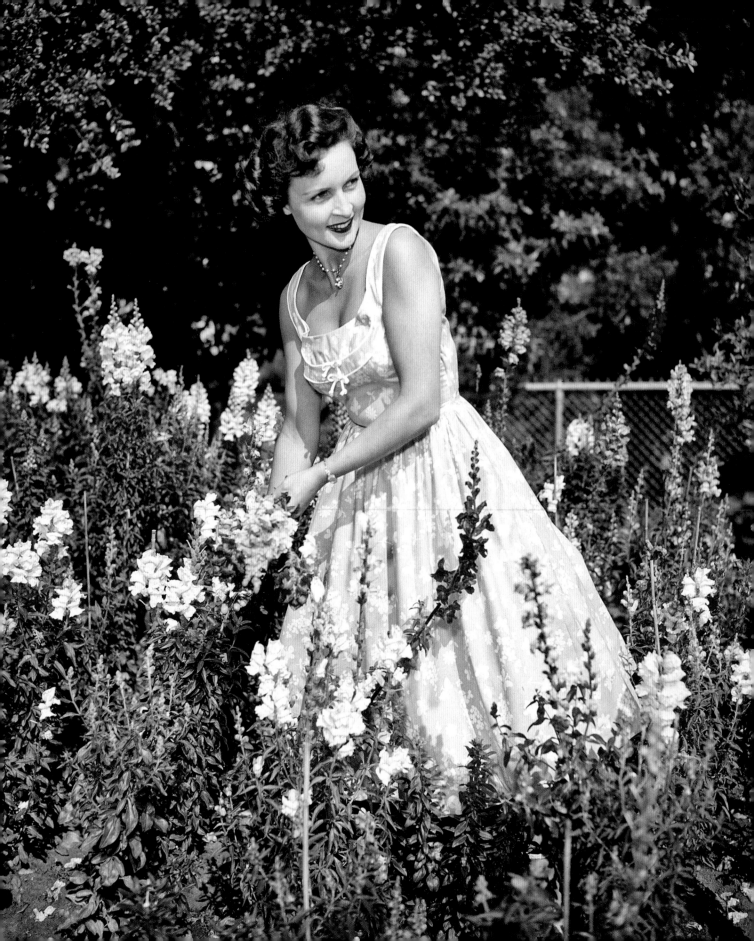

The 1920s and 1930s

Beginnings

"My dad would always ask me how things were, and somehow we'd get into silliness and fun. I think those [talks] went a long way in teaching me how to appreciate the positives as opposed to the negatives."

—Betty White on her home life

OPPOSITE: Betty gets ready to grab life by the tail on a sunny 1950s day.

Off to a Great Start

I t's entirely possible that the single most important moment of Betty White's life was the first one. She entered the world on January 17, 1922, as the first and only child of Tess and Horace White, two people whose lives were driven by humor and joy and animals (not necessarily in that order). As Betty has often maintained throughout her decades on this planet, she hit the jackpot when it came to parents. From the first, they weren't a couple with a child but a threesome of equals presiding over a menagerie of dogs and cats.

This set the tone for everything in young Betty's existence that was to follow, including her love of pets and the outdoors, her freedom to express herself, her assertion of independence, her senses of grace and gratitude, and her ease and élan with friends and strangers alike. Celebrating a century of Betty Marion White delighting us all, we are left to ponder some unthinkable questions: What if Tess and Horace had decided not to have kids at all? What if the Whites had opted to stay in Oak Park, Illinois, where their daughter was born, rather than pick up and move to Los Angeles when Betty was a mere toddler? Might she have followed a different career path had she not been steeped in the arts via living literally in the center of entertainment? Would we all have been denied this ageless compass of optimism, decency, and boundless talent?

Thankfully, these are questions with no answers. The important thing is that Horace White, an electrical engineer by trade, had to get to L.A. for career reasons: his own. Meanwhile, the Whites' little sprite had her sights set on becoming a forest ranger. But this was a different time, when women were barred from so many professions, so Ranger Betty morphed by necessity into Performer Betty. And thank God, really. The lady would no doubt have been a dynamite ranger if given the opportunity to maintain public lands, campgrounds, roads, and trails. But then who would have made us laugh?

She was all of eight years old when performing started to take hold in young Betty's psyche. She was a voice on a radio drama called *Empire Builders*, a medium that was in its earliest phase as the girl moved through her early childhood. When we look back on her story, little Miss Betty's push into show business seems almost like destiny, including the attendant stage fright she endured in the third grade. Her recitation of a poem in front of her class made her clam up and nearly thwarted her future ambitions before they even really began. Her throat closed. Her chest tightened. Her head spun. She finished it, but not before it nearly finished her.

It would be another five years before Bets was inspired to take over the school stage again, this time as the playwright, producer, and director of a production at her school in Beverly Hills. She still felt a little funny about being up in front of an audience, but it mattered less because she was feeling their adoration. Actors will often tell you that the moment they knew the performing life held their future was when they received that first jolt of acknowledgment, the burst of applause that made them feel appreciated, loved, whole. That happened for adolescent Betty in 1935 when she was just 13, and

she couldn't imagine life getting any sweeter than that. Of course it would, but at 13 it's tough to live anywhere but in the moment.

Through the next four years, however, Betty still wasn't a hundred percent convinced that entertaining held all of her career cards. She still wanted to work with animals in some capacity and becoming a zookeeper would more than scratch that itch. But then in 1938, she got the lead role in her high school junior year production of *Pride and Prejudice*, and that again convinced her acting was her future.

Betty was encouraged to cultivate her voice. She took opera-singing lessons and was thought to have some pretty nifty pipes, so much so that she was offered the chance to sing at her Beverly Hills High School graduation in January '39. This was where having a sense of humor hopefully helped senior Betty White make it through the ceremony. The song chosen for her to sing was one of the most mournful pieces of lyricism ever penned. Mind you, this was after the Great Depression had ended and America was still a couple of years away from officially entering World War II. But no matter.

No one would parlay the medium of TV to their professional advantage more than she.

Some might see the Beverly Hills High performance as Betty's first truly great triumph, managing to stand out in front of all those parents and fellow grads despite being given a less-than-stellar script. All she really knew was that she craved a new challenge that would set her on the road to . . . something. Betty found it in an unlikely place: a Packard auto dealership in downtown Los Angeles. Her vocal work at the graduation ceremony brought her to the attention of an entrepreneur in the crowd who was conducting an experiment for this fledgling new medium called television.

Now keep in mind that at this point in time, the idea you could transport moving pictures through the air from one place to another was considered a feat of magic in the same way that getting an airplane off the ground might once have been. The odds were 50-50 that it could even be successful. In other words, it was precisely something that 17-year-old Betty couldn't wait to try.

In February '39, she and a fellow B.H. High grad donned their finest threads, headed for the auto dealership, and managed to put on a show that traveled the necessary yards from the top floor of the building to the bottom to qualify the experiment as a success.

Little did anyone know that Betty had just seen a preview of her professional life staged in the most unlikely of locations and ways. No one would parlay the medium of TV to their professional advantage more than she. The beauty of it, however, was that White never had to sacrifice any aspect of her manner or her humanity to make it in that world. She could be funny and sassy, wholesome and sweet, saucy and edgy, a lady and a tramp, and the screen fell in desperate love with her. She quickly learned what worked on the smaller screen and set about molding her image to fit seamlessly inside it.

A Star Is Born

Betty was a happy kid in a happy household, with parents who instilled in her the confidence, love, and positivity that would become her hallmarks.

Betty Marion White entered the world on January 17, 1922, in Oak Park, Illinois. She would be the only child of Christine Tess White (née Cachikis), a homemaker known by all as "Tess," and Horace Logan White, an electrical engineer.

And if you're looking for early clues to how Betty adopted the cheerful, plucky, indefatigable optimism that would drive her life and career, her mother and father are a good place to start.

It should be noted right up front that the name "Betty" is in fact not short for anything. The word is, Tess and Horace were worried that if they named their baby Elizabeth, she would be nicknamed into oblivion—referred to as Lizzie, Liz, Liza, Beth, Lizbeth, Ellie, anything but her actual name. But the joke was on them, as early on Betty became "Bets" to her friends and ultimately even her folks.

Oh well. You know what they say about the best-laid plans.

The Whites' love affair with their daughter was heartwarming and obvious in the way Betty talked about them even nearly a century later. Her childhood was a blissfully happy one, having arrived on the scene just eleven months after her parents had wed.

In her 1995 book *Here We Go Again: My Life in Television*, Betty described how her parents included her in everything—all the family talks and decisions. She believes her parents were the best in the world, and even though she was an only child, she never felt lonely because she had so many friends, her favorite of whom were her folks.

Tess and Horace certainly raised Betty right, teaching her to be independent, to treat others with respect, and to keep her attitude positive. Oh, and they also showed her how to appreciate animals. Did they ever. She loves all of God's creatures. Dogs. Cats. Horses. Lions. Tigers. Bears. She loves them in zoos. She loves them in nature. And they love her back. That all started pretty much the moment infant Betty emerged from the womb.

Betty was quoted by Lori Golden of *The Pet Press* as saying, "When I was brought home from the hospital, my mother later told me that we had an orange marmalade cat, Toby. If Toby hadn't approved of the new baby, I would have been sent right back to the hospital."

Tess and Horace moved the family from Illinois to Alhambra, California, a 20-minute drive from downtown Los Angeles, when Betty was just 18 months old. As she grew, Mom and Dad doted on their daughter and even included her in the grown-up discussions around the dinner table.

"There wasn't a straight man in the house," Betty told *Closer Weekly*. "My dad would always ask me how things were, and somehow we'd get into silliness and fun. I think those [talks] went a long way in teaching me how to appreciate the positives [in life]."

Betty's idyllic upbringing included lengthy vacations when the three of them would pack to hike in the High Sierra or drive up to Yellowstone National Park for lengthy summertime backpacking trips and campouts, as she described in *Closer Weekly*. "The guide would take the horses out and leave us there," she recalls. "We wouldn't see anybody for three weeks."

Things got tough for the Whites, as it did for most people, once the Great Depression hit in the 1930s. Horace White would construct radios, theoretically to sell for extra cash. But according to *The Pet Press*, Betty said, "The problem was, nobody else had money to buy radios, either. So [Dad] would trade them for dogs. Well, the dogs

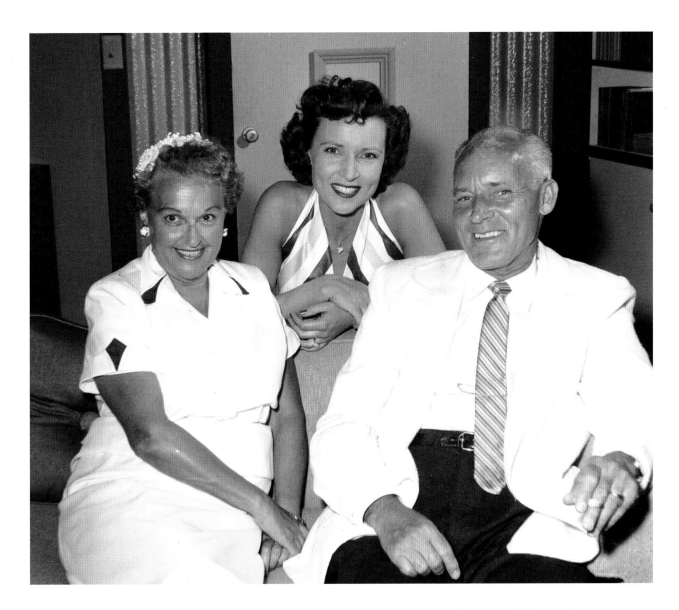

ate and the radios didn't, so it wasn't the best business decision he ever made."

The idea, White added, was to give the dogs better homes than they'd had—which sometimes meant simply getting them off the street. She once recalled that her parents were the only ones in the neighborhood who would come home with a dog and reason, "Betty, he followed us home. Can we keep him?"

As Horace and Tess were apparently incapable of saying no to a homeless pooch, the number of dogs they accumulated as both foster and forever dog parents grew a tad ridiculous. They were in fact their own de facto pet rescue/animal shelter, housing as many as 26 dogs as the canines made their way to new homes. From Pekingese to chow chows to cocker spaniels and German shepherds, the Whites loved and cared for them all.

And so it would go for the rest of Betty's very long life. She has never been without a dog (or several) by her side. And every pooch is a testament to the loving influence of the parents she adored. ▪

ABOVE: Betty flanked by parents she called the best ever, Tess and Horace White.

A Natural Entertainer

From an early age, Betty was an instinctive performer,
and the radio gave the world its first taste of her talents.

With all of her hiking around with Mom and Dad throughout her earliest years, Betty was dead set on becoming a forest ranger. But she still had enough of the ham in her to try her hand at radio drama in 1930 as a spunky eight-year-old, little more than a year after the stock market crash had sent America and the wider world tumbling into an economic quagmire.

Mind you, radio as a dramatic medium was still in its nascent phase, the first play having appeared just a few years before in 1924. Remarkably, some of Betty's radio work from more than 90 years ago survives in recordings of the drama *Empire Builders*, sponsored by the Great Northern Railway Company.

The series told stories meant to highlight moments in American history, with a focus on (surprise, surprise) the development of the railroad. While most of *Empire Builders* episodes have been lost to time—radio wasn't routinely recorded back then—a few shows have been salvaged from the fog of time, including a couple starring a very young and very charming Miss White.

The oldest clip within easy internet reach originally aired on December 22, 1930, over NBC's "Blue Network." It finds Betty depicting Ann, a crippled orphan in a hospital who has quickly grown close to a new patient named Steven Burroughs, aka Uncle Steven, a wealthy bachelor who has taken an affectionate interest in the little tyke.

He asks her how long she's been in the hospital, and 10-year-old Ann tells him a sad story of her getting hurt as a baby in the same accident that killed her parents and landed her in that hospital, owned by her great-aunt, eight years before. The tearjerker of a tale has Uncle Steven ask her, "And have you no other home than the four bare walls of a hospital?" But indefatigable Ann isn't down about the hand she's been dealt. No siree, she's in love with the trees and the bees, and the flowers, roses in particular.

The episode concludes with Ann having charmed the pants off Uncle Steven, who has gotten in the habit of giving the adorable sprite a daily bouquet of the roses she so loves. As Christmas approaches, though, Ann has grown distraught over the absence of her would-be benefactor, but then he suddenly shows back up at her hospital bed.

Ann is ecstatic to see her adopted Uncle Steven, who asks the girl to peer through a pair of binoculars at a large house on a distant mountain. Cue the magic and the joyous Christmas miracle:

> **Betty's earliest performances often worked around the theme of a hard-luck orphan who finds a happy ending . . .**

Uncle Steven: "I'm going to take you away from here this very afternoon to live on the inside of that house, Ann."

Ann: "Oh, it's too wonderful to be true! Maybe when I wake up, I'll be in the hospital again."

Uncle Steven: "Never fear. When you wake up, Ann, you'll be in your own home way up on the hill. And when you're well, we'll travel all over the

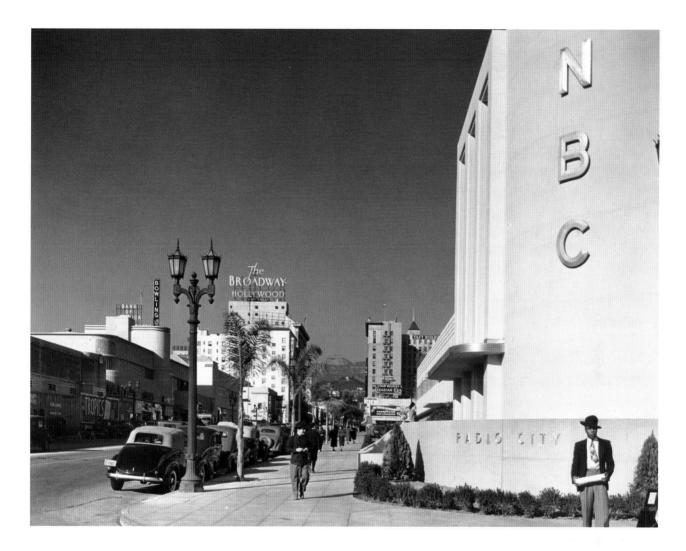

world and see what's on the other side of those hills."

Ann: "On the Empire Builders?"

Uncle Steven: "Yes, on the Empire Builders."

Ann: "Oh, Uncle Steven!"

Indeed, Betty's earliest performances often worked around the theme of a hard-luck orphan who finds a happy ending thanks to her irrepressible spirit. In another *Empire Builders* episode, Betty plays a baby who has been abandoned on a train and coos her way into the hearts of those who are left to care for her. That episode premiered on January 5, 1931, just 12 days before Betty's ninth birthday.

That child actor radio work planted the seeds that would mature into one of the longest careers in all of showbiz history. Betty would later find paying work as an adult on radio in commercials as well as in such shows as *The Great Gildersleeve, Family Theater, Blondie,* and *This Is Your FBI.*

But it all started for her while she was still in the single digits in age, before she even knew that the performing life was her destiny. ▪

ABOVE: Approaching Hollywood's heyday in 1930, NBC Radio City can be seen in the foreground along Wilcox Avenue, with Hollywood Boulevard to the north.

BETTY WHITE

Young Bets Takes the Stage

Ambitious from the start, Betty wrote, directed, and starred in her own production before she even hit her teens.

It was in the third grade that Betty, fresh from her radio stint on *Empire Builders*, had her first (but far from only) experience with stage fright. As she recalled in her 2011 book *If You Ask Me (And of Course You Won't)*, she had to recite a poem for her class, and when she got up to do it, the panic washed over her.

She doesn't remember the details of how the recitation went, but she does vividly recall what it felt like to be afraid of getting up in front of people to perform. Scary as it was for her, young Betty survived that wrenching moment intact—so intact, in fact, that she continued to work on stage throughout her youth, including all through elementary and high school. At 13, she earned the honor of writing, producing, and directing the play that marked her graduation from Horace Mann School in Beverly Hills.

By now she had learned a disappointing lesson about the world: since she was a girl, she couldn't be a forest ranger. Their loss. Adolescent Betty decided to instead set her sights on a career as a writer. For one thing, it didn't matter what your gender was in writing. Anyone with a brain could do it. Performing was also open to both guys and gals, but being a scribe was where her heart resided. Or so she believed at the time. And she evidently wasn't going to let the stage fright she'd felt in grade school boss her around. She wrote herself into the lead of the play as well as gave herself other more minor roles. She was essentially the show.

The production was a tearjerker called *Land of the Rising Sun*, and it emerged out of her class's study of Japan at the time. Demonstrating that she was both ambitious and practical, Betty also crafted the prologue for the show. She explained in it that the production was designed to be traditional Japanese/Kabuki theater and therefore props would be held by nonactors. For example, the play opened with a princess (Betty) having a conversation with a nightingale, so in keeping with Kabuki tradition, a football player stood there holding the birdcage.

Her stage fright was still there throughout the show, Betty remembers. But it was accompanied by another feeling: exhilaration. According to the 2021 book *When Women Invented Television* by Jennifer Keishin Armstrong, as the audience was held spellbound by her performance, she thought, *Well, isn't this fun?*

Writing *shmiting*, she had found her calling in entertaining people with her acting, and she couldn't wait to get out there and in front of as many people as she could.

It didn't hurt that Betty received a standing ovation at the end of the show, helping her to forget the terror that had gripped her. But think about the ambition it required to write and produce and direct and star in a stage production while barely in her teens. That striking work ethic would soon serve Betty very well. And of course the world would love her for it. ◾

Opposite: Betty received her first standing ovation at the Horace Mann School in Beverly Hills.

A Graduation Song to Remember

Even at a place like Beverly Hills High, Betty stood out. She was the clear choice to sing at her graduation, though the song selection was much less obvious.

One of the great little-known facts of Betty White's early life was her obsession with singing. If she couldn't be a forest ranger or a writer or a zookeeper (her top three choices of profession through her youth), she was determined to become a songstress. She studied opera and took singing lessons as a high school senior, and she was good enough to be asked to work those pipes at her senior class graduation from Beverly Hills High in 1939.

Betty was delighted to be picked, though she was somewhat less overjoyed about the song. In her book *Here We Go Again: My Life in Television*, she said she couldn't recall who chose the tune, but she suspected it was her singing teacher, Felix Hughes, who was a very serious man and also the uncle of Howard Hughes.

Indeed, there was 17-year-old Bets, alone onstage, singing a song that she herself would admit was "a tad lugubrious." It's called "A Spirit Flower," and it was written by B. Martin Stanton and composed by Louis Campbell-Tipton in 1908.

My heart was frozen even as the earth
That covered ye forever from my sight
All thoughts of happiness expired at birth
Within in me naught, but black and starless night
Down through the winter sunshine snowflakes came,
All shimmering like to silver butterflies
They seem to whisper softly thy dear name
They melted with the teardrops from mine eyes
But suddenly there bloomed, within that hour

OPPOSITE: Beverly Hills High as it looked when Betty walked its halls.

When the Showbiz Bug Bit

During her junior year in high school, Betty starred as Elizabeth Bennet in a production of *Pride and Prejudice*. Playing such a witty and lovable character with an impertinent streak and a propensity for turning down proposals (see "When Betty Met Allen" on page 62) likely suited her quite well, thank you very much.

And it was in that role that she had a feeling her future would be as a performer. She's quoted in the book *Women Pioneers in Television* by Cary O'Dell as saying, "That's when the [showbiz] bug really hit."

In my poor heart so seeming dead, a flower
Whose fragrance in my life shall ever be
The tender sacred memory of thee

Keep in mind, this graduation was *before* the war. The song was, theoretically, chosen to inspire a group of graduates just starting out their adult lives. In front of a sea of happy faces, anticipating all the world is about to offer them, there was Betty, singing about thoughts of happiness having "expired at birth" and a flower that bloomed on a former lover's grave. Good luck, Class of 1939!

Not exactly "Happy Days Are Here Again." Why, then, does Betty still celebrate her strange high school performance as a key moment in her life? Because it would lead to her television debut, pretty much before the medium itself even existed. ∎

That New Thing Called Television

Betty helped get TV off the ground (literally) in the very earliest days of the medium.

It was kismet.

A man in the crowd at Betty's graduation ceremony at Beverly Hills High saw her singing performance and was somehow able to get past the awful lyrics. A month later, Betty and the Beverly Hills High senior class president, Harry Bennett, were invited to take part in an experimental television transmission signal test.

It should be noted that this predated by more than two months RCA's broadcast on April 30, 1939, at the opening of the New York World's Fair that had marked the beginning of regular television programming in North America. That transmission had gone out via NBC and was the first chance the general public had to see TV in operation on a mass scale. It featured a speech from President Franklin Roosevelt, which has sadly been lost to the ages.

Betty's big television debut, "big" being a relative term here, was to take place at the Packard Motor Car Company building in downtown Los Angeles in February of '39. It should be noted that, like Roosevelt's historic first television appearance, all evidence of this momentous piece of history has disappeared, and in fact the building where it happened has been converted to residential lofts. It would live on in Betty's memory, however, as an important moment on her way into showbiz and set the course of her professional life.

In the presentation, Betty and Harry danced and sang to the light operetta *The Merry Widow* from Franz Lehár. This met with Betty's approval, since her idol Jeanette

MacDonald had starred in the role on-screen just five years before, back in '34.

There the two high school grads were, tucked into a tiny room at the top of the Packard building. The dealership was owned by Earle C. Anthony, a broadcast pioneer and a legendary name in Los Angeles radio lore as the founder of 50,000-watt station KFI. Now, his car lot was serving as the site of an exciting new experiment foretelling a new medium.

Betty wore her white tulle graduation dress with blue halter, which she hoped would flutter and flounce to great effect as she waltzed around the makeshift studio with her partner and fellow grad. The space was nothing more than an office on the sixth floor that had been temporarily taken over for the transmission.

The production was not exactly the most comfortable of affairs. Betty recalled in *Here We Go Again: My Life in Television* that she and Harry were caked in dark brown makeup and even darker lipstick in the hopes that they wouldn't appear washed out on-screen, but Betty likely believed it wouldn't run off her as she poured sweat under the glaring lights.

"I still remember how steamingly hot it was under those lights," Betty recalled while being honored at the 2008 Television Academy salute *Betty White: Celebrating 60 Years on Television*.

Viewing this experiment was a small audience that included both Betty's and Harry's parents and a handful of others, who

"I still remember how steamingly hot it was under those lights."

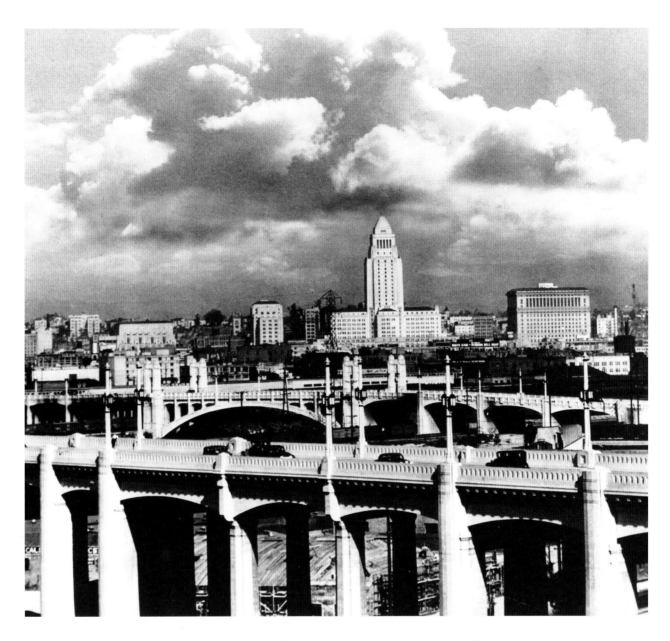

met the historic occasion with an appropriate level of elation and anticipation. They stood on the ground floor in the middle of the Packard automobile showroom amid a collection of gleaming new cars, watching on a small monitor what was going on six floors up. That's as far as the telecast could travel in that pioneering incarnation of an audio/video communication.

"The picture went all the way down to the lobby!" she exulted.

Indeed, it worked. The Whites and the Bennetts were able to see their kids singing and waltzing together.

While this audience may have been considerably smaller than the thousand or so people who were able to witness the East Coast RCA broadcast from the World's Fair, Betty was there in the first West Coast transmission—in fact, the first successful TV transmission, period—and she's still pretty dang proud of that. ▪

ABOVE: The Los Angeles skyline facing downtown in the 1930s, just about the time Betty White was experimenting there with TV.

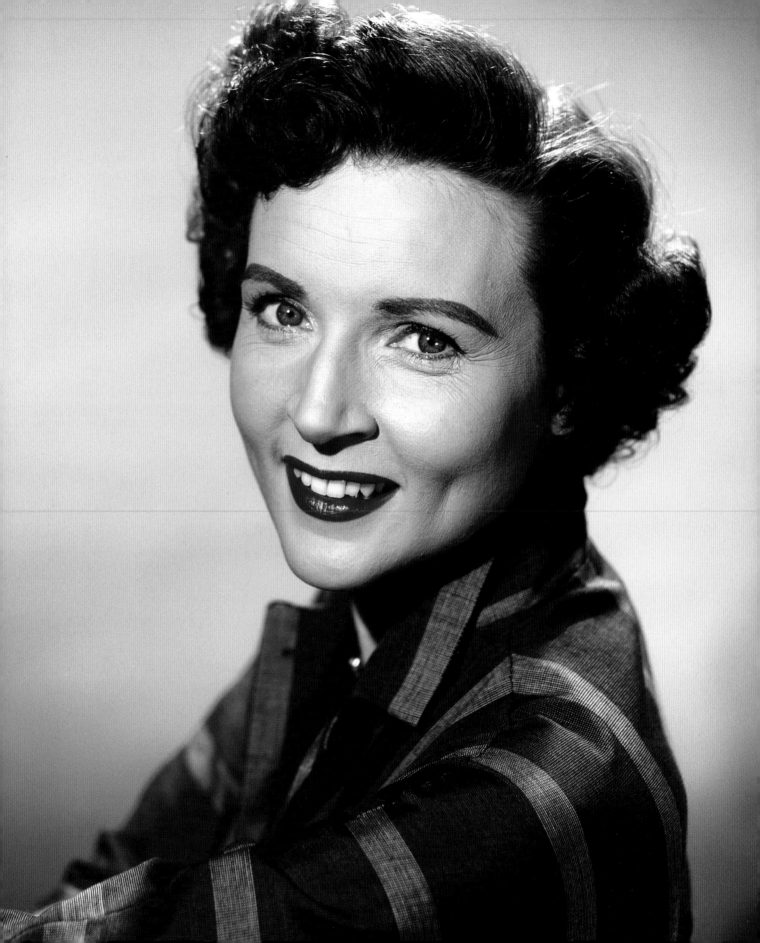

The 1940s

Service with a Smile

"'Would you like to join a union?' he asked.
Of course, I told him 'yes.' 'It will cost you twice as
much as the job will pay,' he said, but that was all
right. I was grateful. It was a beginning."

—Betty White on starting out

OPPOSITE: Betty in the 1950s, flashing the smile that would inspire people to dub her America's Sweetheart.

Country, Career, and a Well-Earned Break

..

Twenty-year-old Betty White's career aspirations were put completely on hold after the United States was drawn into World War II following the Japanese bombing of Pearl Harbor in Hawaii on December 7, 1941. She joined the American Women's Voluntary Services (AWVS) to do her part for the US's war effort.

Indeed, on any given day (or night), you could see Betty driving a truck through the hills of Hollywood and Santa Monica, carting supplies to the bivouacked (a nightmare word in a spelling bee) troops in gun emplacements. And she surely looked the part in her garrison cap, military jacket, collared shirt, tie, and skirt. She'd also host dances for our boys poised to be deployed overseas. Mind you, the lady didn't see any of this as getting in the way of real work. No, she thought it was instead an opportunity and an honor to help out in any manner possible during such a difficult and surreal time.

Once WWII was effectively in the rearview mirror, Betty was smacked with an assessment that would prove wholly ironic and inaccurate as the years piled up. Talent scouts and producers weren't at all sure that this "radio with pictures" known as television would work for White, as she purportedly wasn't enough of a looker. Seeing her lovely pictures from that time today is to question the sanity of those maligning her appearance back then. Nonetheless, she struggled.

In order to keep her acting chops sharp, Betty enrolled with a small theater group that charged performers a tuition of sorts to work onstage. For 50 bucks a month, she was considered for each of its stage productions, and darn if she didn't quickly become one of its superstars. This was the dawn of what would come to be seen as The Betty White Effect. That is, the woman was such a quick study and tireless worker that she could parlay her photographic memory and innate talent (in tandem with her unbridled optimism) to impress all in her midst. So it was at the Bliss-Hayden Little Theater, where Betty received an invaluable acting education.

Still, it was tough for Betty to land work she didn't have to pay for (and would pay her instead) as the 1940s wore on. One fateful day in 1947, White was in the process of again getting turned down for radio work when Fran Van Hartesveldt, the producer of the popular comedy *The Great Gildersleeve*, decided to give the kid a break. He clued her in that she'd never get a job until she joined the union, and she couldn't do that unless someone tossed her a qualifying job. He was willing to throw her that bone, with a commercial gig saying a single word: "Parkay," as in the margarine of the same name.

Never has an actor generated more from less. As soon as Betty had her American Federation of Radio Artists card, she was able to work in her chosen field. Not that she earned a mint or anything close. Her paychecks averaged about $5, but at least she didn't have to pay her employer. Baby steps.

Just before television was to reenter Betty's life in a profound way, she took a significant (but brief) detour into the motion picture business in a forgettable feature called *The Daring Miss Jones*. It was in fact another one of those experiments in film. Remember the 1939 one she was involved

with that tested TV transmission? Well, this movie was an opportunity to assess the merits of a company's color film. The feature, less than an hour in length, co-starred Betty as the leading lady's best friend and also starred a pair of orphaned bear cubs. And wouldn't you know, it was helping to wrangle the bears on the set that White recalls most vividly from the experience of shooting the film in the wilderness.

But Betty understood she wasn't destined to be a movie star. She didn't foresee herself becoming a TV star either. TV, after all, was still barely on anyone's radar; it was seen as a technology of the future at best. Radio was where she was still seeking her fortune in 1949 when she caught on with the new local Los Angeles television station KLAC.

Her life in television began with singing on a special with radio personality Dick Haynes, which led to hosting a 15-minute comedy program. Then she had a stint on an early game show called *Grab Your Phone*. It was from this venture that Betty was given the exciting opportunity to increase her salary to $50 a week and work with a transplanted radio guy named Al Jarvis on a daytime TV show called *Hollywood on Television*. It wasn't long before White and Jarvis were co-hosting a frenetic mélange of interviews, sketches, surprises, and repartee that stretched to five and a half hours daily, six days a week. Every moment of it was live and improvised, including commercials read and performed on the fly. It was, as Betty would later observe, the greatest training ground imaginable for someone looking to hone their entertainment skills before an unblinking camera.

> ## Betty never betrayed a shred of anxiety despite being involved in things no one had ever done before.

As the months piled up, Betty's salary on *H.O.T.* (as the show was known behind the scenes) swelled to $300 a week. A cavalcade of celebrities dropped by to sing and play. Not bad for a gig that had originally been sold to her as a "Girl Friday" role. It turned out to be Girl Monday, Tuesday, Wednesday, Thursday, and Saturday, too. By the time 1950 rolled around, White was well on her way to not only steady employment but actual stardom. It wasn't that she was a young phenom, exactly. In fact, Betty was nearly 28 when *Hollywood on Television* launched. But she was proving the quickest of quick studies and was making up for lost time at an impressive clip.

At the same time, she demonstrated an amazing ability to embrace the new and throw herself into the deep end of the pool without fear of going under. Betty never betrayed a shred of anxiety despite being involved in things no one had ever done before and she'd never been taught to do. She simply picked everything up on the fly and winged it. Betty could sing. Betty could dance. Betty could interview. Betty could tell jokes. Betty could sell soap. Betty could roll with the punches. And Betty could do it all with a smile and a twinkle.

During a time when there were few big names and no rules in television, Betty made it up as she went along, going on instinct. Yet it never felt like a big deal to her. She was just being Betty, and that has always been more than enough.

Betty the Truck Driver

Driving a supply truck in the Hollywood Hills was a surreal experience for her, but Betty worked as hard for her country as she did on her career.

Betty was just two and a half years out of high school and a little more than a month shy of turning 20 when Japan bombed Pearl Harbor on December 7, 1941, drawing the United States into World War II. She'd been frantically looking for work in entertainment since her graduation from Beverly Hills High but put her own showbiz dreams on hold to serve the war effort.

Immediately after the Hawaiian attack, White joined the American Women's Voluntary Services, or AWVS. The AWVS was founded in 1940 on the belief that America would surely soon enter WWII, and less than two years later, that belief would be proved correct. The organization was based on the British Women's Voluntary Services that had already been established in England, which had been fighting since Germany's invasion of Poland in 1939. During the war years, the ranks of the US version soared from 18,000 to 325,000.

Most of those who belonged to the organization weren't performers on sabbatical but women from all walks of life who were sacrificing their time and energy for a cause greater than themselves. Their ranks did include a few famous women of the time, including Oscar winners Hattie McDaniel (*Gone with the Wind*) and Joan Crawford (*Mildred Pierce*).

The AWVS members filled a void on the home front that servicemen could not, because they were busy fighting in Europe and the Pacific. The women sold war bonds, delivered messages, and drove ambulances, motorcycles, and trucks. They also worked in navigation, aerial photography, fire safety, and aircraft spotting. The idea was to aid our troops in any way they could and also protect the mainland from possible attack.

Betty procured her driver's license for the express purpose of working for the AWVS. For the next four years, she drove a truck transporting PX supplies up to the bivouacked troops in both the Hollywood Hills and the hills surrounding Santa

The AWVS Creed

I believe in God our Almighty Ever-Present Father, and I pray that He will guide me always to do unto others as I would that they should do unto me, and that I shall always love my neighbor as myself in the truest sense of the word and understand her better. I promise and pray to uphold the laws of this our great democracy, and to defend it with all my might, so that in years to come our children and those of the world over may still exist and through our efforts thrive.

Monica on the water. Clad in a garrison cap, military jacket, collared shirt, tie, and skirt, she ferried toothpaste, soap, candy, and whatever else was necessary to sustain servicemen and servicewomen set up in the various gun emplacement outfits.

"It was a strange time and out of balance with everything," Betty recalled in an interview with *Cleveland Magazine*. She also wrote about the experience in her book *Here We Go Again*, noting that at night she would help out hosting dances for the troops who were poised to be deployed overseas. She often attended these events in military rec halls, helping to take the boys' minds off what was to come by dancing with them, playing games, and just lending an ear or an anecdote of her own.

When Betty looks back on the war years, she describes those memories as being more like watching a movie than something she actually experienced. ■

OPPOSITE: Women were called into until-then nontraditional roles, like truck driving, during World War II.

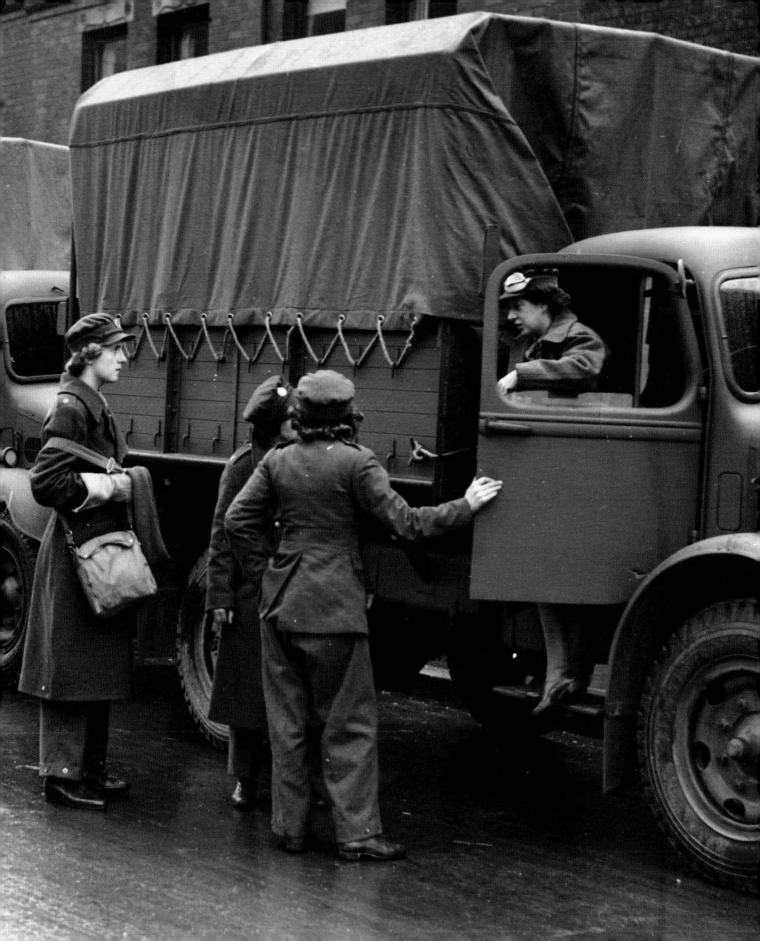

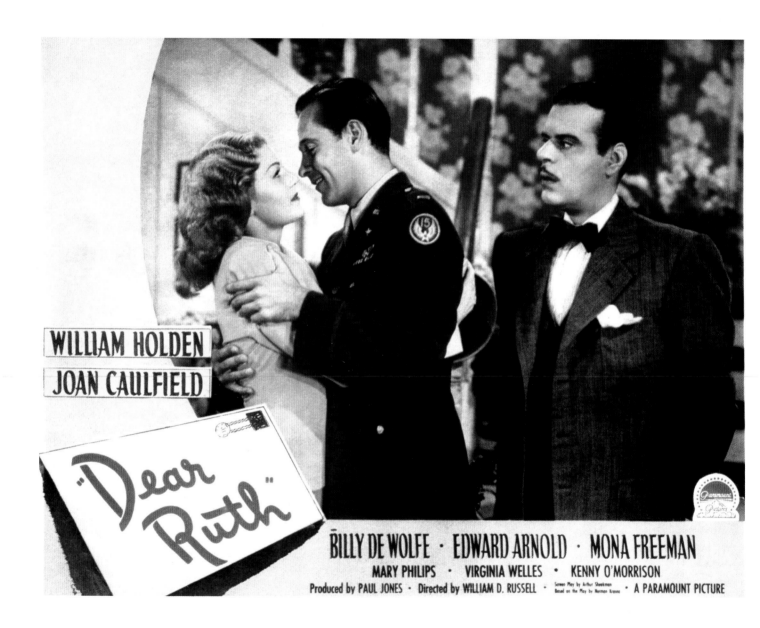

WILLIAM HOLDEN

JOAN CAULFIELD

"Dear Ruth"

BILLY DE WOLFE · EDWARD ARNOLD · MONA FREEMAN

MARY PHILIPS · VIRGINIA WELLES · KENNY O'MORRISON

Produced by PAUL JONES · Directed by WILLIAM D. RUSSELL · Screen Play by Arthur Sheekman · Based on the Play by Norman Krasna · A PARAMOUNT PICTURE

Pay to Play

Struggling to break into the biz, Betty turned an old saying on its head: all work and no pay made Bets a rich gal.

After the war, Betty struggled to recharge her emotional fuel tank and refocus on her career. It was difficult to do, but she was persistent. She landed a few modeling gigs but was consistently told that she wasn't "photogenic" enough to make the transition to film or the fledgling "radio with pictures" medium known as television. (Some 72 years and hundreds of TV credits later, Betty continues to have the last laugh. But we digress.)

Left with few other show business options, Betty landed her first professional gig onstage. But saying "landed" may actually be stretching the term a tad. Just outside of the Beverly Hills city limits resided the Bliss-Hayden Little Theater that was owned and operated by the husband-and-wife film character actors Lela Bliss and Harry Hayden. They were bit players often cast as characters like "new hotel guest," "bartender," "gabby woman on telephone," and "taxi passenger."

As their careers trundled along, Lela and Harry were determined to give back to their profession and earn a few bucks in the process. They offered a stage for aspiring actors and actresses to hone their craft in front of an audience. There was pay involved; however, it wasn't the performers who made money but Lela and Harry.

As Betty explained it in her book *Here We Go Again*, the couple would present a new play every four weeks. By paying a "tuition" of $50 a month, a performer could try out for each succeeding production and either find a role in the play or (failing that) earn a spot on the stage crew.

So, Betty got 50 bucks together and went to the playhouse. She must have instantly wowed Lela and Harry, because they cast her as the young lead in the next play they were putting up, Philip Barry's *Spring Dance*. She loved it so much that she recommitted herself to making performance her life's goal.

Each play at the Bliss-Hayden ran eight performances before the next one was put into rehearsal. *Spring Dance* would lead into the wartime romantic comedy *Dear Ruth* by Norman Krasna, which at the time was still riding the crest of a triumphant 1944 Broadway run.

Betty was excited to move forward as long as her money held out. At least the Great Depression and the war were now behind everyone, so cash and opportunity weren't in quite such short supply.

As Betty remembers it, just before closing night of *Spring Dance*, Lela and Harry called her into their office. She assumed a negative critique of some sort would be forthcoming, if for no other reason than actors—especially young and unproven actors—are dreadfully insecure and poised constantly for the other shoe to drop.

To her delight and surprise, instead of criticism, they had nothing but good news. Not only did they want her to play the title character in their next show, *Dear Ruth*, but they wouldn't even charge her to do it! Fancy that. She could hardly believe her luck or their generosity. She was going to be the lead, and she wasn't even going to have to fork over cash for the privilege!

The Bliss-Hayden work proved to be a key in young Betty White's development as an actress, bringing her the kind of experience and exposure that helped move her to the next level. And by "next level," we mean work that didn't leave her in a financial hole. ∎

OPPOSITE: The play *Dear Ruth* was such a hit that it was made into a movie in 1947.

Just Say "Parkay"

After Betty knocked on every door in town, determination gave way to disappointment. But then one door cracked open, and in went Betty's foot.

Sometimes, it all just comes down to good fortune. Of course, you know what they say about luck: you create your own.

In the case of Betty, she was struggling to land work that she didn't have to pay for and that would compensate *her* instead. The charge that she wasn't sufficiently photogenic continued to ring in her ears, driving her to seek work in radio plays and advertising. But every door that she knocked on refused to open. She showed up at the weekly casting day for every show she knew of but got the same answer each time: "Nothing today." She'd thank them and leave.

Betty kept at it, though, hoping that if she made herself ubiquitous enough, they'd recognize her and—who knows?—maybe even start to book her. Betty recalled in her book *Here We Go Again* that she thought she might trick them into thinking they'd hired her before and therefore employ her again if they kept seeing her around the office.

Sure enough, her persistence paid off. There came a day when she was ushered past the front desk to meet with an actual producer from the ad agency responsible for putting on the popular radio comedy *The Great Gildersleeve*. The producer, a fellow named Fran Van Hartesveldt, pointed out to Betty that unfortunately she couldn't be hired without first joining the union, the American Federation of Radio Artists (AFRA). But in order to join, she needed first to book a job.

This absurd paradox was almost the final straw for Betty. Almost.

She left Van Hartesveldt's office feeling deflated and hopeless. It was lunchtime, so everyone was headed to the elevators on the fifth floor of the Taft Building at Hollywood and Vine in Hollywood. Not wanting to strike up a small-talk conversation right about then, she turned to take the stairs when an empty elevator suddenly opened before her.

Betty entered the lift to head down to the street. But just as the doors were closing, a hand appeared to catch it. It belonged to one Fran Van Hartesveldt. Her worst nightmare. He joined her on the otherwise deserted elevator, and the two took a silent ride down as they smiled weakly at each other. Betty couldn't wait for the trip to be over, as they slowly descended past floor after floor.

She was prepared to get the heck out of Dodge as soon as the doors opened. But just as she exited the elevator, Van Hartesveldt changed her life. As quoted in *Women Pioneers in Television*, Betty said, "He took pity on my disappointment. 'Would you like to join a union?' the producer asked me. Of course, I told him yes."

Van Hartesveldt knew how tough it was to get a union card, but he also understood the workarounds you could use to get one. He offered her a job saying one word, "Parkay," the name of a margarine company that was sponsoring that week's episode of *Gildersleeve*. All she had to do was utter the name of the sponsor during a commercial, but he still asked her if she thought she could pronounce it without "lousing it up."

Betty was sure she could, and she would receive a whole $37.50 for her trouble. It cost $69.00 to join the union, so she was actually out $31.50, but Betty didn't care. Even though the job would only pay her half as much as the union card would cost her, it was work, and it would launch her grown-up radio career. (She'd already had that job as an eight-year-old, you may recall.)

Needless to say, Betty was thrilled. All she'd wanted was an opportunity, and now she had it. She just had to be able to say the word "Parkay" twice (once live for the Eastern Time Zone and once for the Pacific) without stumbling or mispronouncing it.

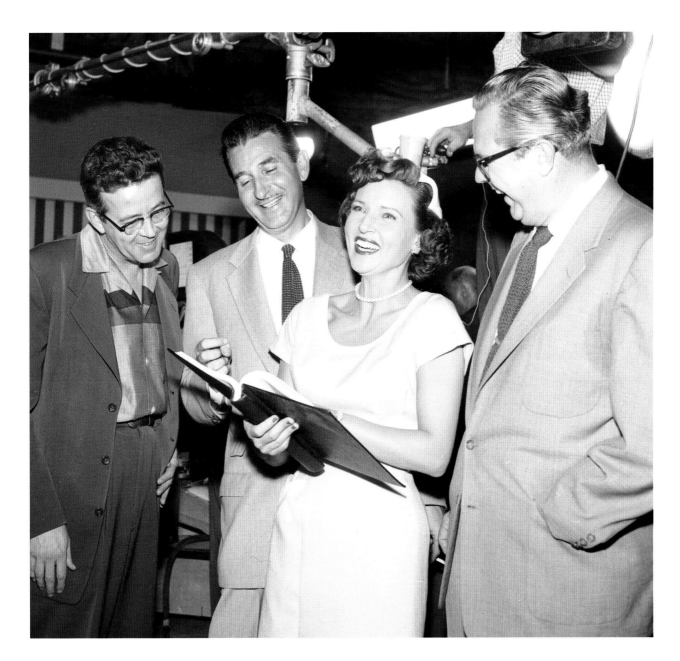

She didn't have the money to make up the difference in the cost of the card, so she called her father to ask for a loan. Having long been her biggest fan, he was thrilled to help out by giving her the money she needed.

Betty experienced a few sleepless nights before doing the Parkay gig, worried that she might accidentally blurt

"Parfait," "Parkway," or some other erroneous P-word instead. But she got the consonant right and made it through unscathed. She thankfully had the script right in front of her—and it was, after all, just a single word.

She would *not* go on to a great career as a radio artist, but things started to roll for her—albeit pretty slowly at first. Sometimes, she would be hired just to supply crowd noise. Her first paychecks averaged only $5 per gig. But it didn't matter. Betty had her AFRA card, so the world was now officially her oyster. ∎

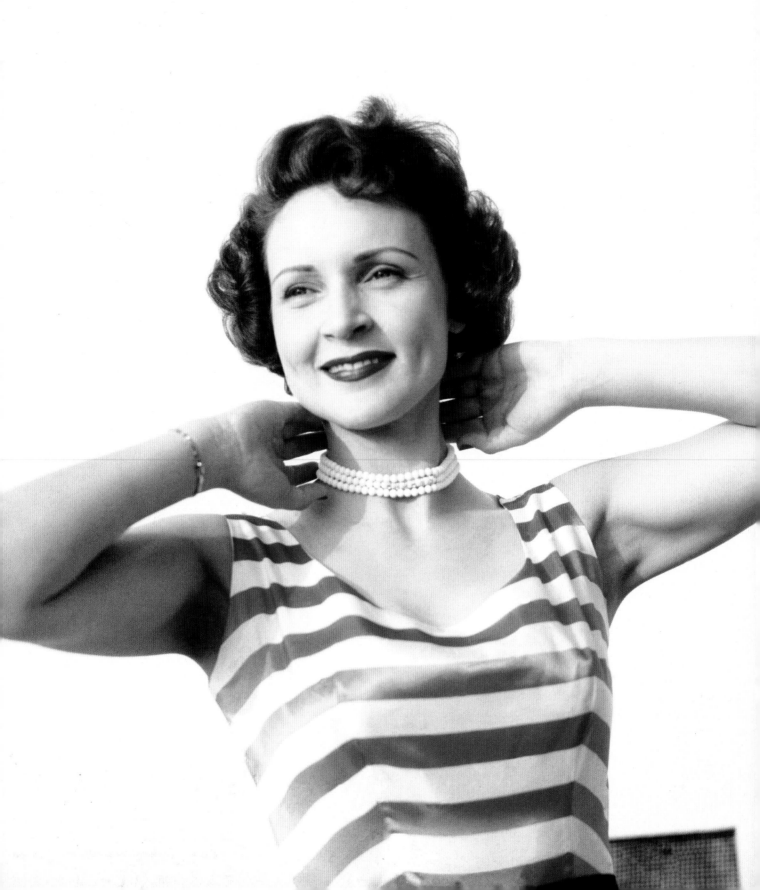

Bearly in the Movies

Betty's film debut was a bit more hands—
and paws—on than she'd expected.

While she never had aspirations to be a movie star per se, it came as a surprise and a thrill when, in 1949, Betty got the opportunity to play a supporting role in a feature film titled *The Daring Miss Jones*. It was made by Ansco Film, which sounds like a big-time studio but was in fact a camera company that primarily made film, paper, and cameras used in photo creation and development.

The idea behind the movie was something of an experimental one, designed to showcase Ansco's new color film. The shoot would run six weeks in the High Sierra and co-star a couple of bear cubs named—drum roll, please—Mike and Ike (yes, like the chewy candy).

While there were several challenges to the shoot, it proved to be mostly a positive experience for Betty. For one, as she revealed in her book *Here We Go Again: My Life in Television*, the 52-minute film's star, Sally Feeney (who would soon change her name to Sally Forrest), became a close friend. Second, she got to hang out for a month and a half with the aforementioned bears, and as we know, bonding with furry four-leggers is one of her favorite things to do.

Betty, animal lover that she is, was asked—and enthusiastically agreed—to be both the "script girl," keeping track of shots, and the bears' unofficial handler on set. She was just starting out and knew that entailed paying some perhaps unconventional dues, because this was show business after all.

This is not to say that watching over bear cubs didn't come with its own set of complications. For one, the bears didn't want to stay cubs. During the few weeks that it took to shoot the movie, they grew to practically twice their initial size. This proved a pretty significant challenge when it came to continuity and matching shots. The animal "trainer" on location was also having a challenging time keeping the sprouting cubs under control, given that he was drunk most of the time.

Betty, too, faced her own set of issues in trying to cake on enough makeup to cover up all the scratches she was getting from the increasingly strong and rambunctious bears that were no longer cute, cuddly babies. As mixed as the memory might be, this event underscores just what a trouper Betty was, making the best of the situation and soldiering on no matter the obstacles.

The plot of *The Daring Miss Jones* found Judy (played by Sally) becoming lost in the remote wilderness of southern Alaska with her father, Hank (James Wilson), and the two orphaned cubs. They discovered an abandoned gold mine that Hank believed contained uranium. All sorts of madcap mix-ups and jeopardy ensue. Betty plays Judy's anxious best friend, who flies a plane in to rescue everyone, including the ever-growing bears.

The film, which still shows up once in a while on Turner Classic Movies, ultimately got released. So did Betty, from remote captivity. She survived the bears and hightailed it out of the woods in time to launch the most important phase of her career. Television beckoned, and Betty White was more than ready for her close-up. ∎

The shoot would run six weeks and co-star a couple of bear cubs.

OPPOSITE: Betty shows off her patriotic striped spirit (and her gorgeous pearls) in 1954.

Hooray for Hollywood . . . on Television!

Kismet can strike when you least expect it. For Betty, it happened completely out of the blue.

In a 1998 interview with broadcast journalist Mitch Waldow, Betty recalled a time when she was looking around for radio jobs in 1949 and inquired at TV station KLAC (whose call letters stood for Los Angeles, California), which was just beginning to air programs for the public. There were in fact fewer than a million TV sets in use throughout the entire country at the time, so the audience was limited but certainly growing.

"They said, 'We have a television thing here. Can you sing?'" Betty remembered. "I said, 'Well sure.' I mean, in those days you said yes to anything. 'Can you juggle? Can you stand on your head?' It was always 'Yes.' Then you think, well, I'll go home and learn to do it before I come back and have to do it."

So, Betty sang the tunes "Somebody Loves Me" and "I'd Like to Get You on a Slow Boat to China." That grew into her hosting a 15-minute TV comedy program called *Tom, Dick and Harry*, which led to doing a game show (her first of more than six dozen) titled *Grab Your Phone*. It found viewers calling in live answers to quiz questions on phones answered by four women, one of whom was Betty. It paid the other phone ladies $10 a week, but Betty got bumped up to $20 because she was so good at ad-libbing. (They asked her to keep that part secret from her fellow answerers.)

This brought Betty to the attention of local Los Angeles radio heavyweight Al Jarvis. In early November of '49, Jarvis made White an offer she couldn't refuse. He increased her salary to $50 a week to be his "Girl Friday" for a new daytime TV show he was putting together called *Hollywood on Television*. The idea had Betty penciled in to do a pair of weekly segments live. They had to be live, as there was no tape or film in those earliest days of the tube.

Before the show even premiered, "Girl Friday" turned into Girl Monday, Tuesday, Wednesday, and Thursday as well. Jarvis intended to put his daily record-playing radio deejay program on camera and wanted Betty to be his second banana. His instruction to Betty was as simple as it was vague: "All you have to do is respond when I talk to you. Just follow my lead."

"When we started doing the show, we'd play records," White remembered, "and while they played, people at home could see us talking and moving around the set. It drove them crazy. They demanded to know what we were talking about. By the end of our first week, the records stopped and it was just five hours of our banter. It was wild."

Indeed, *Hollywood on Television*, or *H.O.T.* as it came to be known behind the scenes, hit the ground running. It was wildly popular from the get-go with its live, improvisational blend of interviews, entertainers, sketches, viewer mail, general repartee, and commercials. Lots and lots of commercials. It ran from 12:30 to 5:30 p.m. each weekday, but it wasn't tough for Betty and Al to fill the time.

After three weeks, *H.O.T.* was such a smash that Jarvis approached Betty about increasing the show's length by a half hour each day (now 12:30 to 6:00 p.m.) and adding a full day's program on Saturdays as well. For the extra work, he offered to sextuple her salary to $300 weekly (the equivalent of nearly $3,300 in 2021 dollars).

Betty was over the moon. She was now essentially vamping on live television for 33 hours a week. That included Thanksgiving, Christmas, New Year's, all holidays, six days a week without fail.

"It was like going to television college," White recalled to Waldow. "We could do anything we wanted. Whatever

happened, happened on camera. Sometimes, Al would open the gate leading to outside our studio and whoever walked by would come in and we'd interview them. It was a grab-bag kind of thing, sort of anything-goes."

Celebrities also dropped by *H.O.T.*, including promising singers named Sarah Vaughan and Peggy Lee, Billy Eckstine, Nat King Cole, Hoagy Carmichael, Johnny Mercer, and Tony Martin. Even silent film legend Buster Keaton appeared once.

"I mean, there was no scripting at all. Al would throw something at me and I'd never know quite where he was going, but I'd try to read him and it made it so exciting because it was like playing an improv game every day—except it was going out live for the city to watch! He might hand me a typewritten note that said only 'GETTING INTO A CARRIAGE . . . GETTING OUT OF A CARRIAGE.' And I'd have to ad-lib and figure out what he had in mind."

At the same time, the hosts were required to read all the commercials in the middle of everything. When we say they did five and a half hours daily nonstop, it really *was* nonstop. No breaks to run the ads. Those were done on the fly simply as part of the programming mix. If Al or Betty had to use the restroom, they would simply excuse themselves while their partner filled the time until they returned.

White recalled that the most commercials she was ever obliged to do in a single day was 58. Fifty-eight!

"And it wasn't like today, where you just shove a cassette or a digital file in," she told Waldow. "In those days, there was no cutting away. They'd hand you a piece of paper from offstage. They had just made the sale in the sales department and the ink wasn't dry yet. So, while Al was talking, I'd be trying to glance down and see what the copy said and then try to ad-lib around the product."

Of course, it worked better on some days than others. Betty recalled a day when a sponsor advertised a new product that made soap come out of a sink's faucet. But no matter how hard she tried, she couldn't think of the word "faucet."

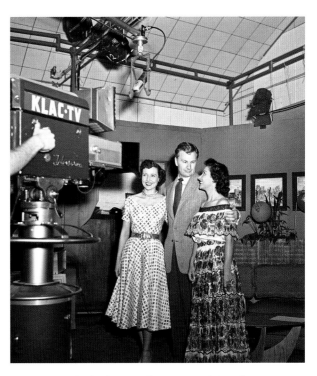

"So, I said, 'And . . . and you press this and soap comes out of your . . . your . . . um . . . your . . . of your gizmo.' And the cameraman was laughing so hard that I saw water coming out of his nose. The tears were literally falling down his face. And that made *us* start laughing. And laughing. And when you're live, there's nobody you can throw it to. We were it.

"Another time, we were doing an ad for Kermin's Frozen Meat Pies, and at the end of the meat pie spot they accidentally played the jingle for Dr. Ross Dog Food. That was very embarrassing."

Hollywood on Television cemented Betty's status as an early TV star. Jarvis would leave *H.O.T.* in 1951, replaced as co-host by film star Eddie Albert for six months. When Albert left, Betty would host the show alone, talking directly into a live camera lens for hours at a time, six days a week. The woman was irrepressible.

Betty soon began inviting on guests to interact with, leading to some clever sketches. One of those routines would spin off into a memorable television series of its own. To find out more about that, read on. ▪

ABOVE: Betty poses with co-host Eddie Albert and an unidentified woman during a live production of her local KLAC-TV show *Hollywood on Television* in 1952.

The 1950s

Lights! Camera! Television!

"A comedienne who somehow seems to have been overlooked this season is Betty White. It is a slight that should be corrected because she is an immensely personable young lady with a very real talent in a number of directions."

—Jack Gould writing for the *New York Times*

OPPOSITE: If apple pie took human form: Betty White shows off her pearly whites in the mid-1950s.

Betty White Took to TV Like a Duck to You-Know-What

...

She was born for the camera. She loved it, and it loved her back. And when they created awards to pay homage to those in the industry, she was one of the first who was honored—first with an Emmy Award nomination (in 1951) and then, early in 1953, with a win over no less than Zsa Zsa Gabor.

While that first award solely took into account Los Angeles–area programming rather than shows on a national scale, Betty had no intention of giving it back. God knows she'd earned it with all of the work she had done on *Hollywood on Television*—five and a half hours daily, six days a week, month after month. And because she's Betty, 33 hours of live, improvisational hosting on camera didn't keep her quite busy enough to satisfy her insatiable appetite for work. When her station, KLAC-TV, approached her about spinning out a short comedy sketch called *Life with Elizabeth* into its own half-hour series, she jumped at it even though she basically had no time in advance of each presentation to rehearse it. Who, after all, needs preparation?

So it was that White and co-star Del Moore performed *Life with Elizabeth* before a live audience each Saturday night in Beverly Hills and televised over KLAC starting in 1951. It was a hugely popular affair on which Betty served as co-producer, with a single writer (George Tibbles) crafting scripts that she and Moore would often forget due to the lack of rehearsal time. Viewers loved the very danger that embodied live television. When *Life with Elizabeth* went on film for national broadcast in 1953, some of that edge was lost. But critics raved about it nonetheless. Just six years after struggling to find radio voice work, Betty was now a sitcom star and—along with folks like Lucille Ball, Sid Caesar, and Milton Berle—the toast of TV.

Once *H.O.T.* and *Elizabeth* rode off into the sunset, White was determined to remain in front of the camera. She was hired to host her own daytime talk/comedy/variety series, helping to usher in a television genre in the process. *The Betty White Show* hit the air in February 1954, chock-full of celebrity guests and singing (her own and that of others). Basically, Betty's charm carried the day. Pretty soon, she was routinely being called America's Sweetheart.

But being nationally syndicated brought some challenges. The civil rights movement was dawning across the country, but Jim Crow laws were still alive and very much well in the American South. Betty had Arthur Duncan, an African American tap dancer who was a regular guest on *H.O.T.*, perform on *T.B.W.S.* as well, and many Southern station managers threatened to pull Betty's show unless Duncan was dumped.

Instead of caving to the pressure, White thumbed her nose at the threats and *increased* the dancer's exposure on *The Betty White Show* with the sentiment "Live with it." The wonderfully talented

Duncan would go on to a long and fruitful career, made possible in part by people like Betty standing up to racist forces. In fact, this would become a hallmark of the Betty brand, if you will. She saw neither color nor gender but merely talent. She wasn't militant about it but was instead simply dismissive of discrimination in any of its various and ugly forms.

This kind of diplomacy drove some to hint that White should consider going into politics. While that never quite happened, Betty did agree to be put on the "ballot" for the Honorary Mayor of Hollywood and was elected to the position in 1954. Though she had all the passion and energy required to be an effective advocate on behalf of Hollywood's interests, it cut into her very active career a bit too heavily for her to stick with it. There was just so much that Betty wanted to do. Her life was a parade, and she intended to do plenty of marching. Speaking of which, the lady put her well-honed improvisational skills to use as a host for the Tournament of Roses Parade telecast on NBC for 19 straight years beginning in January 1955. (She also did a 20th year on CBS.)

Indeed, 1955 is an important year in the Betty White narrative because that's when she served as a guest panelist on *What's My Line?* This launched what would become a career in itself, as a game show celebrity panelist. Appearances on nearly 80 different shows or versions of shows would follow, covering hundreds of episodes. Rumor has it that there was once consideration given to changing the name of the genre from "game shows" to "Bettys." Is it any wonder that Betty would also find a husband sitting in the host's chair of one of these programs? We think not. But that would be a few years down the road.

Meanwhile, Betty started to grow in demand throughout the television universe, including the world of network drama. It gave rise to her appearing in a 1956 guest spot on the hit series *The Millionaire*, whose gambit involved an unseen millionaire doling out $1 million to a different random individual each week. One week, that was White, whose character hooked up with a dashing Italian count in (where else?) Italy. While Betty herself wasn't yet a millionaire in reality, she was well on her way. But the truth is that money never seemed to matter to her very much. It was all about the work, more of which came her way in 1957 when she was hired to co-star with Bill Williams in the ABC sitcom *Date with the Angels*.

> This would become a hallmark of the Betty brand, if you will. She saw neither color nor gender but merely talent.

Betty and Bill played newlyweds, a common enough theme, but what distinguished the show was Betty's frequent daydreams that allowed her to slip into fantasy worlds. The audience loved the *Walter Mitty*–styled elements; unfortunately, the sponsor, Plymouth, did not. So, they were summarily dropped, the show heading back to standard-issue comedy. Once *Date with the Angels* was yanked from the schedule in the middle of its second season, ABC revived another version of *The Betty White Show* for 13 weeks. It had become a tried-and-true formula: when in doubt, just reboot her comedy/variety series.

While a relatively small blip on White's career arc, *Angels* stood out for another reason. It found Betty hiring a fellow named Fran Van Hartesveldt as a staff writer, the very same Fran Van Hartesveldt who once helped her to procure her union card while an aspiring radio artist ten years before. This would prove an important element in the Betty White formula. Loyalty was embedded in her DNA. She did unto others as she would have them do unto her, and that golden rule served this future Golden Girl flawlessly.

The Emmy Awards Enter Betty's Life

It didn't take long for Betty to make her mark on television's earliest honor roll.

How long has Betty White been around? Long enough that she was already well into her 20s when the Emmy Awards were conceived in 1948 around the idea that this burgeoning medium deserved its own ceremony honoring achievement.

For those first Emmys in 1949, held at the Hollywood Athletic Club, the awards were restricted to television programming serving the Los Angeles area. There were fewer than a million TV sets *total* in the United States at that time.

By 1950, that number would quintuple to five million, to 12 million by 1951, and 55 million by the end of the 1950s, and the Emmys would grow along with those numbers. But that first show was broadcast on a local station called KTSL and was mainly meant just for industry folk.

While Betty wasn't recognized at the very first ceremony, it wouldn't take long for the Emmys to start showing her some love. In 1951, at the 3rd Emmy Awards, she was nominated in the Best Actress category for *Hollywood on Television*.

The honors were presented at the Ambassador Hotel in Los Angeles on January 23, 1951. It was hosted, somewhat shockingly, by Earl Warren, who two years later would be appointed chief justice of the Supreme Court. In hindsight, he was an altogether bizarre choice as Emmy host.

While she didn't win that year, White was in some good company in the category. Her fellow nominees included Judith Anderson for *Pulitzer Prize Playhouse*, Imogene Coca for *Your Show of Shows*, and the First Lady of the American Theatre, Helen Hayes, for *Prudential Family Playhouse*. The winner was Gertrude Berg for her pioneering sitcom *The Goldbergs*.

The following year, Betty was nominated again, this time as Most Outstanding Female Personality for *Hollywood on Television*. Her chief competition: Zsa Zsa Gabor, up for her show *Bachelor's Haven*.

Recalling that night in early 1953 (which was when the ceremony for the 1952 awards was held) in her book *Here We Go Again: My Life in Television*, Betty believed that it was no contest, Zsa Zsa was going to win and that was that. Gabor herself seemed convinced of this as well. She retouched her lipstick, powdered her nose, and put her napkin down on the table, confidently preparing to take the stage as it came time for her category to be announced at the end of the night.

The Early Emmys

The first Emmy statuette ever handed out was awarded to a ventriloquist, Shirley Dinsdale, and her puppet sidekick, Judy Splinters, for the *Judy Splinters* show. She won for Most Outstanding Television Personality. Local Los Angeles station KTLA (the first commercial TV station west of the Mississippi) won a Station Award for Outstanding Overall Achievement.

An engineer named Charles Mesak was given a technical award for the introduction of TV camera technology. The Best Film Made for Television was a half-hour short story adaptation called *The Necklace*, while the Most Popular Television Program honor went to a game show called *Pantomime Quiz*. And a special Emmy was bestowed on Louis McManus for designing the Emmy statuette itself. An *Emmy* Emmy!

Betty was still heart-poundingly excited just to have been nominated and present at the festivities, but she was barely even listening to the announcer. After the winner was revealed, Betty noticed that Zsa Zsa, whom she'd been staring at the whole time, didn't rise from her chair. Then it dawned on Betty that she'd just heard her own name called.

Stunned and thrilled, Betty admitted that it was a pretty big ego boost. Her peers had honored her, and the high from that is something that's stuck with her all the years since. But the award has something of an asterisk next to it. Betty's win was for the Los Angeles Area Emmys competition. It wasn't until the following year that the nominations were considered on a national television network basis rather than just for L.A.

That said, heck, an Emmy is an Emmy, and Betty was now batting .500 at the awards. It was pretty heady stuff for someone who four years before was still struggling to land bit parts in radio plays. It was also something she would have to get used to, as 22 more Emmy nominations and seven more wins would be forthcoming. ■

ABOVE: Betty strikes a classic '50s pose.

Life with Elizabeth

Five and a half hours a day on live TV just wasn't enough for the pioneering star, who was about to land her very own sitcom.

It can be said with a measure of certainty that there has rarely been a performer in entertainment history with Betty's work ethic. Here she was, working no less than 33 hours a week on a live, improvisational program, *Hollywood on Television*. Yet when someone approached her about doing *more*, not only didn't she balk; she excitedly agreed.

Such was the backdrop for the creation of *Life with Elizabeth*, which began its life as a series of five-minute Alvin-and-Elizabeth sketches on *H.O.T.* The station manager at KLAC-TV, Don Fedderson, met with Betty and writer George Tibbles in 1951 to discuss spinning *Elizabeth* out as a weekly half-hour situation comedy. It's the same idea that would drive the creation of *The Honeymooners* out of Jackie Gleason's variety show in 1955. But this was four years earlier. Betty got there first, as she did for seemingly everything.

The plan was set into motion. Tibbles was installed as the writing staff of one. Fedderson and White would co-create and produce along with Tibbles, making Betty the first woman producer of the era through her newly formed Bandy Productions (so named after her dog, Bandit).

"George and I basically took the situations out of the incidents in our own lives," Betty recalled during the 2008 TV Academy salute *Betty White: Celebrating 60 Years on Television*. "It wasn't classy television, but it was fun."

The premise of the show—as it had been for the *H.O.T.* sketches that preceded it—cast Betty and her husband, Alvin (played by the newly hired Del Moore), as an ordinary suburban couple who became embroiled in various comic predicaments. At some point, Alvin would wander off, leaving Elizabeth to ponder the situation and her fate for the camera.

At that point, a busybody observer and de facto third character (played by announcer Jack Narz) would break the third wall as an off-camera voice asking Elizabeth to assess things. Usually, it took the form of him inquiring, "Elizabeth, aren't you ashamed?" White would flash a devilish grin and "Who me?" expression.

Betty told TV critic Tom Shales in 1977, "We didn't worry about relevance in those days. [The stories were] about things like Elizabeth's biscuits not turning out."

Life with Elizabeth was divided into a trio of comic shorts/situations that ran between eight and ten minutes, referred to as "incidents." The music was supplied by a harpist playing solo.

The show went out on the air before a live audience each Saturday night from the Music Hall Theatre in Beverly Hills. It ran only locally in the Los Angeles market during its first year and was directed by another Betty, Betty Turbiville. Because White was continuing to do six days a week of *Hollywood on Television*, she and Moore had to fit in a rehearsal (of sorts) on Friday after work and a run-through on Saturday early in the evening.

While *Elizabeth* was indeed scripted, it often looked and felt like it wasn't, due to the minimal time Betty had to go over it (despite being an especially quick study). As she told broadcast journalist Mitch Waldow, "We were a little light on our lines. We sort of knew them, but we weren't rock-steady as you would be if you had a week's rehearsal—like you do today."

While it usually worked, sometimes it got hairy. In her book *Here We Go Again: My Life in Television*, Betty recounted a scary time when she and Moore both went sideways at the same moment. They were performing a restaurant sketch. They knew that because they were in a booth and the set was dressed for that. But beyond that, they were at a loss.

Moore excused himself from the table to furiously read the script offstage, but that left White sitting there. Alone. In front of a live audience and rolling cameras. All she could think to do was play with the salt and pepper shakers, the only things she had at hand, making them dance for the audience. After the dance number, she built a wall of sugar cubes.

She recalled, "I got so involved with my mindless little demonstration that I was mildly surprised when, after an eternity, Delsy slid back in beside me, delivering a line that would get us back on track."

Moments of panic aside, Betty generally had the time of her life co-starring in *Life with Elizabeth*. And while she co-produced and used a female director, she said, "We never thought of a gender gap. I never found it a handicap to be female back then. Maybe I just didn't know any better."

Nonetheless, history shows that Betty co-created, produced, and starred in her own show decades before the term "glass ceiling" came into popular use. She didn't have to actually shatter any glass because this particular ceiling didn't exist, but that's not to say there wasn't a bedrock of sexism in the industry and culture in general at the time. It was just arguably less visible because it was so enormously pervasive. But nothing could stop Betty. Moreover, she accomplished this feat while back living at home in Brentwood with her parents.

The show would be performed live in front of a theater audience for the first year and a half of *Elizabeth* before it went to film and national syndication from 1953 to 1955. The latter meant shooting in a studio without anyone present to react off of. Betty far preferred having live people to perform for, but film was the price of putting the show out coast-to-coast in the age before satellite transmission.

Elizabeth was sold on a market-to-market basis, with each show put together in the studio using a single camera, shooting the same scene from various angles. It was a decidedly different program than the live incarnation, even if it was essentially the same script.

ABOVE: Raiding the refrigerator on the set of her pioneering sitcom *Life with Elizabeth* in 1954.

To watch several of those filmed shows now is to be charmed by their sassiness, their innocence, and the chemistry and affection between the performers.

The critics of the time tended to agree. *Variety* called *Elizabeth* "amusing and wacky," while Jack Gould of the *New York Times* said, "A comedienne who somehow seems to have been overlooked this season is Betty White. It is a slight that should be corrected because she is an immensely personable young lady with a very real talent in a number of directions, and a high quotient of charm."

Sadly, the live shows are all gone without a trace, but they went a long way toward molding the jack-of-all-trades performer White was becoming while setting the stage for the filmed version of *Elizabeth*. Fortunately, they live on in her. ∎

Color-Blind Ahead of Her Time

Work wasn't the only arena in which Betty had strong ethics.

After four years of toiling her fanny off, *Hollywood on Television* was coming to an end. Betty was offered the chance to host her own live weekly daytime talk/comedy/variety series that carried the straight-ahead name *The Betty White Show* (the second incarnation of this specific title). Unlike *H.O.T.*, which ran for five and a half hours six days a week, this one was just 30 minutes each week.

Finally, the woman could get a little rest.

The Betty White Show launched in February 1954, starting production out of Hollywood and moving after a few weeks to NBC's newly built facility in Burbank. Her new digs were fit for the star she had become, including a carpeted dressing room with her name on the door and her very own private bathroom. She was given her own makeup and hair people and another crewmate who was in charge of her wardrobe.

T.B.W.S. featured celebrity guests and plenty of singing from the host and others, backed by the show's very own band. Betty was briefly dubbed the "female Godfrey" (after entertainer and broadcast pioneer Arthur Godfrey).

In a review of the show, writer Jack Lait was quoted in *Women Pioneers in Television* as describing *The Betty White Show* thusly: "Rolling along at an easy gait, Betty sings a song or two in an untrained but thoroughly competent voice. She interviews visiting celebrities, clowns with [bandleader Frank] DeVol . . . and, all in all, seems to be enjoying herself every minute. The listener catches the same spirit, and the half-hour is gone before you know it."

As quoted in the 2021 book *When Women Invented Television, Billboard* also gushed, "Attractive, charming and talented Betty White is a bright new network personality who

emcees a program that has great potential." And *TV Guide* noted that Betty had "the disposition of a storybook heroine. She is utterly unspoiled. Furthermore, she has talent."

The lady now being dubbed America's Sweetheart was well on her way.

One of the regulars on *The Betty White Show* was Arthur Duncan, a 21-year-old African American tap dancer who had been featured as a guest on *H.O.T.* on several occasions. He would go on to be a regular presence on *The Lawrence Welk Show* for some 18 years (1964–1982), the first such African American performer to star on a television variety show.

Racial strife was alive and well in America. It was a decade before the University of Alabama was officially desegregated. But almost as soon as *The Betty White Show* premiered, an uproar ensued. Letters of protest began arriving from station managers in the South threatening to pull the show if Duncan weren't taken off the show.

Betty was shocked. She could hardly believe that some stations were calling for Duncan to be pulled from the program. She was also defiant. Once the threats started coming in, they began booking Duncan as often as they could. Betty's sentiment was that the protesting stations had to "live with it." Fortunately, NBC backed up the show's stance, though the network perhaps didn't convey Betty's exact sentiments, which were of the shove-it variety.

In an interview for this book, Duncan, now 88, professed that he had no idea at the time that the letters were finding their way to Betty and the network.

"I didn't discover that until years later, when I read about it in her own book," Duncan said, "and I have to say, I was so appreciative when I heard Betty's response. Not that it

surprised me in any way. That was Betty. She wasn't going to take any guff from anyone, certainly not about someone's skin color. She didn't cave in to that pressure when she so easily could have."

Duncan credits White with "opening a lot of doors for me in performing. Her support of me put me in line for all sorts of opportunities that may not have happened had she not put me on her show, and she defended my staying on there. I've had a beautiful career because she started it for me. My visibility was all due to Betty."

Among Duncan's career highlights were touring with

Sophie Tucker, Johnny Mathis, and Mae West in addition to his lengthy run on *Lawrence Welk*. But the list of his thrills is topped by *The Betty White Show*.

"What I remember about doing her show was the great sense of love for one another from everyone who worked there," he recalled. "She also had a great sense of humor. I'm telling you, she's as close to a perfect person as there is."

Duncan got an opportunity to thank Betty face-to-face in 2017 when the two were reunited on the TV special *Little Big Shots: Forever Young*. White knew Duncan would be there, but it was a surprise for him. Seeing each other more than a half century later thrilled them both.

"Oh my gosh, that made me happier than I can say right here," Duncan said. "My life was made." ▪

ABOVE: On the set of *The Betty White Show*, a title that would enjoy four different incarnations throughout Betty's illustrious career.

The Mayor of Hollywood!

Not only has Betty been recognized as the
First Lady of Television, she also was once voted the
Honorary Mayor of Hollywood.

Her unpaid, unofficial position as Hollywood's mayor was conferred on Betty in October 1954 and carried her into 1955. It was not, however, a free election in the technical sense.

Performers from all the local L.A. stations were on the ballot, and the election was open to the public, but they had to pay a dime to vote, and they could buy as many votes as they wanted to. While not a particularly great model for fairness in democracy, the proceeds went to charity. Betty was duly elected in good fun and for a good cause.

It's also true that Mayor of Hollywood isn't a traditionally elected title. Yet she still had to beat some formidable and popular opposition to win. Her fans came out and made her the victor over the likes of Pinky Lee, Hugh O'Brian, bandleader and variety show host Lawrence Welk (who would go on to earn the title in both 1958 and '72), and many others.

More Mayors

Others who were honored with the post include such luminaries as Art Linkletter (1957), Charlton Heston (1962), Steve Allen (1963), and longtime *Let's Make a Deal* host Monty Hall (1975–1980). The last person to hold the title was radio/TV personality and TV producer Johnny Grant (1980–2008). The office has been vacant since Grant's death in 2008.

It's also a fact that White was just the second woman ever elected to the position, after western film actress Barbara Britton (1952).

In truth, there can be no *actual* Mayor of Hollywood because it's an unincorporated district of Los Angeles. The duties of the mayor are mostly ceremonial, including serving as emcee of award ceremonies for new honorees on the Hollywood Walk of Fame (in tandem with the Hollywood Chamber of Commerce).

Another thing you're expected to do as the Mayor of Hollywood is produce the annual Hollywood Christmas Parade and serve as an ambassador representing Hollywood at shows overseas for our troops.

Betty certainly had the drive, the energy, and the enthusiasm necessary to oversee Hollywood's interests at event after event. But it also required an awful lot of time during a moment when she was still working to establish herself as an actress and all-around performer. So, you can imagine where it might have quickly created something of a conflict.

White's career was indeed just starting to heat up. She had charmed the nation's critics with her turns on both *Life with Elizabeth* and *The Betty White Show*. She was hoping to keep that momentum humming. Putting everything on hold to work as a Hollywood ambassador—while certainly a skill that came naturally to Betty—served in almost every way to stop her professional trajectory cold.

Nevertheless, the Honorary Mayor of Hollywood title proved a giant feather in White's cap and more evidence of her ongoing evolution into a show business stalwart. ■

OPPOSITE: Betty checks out her own busy schedule in *TV Guide* while on the set of *Life with Elizabeth*.

Days of White and Roses

A master of improv, Betty was ideally suited to play host to the Rose Parade.

When *The Betty White Show* ended, Betty didn't have much time to mourn its passing. The very next day after hosting her final edition of the show, she was asked and agreed to co-host the Tournament of Roses Parade on New Year's Day alongside Bill Goodwin (the announcer on the *Burns and Allen* radio show) for NBC.

She had no way of knowing it at the time, but it was the first of what would be 20 straight years as Rose Parade host (19 at NBC, a single one at CBS).

The 1955 New Year's Day show was poised to be a star-studded affair. It featured as Grand Marshal that entertainment icon Supreme Court Chief Justice Earl Warren—who apparently was having more fun chasing showbiz than he was making legal decisions—along with a bevy of western luminaries, including Roy Rogers and Dale Evans, Andy Devine, and Hopalong Cassidy. And while this was to be the last Rose Parade presented by NBC in black-and-white, it offered for the first time pictures transmitted from the Goodyear Blimp hovering 700 to 1,000 feet above the parade route.

This being the era long before presenting pictures from the air was as simple as hooking a camera up to a drone, telecasting from an airship was positively state-of-the-art.

In its infinite wisdom, however, NBC decided that it made the most sense to have Betty and Bill stationed not on the parade route along Colorado Boulevard in Pasadena but in a studio in Burbank describing the action. They would be recounting what they were seeing on a monitor while being provided with minimal information about the various floats, drill teams, and marching bands.

Even though the two hosts weren't actually *at* the parade, they were told to just pretend that they were there. It was a good thing Betty had all that experience doing live performances! Her remarkable skills as an ad-libber certainly paid off for the parade, but her performance wasn't what Betty recalls as the most memorable part of the day.

That award goes to their makeup man, Paul Stanhope, who had worked with White on *The Betty White Show*. He had evidently partied a little too hard the night before and arrived for their predawn call time straight from a New Year's Eve party. He tried his best to stay on point, but as the morning went on, he faded until he straight-up passed out, midway through makeup touch-up.

Betty and Bill would never let poor Paul forget his embarrassing loss of consciousness. But it wound up giving them a sight they likely would never have been treated to in Pasadena, and for that Betty remained grateful for years thereafter. ∎

> ## Betty and Bill would never let poor Paul forget his embarrassing loss of consciousness.

OPPOSITE: Everything's coming up roses for Betty as she prepares to host the Tournament of Roses Parade.

Let the Games Begin

With her sharp wit and keen off-the-cuff skills, Betty became the reigning Queen of the Game Show.

The date was June 19, 1955. It was just another Sunday night on the CBS game show smash *What's My Line?* Betty was sitting in as a guest panelist for Arlene Francis, joined on the panel by regulars Dorothy Kilgallen, Fred Allen, and Bennett Cerf and overseen by its erudite host, John Charles Daly.

No one could know it at the time, but that night would launch a game show career for White in which she appeared on nearly 80 different shows or versions of shows and hundreds of episodes as a panelist. It wouldn't take White long to cement her status as Queen of the Game Show, a title that no one else has come close to earning.

Betty would appear in place of Francis for two weeks on *What's My Line?* and make additional appearances on the show at various times as that week's mystery guest. On her first panel, Betty was certainly nervous, but as a fan of the show, she was also incredibly excited to appear with the people she'd watched so many times and held in the highest regard.

A Conversation with Adam Nedeff

Game show producer, historian, and author Adam Nedeff talks about why Betty was the queen.

Q: *Would you say that Betty White is the all-time biggest celebrity panelist in game show history?*

ADAM NEDEFF: Without a doubt. Of all the stars who have done game shows, she's probably the one most associated with them. You have individual stars whose identities are more tied in with specific shows—like Charles Nelson Reilly on *Match Game* or Paul Lynde on *Hollywood Squares*—but no one more than Betty with game shows in general.

For a while there, if you were a game show with celebrity players, legally you were not allowed to go on the air until you secured a booking with Betty, because she played all of them and played them well. She also played them in a way that was entertaining. This is what you need to appreciate. It's not as easy as it looks to be a celebrity player on one of these shows. You have to be witty, engaging, and downright funny while playing a game. Try to simultaneously be funny the next time you play Scrabble.

Q: *You mean being glib and clever while still focusing on the task at hand?*

NEDEFF: Exactly. It's a tough skill that Betty mastered perhaps better than anyone else, ever.

Q: *How was Betty able to appear on so many shows over the years while working for so many different producers and networks?*

NEDEFF: That's how you know she was so good. She had extraordinary clout as a game show panelist because she was both an exceptional player and had the star power to back it up. Most celebrities had one or the other, not both. So, she could star on *The Mary Tyler Moore Show* and *The Golden Girls* and remain an in-demand game player. She had this lovable quality that made people want to watch and root for her. And she played every game very, very well, so her being a part of it made every show stronger.

Q: *And you're saying she had unusual clout as a result?*

NEDEFF: Absolutely. Betty didn't have to worry that going on one show would upset the producer of another show they were in competition with. She was unique in having the freedom to go on whatever show she wanted to without fear of being shunned elsewhere. She had what every game show was looking for.

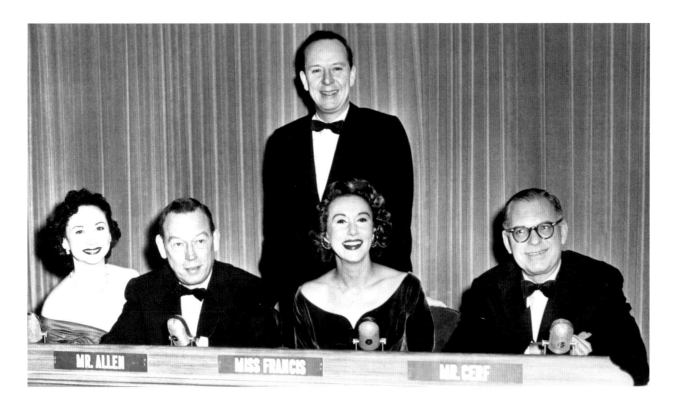

ABOVE: The famed 1950s *What's My Line?* panel of (left to right) Dorothy Kilgallen, Fred Allen, John Charles Daly (the host), Arlene Francis, and Bennett Cerf.

Shortly after that first *What's My Line?* stint, Betty was hired as a regular on the new weekly nighttime game *Make the Connection*, launching a relationship with mega-producers Mark Goodson and Bill Todman that would last for decades. It included her participation in such classics as *Match Game, Password, To Tell the Truth,* and *The Price Is Right.*

Make the Connection hit the air on July 7, 1955, with original host Jim McKay of ABC Sports and *Wide World of Sports* fame. He would be replaced after four weeks by Gene Rayburn. Besides White, the regular panelists were deejay, columnist, and author Gene Klavan, singer-actress Gloria DeHaven, and comedy performer Eddie Bracken.

The game was similar to *I've Got a Secret* in that it too featured four celebrity panelists who were each given a limited time frame to ask questions. Each time a panelist failed to "make the connection" between two people within 30 seconds, the contestant snared $25. (Hey, this was a long time ago, when 25 bucks was real money.) The game continued until either the panelist figured out the connection or the contestant earned up to $150.

Celebrity guests also made appearances on *Make the Connection*, leading to what was undoubtedly the show's most memorable moment. J. Fred Muggs, a chimpanzee who became the *Today* show's official mascot from 1953 to 1957, dropped by the show along with a woman named Joanne Cottingham (serving as his chimpsitter). The panel was supposed to guess her relationship to the chimp.

However, Muggs proceeded to cause a giant ruckus on the set, scampering around uncontrolled and having a great old time. Host Rayburn ultimately called off the game before it started and awarded Cottingham the $150 maximum without her having to actually play. Such are the quirks of live television. (Note: As of this writing, Muggs was still alive, having turned 69 on March 14, 2021. Perhaps some of White's longevity rubbed off on the chimp.) ∎

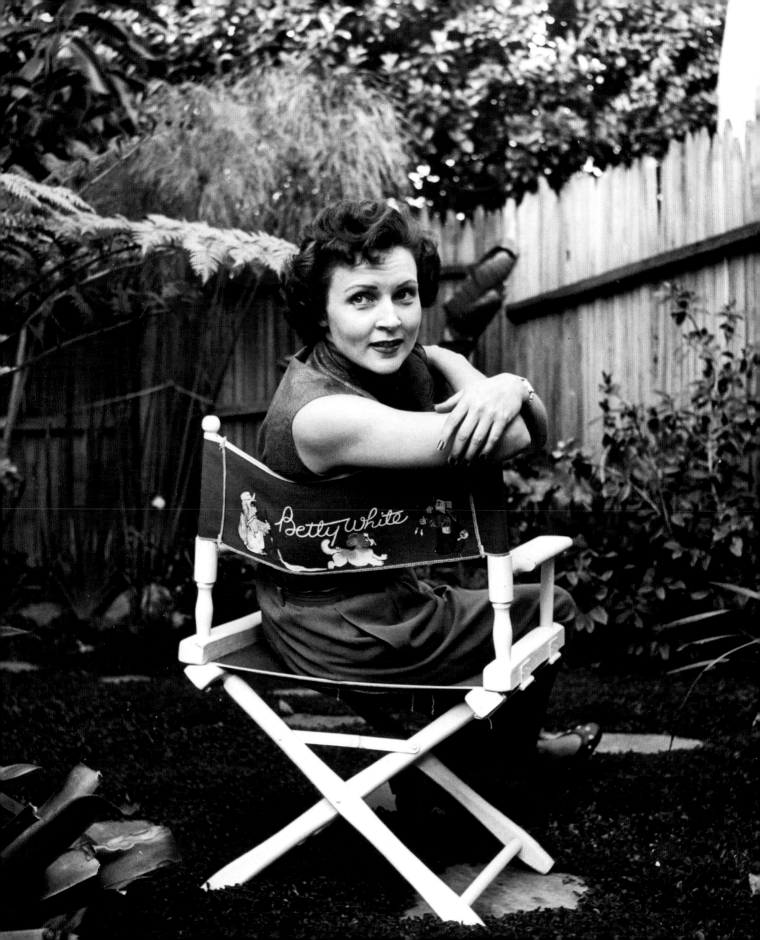

If You Had a Million Dollars . . .

Though known for being quick on her feet and funny to boot, Betty also had considerable dramatic chops.

As Betty's game show star began to rise, she linked up with her old production partner Don Fedderson to appear in a third-season installment of the hit anthology series *The Millionaire*, an early Golden Age of Television hit produced by Fedderson that ran for six seasons.

The show's ploy cast a multimillionaire named John Beresford Tipton (portrayed by Paul Frees) whom we never see but whose voice we hear making observations and giving instructions to his executive secretary, Michael Anthony (portrayed by Marvin Miller).

The idea was that every week, Tipton would choose someone at random to receive $1 million, an expensive hobby that permitted him to sit back and witness how the sudden wealth would change the person's life. No one could know the identity of the benefactor and had to sign an agreement that they would never divulge how they got the money.

We imagine that this Tipton character is literally richer than God, as viewers are treated to sweeping views of his 60,000-acre estate. For his money, he would be treated to a series of snapshots of the way riches impact human nature.

This brings us to Betty's October 17, 1956, episode, titled "Millionaire Virginia Lennart." It finds her portraying the Virginia of the title, a hardworking woman who owns the diner where she waitresses in Keokuk, Iowa. As soon as she's given the million bucks and realizes it's legit, she closes the diner and plots with her friend Emmy Haynes (Mabel Albertson) to jet off to Rome in search of adventures and frolic.

As it happens, Virginia gets significantly more than she bargained for while the two of them shuttle through Italy. They tour a historic home owned by a handsome and available Italian count (Jacques Bergerac) who is having some financial issues and thus needs to sell some of his paintings to make ends meet. Of course, the count doesn't tell Virginia he's a count. She'll just have to discover it for herself.

It turns out that both parties are misrepresenting themselves. Virginia isn't the wealthy heiress she purports to be. She messes up the first rule of inheriting a million dollars: don't pretend to be something you're not. It all looks like everything is going to implode due to the falsifications on both sides. Cue the miracle and the happy ending. True love, it seems, conquers all, especially on TV.

The Millionaire was an excellent showcase for Betty and her talents. It also put her in some heavyweight company of guest star million-dollar beneficiaries, including the likes of Charles Bronson, Dennis Hopper, Angie Dickinson, Mary Tyler Moore (some five years before *The Dick Van Dyke Show* launched), Peter Graves, Rita Moreno, a pre–*I Dream of Jeannie* Barbara Eden, John Carradine, DeForest Kelley (later "Bones" of the original *Star Trek*), and Agnes Moorehead (who went on to star as Samantha's mother on *Bewitched*).

It would still take a while before White earned her first actual million. But she was a working actress, and for now, that was more than enough. ◾

OPPOSITE: Looking like the world's most relaxed director in her personalized chair, Betty glances over her shoulder in a backyard garden in 1956.

A Comedy Fit for an Angel

Betty returned to the role of co-star in a domestic sitcom, this time in Lucille Ball's backyard.

This will tell you an awful lot about Betty White's character. Do you remember the name "Fran Van Hartesveldt"? He was the producer who gave Betty the opportunity to get her union card as a radio performer back in 1947 following a fateful elevator ride. Well, she returned the favor in spades by putting in a good word for Van Hartesveldt to be hired as a staff writer on her new ABC comedy *Date with the Angels*. He would be credited with scripting 21 episodes of the series.

A classy and gracious gesture from Betty, to be sure.

The multi-camera show—Betty's second prime-time sitcom—also again reunited her with its creator Don Fedderson and her *Life with Elizabeth* writer George Tibbles. The show was ahead of its time (perhaps a bit *too* ahead) in the way it incorporated fantasy sequences involving daydreams conjured by the lead character Vickie Angel (played by White). It had a certain *The Secret Life of Walter Mitty/Ally McBeal* quality that separated it from the spate of sitcoms suddenly populating the dial, including *I Love Lucy* (which was actually just leaving its first run on the air) and *The Adventures of Ozzie and Harriet*.

Date with the Angels, filmed in front of a live audience each week at Desilu Productions in Hollywood (the creation of Lucille Ball and Desi Arnaz), premiered on May 10, 1957. It was loosely based on the Elmer Rice play *Dream Girl* and featured Betty and Bill Williams as newlyweds Vickie and Gus, an insurance salesman. All the action revolved around them and their friends and neighbors. One critic referred to Betty's character as "a smarter Gracie Allen," according to the book *Women Pioneers in Television*.

As in *Life with Elizabeth*, Betty's character was no shrinking violet. She stood up to her hubby and gave as good as she got, even if it was always accompanied by fluttering eyelashes and an apple-pie smile. And as with *Walter Mitty*, more than half of the episode was dedicated to the lead character's flights of fantasy—at least initially.

The storylines themselves were fairly standard-issue domestic comedy. In one episode, Vickie accidentally takes a job at a department store when she goes to buy Gus a tie. In another, Gus's elaborate plan to surprise Vickie on her birthday doesn't go quite as planned. In a third, Vickie freaks out when Gus's old high school girlfriend pays them a visit.

The fantasy and daydream stuff went over well with viewers at the outset, but then three episodes in, sponsor Plymouth got involved. As White recalled in her book *Here We Go Again: My Life in Television*, the car company made the sweeping generalization that audiences never took to those kinds of fantasy sequences.

The sponsor pushed the show harder and harder to ditch the dream stuff and keep everything in the traditional sitcom realm. Once it got its way, the show just blended in with all the other sitcoms of its kind that were out at the time, of which there were plenty. It was the only time Betty recalls wanting to leave a show.

After the series was canceled in the middle of its second season—at the end of January 1958—ABC rebooted Betty's live comedy/variety series *The Betty White Show* (the third such series to carry this title) to close out the season and fulfill her contract with 13 episodes. The Frank De Vol Orchestra returned, along with her *Life with Elizabeth* co-star Del Moore. It also featured guest appearances by acting legends, including silent-movie pioneer Buster Keaton and horror maven Boris Karloff.

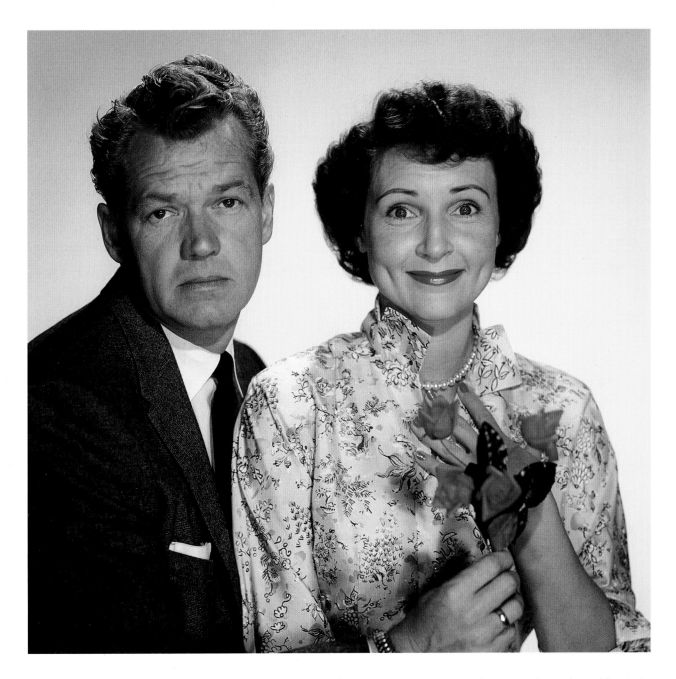

Thirty-three episodes of *Date with the Angels* were produced before the show was yanked. As much as the sitcom seemed to be very much a mixed blessing in Betty's mind's eye, it gave her a new and different foothold in the network sitcom world—one that would serve her well decades down the road on *The Mary Tyler Moore Show, The Golden Girls,* and *Hot in Cleveland*.

And because Betty is Betty, she prefers to look back on the venture for the lessons she learned and the fun she had instead of the disappointments she endured. ▪

ABOVE: TV husband and wife Bill Williams and Betty White practice a little flowery promotion on the set of their ABC sitcom *Date with the Angels* in 1957.

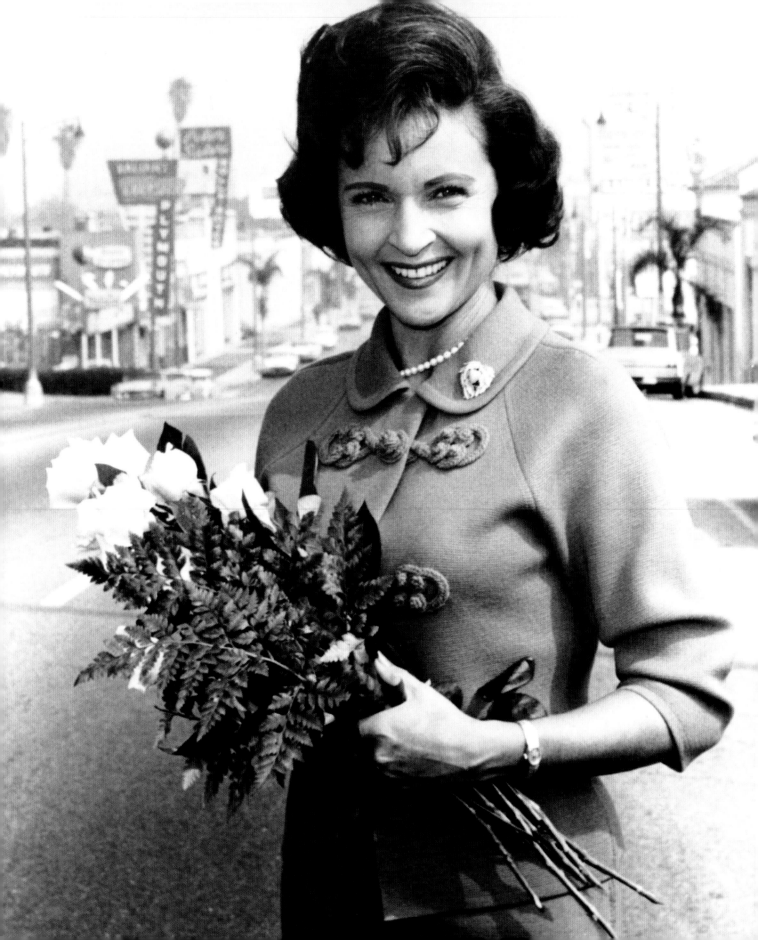

The 1960s

A Game Called Love

"I kept saying, 'No, I won't marry him. No, I won't leave California. No, I won't move to New York.' But we finally made it together."

—Betty White on Allen Ludden's *many* marriage proposals

OPPOSITE: Betty promoting the 1963 Tournament of Roses Parade that she co-hosted on NBC live on New Year's Day from Pasadena, California.

From Militantly Single to Blissfully Married

..

Everyone in Betty's life took it as a given that she was done with husbands. Love and marriage had not served her well. Two quick weddings. Two equally rapid divorces. She was married to her career, and she was just fine with that. But fate had other plans. There came a day in November 1961 when White appeared on this new game show called *Password*, hosted by a charming guy in horn-rimmed glasses named Allen Ludden. His wife had just died tragically of cancer days before, at 45, and he wasn't looking for a date but a place to work off his grief.

Love, it seems, has its own agenda, however. So did Ludden. He was smitten with Betty from the first and simply was not going to take no for an answer. He pursued her in earnest for months despite having three young children at home on the other side of the country, on the East Coast. Everywhere Betty went, Allen seemed to follow, wining her, dining her, wooing her, courting her. At events, at dinner parties, he became her ever-persistent shadow. He vowed to win her over. She just as determinedly rebuffed him. Not that she didn't like the guy or enjoy his knack for showing up. Not that he wasn't charming. She just wasn't interested in being tied down, and it was clear Allen was.

Numerous (weekly?) marriage proposals soon followed. When Betty turned him down, and down, and down, Allen took to wearing the engagement ring she refused around his neck. Only his sending a stuffed white bunny adorned with diamond earrings convinced the "militantly single" Betty to finally say yes.

The two got hitched in Las Vegas on June 14, 1963, in a ceremony performed by the same judge who had joined their friends Mary Tyler Moore and Grant Tinker the previous year. In attendance were Betty's parents, Tess and Horace, a hotel bellhop, and a couple of photographers hired by the Sands Hotel and Casino. She was now officially Mrs. Betty Marion White Ludden, a married lady once more.

One reason she finally agreed to become the Mrs. to Ludden's Mr. was the fact that he too was in show business and had no intention of trying to stifle Betty's creative aspirations. In fact, he encouraged them. He was proud when his wife (then girlfriend) landed a choice cameo in 1962's *Advise & Consent,* a Columbia Pictures release and White's first big-studio, big-screen role. In the movie, White portrayed the fictitious Kansas senator Bessie Adams, the only woman in the Senate, who takes on a corrupt system. It featured an all-star cast headed by Henry Fonda, Charles Laughton, Walter Pidgeon, Peter Lawford, and Burgess Meredith.

While it would be 37 years before Betty again graced such a large screen, she lit it up in this political film of considerable heft. It earned her great notices from a critical community that didn't know she could do drama. Neither, perhaps, did she. After Betty and Allen returned from their all-too-brief honeymoon (he had to get back to work), they were met with a new dynamic on *Password*. Suddenly, it wasn't host and celebrity guest but husband and wife. It was uncharted waters in terms of television, and initially viewers could sense both the awkwardness and—at the same time—underlying sweetness.

From the moment the first word was passed out on the June 24, 1963, show, everyone was playing it for laughs rather than keeps. The passwords matched the status of the betrothed couple, including (memorably) "henpecked." It was indeed something everyone was going to have to get used to, since Ludden was going to keep hosting, White was going to keep appearing, and both were going to go home to the same bed. Can one be "militantly married"? If so, that was now Betty.

Later in 1963, because Betty was peerless when it came to parade hostess commentary, she landed a second job (in addition to the Rose Parade) overseeing TV coverage of the Macy's Thanksgiving Day Parade alongside *Bonanza* star Lorne Greene beginning that November. That was a heck of a time to be hosting your first Macy's, as it was just six days after President John F. Kennedy had been assassinated and a few days since the bracing national trauma of his televised funeral. America was in a state of collective mourning like few times in her history, and real consideration was given to canceling the parade altogether.

Ultimately, it was decided that the Macy's Parade must be held on November 28, 1963, so as not to disappoint the millions of children who would be watching. It was left to Betty and her partner to soothe a devastated country and show that life would go on, and they delivered. Not every year would prove as difficult a sell as that first one, and Betty kept at it to rave reviews for ten years. Betty showed that she could colorfully describe the helium-filled animals on the Macy's route, but she was even better at interacting with the real thing. She demonstrated her storied love of all creatures great and small after the Los Angeles Zoo officially opened to great fanfare in November 1966.

Everywhere Betty went, Allen seemed to follow, wining her, dining her, wooing her, courting her.

The 133 acres on which the L.A. Zoo sits are, as far as White is concerned, hallowed ground, and she considers all of its residents to be her personal friends. No one has greater love and respect for animals than does Betty, who has long defended zoos as places of sanctuary and rehabilitation. No zoo inhabitant has, however, captured Betty's heart quite like Gita the elephant. It was from Gita that she learned pachyderms love having their tongue slapped, and that such a greeting was part of a special way for human and elephant to bond. Betty and Gita would go on long, heavenly morning walks with her handlers. They became actual close friends who were always thrilled to see each other.

This goes a long way toward explaining the kind of human being Betty White has long been. She doesn't advocate for animals because it's trendy, or because it would help bolster her rep as a good person. She does it because it's who she is, and the hours she's logged with beasts like Gita are some of the most meaningful of her life.

Similarly, White doesn't treat all people with affection and respect because she's looking to strengthen her image or enhance her brand. What you see is simply who she is, and that inherent decency, that intrinsic goodness, would continue to move her career forward in an unprecedented way as the 1960s moved along.

When Betty Met Allen

The "militantly single" Betty had met her match—even if it took her some time to admit it.

It happened in November of 1961. The future Betty Marion White Ludden appeared as a panelist on a new daytime game show called *Password*, hosted by Allen Ludden. His wife of 18 years, Margaret McGloin, had tragically died just days before of lung cancer. But Ludden, now a widowed father of three, was required to be at work. It's safe to say that the last thing he was thinking about was romance.

Betty has recalled that there was an instant attraction on both sides. She loved the ease Ludden had with guests on the show, his sense of humor both on-camera and off, and the warmth with which he presided. But she fought the feeling of falling for him, having been twice burned in her 20s by marriages followed by quick divorces. She liked to tell people she was "militantly single," according to the book *Women Pioneers in Television*. No more husbands. That was all in the past.

The following year, White and Ludden were reunited when they were cast together in a summer-stock production of *Critic's Choice* in New England. But Allen's handiwork was already in motion behind the scenes. He'd been cast in the play and requested that word go out to Betty to join him.

Then, as detailed in her book *Here We Go Again: My Life in Television*, Ludden called her in May of '62 to say that *Password* would be doing a week's worth of shows in L.A., and he invited her to see *Critic's Choice* with him at a little theater in Hollywood. Didn't she think it might be a good idea for them to watch the play before heading into rehearsal?

Clearly, the courtship was on—for Allen, anyway. Their friendship was cemented during the run of their play.

Complicating matters were the facts that Betty happened to be dating someone else, and Allen had three children aged 14, 13, and 10—difficult ages in the best of times but especially hard for kids who had recently lost their mother.

Oh, and there was also the little problem of Betty being on the West Coast and Allen tied to the East. White was in no hurry to pick up and move to the other side of the country, and certainly not for a man. But Allen Ludden wasn't just *any* man, and the fervor with which he pursued the woman he had fallen for was flattering and ultimately overwhelming.

On one trip to L.A., White recalled to the *Los Angeles Times*, "He brought his three kids, and they all started courting me." At dinner one night, Allen handed Betty an engagement ring and she handed it right back with a firm no. But even the other man she was dating, Phil, could see it, telling Betty she was in love with "that man" and imploring her to admit it.

Ludden placed the refused engagement ring on a chain that he took to wearing around his neck for three months. "I'm going to wear it till you put it on your finger," he vowed to Betty, who later admitted, "He was a good salesman."

Indeed, every time they spoke from that moment on, Allen would keep re-proposing: "Will you marry me now?" "No!" Betty told *Newsweek,* "He wouldn't even say hello. It was just, 'Will you marry me?' And I'd say, 'No way!'" But Ludden was relentless and would not be denied. Or maybe he just appreciated a good challenge. Betty surely supplied that.

Then came Easter season of 1963, and Allen sent Betty a cute fluffy stuffed white bunny with diamond earrings

> "He brought his three kids, and they all started courting me."

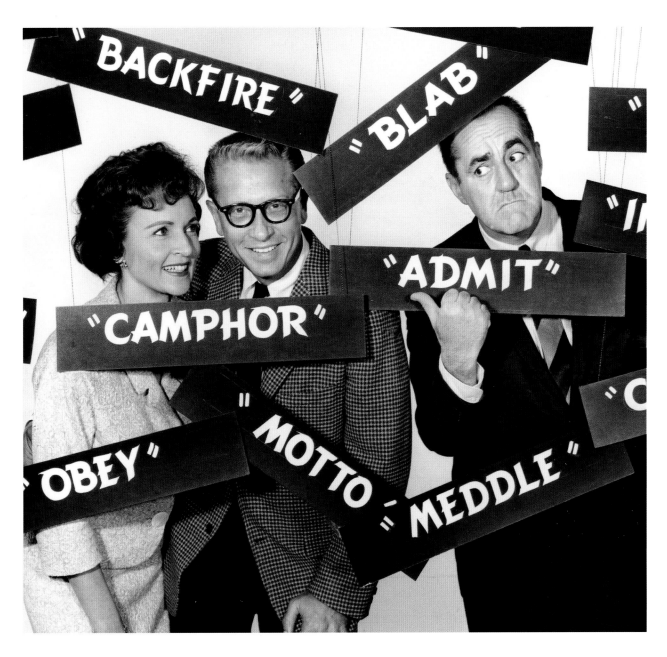

clipped to its ears. The card inside read, "Please say 'YES.'" When she answered the phone that night, she didn't say "Hello," only "Yes."

"It wasn't the earrings that did it," White insisted in an interview with *Closer Weekly*, "it was the goddamned bunny. I still have it."

Persistence sometimes pays off, particularly when the heart understands something before the mind has a chance to grasp it. "I wasted a whole year that Allen and I could have had together," Betty told Oprah Winfrey. "I kept saying, 'No, I won't marry him. No, I won't leave California. No, I won't move to New York.' But we finally made it together." ■

ABOVE: Betty gets wordy in 1962 on the set of *Password* with host (and future husband) Allen Ludden (center) and actor Jim Backus.

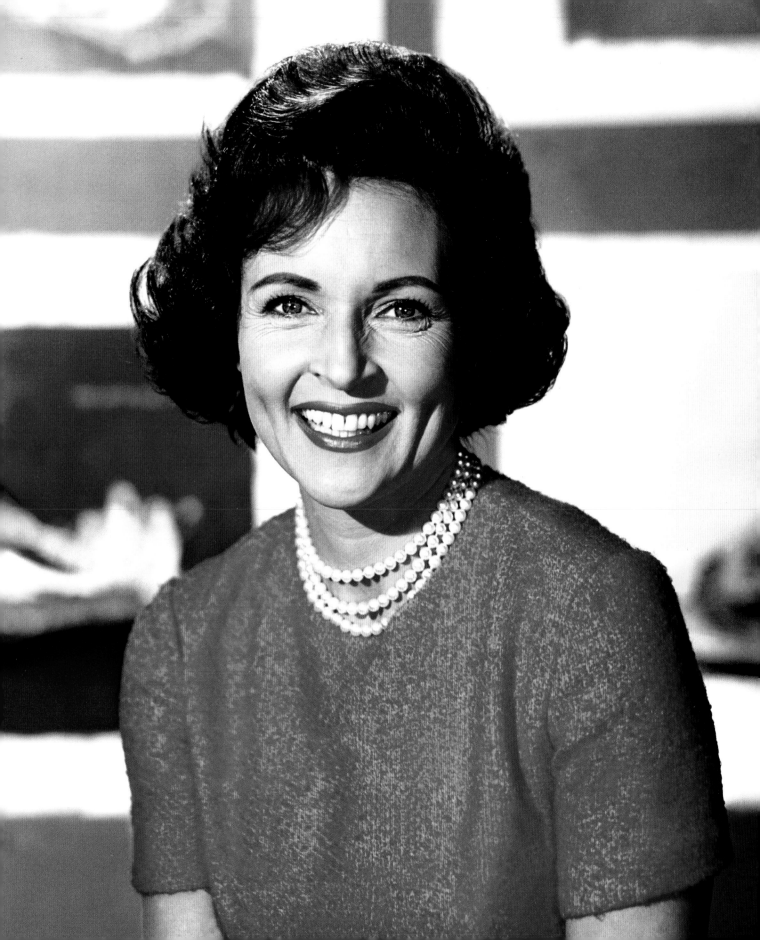

Madame Senator Has the Floor

When Betty hit the big screen as Senator Bessie Adams, she reminded the world that she was an actor.

During a time when she was mostly making appearances as a game show celebrity panelist and emceeing parades, Betty landed her most significant dramatic role to date. The supporting work she did in *Advise & Consent* (released on June 6, 1962), her first major studio feature film, proved yet again that she had superb acting skills.

The film—a Columbia Pictures release based on the Pulitzer Prize–winning 1959 novel of the same name by Allen Drury—was a political feature adapted for the screen by Wendell Mayes and directed by Otto Preminger. The star-studded cast included Henry Fonda, Charles Laughton, Walter Pidgeon, Peter Lawford, Gene Tierney, and Burgess Meredith. White was one of just a few women in the movie, portraying fictitious Kansas senator Bessie Adams.

One exchange in particular stands out for Betty. Her Senator Adams is locking horns in a courtroom fight with Senator Fred Van Ackerman of Wyoming (played with maximum wattage by George Grizzard). In this case, her character is based on Margaret Chase Smith, at that time the only woman in the Senate, while Senator Van Ackerman is a stand-in for the notorious Communist hunter Senator Joseph McCarthy.

Van Ackerman is a vocal supporter of Robert A. Leffingwell (Fonda), who has been nominated by the president to be the new secretary of state. Senator Adams is part of the opposition to the nominee. She and the Wyoming senator are just starting to go at it—he hot under the collar, she cool as a cucumber.

Senator Van Ackerman: "Mr. President, I'm sorry if the senator from Kansas was not perceptive enough to grasp what was obvious [at the hearing]. I am telling the Senate exactly what happened!"

Senator Adams: "As much as I appreciate hearing about the senator's particular view, I am constrained to say I will need more substantive proof than the senator's personal description."

Senator Van Ackerman: "Mr. President, is the senator calling me a liar?"

Senator Adams: "The record must stand as it is, Mr. President. How the senator interprets that record is his own problem, not mine."

It's a great scene for several reasons, chiefly that it shows off White's dramatic chops and finds a female politician getting the better of a sexist and condescending male. It leaves us wanting to stand up and cheer. It's the kind of powerful performance that generally leads to many more roles just like it. But in fact, it would be 36 years before White would appear on a big screen again.

Not that it was difficult to find her around smaller screens. On those, she would remain ubiquitous—and then some. But for a shining moment, she lit up movie theaters in the early '60s too. ▪

OPPOSITE: The early 1960s version of Betty, right around the time she was in *Advise & Consent*.

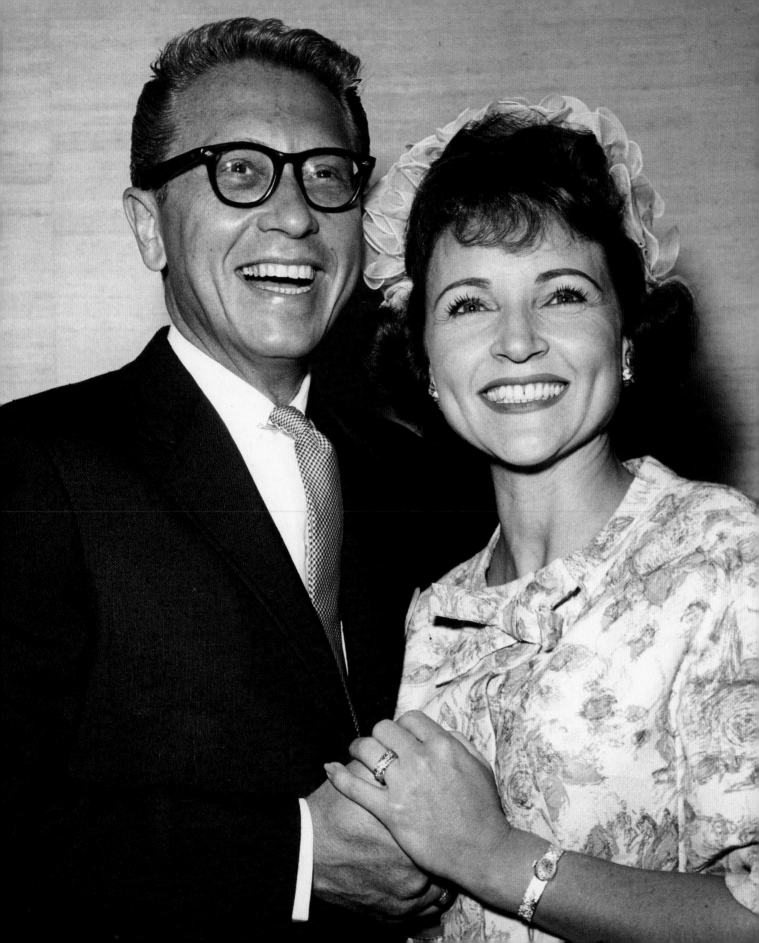

Getting Hitched in Vegas

After swearing she'd never marry again, Betty finally wed the man of her dreams.

Only about two months after Betty told him yes, she was married to Allen Packard Ellsworth—better known by his stage name, Allen Ludden—on June 14, 1963, at the now-defunct Sands Hotel and Casino in Las Vegas. The hitching was performed by Judge David Zenoff, who had joined Betty's and Allen's friends Mary Tyler Moore and Grant Tinker the previous year.

As you might suspect from the fact it went down in Vegas, the ceremony was a small affair attended only by the bride and groom, Betty's parents, Judge Zenoff, a hotel bellhop, and a few photographers hired by the Sands.

Allen's three kids from his previous marriage, David, Sarah, and Martha, were reportedly not in attendance due to the whirlwind nature of the nuptials. The look of blissful happiness on both their faces is evidence of how exciting the day was for the joyous couple.

Because the groom needed to return to work to tape *Password*, the pair went off on an abbreviated honeymoon in Laguna Beach, California, before moving with Ludden's children and two poodle puppies to a new home—a 150-year-old farmhouse in Chappaqua, New York—to set up shop. (They also maintained a residence in Los Angeles.)

This isn't to say there weren't challenges for the Luddens to get past in the months ahead. Besides Betty's adjustment period involved in being a second wife and stepmother, just five months later, President John F. Kennedy was assassinated, casting a pall over the nation. But the trauma had the effect of bringing the newlyweds closer together.

A Hot Spot for Celeb Weddings

By marrying in Las Vegas, Betty and Allen joined a host of other celebrity couples to be hitched in Sin City. They included Paul Newman and Joanne Woodward (1958), Jane Fonda and Roger Vadim (1965), Frank Sinatra and Mia Farrow (1966), Elvis Presley and Priscilla Ann Beaulieu (1967), Richard Gere and Cindy Crawford (1991), and Kelly Ripa and Mark Consuelos (1996).

As Betty told *Closer Weekly*, "It finally penetrated my thick skull that Allen and I were a unit. From that day forward, any problem we had came from the outside. [Allen] had taught me to stop running."

And as White consistently repeats, the chief regret of her life is that she made Ludden beg her to get married for a year due to her unreasonable reluctance. After her husband died of stomach cancer in 1981, Betty would never remarry. As she told Anderson Cooper in 2011, "He was the love of my life. If you've had the best, who needs the rest?"

Indeed, if Betty could change one thing in the course of her century of life, as she told *New You* magazine, "it would be to bring Allen back." The 18 years they spent together would be the most fulfilling of her life, proving there may be something to that old axiom about the third time being the charm. ∎

OPPOSITE: Allen Ludden, 45, and Betty, 41, positively beam on their wedding day after reciting their vows at the Sands Hotel in Las Vegas on June 14, 1963.

The Password Is . . . Love

The happy couple went before the camera together with exponential charm.

On June 24, 1963, just ten days after their wedding and all-too-brief honeymoon, Betty White and her new husband, Allen Ludden, were back at work taping a new episode of *Password*. It proved to be a memorable half hour, chock-full of euphoria and fun and just the right touch of awkwardness.

Late-night talk show host and Betty's good friend Jack Paar was on the panel with Betty, appearing as a wedding gift to the newlyweds. Everyone had a good time making gentle light of the situation, with Ludden opening the show asking, "What are your plans for the summer, Betty?" and White replying, "Allen and I are gonna do *Brigadoon* in Paterson, New Jersey, and then we're gonna have a big fight when I go to St. Louis to do *The King and I*."

Once the game began, most of the passwords fit a Betty-Allen marital theme, including "Stage," "Romance," "Sorry," "Clumsy," and, hilariously, "Henpecked." For the last word, the clues included "Unhappy," "Divorce," "Belittled," and "Degraded" before "Chicken" spurred the correct response.

Hilarity Was in the Air

This specific show likewise featured something of a historic moment that had nothing to do with the freshly betrothed couple. It involved the password "Me." Paar, playing to the crowd for laughs, uttered the clue "Marvelous."

This was, by any measure, a horrible clue. But the contestant, announcing that he too was going to carry the spirit of the comedy theme, correctly guessed "Me." The look of shock on his face was priceless. The excitement of the studio audience carried on for a good minute. Once it subsided, Ludden was moved to utter, "I think that's a high point of all the passwords we've ever played."

Quipped Allen: "I am neither chicken nor henpecked . . . am I, dear? Responded Betty sheepishly: "No, dear."

It was all in good fun. Both Luddens were clearly having the time of their lives, and those lives together had only just begun.

Game show producer and historian Adam Nedeff—author of the 2017 book *The Life (and Wife) of Allen Ludden*—weighed in on the episode in an interview for this book. He noted, "The half hour is fascinating to me because you can see Betty and Allen are in uncharted waters with game shows here. I since spoke to some people on the *Password* staff who discussed how they needed to adapt to having a married couple conducting themselves regularly as host and panelist."

Nedeff added, "It was a very strange transition, which you can certainly see at the beginning of this half hour when Allen starts out trying to be formal with Betty and it winds up just becoming a running joke."

At the conclusion of the episode, Allen left the viewing audience with "The password tonight is . . ."

"Home," replied Betty, not missing a beat. "Will you take me home, Mr. Ludden?"

"I certainly will, Mrs. Ludden," he concluded.

In game show annals, cuteness has never abounded quite so delightfully.

White would go on to appear repeatedly on *Password* over the ensuing years and decades in all the show's incarnations, including on CBS daytime, CBS nighttime, and an ABC version in the '70s, and then on *Password Plus*, *Password All-Stars*, *Super Password*, and *Million Dollar Password*.

If you're keeping count, that's seven different editions between 1961 and 2008 (the latter two after Allen's death), 72 weeks' worth of appearances in all. ∎

OPPOSITE: Betty White and Arlene Francis guest on *Password* along with Betty's husband in May 1965.

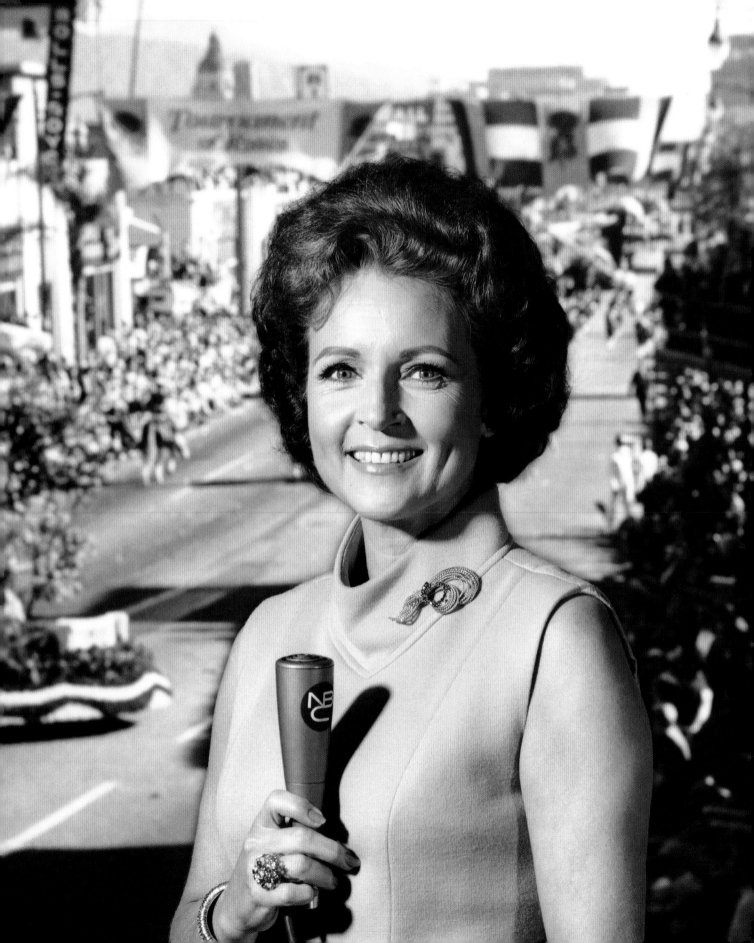

Betty and the Big Parade

Betty was the right woman for the not-nearly-as-easy-as-it-looks job of hosting the Macy's Thanksgiving Day Parade.

With her effervescent personality and ability to intensely focus on the task at hand while quashing potential snafus as they develop, Betty's skills are uniquely tailored for the role of parade host.

She proved it as a Rose Parade commentator and, simultaneously, during a decade (1963–1972) sharing the hosting perch at the Macy's Thanksgiving Day Parade alongside *Bonanza* star Lorne Greene. White told *The Hollywood Reporter*, "It was exciting working with Lorne. We had a great time."

Betty consistently proved during her years as host to be the right woman providing commentary at the right time. Who better, after all, to reassure a shattered nation and help raise the national spirit a mere six days after the assassination of JFK? That first year Betty was set to host, the parade was nearly canceled due to the tragedy, but the powers that be ultimately ruled in favor of holding the event after all.

As the *New York Times* reported on November 28, 1963, "In the aftermath of the President's death, most public celebrations and receptions have been canceled. An exception will be the annual Macy's Thanksgiving Day Parade here. Macy's decided that its cancellation would be a disappointment to millions of children."

That '63 Macy's spectacle featured appearances by stars Fred Gwynne (a year away from starring on the hit series *The Munsters*), Michael Landon of *Bonanza* fame, Ray Bolger (the Scarecrow from *The Wizard of Oz*), actor Troy

OPPOSITE: Betty's extensive experience hosting the Tournament of Roses Parade (shown here) prepared her for the challenges of the Macy's parade.

The Parade Must Go On

NBC has broadcast the Macy's Parade since 1948. It goes on, rain or shine. National tragedies and global pandemics can't stop that Sixth Avenue tradition. The only exception was during World War II, specifically 1942–44, when helium shortages grounded the parade. It requires an awful lot of the stuff to fill those giant balloons.

Donahue, singer-actress Leslie Uggams, and film and stage legend Janis Paige.

The following year, Betty and Lorne presided over a parade broadcast in color for the first time. High winds of 20 miles per hour made navigating the 2.7-mile parade route a particular challenge. It's said to have blown around the colorful marionettes from the forthcoming feature film *The Sound of Music* and driven the Dino the Dinosaur balloon into a lamppost in Columbus Circle, partially deflating the helium-filled reptile.

Too, reports at the time note that Gwynne and Al Lewis (Gwynne's castmate on *The Munsters*) rode in a *Munsters* coach down the parade route. Gwynne, in his Herman Munster makeup and costume, reportedly nipped at a bottle in a paper bag that contained "nerve medicine." And when he passed Betty and Lorne in the media box, he is said to have fired off an expletive in their direction.

No one ever said that parade commentary would be without its challenges. But Betty always made it look (and sound) easy. ∎

It's a Zoo in There!

White's lifelong love of animals shines in her long-term association with the Los Angeles Zoo.

From the time of its official opening on November 28, 1966, Betty has been associated with the Los Angeles Zoo and Botanical Gardens. The opening day festivities included a dedication from Los Angeles Mayor Sam Yorty, the United States Army Color Guard, and the Los Angeles Symphonic Band. A few animals were also there, it being a zoo and all.

How much does Betty love the zoo? So much that she wrote a book titled *Betty & Friends: My Life at the Zoo* in 2011. It's a scrapbook of all her favorite animals and animal stories, chock-full of zoo pictures, anecdotes, and memories. In the book, Betty calls her decision to become involved with the L.A. Zoo one of the happiest choices of her life. She has seen it grow from a fledgling project to a state-of-the-art facility that has done much to foster breeding and conservation among a number of species, in her view.

In a 2012 interview with *Smithsonian* magazine, White discussed some of the highlights of her involvement with the zoo, which included her becoming a trustee of the Greater Los Angeles Zoo Association (GLAZA) in 1974.

At the top of her list of zoo thrills was spending two hours watching a baby camel attempt to stand up. "He would get one leg up and then he would get a second leg up," she told the magazine. "He would try the third leg, and then the first two would fall down. He really had to work at it. Just about the time he got four legs under him, one of the adult camels came over. She touched him with her nose and splat! Down he went. He had to start all over again."

Betty understands the zoo debate and realizes that her defense of zoos puts her squarely in the middle of the dispute. She explained to *Smithsonian* that too many people have a closed mind on zoos, believing no animal should be in captivity and instead in the wild in their own habitat.

"That is a myth," she said. "Humans have already taken their habitat; many species have no wild habitat anymore."

Zoo Stats

The L.A. Zoo today is home on its 133 acres to more than 2,200 mammals, birds, amphibians, and reptiles representing more than 270 species, of which some 58 are endangered. It includes a Chimpanzees of the Mahale Mountains exhibit that features the largest multi-male, multi-female chimp troop of any zoo accredited by the Association of Zoos and Aquariums (AZA).

She explained that zoos work not only with the captive animals "but also with the dwindling populations in the wild. And what they learn from the captive animals they can apply to those wild populations."

In fact, she concluded, zoos allow species that would otherwise have died out to survive and potentially once again thrive. Betty cited the example of the California condor and how breeding programs at the L.A. and San Diego zoos have replenished their numbers into the hundreds.

White has made no secret of her obsession with animals—all animals—as an "advocate" rather than an "activist," as one strictly concerned for their health and welfare. And for her, that adoration and protectiveness begin at the zoo of her adopted home city. She recommends that people pay a visit to their own local zoo and check out what's going on there for themselves. As she told *AARP The Magazine* in 2011, "Spend real time there. See animals in a way that you can't otherwise. If you see something you like, celebrate it. And if you see something you don't like, report it. By being an active participant in your zoo, you'll get a lot of reward."

OPPOSITE: Betty embraces a chimpanzee at the L.A. Zoo in 1974.

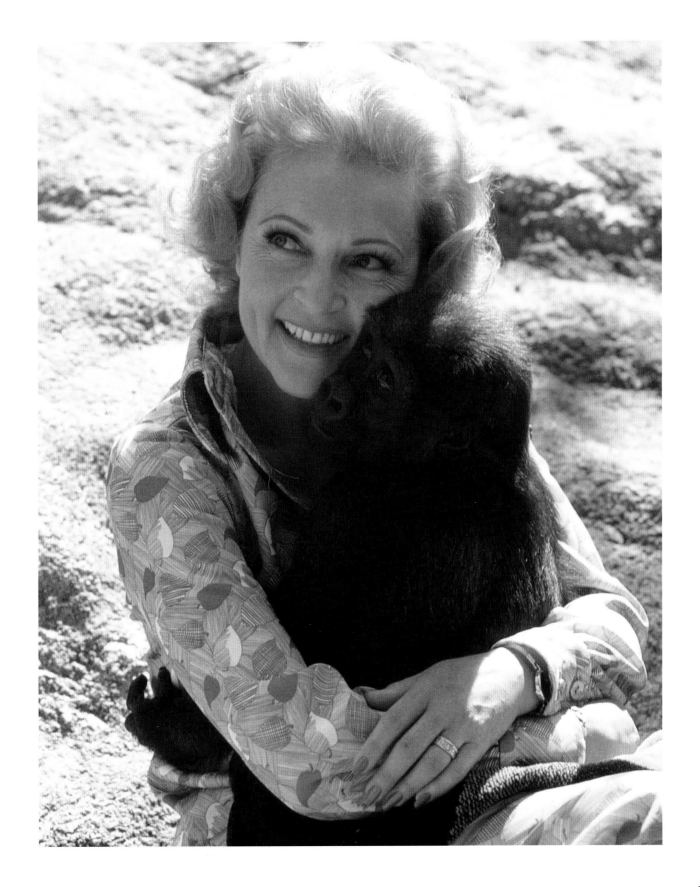

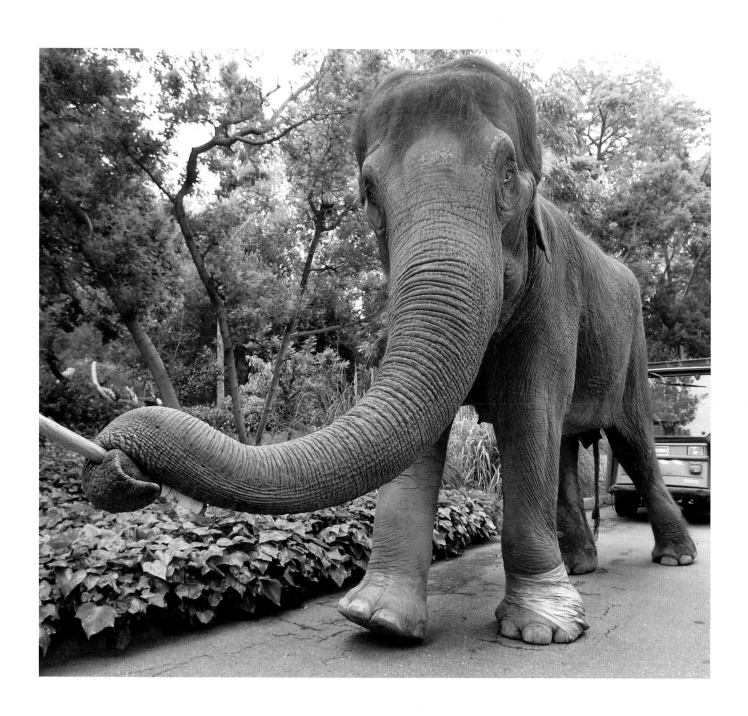

BETTY WHITE

Betty and Gita

During her walks with Gita the elephant, Betty found a real friend.

No one is a greater friend to the L.A. Zoo animal community than White, who had special visiting privileges due to her fame and commitment. And none of the beasts gave her more pleasure than Gita the elephant, with whom Betty would take walks on Saturday mornings before the zoo opened.

Gita had actually been part of the Los Angeles Zoo animal community since 1959 and led elephants on a journey down the hill from their old location to the newly rebranded and rechristened one in 1966.

In an interview with the *Los Angeles Times* in 2010, Betty recalled the first time she had the opportunity to engage with Gita. It was love at first sight. "I said, 'Gita, trunk up!' And she put her trunk up, and I'd stand on my tiptoes and slap her tongue as hard as I could."

If that doesn't necessarily sound like the most loving of gestures, Betty insisted that it actually was. Somewhere along the way, she'd discovered that elephants love to have their tongue slapped. "And how many people can come up to a strange elephant and say, 'Hello sweetheart, put your tongue out, let me slap your tongue'? I've tried it on fellas. It doesn't work as well as it does on elephants."

What she found particularly amazing was that she could hear no footfall from the giant beast.

But even among fellow pachyderms, Betty could see that Gita was truly exceptional. As she described in her 2011 book, *Betty & Friends: My Life at the Zoo*, the tongue-slapping greeting was a universal language for communication and a lifelong friendship. She was amazed at the elephant's gentle disposition during their long, rambling walks with her zoo handlers. Sometimes they'd come upon a small tree or bush that Gita tried to snack on, but all it took was the keeper telling the elephant no for Gita to give up on making a meal of the landscaping.

Walking with Gita was "heaven," White wrote. What she found particularly amazing was that she could hear no footfall from the giant beast. That's how gentle and elegant she was. Gita would make soft squeaks and other vocal noises as if she were taking part in the conversation, but that was all the noise that came from her.

Betty told Frank Bruni in a 2011 *New York Times* interview, "I knew Gita very, very well. We were great friends."

Gita was 48 when she died in 2006, but she will live on in the hearts of all her admirers, with Betty at the top of that list.

And what a special time they had together. ■

OPPOSITE: Gita the Asian elephant, long a close friend of Betty's, takes a morning walk.

The 1970s

She's Gonna Make It After All

"She was so great, so inventive, that we couldn't *not* have her back on. . . . She became everyone's delicious pixie. She represented all the evil places and dark corners we have inside us, and we cheered her on."

—Mary Tyler Moore on Betty as Sue Ann Nivens

OPPOSITE: Betty White as Sue Ann Nivens and Ed Asner as Lou Grant on *The Mary Tyler Moore Show*.

Betty's Dreams
Keep Coming True

The '70s kicked off for Betty in the best way imaginable: surrounded by animals. She formed a production company with her beloved Mr. Ludden—Albets Enterprises, a fusion of their first names—and they launched *The Pet Set* in 1971. This syndicated half-hour series hosted by White ran for 39 episodes, all featuring celebrities and their pets. What could be better for a woman who loves entertainment and critters (not necessarily in that order)? Dogs, cats, horses, lions, tigers, bears, snakes—they all made regular appearances on *Pet Set*, which featured star after star, including Burt Reynolds, Eva Gabor, Shirley Jones, and Jim Nabors. And then—*poof*—after a single season, the show disappeared from sight. Gone without a trace. Until it surfaced some 50 years later to entertain a new generation.

But Betty didn't merely show off her furry friends on television. She gave back behind the scenes, too, as a patron of the Los Angeles Zoo and its supporting association. She helped to launch an annual fundraiser in 1971, which, in 1972, was christened the Beastly Ball. The event routinely earns hundreds of thousands each year to protect endangered animals and fund global conservation efforts. In fact, White's presence grew to become one of the silent auction attractions: hanging with her for lunch and a zoo tour ultimately fetched as much as $50,000.

When she wasn't fussing over the four-legged community, Betty was still ubiquitous on the TV game show circuit, particularly on a little show called *Password* that was hosted by her hubby. So famous were they as celebrity host and guest, that they were featured on a 1972 episode of the classic comedy series *The Odd Couple*. In that half hour titled *Password*, Felix (Tony Randall) and Oscar (Jack Klugman) are invited on the game show to play against the real-life Betty White while Ludden presides over the festivities as host. It's uproarious good fun. And it's safe to say that if you ever get a chance to watch the episode, you'll never look at the name "Aristophanes" quite the same way again.

But the real life-changing moment of the decade would arrive the following year, when Betty was recruited by her good friend Mary Tyler Moore to guest star in an episode of her wildly popular and award-winning comedy *The Mary Tyler Moore Show*. Thus was born the character of Sue Ann Nivens, a.k.a. The Happy Homemaker, of Minneapolis's fictitious WJM-TV. Sue Ann strode onto *MTM* as a fully formed character from day one, a man-crazy, lewd, crude, backstabbing, but relentlessly chirpy Martha Stewart type before Martha actually became known. During her first episode in 1973, titled "The Lars Affair," the audience went nuts for Sue Ann, and it was clear she had to be more than a one-shot wonder.

White herself was instantly transformed from being a jill-of-all-trades who could fit in wherever you put her to a genuine star. She was woven into the *Mary Tyler Moore* culture so seamlessly that it's difficult to believe she wasn't there right from the start. Sue Ann became the writing team's newest, shiniest star, growing increasingly essential and hilarious in the ongoing storyline. What started with

her trying to steal Phyllis's (Cloris Leachman) husband as soon as she appeared on the scene evolved to showcase her hostility and competitive nature ("A New Sue Ann"), her unique form of yuletide cheer ("Not a Christmas Story"), and her passion for one Lou Grant (Ed Asner) in "The Happy Homemaker Takes Lou Home").

It surprised precisely no one that Betty would be not only nominated but victorious at the Emmy Awards two years in a row (1975 and 1976), and that her wins would inspire no angst or jealousy on the *MTM* set. It was simply beyond dispute that the lady deserved to be recognized among the finest in TV, even if it had been nearly a quarter-century between her first and second Emmy triumphs.

As White moved through her 50s, her career continued to gain momentum thanks to *Mary Tyler Moore*. But she hardly rested on her successes, and when the situation called for it, she sacrificed her body for a performance. The proof of that can be seen in the December 20, 1975, episode of the show titled "What Do You Want to Do When You Produce?" in which co-star Gavin MacLeod accidentally wrenched Betty's back while plopping her onto a cake. Notably, Betty didn't flinch, finishing the scene before betraying her pain. As far as she was concerned, that's just what professionals do.

The final seasons of the series found Betty doing some of her most exceptional work, notably in the episodes "Sue Ann Falls in Love," "Sue Ann's Sister," and "Sue Ann Gets the Ax." Only someone with White's performance skills could make the audience love a character so needy and pathetic.

Word had indeed spread that Betty White was a good person to have around.

Once *MTM* had run its course, the production team decided it had to keep working with White. In the fall of 1977, they created yet another version of *The Betty White Show* (this was the fourth rendering in case you're keeping score). In this one, she starred as a washed-up actress headlining a show-within-a-show cop drama called *Undercover Woman*, spoofing the very medium that had brought her such renown. While this *Betty White Show* proved to be short-lived, it's seen today as a creative success that paved the way for future satires like *The Larry Sanders Show*. But Betty got there first.

The quick hook for *T.B.W.S. 4.0* allowed White to take a breather and hang out with her friends for a little while—on-screen of course. She made an appearance with good pal and fellow comedy legend Carol Burnett on the latter's namesake comedy-variety hour, including one memorable sketch in '78 that found the two spoofing both '50s life and '60s beach movies. Along for the ride was a hot, young comedian named Steve Martin.

And never was Betty more comfy than when sharing the stage with one Johnny Carson on NBC's *The Tonight Show*. Their friendship dated to 1951, when she would appear with him on his local comedy series *Carson's Cellar*. As the years piled up, Johnny would trust Betty to have his back as he did few others, particularly when performing skits like those they did together in the '70s and '80s.

Word had indeed spread that Betty White was a good person to have around, whether it be on your sitcom or your game show, your late-night talk show or your parade. Everything she touched seemed to instantly get better—generally *much* better—and she'd prove that time and again through the decades to come.

Pets Enter the Picture

Celebrities? Check. Animals? Check.
A dream job for Betty? You bet.

The show that gave Betty White perhaps more pure pleasure than any other with which she's been involved hit the air in first-run syndication in 1971 and featured as many mammals with fur as without. *The Pet Set* was produced by husband Allen Ludden and White's company, Albets Enterprises, in tandem with its primary sponsor, the Carnation Company. It featured celebrities and their pets across 39 adorable episodes.

"When Allen and I started out our production company so many years ago, the one show I wanted to do was *The Pet Set*," Betty told the Associated Press in an interview a half century later. "Allen's offices were the most exciting in the building because we were the only show pre-screening guests who were furry and four-legged.

"What a time! It remains probably my favorite show even fifty years later."

It's easy to see why *The Pet Set* concept would so appeal to Betty. The star-studded half hour found celebrities sharing screen time and conversation with their animals. Participants included everyone from fellow animal advocate Doris Day to Carol Burnett to Burt Reynolds, Mary Tyler Moore, Barbara Eden of *I Dream of Jeannie* fame, Shirley Jones from *The Partridge Family* and *The Music Man*, Jim Nabors of *Gomer Pyle, USMC*, Michael Landon from *Bonanza* and *Little House on the Prairie*, Rod Serling of *The Twilight Zone*, Eva Gabor of *Green Acres*, James Brolin, and many others.

Pet Set had four segments. In the first, Betty would bring on that week's guest star and his or her pet to share stories about their animal(s) (most often dogs). The focus shifted to a second segment on a select species, while in segment three an animal expert would join the discussion. The show concluded with White and sometimes her guest star visiting outdoors with a wild animal, such as a Bengal tiger, black bear, or Asian elephant, and animal behaviorist

Ralph Helfer (who coined the term and process of "affection training").

On the episode featuring Serling, he comes on with an adorable Irish Setter. His Setter and its mother often ran away "and I had to bail them out of the city jail, the dog pound," he says. They then meet a couple from Kenya and later a lion cub. The Kenyan couple shares home movies

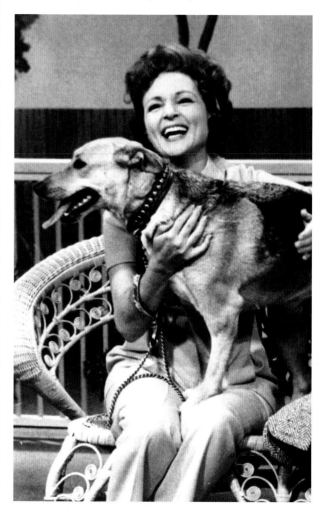

A Conversation with Darren Wadyko

The producer who uncovered, restored, and distributed the show's rerelease as
Betty White's Pet Set talks about the painstaking process.

Q: *Take us briefly through the process of locating and restoring* The Pet Set.

DARREN WADYKO: Well, this goes back to 2014, 2015. I was approached by Betty's agent, Jeff Witjas, who was trying to find the show after it had disappeared for decades. After searching for months in what became a virtual Indiana Jones expedition, I was finally able to uncover some pretty degraded tapes at the Paley Center for Media in Beverly Hills. Then by chance, I was tipped off that another set of *Pet Set* tapes were located in Betty's own archives in her home. And they were somewhat better quality. I got really lucky!

Q: *But that wasn't quite the end of the story, I'm guessing.*

WADYKO: Oh, are you kidding? That was just the beginning. The tapes were so brittle that a few special processes were required before they could even be digitized. Before they could get run through that machine and prevent the information from peeling off, the tapes had to be baked at 125 degrees for seven days.

Q: *So, you're literally cooking them.*

WADYKO: Yes! It was a huge but fascinating procedure that needed to be done before the sharpening and color-correcting and ultimately digitizing could take place. We're talking fixing it frame by frame to get the glitches, bumps, and hitches out. The whole thing took a good year and a half to complete. I mean, I'm a producer and development executive, but I had to become an investigator, curator, and restoration artist to bring these up to pristine viewing quality. It was a six-figure investment.

Q: *Was it ultimately worth all this trouble, expense, and hassle?*

WADYKO: Absolutely. I'm a gigantic fan of Betty's, and this show was really the ultimate experience for her. Not only did it feature some of her favorite furry four-legged and two-legged friends, but it was produced and crafted in tandem with her beloved husband, Allen Ludden, who was also the show's announcer and final guest of the series. I like to think she saved the best for last. Their labor of love became my labor of love. I could not have done any of this without the help of Betty's agent, Jeff; her lead assistant, Kiersten; her business manager, Glenn; and the best darn producer and curator of classic TV out there, Jim Pierson.

Q: *What was it about a 50-year-old show that made you want to devote so much of your time and energy to it?*

WADYKO: It's the fact that it wasn't just a cute show about celebrities and their pets but also took the time to teach us about the health and wellness of animals, including endangered ones. It was able to make an important contribution to the animal dialogue through entertainment. To my mind, that still resonates half a century later.

of elephants, lions, wild dogs, and baby leopards and, in studio, a striped hyena. Other canines join the fray before everything wraps.

Throughout, it's clear that Betty is in her element, drawn to interact with the animals with a natural ease. She is at least as comfortable with the four-legged creatures as she is with her fellow humans. Actually, the right word for how she is with animals might be "fearless."

In another segment, Burnett is initially skittish as she tries to bottle-feed a baby elephant but cracks, "These Playtex nursers, you can't beat 'em." White, meanwhile, is completely unfazed by every contact, whether it be an elephant, a bear, a gorilla, a cougar, even a snake. One moment finds her snuggling a 500-pound lion as if it were her child.

Once *The Pet Set* failed to be renewed after its single season due to Carnation's insistence on going in a different direction with its advertising budget, the show disappeared, never to be seen in reruns. But with Betty's status as an icon and living legend, *Pet Set* was revived at considerable cost and effort. (See accompanying story.)

Finally, *Betty White's Pet Set* was rereleased to the public on streaming platforms and DVD on February 23, 2021. As a result, a whole new generation is now able to enjoy a show that gave Betty such immense pleasure. ▪

OPPOSITE: Betty and Carol Burnett's mixed-breed pooch Phoebe on the set of *The Pet Set*.

Lions and Tigers and Betty (Oh My!)

As a longtime patron of the L.A. Zoo, Betty has helped raise immense sums of money to help the animals there thrive.

Betty has contributed tens of thousands of dollars over the years to her favorite animal causes, in particular the Morris Animal Foundation. But at the very top of that list is the Greater Los Angeles Zoo Association (GLAZA). Its first fundraising gala happened on September 24, 1971, and was known as the Primate Ball, co-chaired by actor Jimmy Stewart's wife, Gloria.

Why "Primate Ball"? Because its goal that first year was to raise money for a planned Primate Village at the L.A. Zoo. Ed McMahon of *The Tonight Show* was the master of ceremonies. The attending guests included Lucille Ball and actor Gregory Peck. Betty was there, too, of course. It brought in about $55,000, or the equivalent of $355,000 today. Not too shabby for a kickoff fundraiser.

Oh, and Jimmy Stewart himself? The man knew how to make an entrance, riding in on an elephant.

The following year, the event was rebranded as the Beastly Ball, and the BB has been an annual shindig ever since—live from 1972 to 2019, virtual in 2020 and 2021 amid the COVID-19 pandemic. As GLAZA's major yearly funding event, it has annually raised awareness and funds (millions to date) to protect endangered animals and their habitats and foot the bill for global conservation efforts.

Betty has proudly acted as a trustee of GLAZA since 1974 and also sits as one of four serving on the GLAZA Foundation. Her support of zoos extends back well over half a century and remains an honored and important part of her legacy.

A not insignificant percentage of the Beastly take can be attributed to Betty directly. In 2010, a tour of the zoo and lunch with her snared $10,000 as part of that year's silent auction. That same year, she was bestowed the GLAZA Beastly Ball Award for her service by California congressman Adam Schiff.

It was a few years later that Betty's best friend, actress Millicent Martin, recalled in an interview that the Beastly Ball again put up Betty for lunch and a guided tour in the silent auction and had two parties bidding against each other. They stopped the bidding at $50,000.

"And she did lunch and the tour of the zoo with both of them," Martin remembered. "Neither of them would give

Strength in Numbers

When the Beastly gathering was in person in 2019, more than 800 guests came out to the evening event that featured gourmet cuisine and exotic beasts in equal measure.

Some $1.2 million was raised. The strength of the Beastly Ball concept itself, however, was demonstrated when a virtual gala on May 15, 2020, generated better than $1 million, hosted by actor and comedian Joel McHale (who oversaw a second virtual ball in June of '21). The advantage of putting the whole thing online was that the livestream reached more than 12,000 people, or 12 times the typical in-person crowd.

The downside to that, of course, is that it's not held at the zoo itself and there are no animals with whom to share your personal space. But it's people like White whose participation and dedication brought the annual shindig of fun and philanthropy its exposure and popularity.

up, so she devoted double the time. That's just the way the woman is."

The Beastly Ball gives safari-attired guests the opportunity to enjoy entertainment and numerous tasty morsels from area restaurants while wandering through the zoo

ABOVE: Betty holds a baby orangutan during the Beastly Ball, which annually raises money for the Greater Los Angeles Zoo Association (GLAZA).

and witnessing animal feedings and walkabouts, affording them the opportunity to interact with zookeepers and small animals.

If Betty were planning the perfect Betty White party to satisfy her every sense and emotion, it would look an awful lot like the Beastly Ball. It has food. It has generous people paying $1,000 apiece for admittance to raise money for a great cause. It has adoring animal lovers. And best of all, it has the animals themselves. ▪

Playing with Felix and Oscar

Arguably the funniest episode of one of TV's funniest shows starred Betty as her charming self.

*T*he *Odd Couple* has long been hailed as one of television's greatest situation comedies. It aired on ABC in originals from 1970 to 1975 and ran for 114 episodes, starring Tony Randall as Felix Unger and Jack Klugman as Oscar Madison. The weekly sitcom was a version of what began as a 1965 play and 1968 film of the same name from the legendary playwright Neil Simon.

Never was *Odd Couple* funnier than it was in the episode that was originally broadcast on December 1, 1972, titled simply "Password." It ranks number five on *TV Guide*'s 100 Greatest Comedy Episodes of All Time list. And Betty and her hubby, Allen Ludden, played a big part in that.

In the episode—written by Frank Buxton—Felix and Oscar run into Betty and Allen (guest starring as themselves) at a restaurant. It happens that Oscar is Ludden's favorite sportswriter, and Ludden asks him to appear on an episode of *Password*. Oscar politely declines the invitation, only to have Felix pipe up and insist that Oscar accept and bring him along as his contestant partner. This sounds like Oscar's idea of hell. But through a series of events, it's decided the two men will indeed partner together on the show.

When they arrive at the studio for the taping, however, they find out they'll be competing against seasoned game superstar Betty White herself. "And I take my *Password*

> ## While the odd couple do get one right, they prove to be no match for Betty's practiced game show prowess.

very seriously," Betty assures Felix. "I play to win." Ouch. Once taping begins, Ludden introduces Felix and asks him to say "a little" about himself.

"Well," Felix replies, "I'm a commercial photographer, portraits a specialty. Uh, I was married but not now, unfortunately. Although I wish I were. I have two extremely beautiful children, Leonard and Edna, whom I don't see as much as I'd like to. I only get them on weekends."

The stage is set for game show disaster. In trying to clue Oscar in to the word "Gravy," following the clue "Mayonnaise," Oscar tosses out "Meat." Out of nowhere, Felix guesses "Lincoln." When Oscar is completely flummoxed by this, Felix explains, "It's a known fact that Lincoln loved mayonnaise."

The next password is "Bird." Felix clears his throat and utters the clue "Aristophanes." To which Oscar replies, "Greek?" It goes back to Betty and she and her partner immediately guess it correctly.

Oscar (to Felix): "Aristophanes?"
Felix: "That's a perfect clue. Everybody knows Aristophanes wrote a play called *The Birds*."
Oscar: "Everybody but me."

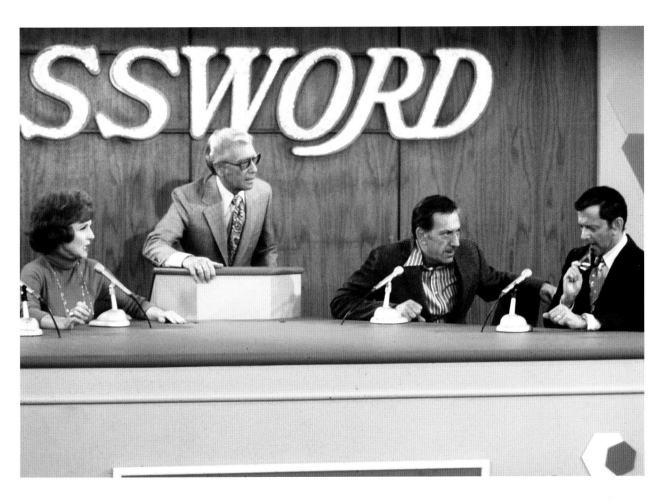

Back-and-forth hilarity ensues, and while the odd couple do get one right, they prove to be no match for Betty's practiced game show prowess. Felix argues with Allen that his clues were good, he believes he deserves to stick around, and ultimately he has to be escorted offstage after refusing to give up his seat, to the utter embarrassment of Oscar. Allen apologizes to the audience, who are no doubt delighted to be in on the joke.

It's well worth watching the episode today, as it's truly a classic piece of television. And as uproarious as Randall and Klugman were, Betty and Allen were equally perfect as their "straight men." It's unquestionably one of White's finest moments. ▪

ABOVE: A scene from the December 1, 1972, "Password" episode of *The Odd Couple* that guest starred Betty and husband Allen Ludden along with regulars Jack Klugman and Tony Randall.

Watch Out World, Here Comes Sue Ann!

Life was about to change forever for one Betty Marion White Ludden and *The Mary Tyler Moore Show*.

Betty feared that she had gotten stuck in a rut as a talk show guest and game show panelist. As she's quoted in the book *Women Pioneers in Television*, "Once you get into the talk routine, producers don't want to trust you as an actress. They forget you started out as an actress."

Well, Mary Tyler Moore certainly didn't forget. She and her husband, Grant Tinker, were good friends with Betty and husband Allen Ludden, and when the first script for the fourth season of Moore's runaway CBS hit *The Mary Tyler Moore Show* came in, it called for a guest star to play an "icky sweet Betty White type but also as vicious as a barracuda."

When the casting director, Renée Valente, suggested Betty White herself, the fear was that if she were terrible, Mary—being real-life friends with Betty—would have an awkward time telling her it wasn't going to work out. But after a dozen other actresses read for the part and none were nearly nice/nasty enough, they finally relented and called Betty in to read.

Moore remembered in an interview with the Television Academy Foundation's *Archive of American Television* that the role of Sue Ann Nivens, the Happy Homemaker, was always designed as a one-shot. After all, in that episode introducing Sue Ann—titled "The Lars Affair," written by Ed. Weinberger, directed by Jay Sandrich, and premiering on September 15, 1973—she was so loathsome for having a fling with Phyllis's (Cloris Leachman) husband that it never occurred to anyone that audiences would want to see her again.

"But she was so great, so inventive, that we couldn't *not* have her back on," Moore recalled. "She became everyone's delicious pixie. She represented all the evil places and dark corners we have inside us, and we cheered her on."

Indeed, White made a deep and immediate splash in portraying Sue Ann in that first episode of what would be a four-season recurring run on *MTM*. As the Happy Homemaker of Minneapolis's fictional WJM-TV, she was man-crazy, tart-tongued, judgmental, bitchy-with-a-smile, superficially cheerful, and simultaneously snarky—the woman everyone loves to hate but just can't. If Mary could turn the world on with her smile, Sue Ann Nivens could turn it nuts with a lusty stare.

Once *The Happy Homemaker* camera stopped rolling, the apple pie-à-la-mode gal disappeared and she turned calculating, catty, caustic, and in hot pursuit of anything male. Her casting was a stroke of sitcom genius and a match made in comedy heaven.

Author Michael McWilliams, in his 1987 book *TV Sirens*, noted of White's performance in "The Lars Affair," "When she sashayed onto the set of *MTM*, she brought with her the history of TV. Every leer, every twinkle, every wisecrack was attuned to the dynamics of video. She knew how to fill the box with expansive effect."

What Betty was actually doing was satirizing her own divertingly wholesome small-screen image. And everyone who had been concerned about the show's losing Valerie Harper and her popular character Rhoda Morgenstern to her own sitcom spin-off instantly relaxed. Never fear, Bets was here.

"Betty was so easy to write for," recalled Bob Ellison, a *Mary Tyler Moore* executive story editor and writer. "She came in and just bowled everyone over with her talent and her ability to fit into the show so perfectly. There was no attitude, no nothing. Just a total pro."

Weinberger, who wrote White's debut installment, recalled in an interview for this book the moment when everyone breathed a sigh of relief at her casting: "It happened during the week of our rehearsal run-through. It was

the scene where Betty was being confronted by Phyllis in the kitchen and took her soufflé out of the oven. Her hands were full and she had no other way to close the oven door, so she slammed it shut with her left foot.

"That was something we hadn't scripted, the perfect melding of an actress and a character. We knew right then we were home free."

While she was never a full-on series regular—appearing in 45 of the show's 168 total episodes—she used the show to successfully alter her virginal persona. And it really took only that first episode to smash the old Betty White to bits forever.

To be sure, the relentlessly perky-yet-backstabbing Sue Ann is on full display in "The Lars Affair," which many put in the top five of all *Mary Tyler Moore* episodes ever and some even call the best of them all. She makes quite the entrance at the outset while attending a party at Mary Richards's apartment.

As she's saying goodbye to the party's host, Sue Ann reminds poor Rhoda of a hundred odious household tricks she can do to fix scratched furniture, clean stains out of the carpet, and generally scrub down the whole apartment, assuring her, "You'll be done in two shakes of a lamb's tail."

Phyllis's husband, Lars (whom we never see), offers to drive Sue Ann home, and hours later he still hasn't arrived home, spouting some insane tale about an accident and an all-night repair shop. But Phyllis refuses to believe he could be cheating on her even when it's absurdly obvious.

When Phyllis finally confronts Sue Ann in the *Happy Homemaker* kitchen on set, it's at once tense and hilarious.

"There's no need for violence," Sue Ann insists. "Why you should deliberately destroy an innocent soufflé that never did you any harm is beyond me. I think you've gone too far!"

Phyllis thinks Sue Ann is crazy for being concerned with a fancy baked dessert at such a moment, and it concludes when Phyllis asks Sue Ann if she knows how to remove chocolate stains. Sue Ann insists that of course she does, and so Phyllis flings chocolate sauce onto her crisp, white apron.

ABOVE: Betty in the kitchen as Sue Ann Nivens, the Happy Homemaker, on the *Mary Tyler Moore Show* episode "The Lars Affair," which introduced the character.

The half hour represented a bravura performance for both Leachman and White, and the episode earned Leachman a supporting comedy actress Emmy nomination and a win the following year. All it won for Betty was a consistent role on the hottest comedy on television.

After the live audience went nuts for Betty and Sue Ann that first week, *Mary Tyler Moore Show* co-creators and executive producers James L. Brooks and Allan Burns approached Betty to tell her they were going to start on another Sue Ann Nivens script immediately.

Betty was thrilled to be asked back. She was assuredly jostled out of the rut she feared she was in, while the show had just received a jolt of fresh electricity that kept it from growing at all stale. And it was all because of Betty. ▪

"A New Sue Ann" Arrives on the Scene

An episode that Betty could really sink Sue Ann's
passive-aggressive teeth into.

On October 26, 1974, a little more than a year after Betty made her momentous first appearance on *Mary Tyler Moore*, came the episode that really cemented her status as a series castmate in good standing. It was called "A New Sue Ann" (written by David Lloyd and directed by Jay Sandrich), and, boy, did it set the Happy Homemaker back on her high heels in spoofing the 1950 film classic *All About Eve*.

In the episode, sweet and seemingly timid Gloria Munson (played by Linda Kelsey), the younger sister of a high school classmate of Mary's, pays the station a visit on the pretext of wanting to get into television.

Wide-eyed and ultra-ambitious, Gloria is Sue Ann's biggest fan, so much so that she wants to essentially *be* Sue Ann. As she cozies up to her television idol, she simultaneously plots to take over her show. To that end, she convinces the womanizing station manager, Ed Schroeder (Ron Rifkin), to hire her as Sue Ann's stand-in. Her role on *The Happy Homemaker* segment keeps growing, however, commensurate with her seemingly budding romantic relationship with Schroeder.

At first, Sue Ann is flattered by Gloria's attention and not at all threatened. As she says, "I think television needs bright young women. Look at me—and to a certain extent, Mary."

But soon enough, it occurs to Sue Ann that this kid is being groomed as her replacement, particularly given the station manager's view that her segment needs some changes to stay relevant. While playing around with a flower arrangement, she shares her feelings with Mary.

Mary: "Sue Ann, why do you keep changing the subject?"

Sue Ann: "Because I'm arranging flowers, dear. If I concentrate on these aromatic blooms, I can create a floral fantasy, whereas if I think about Gloria, I'd have to rip their smelly little heads off."

Her hostility fires out directly at Gloria too when Gloria asks Sue Ann what she should do for her first on-air exercise routine in a new segment, and Sue Ann suggests a headstand.

Gloria: "You mean, you just want me to stand on my head."

Sue Ann: "No, *I* want to stand on your head."

The primary reason that Sue Ann is so clued in to what Gloria is up to is her admission that compromising her morals was how she herself got hired at the station in the first place. As White would later say of the character, "You can't get much more rotten than the neighborhood nymphomaniac."

Schroeder continues to give Gloria more and more on-air responsibilities. So, Sue Ann decides to take matters into her own hands, making sure that the cream filling on Gloria's croquembouche pastry creation is left unrefrigerated overnight. It leads to everyone facing a bout of food poisoning.

"As I said to Gloria just now," Sue Ann offers, an ironic grin crossing her face, 'if you can't stand the heat, dear, get out of my kitchen.'"

It was a perfect denouement to a superb Sue Ann showcase for Betty, one that would lead to her first Emmy triumph in 23 years. That's just what happens when you steal nearly every scene you're in. ∎

OPPOSITE: The *Mary Tyler Moore Show* cast. Top row (left to right) Gavin MacLeod, Ed Asner, Ted Knight; seated (left to right) Betty White, Mary Tyler Moore, Georgia Engel.

Dreaming of a White Christmas

Betty decked the halls with boisterous holiday hilarity in
a Christmas episode that was anything but traditional.

Another *Mary Tyler Moore* classic, "Not a Christmas Story" (written by Ed. Weinberger and Stan Daniels, directed by John C. Chulay and premiering on November 9, 1974) is one of those rare Christmas-themed episodes that deserves to surface every holiday season. The difference here is that it has little of the traditional gooey sentimentality we've come to associate with yuletide television because, well, that's just the kind of mold-busting series this was.

Betty, as Sue Ann, has her deliciously cloying paws all over this half hour that primarily surrounds a newsroom fight erupting between vain, self-aggrandizing anchorman Ted Baxter (Ted Knight) and news writer Murray Slaughter (Gavin MacLeod) over Ted's refusal to read a new opening penned by Murray.

Sue Ann is as alternately sunny and caustic as ever. She waltzes into the newsroom early on looking as Christmas-y as Santa himself, with a sprig of mistletoe pinned to her lapel because, after all, this is Sue Ann. Her entrance sparks a prototypical bit of Nivens cheer that begins, "Isn't it beautiful out there?"

Her newsroom mates grumble a retort, moving Sue Ann to utter philosophically, "I mean, snow always inspires such awe in me. Just consider one single snowflake, alone. So delicate, so fragile, so ethereal. And yet, let a billion of them come together, through the majestic force of nature, they can screw up a whole city."

> "Not a Christmas Story" turns out to be the best Christmas show that's not really a Christmas show.

Indeed, a blizzard has hit Minneapolis and essentially shut down the town. The WJM-TV staffers are, in fact, snowed in, turning everyone's mood surly as their confinement together quickly rubs their nerves raw. All of them, that is, except Sue Ann, who exults in their unexpected incarceration.

She flutters around the newsroom in a Santa Claus apron, having just taped a holiday episode of *The Happy Homemaker* on Christmas dinners from around the world—or, as she calls them, "Yuletide Yummies for Worldwide Tummies."

As it becomes clear that none of them are going anywhere until further notice, Sue Ann takes matters into her own hands. She invites her crabby associates to follow her downstairs into the studio to partake of a gourmet holiday meal prepared for her Christmas special, preceded by laying a lengthy, lusty kiss on the lips of Lou (Ed Asner), purportedly under the mistletoe.

"Actually, it's asparagus fern," Sue Ann acknowledges, "but what the hell."

Once in the studio, everyone sits down at the table despite feeling completely festivity-challenged. That's when things really get both angsty and hilarious. Sue Ann coaxes them all into wearing the international-themed hats she'd incorporated into her program—Mary in a ridiculous Kaiser Wilhelm WWI helmet, Lou in a sombrero, and Sue Ann in a "little Dutch girl" head covering. What follows is the most half-hearted, borderline-angry rendition of "The Twelve

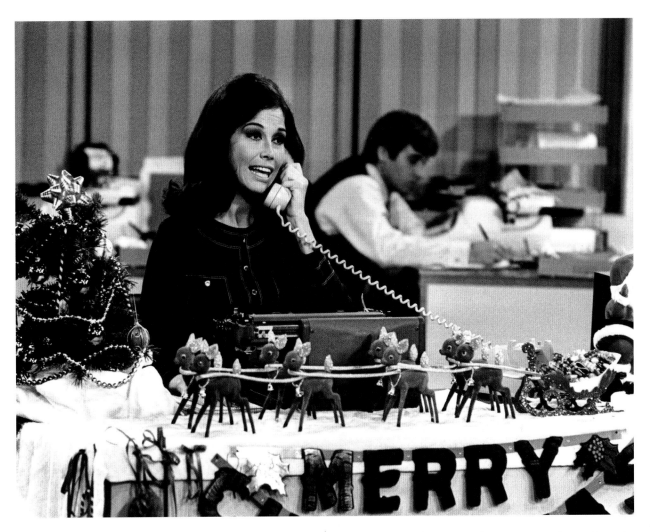

Days of Christmas" in prime-time TV annals. It's ultimately rescued from oblivion by Georgette (Georgia Engel), who croons a tender and sincere interpretation of "Silent Night" in her delicate voice.

"Not a Christmas Story" turns out to be the best Christmas show that's not really a Christmas show in sitcom history. And with all due respect to the rest of the cast, it's because Betty's depiction of Sue Ann here is so vividly, masterfully realized, an uproarious blend of down-home Americana and thinly veiled aggression.

ABOVE: Mary Richards (Mary Tyler Moore) stuck in the office at WJM-TV at Christmastime.

MacLeod, who portrayed news writer Murray throughout the show's seven seasons, said in an interview for this book that he believes this episode was "easily one of our funniest, and Betty had so much to do with that. Everybody talks about 'Chuckles Bites the Dust' as being our best episode, but for my money 'Not a Christmas Story' was as good as we ever got."

White would only continue to get better as the show went along. Pretty much every episode that emphasized her character proved to be a comedy grand slam. ▪

Emmy Days Are Here Again

Those little golden ladies called for Betty over and over,
and she was always happy to answer.

Betty wasn't thinking about Emmy Awards when she got the gig on *Mary Tyler Moore*. Like all actors with a hard-core work ethic, she was simply looking for a steady job. She found recurring employment in the character of Sue Ann Nivens, all right—and much, much more. Emmys would prove the gravy atop the biscuits, to take the analogy entirely too far.

After having won her first Emmy way back in 1952, she was thrilled to be nominated for a 1975 Primetime Emmy in the Outstanding Continuing Performance by a Supporting Actress in a Comedy Series category. She faced some formidable competition in Nancy Walker and Julie Kavner for *Rhoda*, Loretta Swit for *M*A*S*H*, and castmate Cloris Leachman for *MTM*.

In fact, however, this honor came with a bit of a twist. Leachman was actually cited in a different category as well— for Outstanding *Single* Performance. And as it turns out, they both won, while Valerie Harper took home the trophy for Lead Actress in a Comedy for *Rhoda*. So, it proved to be a giant celebration for the world of MTM Productions all around.

"I really am more delighted than I can tell you," Betty said while clutching her statuette. Holding it aloft, she added, "And this lady, I'm going to take home and introduce her to her 23-year-old cousin. Thank you very much." She then got a big kiss on the cheek from presenter Ed Asner.

Just to prove the TV Academy meant it, they voted another Emmy to Betty the following year, over fellow nominees Walker, Kavner, Swit, and *Mary Tyler Moore* co-star and good friend Georgia Engel.

If you see a clip of White's acceptance speech in '76, you'll notice that no one is applauding harder or more enthusiastically than Asner and Betty's husband, Allen Ludden, who clearly are thrilled for her.

Appearing even more ebullient onstage in '76 than she was in '75, Betty delivered her acceptance like so: "I tell you, when you hear that list read, Julie and Nancy and Loretta and Georgia, I really am so proud to be in that company. And I am *so* grateful to each and every one of those evil, adorable, wonderful, nasty people at *MTM* who make Sue Ann the rotten lady that she is."

Clad in a beautiful black-and-white chiffon gown, she continued, "You can't help but give a few thank-yous on an evening like this. Thank you, Grant (Tinker). Thank you, Mary. Thank you, Carol Burnett, for the dress."

As Betty would recall in her memoir, she and Allen flew to Hawaii for a week's vacation the next day and "could have made it without the plane."

The Mary Tyler Moore Show went on to win a then-record 29 Emmys all told, including statuettes in 1976 for White, Moore, and Ted Knight along with David Lloyd for writing and the show itself (as Outstanding Comedy Series).

Betty would be nominated again in 1977, losing out to Mary Kay Place for *Mary Hartman, Mary Hartman*. But her Emmy cup already runneth over. At least for now. There would ultimately be plenty more where this came from. ▪

OPPOSITE: Betty shares a triumphant moment backstage with co-star Ted Knight at the 28th Primetime Emmy Awards after each won for their supporting roles on *Mary Tyler Moore*.

Sue Ann Makes a Spectacle of Herself

The Happy Homemaker would do anything to get her man.

The reputation of Sue Ann Nivens as a proud man-eater with a voracious sexual appetite is given significant fuel in the *Mary Tyler Moore Show* episode "The Happy Homemaker Takes Lou Home," which premiered on CBS on December 6, 1975, and demonstrated just how far Betty had come with the character in two short years. It was like watching a comedy acting clinic unfold.

In the episode, written by David Lloyd and directed by sitcom master James Burrows, Mary (Mary Tyler Moore) is hot on the trail of booking Prince Charles of Britain for her talk show *Talk of the Town* but ultimately gets turned down by Buckingham Palace. She has to settle for a drunken King of the Gypsies. On top of that, she complicates Lou's (Ed Asner) life by tricking him into going out on a date with Sue Ann, who is hot for his lumpy body.

How do we know this? Because Sue Ann herself tells him, over and over. And even when Lou shows complete disinterest, she simply won't hear of it.

> **Sue Ann:** "Don't try to hide it any longer."
> **Lou:** "Don't try to hide *what*?"
> **Sue Ann:** "Your true feelings toward me. I know how much you're attracted to me, and you know how I know? Because you go to such lengths to hide it."

While looking to rope Mary into a depraved little scheme to get Lou to go out with her, Sue Ann knocks on Mary's door at 2 a.m. Mary complains that she was in bed, and Sue Ann replies, "Good, then you're alone."

Their plot succeeds and ultimately leads Lou to a completely awkward dinner at Sue Ann's place, followed by the moment of seduction. "A great dinner is the prelude to the symphony of love," she assures Lou. Lou does everything he can to draw out the dinner and delay the inevitable, which explodes in a moment of passion (Sue Ann's) on her couch.

Sue Ann plants a giant, lusty kiss squarely on Lou's lips, and the stiff-arm match that ensues during their lip-lock is a thing of performance brilliance. We feel her heat and his terror in spades, and that's where great acting resides. White's and Asner's chemistry while demonstrating a complete lack of it showcases why they're both Emmy winners.

The date concludes without lovemaking but with Lou doing his best to reacquaint Sue Ann with her dignity—at least whatever's left of it. He assures her she's better than all this scheming and throwing herself at men. Sue Ann confesses that this is the greatest rejection of her life, leaving her feeling "like a million dollars."

And so it goes at *MTM*, on which Betty White is not just a valued supporting player but every bit as important an element on the show as any of the other actors, including those who have been a part of it since day one. Everybody was fairly certain that White would fit into the show well once her initial guest spot turned into a recurring character, but no one dreamed she'd be *this* good. ■

OPPOSITE: Sue Ann (Betty) makes a play for the man of her dreams, her boss Lou (Ed Asner), in the 1975 "Happy Homemaker Takes Lou Home" episode of *Mary Tyler Moore*.

Anything for a Laugh

Even though Betty makes it look easy,
acting can be backbreaking work—literally.

If you follow Betty's career from its inception through the new millennium, one thing you'll notice is that the woman loves to work. It's her fuel, her energy source, her raison d'être. It's likely that no one in showbiz history has worked harder or had more jobs than has this woman.

But it isn't just the roles themselves that stand out. It's the fact that White is game to embrace whatever is tossed her way. She will do literally *anything* for a laugh, including muss her makeup and, if necessary, shred her reputation. And at the same time, she's a total professional who never breaks character—or a sweat.

Case in point: The *Mary Tyler Moore* episode titled "What Do You Want to Do When You Produce?" that premiered on December 20, 1975. Written by Shelly Nelbert and Craig Hafner and directed by Jay Sandrich, the installment was a tour de force for Betty that vividly demonstrated how little respect Sue Ann Nivens has for her coworkers as well as herself.

This is a woman who opens the episode with this classic sign-off: "Until tomorrow, this is your Happy Homemaker reminding you that a woman who does a good job in the kitchen is sure to reap her reward in other parts of the house."

In the storyline, our favorite forerunner to Martha Stewart has lost another in a series of producers. She dangles big money in front of Mary to bolt from her newscast position at WJM and work as a producer for her. Mary turns her down flat, leaving Sue Ann to assure Mary, "If you should ever change your mind, don't hesitate to come crawling."

News writer Murray Slaughter (Gavin MacLeod) volunteers for the job and the extra cash it promises—and Sue

Ann accepts. It turns out to be the biggest mistake of his life. Pretty soon, Murray is Sue Ann's personal slave, opening sardine cans, fetching coffee, scrubbing the stove, and cutting out doilies. He's being humiliated on an hourly basis.

Things come to a head when Sue Ann forces Murray to model a formal wedding gown in front of all their coworkers at the station. It boils over in Murray picking her up and sitting her smack down in the middle of a low-calorie wedding cake.

This is White's crowning moment on the series for a simple reason: MacLeod accidentally wrenched her back when he plopped her onto the cake, yet the actress didn't flinch. MacLeod would later recall that they had only one cake and therefore had to get the scene in a single take/cake—and Betty knew it.

In an interview for this book, Ed Asner—who was part of the scene and witnessed it firsthand—recalled hearing a nasty cracking sound at the moment when White hit the cake, which had a plank of wood underneath supporting it.

"We knew from that sound that something had gone wrong in her spine or her back," Asner remembered. "It was clear she'd thrown something out of whack because it had taken such a jolt. But she blithely weathered it. She was a fucking soldier. Didn't even flinch. The script called for her to taste the cake she was sitting in and say, 'Could use a little vanilla,' and she nailed it.

"I've got to say, the way Betty handled this impressed the hell out of us. She's the liveliest woman you will ever find, and the most determined." ∎

OPPOSITE: Sue Ann (Betty) makes a condescending point to Murray Slaughter (Gavin MacLeod) on an episode of *The Mary Tyler Moore Show*.

When "Sue Ann Falls in Love"

Betty takes Sue Ann to new heights and new lows that evoke audience emotion in a way few actors can conjure.

On February 28, 1976, CBS aired the *Mary Tyler Moore* episode "Sue Ann Falls in Love," and it marked the birth of a different facet of Betty's beloved alter ego Sue Ann Nivens. The by turns sweet-as-honey and gritty-as-dirt persona that had dominated her work to date gave way to vulnerability, despair, emptiness. For a few minutes, anyway.

The half hour, written by Bob Ellison and directed by Doug Rogers, featured guest star James Luisi as Doug, a ruggedly handsome Canadian outdoorsman who makes an appearance on the *Happy Homemaker* show and falls into a passionate fling with its host.

> **Doug:** "I've been teaching Sue Ann the joys of the great outdoors."
> **Sue** Ann: "And I've been teaching him the joys of the great *indoors*."

So intense is Sue Ann's passion for Doug that she breaks a long-standing date (in her mind, anyway) with Lou to attend the fictitious Teddy Awards with him so she can take Doug instead. Lou transparently pretends to be devastated by the news, so Sue Ann struggles to be thoughtful in her rejection: "How can I make this easy? I've met someone better."

But ol' Dougie shows his true colors when he's over at Mary's apartment and he puts the moves on her. At the Teddys, Sue Ann announces to Mary and Lou that she and Doug are going to form a new business partnership. So, when Sue Ann goes to powder her nose, Mary has no choice but to follow her into the ladies' room to break the devastating news that her sweetheart isn't all he appears to be.

Sue Ann at first is in denial ("Doug loves me, respects me, understands me") but soon accepts reality. She breaks down in tears of humiliation and wonders what she's going to do now, what with Doug waiting for her back at their table.

Devastated and in need of some comfort, Sue Ann instructs Mary to take her head and pat it. Mary does as she's told. "I think," Sue Ann concludes, "that we're doing wonderfully for two people who don't like each other."

When Sue Ann asks again how she's supposed to handle this, Mary asserts, "You tell him he is the lowest kind of

A Pioneer for Women

In 1976, Betty was honored twice for her work as a trailblazer for women in media—with a prestigious Golden Mike Award from Pacific Pioneer Broadcasters and a Genii Award (celebrating programming for, by, and about women) by the Alliance for Women in Media.

What's perhaps most interesting is that Betty never particularly saw herself as an activist for women's workplace rights. While she was one of the first women to exercise control on both sides of the television camera and is recognized as the first woman to co-create and produce a sitcom with *Life with Elizabeth*, she never saw it as a gender thing.

Indeed, White was too busy doing it to give much thought to all of the doors she was kicking open. The medium in which she was making such inroads was too new to know she should worry about any of that. Assessing her impact would come later and ultimately fall to others.

ABOVE: Sue Ann (Betty) pretends to enjoy the company of Mary in the WJM-TV Minneapolis newsroom.

cheap, unfeeling, money-grubbing parasite and you never want to see him again."

"All right," Sue Ann agrees. "I just hope he doesn't take it the wrong way."

Sue Ann returns to the table angry and primed for a fight. But as soon as it's announced that she won a Teddy and must now take to the microphone to give her acceptance, she's completely composed and sporting a wide smile. That's our Happy Homemaker.

The episode would prove a breakthrough for White in her portrayal of such a lovably loathsome character, bringing Sue Ann a sympathetic edge and thus another layer of complexity. Betty pulls it off so seamlessly that we barely notice it hasn't been residing there all along. Clearly, the writers and producers of the show increasingly understood how to incorporate Sue Ann, infusing her with a greater color palette and giving her more to do.

As co-star Gavin MacLeod wrote in his 2013 biography *This Is Your Captain Speaking: My Fantastic Voyage Through Hollywood, Faith and Life*, "Betty made every moment count. I've declared her an American treasure because she is just that." ◾

My Sister, My Rival, My God!

Two Sue Anns are not in fact better than one.

You can tell that Betty White is wearing her Sue Ann Nivens character like a perfect-fitting pair of jeans while watching the "Sue Ann's Sister" episode of *Mary Tyler Moore*. She's not just all wisecracks anymore. Her humor now emerges much more organically from her character, because she's been around long enough for the writers (in this case, David Lloyd) to incorporate her effortlessly into the fabric of the series.

Premiering on October 9, 1976, at the dawn of the show's seventh and final season, it actually leaves the punch lines to Murray (Gavin MacLeod) in setting up a visit from Sue Ann's little sister Lila (Pat Priest, Marilyn from *The Munsters*) on the eve of Sue Ann's birthday. Murray: "What do you get for the woman who's had everyone?"

Lila, it turns out, hosts a televised cooking show in Georgia. She breezes into town and immediately attracts the eye of Lou, setting Sue Ann into a defensive posture and drawing out her claws. She admits that she had been looking forward to Lila's visit "like cramps."

Sue Ann struggles to put a positive spin on it, admitting, "I was jealous of her when she was 14 and I was 19. I'm sure it'll be different now that we're both 35."

But it isn't. Lila connects with Lou at Sue Ann's birthday party and playfully slaps his knee, inspiring Sue Ann to kick her sister's hand off. She then confides to Mary that the best thing to do might be to push her sister off the balcony. That hostility grows to outright fury when Lila announces she's interviewed for a job hosting a homemaking show similar to Sue Ann's at a rival station in Minneapolis—and landed the job.

Devastated and broken, Sue Ann takes to her bed, pushing Mary to rally her newsroom colleagues to rush over to Ms. Nivens's place and talk her off the ledge. The scene that follows is one of the most memorable in *MTM* history. The sight gag alone is magnificent, showing her extravagantly outfitted bedroom to be everything the audience had always imagined it to be: giant round vibrating bed, elaborate pink ruffles, mirrored ceiling, mood lighting, surround-sound stereo.

One by one, the cast members come in to cheer up Sue Ann as she lies in bed completely made up and dressed in a gorgeous nightgown. She assures Mary, "Nobody misses a vain, selfish, egotistical, middle-aged shrew," but Mary assures her, "Of course they do."

The funniest moment has Lou struggling to give Sue Ann all the praise she demands as the full force of the bedroom and its absurdly seductive allure is brought to bear. Just seeing and listening to her play it with mock distress is sublimely entertaining, as is the denouement that finds Mary briefly but joyously submitting to the bedroom's charms after everyone has left.

Just when you think Betty can't possibly get better in this role, she does. ∎

> "What do you get for the woman who's had everyone?"

OPPOSITE: Sue Ann (Betty White) says something that clearly startles Georgette (Georgia Engel) and amuses Ted (Ted Knight).

The Ax Falls on Sue Ann

Somehow, Betty even made getting canned seem funny.

As *The Mary Tyler Moore Show* was careening toward its conclusion after seven glorious seasons, things looked like they were going to end even sooner for poor Sue Ann Nivens. There's no way to sugar-coat it when the title of the installment is "Sue Ann Gets the Ax," which premiered on January 29, 1977, and kicked off with the news that Sue Ann's show, *The Happy Home-maker*, had been canned due to low ratings.

In fact, this episode foreshadows the entire staff at WJM-TV Minneapolis getting sacked in the last show some seven weeks later. And while there is nothing inherently funny about people getting fired—particularly our beloved Sue Ann—the way it all goes down demonstrates just how adept Betty is at making anything and everything amusing.

As things progress in the half hour written by Bob Elli-son and directed by Jay Sandrich, Sue Ann is initially defi-ant, vowing, "Sue Ann Nivens doesn't give up without a fight!"—prompting Murray (Gavin MacLeod) to retort, "That's not what the cab drivers tell me." She then bursts into tears and begs for a job in the newsroom.

Lou, demonstrating shockingly little backbone, imme-diately promises Mary increased responsibility in the news operation going forward, thereby putting the Sue Ann deci-sion squarely on her shoulders. But an angry Mary, taking her new role of making hiring decisions seriously, won't hire Sue Ann no matter how much she pleads and prostrates herself.

In the meantime, Sue Ann does anything asked of her to ful-fill her contract and stick around. It initially means voice-overs recorded in a cramped studio beside a hands-y, cigar-smoking,

potbellied engineer. Sue Ann observes to Mary, "Isn't that a beautiful aroma? It's like living in Fidel Castro's mouth."

Cut to the set of *The Uncle Bucky Show*, a *Kukla, Fran and Ollie*–style puppet presentation. Sue Ann is clad in a humiliating daisy costume. Lou and Mary bear witness as she launches into a routine with a pair of hostile, obnox-ious puppets. They call "Aunt Daisy" over to help them solve a problem, and when Betty as Sue Ann as Aunt Daisy asks them why they aren't doing so well, Mucky the puppet informs her, "Because, Sue Ann, you're blocking my shot!"

Sue Ann apologizes, but the puppets berate her:

Hucky: "I thought you said you worked
 on television before!"
Sue Ann: "Well, I'm sorry . . ."
Mucky: "You don't know enough to stand
 on your mark!"
Hucky: "I told them I didn't want her on
 this show."

On it goes, inspiring Lou to lose it and begin strangling one of the puppets.

Sue Ann would ultimately be relieved of having to embarrass herself in front of angry felt creatures any longer, as Mary finally relents and hires her. She sticks around until the rest of the gang is terminated right along with her just weeks later.

As the show goes, this was a particularly dark piece of business. Only someone with White's acting chops could simultaneously evoke mirth, pity, rage, and sympathy, all in the space of the same half hour. It's only too bad she couldn't remain on this show forever. Four seasons wasn't nearly enough. ∎

OPPOSITE: Lou Grant (Ed Asner) consents to give Sue Ann (Betty) a tension-reducing massage during the January 1977 "Sue Ann Gets the Ax" episode of *Mary Tyler Moore*.

The Betty White Show, Take Four

She's gonna make it again after all.

Betty is not one to sit idly by for very long. *Mary Tyler Moore* wasn't off the air for six months and there she was again, starring in her own namesake *The Betty White Show* (the fourth such series to bear her name as the title in the space of a mere 26 years). This one was created by *MTM* writer-producers Ed. Weinberger and Stan Daniels and produced by *MTM* writer Bob Ellison, so everything was familiar to the star. It even featured her pal and *MTM* castmate Georgia Engel portraying her best friend and roommate, Mitzi Maloney.

The CBS sitcom cast White as Joyce Whitman, a middle-aged (read: over-the-hill) actress who has landed the lead in a fictitious, show-within-a-show cop drama called *Undercover Woman*. It was a satire on the Angie Dickinson series *Police Woman,* and in the context of the comedy, it was purposely dreadful.

But it wasn't just that *Undercover Woman* was terrible. The pilot was also directed by her prickly ex-husband John Elliot (played by John Hillerman of *Magnum, P.I.* fame). It's clear from the get-go that there are still sparks flying between them, mixed in with the sparring and contempt, but that romantic ship has, alas, sailed.

Betty is razor-sharp in the lead. She simply doesn't have a bad performance in her. And it was a thrill for her to get her own show once again hot on the heels of her last comedy series effort. Moreover, she and Hillerman sport a

Ed. Weinberger Repents

And now, for a completely different take on *The Betty White Show,* we present Ed. Weinberger with a direct message to Betty: "I'm terribly, terribly sorry."

Why is Ed. terribly, terribly sorry?

"Because I nearly derailed her career with my stupidity," Weinberger maintained in an interview. "Grant Tinker [principal in MTM Enterprises] asked me and my partner [Stan Daniels] to take on this show. We were already on our way to Paramount, where we ended up doing *Taxi* among other shows. We left after creating the pilot. But I want Betty and the world to know that I take full responsibility for the ultimate failure of *The Betty White Show.*"

Oh really, Ed.? And why is that?

"It was my bright idea to get rid of this great character Betty White had created on *Mary Tyler Moore,* Sue Ann Nivens, and invent a totally new person for the show instead of just making it a spin-off. To this day, I have no idea why I did that or what I was thinking. I still wake up in the middle of the night wishing I had that decision back."

Let it be known that the author of this book did his best to reassure Weinberger and help him forgive himself, even though he has no formal therapeutic training. Perhaps any series was going to pale in comparison to *Mary Tyler Moore,* for one thing. After 44 years, furthermore, you would think

it should be water long gone under the proverbial bridge. But Ed. is in no mood for reconciliation.

"If there is a television hell, I will be going there," he insists. "Has Betty ever forgiven me? I can't say. We've never discussed it. I'm sure she's too good a person to hold a grudge. Unfortunately, I'm not too good to hold one against myself.

"But please relay to Betty that I love her dearly and that one day I'll make this whole thing up to her. And if I don't, she needs to know that I'll take the shame to my grave. That should give her some solace."

deliciously acerbic chemistry that sizzles from the outset. These are a pair of pros operating at the top of their game.

There was indeed a lot to like in this ahead-of-its-time spoof of the TV business, carrying elements of successful shows that would come later—namely, *The Larry Sanders Show* and *Cybill*.

Unfortunately, *The Betty White Show* never caught on with viewers, in part because it was scheduled in a deadly time period opposite ABC's *NFL Monday Night Football* and a popular movie franchise on NBC. It was also true that besides White, Hillerman, and Engel, the rest of the

ensemble didn't really pull their weight with the same heft and fervor.

Of the quick hook for the show, Betty was quoted in *Women Pioneers in Television* as saying, "There's a sadness in me I can't ignore—and a lot of embarrassment, too. You feel you promised so much and delivered so little."

But Betty was being overly hard on herself. And on the bright side, the fact that *The Betty White Show* survived for just half a season (14 episodes) bought her a bit more time to catch her breath between regular gigs. That work ethic of hers is quite something to behold, indeed. ∎

ABOVE: Betty during a promo shoot for her fourth incarnation of *The Betty White Show*, which premiered on CBS in September 1977.

Making a Splash with Carol Burnett

Pioneering women, comic geniuses, and great friends.

Betty and Carol Burnett have a lot in common. Oh sure, they're both television comedy giants with extraordinary careers. Burnett's *The Carol Burnett Show* was a CBS prime-time staple from 1967 to '78. White has been a presence on the TV scene literally from the medium's inception. But it goes beyond that, to the fact that both women are the very definition of goodness. It makes sense that they'd become close pals.

Over the course of Burnett's 11 seasons on her original show, she featured Betty three times. The last came on March 5, 1978, just weeks before she left the first-run air. It was in a memorable beach movie parody sketch titled "Beach Blanket Boo-Boo" that found her and Carol fighting over the same ditzy dude (played by Steve Martin, just as he was sailing into his stand-up comedy peak).

If you watch the clip today, you'll see both Carol and Betty in ridiculous 1950s getups. White sports a blonde beehive, a black leather jacket and leather pants, a tight low-cut yellow T-shirt, an orange scarf, black leather stiletto boots—and the word "Swinette" on the back of her jacket along with the likeness of a pig.

Betty: "Something about the smell of Coppertone makes me goose-pimply all over."
Steve: "I know. I get the same way smelling axle grease."

A Conversation with Carol Burnett

Carol fondly recalls her near lifelong friendship with Betty.

Q: *How far back does your friendship with Betty go?*

CAROL BURNETT: Way, way back. Before she married Allen [Ludden] actually, so back to the very early '60s. Then after they got hitched, they had a place here in California and they'd have these game nights. It would be like *Password* and charades and various board games. I remember playing Pictionary much later on. And they would have people there like Fred Astaire just hanging around. And Burt Reynolds. Oh my gosh, there were just so many.

Q: *Then, of course, Betty would show up from time to time on your variety show.*

BURNETT: Uh-huh. We did some sketches and musical numbers, and Betty also had a running part in our family skits playing Eunice's snooty sister, Ellen. We even shot a made-for-TV movie together extending that sketch, but it was during the time when Allen was very sick. Betty soldiered on, but it was extremely tough.

Q: *So, you remember that time in 1981 well?*

BURNETT: Gosh yes. I couldn't believe how Betty could still focus on work. She was so worried. When she wasn't rehearsing, she would be with Allen. It was a sad time, but she was there both for him and for us. I know her heart was breaking, but she was such a pro. We all just put our arms around her and did everything we could to help. I simply adore her.

Q: *Didn't you also make an appearance on her animal show, The Pet Set?*

BURNETT: Oh yeah. I brought on my dog, Phoebe. She was a mixed breed that had been shot in the leg and could use only three legs. Betty was quite the animal whisperer.

Q: *It's hard to believe that was 50 years ago. But the two of you have stayed in good touch over the years, it seems. When was the last time you got together?*

BURNETT: Well, I was there for her 90th birthday celebration on television. I remember coming out and saying, "I want to be here ten years from now, for your 100th." So,

I'm hoping that can happen. I also got a chance to work with her in two episodes of *Hot in Cleveland*, which was wonderful.

Q: *Do you think that because she's so sweet and kind and inherently decent, maybe Betty has sometimes been underestimated as a performer?*

BURNETT: Yeah, actually. She's practically perfect in every way, so that gave her a reputation of being Miss Goody Two-Shoes. But then she'll do something like go on with Johnny Carson and tear him a new one in jest to dispel that.

Q: *What do you recall about your time working together on your variety show?*

BURNETT: Just that she was so well prepared and gracious. You know one way you can tell? Whenever she would come on, she knew everybody's name. The cameraman. All the crew members. Everyone. For that and so many other reasons, they just loved her. They also loved the fact she would make blue jokes during rehearsal. She was just one of the gang.

She would later admit that she liked her guys "weak and yucky," while he preferred his gals "strong and greasy." Both were getting their way, as it turned out.

The point that this skit once again drove home was that Betty was up for anything and everything. She didn't worry about how she looked or how something stood to impact her reputation. She just went for it and let the chips fall where they may—and somehow, they always fell just right. Let's remember that this was a 56-year-old woman being asked to portray a gum-smacking teenager. That requires a certain measure of guts, not to mention boundless confidence. No matter what the comedy job was, the *only* thing that counted to White was getting the laugh. The end of generating that guffaw justified the means.

It would be just seven and a half years before Betty would be playing a mature, older woman on *The Golden Girls*. And in hindsight, maybe that would prove the bigger stretch than portraying a leather-clad teenybopper. ∎

OPPOSITE: (Left to right) A young Steve Martin, Tim Conway, and Betty star in a memorable 1978 beach-movie parody sketch on *The Carol Burnett Show*.

Adam and Eve Are Separating!

It seems like Bionic Betty's been around forever,
so it makes sense that she made a great Eve.

For such a major public figure, Johnny Carson was known to be notably shy and reclusive. He didn't trust or hang out or party with a lot of folks. But throughout the run of his *Tonight Show Starring Johnny Carson* in late night, one of those Carson allowed in was Betty White.

It seems that the two of them went way back. How far back? Try 1951, when Betty was hosting her early comedy series *Life with Elizabeth* along with the daily live local broadcast *Hollywood on Television*. A few blocks away, Carson had been hired by CBS affiliate KNXT (later KCBS) to host the comedy series *Carson's Cellar* that often featured . . . Betty White.

Carson would schedule appearances with Betty from his earliest years in the 1960s hosting *Tonight* back in New York. The respect they had for each other ran deep, found Raymond Siller, a staff writer for *Tonight* from 1974 to 1978 and head writer from late 1978 to 1988.

"Johnny and Betty had a shorthand that he enjoyed with almost no other star," Siller recalled. "That's why he loved having her on when he did sketches that could have thrown him off if, say, someone tried to ad-lib on him. He knew Betty wouldn't."

One of their most memorable skits from the Mighty Carson Art Players (the recurring title of Carson's sketches) was performed on February 8, 1979, when the clock had struck midnight in the Garden of Eden for humanity's First Couple.

Yes, Adam and Eve had decided to call it quits, and the pair were taking their cue from Lee Marvin and Michelle Triola, who at that moment were in the middle of a trial during which Triola was claiming she deserved alimony for longtime cohabitation (or, as it came to be known, "palimony").

Adam and Eve were standing in here for Lee and Michelle, with Johnny (Adam) and Betty (Eve) locking horns out in the garden. For the occasion, Betty wore a white one-piece with leaves obscuring sensitive portions of her anatomy and a long silver wig, while Johnny donned a black wig, ivory briefs, and some fig leaves over his manhood.

As White told *Entertainment Weekly* in 1992, "The joke has always been that if Johnny wants to take his clothes off [on the show], he calls me."

Let it also be noted at the outset that both Betty and Johnny looked pretty fabulous despite having plenty of skin showing and their outfits being formfitting. He was 53 and clearly playing tennis regularly. She was 57 and boasted a fit physique that appeared significantly younger.

The resulting skit is very clever. The mere idea that the original couple from paradise could suffer from marital problems is by itself pretty inspired. Betty/Eve believes she's entitled to half of everything in the garden, while Johnny/Adam feels aggrieved and a little insecure. He asks her, "Eve, was I the first?"

> "Johnny and Betty had a shorthand that he enjoyed with almost no other star."

Eve: "How can you ask such a ridiculous
 question?"
Adam: "It's just the way the snake keeps winking
 at me."
Eve: "Listen, buddy, I want half of our community
 property. And custody of the snake. I only am
 taking what is rightfully mine."

Eve ultimately throws up her hands and wonders how in
the world they're going to come to an agreement. It's then
that a lightning bolt explodes and God intones, "Adam!"
When Adam notes how unreasonable it is that Eve wants
half of all he's worth, God pointedly replies, "Wrong! She
gets *everything*! Let there be alimony!" And then a lawyer
arrives right on cue, sporting red horns and clad in a suit.
The devil, it seems, is in more than just the details. He pro-
ceeds to hand Adam a palimony bill, giving Eve her opening
to make off with his protective leaves and disappear.

Subtle? No. But witty nonetheless, and a classic moment
for both White and *Tonight*. ▪

ABOVE: Betty and Johnny had a long history, and her work ethic
made her one of the few performers he really trusted.

The 1980s

The Golden Girl

"As an actor, you get so many bad scripts, but when I read the pilot script for *The Golden Girls*, I sat up and took notice. It was different from anything I'd gotten, and it was all because of the wonderful writing."

—Betty White on becoming a Golden Girl

OPPOSITE: Betty as Rose Nylund on *The Golden Girls*, which ran on NBC's primetime schedule from 1985 to 1992.

At an Age When Most Retire, Betty Was Just Warming Up

...

I t had grown abundantly clear to anyone who was paying attention that Betty White was a full-service performer, something of an industry unto herself. Wherever she appeared, she looked like she belonged there, and soon it was fairly impossible to imagine the thing without her.

That even went for *The Tonight Show*, with host Johnny Carson making White feel so intrinsically a part of it that she practically became a co-host during her numerous appearances. When she dropped by one night in August 1981 to play a sketch as Jane to Johnny's Tarzan—she in a leopard-skin one-piece, he bare-chested and in a loincloth—the resulting skit would be fondly recalled by staffers as an iconic (if decidedly sexist) moment for the show.

It was two years later, in September 1983, when Johnny Carson nearly had Betty killed—by accident, of course. It happened during a skit where they played a couple dining in a Malibu restaurant that was flooded by 500 gallons of water, which knocked both of them off their chairs and laid them out on the ground facedown while Johnny fought off an octopus. But White, game as ever, rose up and played on.

Broadway legend Carol Channing also became a close friend to Betty. The two made it count in several episodes of *The Love Boat*, including a December 1982 installment in which they performed a song-and-dance cabaret to the tune "Two a Day" that showed White's ability to hold her own even beside a Tony Award winner.

Through all of her TV work, the one constant for White was her game show appearances. Yet it never quite extended to her actually hosting one until 1983, when Betty was finally entrusted with the reins of the new show *Just Men!* And while it didn't prove a schedule sticker, it did result in her winning yet another Emmy. This one was for Daytime Game Show Host, making her the first "femcee" to be so honored.

While Betty was never without work, by her own admission she longed to return to a steady gig in the prime-time world. She got it when a little show called *The Golden Girls* came into her life in 1985. It required a fateful series of decisions for the NBC comedy to happen for White at all. For one, the idea of a sitcom centered on four older ladies cohabitating in Miami started off literally as a joke. No one could have ever imagined such a series catching on in a universe where advertisers target adults aged 18 to 49, but then a skit starring Selma Diamond and Doris Roberts parodying *Miami Vice* as *Miami Nice* made hilarious waves and *The Golden Girls* was created to ride them.

Betty was originally penciled in as the man-hungry Blanche rather than the naïve Rose, since that had been closer to her Sue Ann character on *Mary Tyler Moore*. Fate dealt Betty a royal flush, however, when she was recast as the proper character. NBC nurtured *The Golden Girls* starting in

September 1985 by placing it in the Saturday 8:00 p.m. time period (which it would effectively own for six years running). Suddenly, White was no longer a performer searching for her next job, but a legend blessed with a second comedy classic.

White established Rose immediately in a pair of season one episodes that demonstrated the character's endearing nature and surprising range. She drew on her own recent experiences with death in an episode titled "The Heart Attack" and memorably had a romance with a little person in a half hour ("A Little Romance") in which Rose is shocked that her undersized boyfriend can't continue seeing her because she isn't Jewish.

Golden Girls grew in popularity through its first season and into its second. Rose's reputation for inadvertently killing off men she has just slept with was burnished in the episode "In a Bed of Rose's," while Rose's simply telling someone to "Drop dead!" could have an equally fatal impact, as viewers learned in the November 1, 1986, episode "It's a Miserable Life." It was only a week later that the show broke new ground in the LGBTQ community with a half hour titled "Isn't it Romantic?" in which a woman who'd recently lost her partner is sweet on Rose. The breakthrough was the way the episode focused on the characters' humanity rather than shock value.

When the Emmy Awards came around in September of 1986, all four of the show's principals (Betty, Bea Arthur, Rue McClanahan, and Estelle Getty) were nominated. But only one went home with the statuette: White. She graciously shared in her acceptance, "We're a matched set. You can't split us up." Betty was back full force as a weekly comedy staple. But that didn't cause her to give up everything else. She continued to do the game show circuit. And when she met up with old friend Lucille Ball on *Super Password* in December 1986, it happened to be the same day Lucy's famed ex and father of her children, Desi Arnaz, died. It proved to be a rough day for Lucy, made significantly less so by Betty's comforting presence.

How do you top a royal performance in London? Perhaps you don't.

A much more jovial occasion arrived the following April, when White was surprised by Ralph Edwards as a *This Is Your Life* honoree. She was visited by longtime game show friends, by the *Mary Tyler Moore Show* gang, and by her talk show host buddy Jack Paar. It was a moving and meaningful event.

Equally signficant to her was her appearance on Hollywood Boulevard's Walk of Fame in March 1988 to oversee a ceremony for her late beloved husband, Allen Ludden, in which he posthumously received a star for a life and career of great distinction. Betty herself had been honored with a star in 1960, but this one meant considerably more to her.

Yet when it came to thrills, few could equal what happened to the *Golden Girls* stars on November 24, 1988, when they were commissioned for the annual *Royal Variety Performance* before Elizabeth the Queen Mother. The four American ladies were in character, reenacting scenes from previous episodes, and they were left floating on air by the queen mother's delighted response to their work.

How do you top a royal performance in London? Perhaps you don't. But for Betty, plenty more would be coming in the ensuing third of her life. There were more *Golden Girls,* more game shows, more special times with animals, and many more awards and honors to come. Indeed, at an age when most performers are contemplating retirement, this lady was just getting started. The first 68 years were merely the warm-up for a third act that promised to be her most thrilling and fulfilling one yet.

In the Jungle with Johnny

He Tarzan. She Jane. We laughing.

Once again, when Johnny Carson was looking for a sketch partner in crime, he turned to Betty White. It happened on the night of August 14, 1981. A new Tarzan movie, *Tarzan the Ape Man*, was just being released into theaters, starring Miles O'Keeffe as the man of the jungle and Bo Derek as his jungle mate, Jane. To parody the hopeful blockbuster, Johnny emerged on a swinging rope "vine," bare-chested and clad only in a loincloth with a shaggy-haired gray wig. Betty, meanwhile, was in a loose-fitting leopard-skin one-piece for their eleven-and-a-half-minute routine.

They performed the sketch on an elaborate overgrown jungle set replete with palms and a straw hut. This Tarzan and Jane were cynical and middle-aged rather than young and adventurous. Vocally, Betty's Jane sounds pretty much like Betty, while Johnny's Tarzan satirizes the clipped, third-person speech of the Tarzans who have come before. After questioning him on being late, she berates him for not keeping up his end of the housework. To which Tarzan/Johnny maintains, "Little chores woman's work. Only have one chore."

Jane: "What's that?"
Tarzan: "Empty hippopotamus litter box." [He then empties it.]

A Conversation with Raymond Siller

The head writer on *The Tonight Show Starring Johnny Carson* from late 1978 to 1988 talks about Johnny's trust in Betty.

Q: *Why do you think Johnny trusted Betty so much in their sketches together?*

RAYMOND SILLER: Well, first off, they'd been friends for a long time. Johnny knew when he was doing a skit with her that she'd stay right there with him. People like Burt Reynolds asked to become part of the sketches with him, but Johnny always said no because he couldn't count on Burt and the others to stick to the material. Betty also didn't need cue cards. Johnny would call her at home, messenger over a copy of the sketch, and by the day of the appearance she'd already have it down.

Q: *It also seemed that Johnny respected Betty enough to give her some of the laugh lines and not just the setups.*

SILLER: Exactly right. He'd feed her lines that allowed her to put him down, that were at his expense. I'm not sure he did that with anyone else. He was really generous with her because he respected her so much.

Q: *What else do you remember about Johnny and Betty's interaction?*

SILLER: They just really liked each other. Johnny had his pick of comedy actresses to play off, and if he had a choice, Betty was the one he'd choose. Every time.

Q: *Which was your favorite of their sketches?*

SILLER: Absolutely, it has to be the Tarzan and Jane one. If I remember correctly, Betty's husband, Allen Ludden, had passed only a few months before, but you would never have known it from her professionalism that day. It was a testament to her work ethic. But that skit just worked to perfection. Everything about it clicked beautifully.

Then, Jane *really* gets her henpecking wife attitude on.

Jane: "You're completely primitive. You're totally unskilled. You have the manners of a baboon and the I.Q. of an ape. Where could you possibly get a job?"

Tarzan: "Tarzan already been accepted at post office. (beat) As supervisor."

It's all pretty silly stuff, if a mite on the stereotypically sexist side. This was, after all, 40 years ago, well before the age of gender enlightenment. But it's again easy to see how comfortable Johnny is with Betty, in a way he was with few other performers. There aren't many with whom Johnny would so let down his guard and appear almost vulnerable, placing his trust in her to have his back (and a shirtless one at that).

The moment also belongs to White. Carson was still in his heyday here, with a godlike power in the Hollywood community. As Johnny's on-screen playmate, she was being granted status as an equal by the King of Late Night himself. And she was fearless. There wasn't an ounce of nervousness evident here, which was largely why Johnny had such faith in her in the first place.

At the same time, Betty shared the spotlight graciously, never insisting on it, making her the perfect sketch buddy. ∎

ABOVE: Johnny Carson yelling as he swings in on a vine as Tarzan to Betty's Jane in a *Tonight Show Starring Johnny Carson* sketch on August 14, 1981.

All Aboard!

Betty and Carol Channing hit the high seas on everyone's favorite funny boat.

One of the benefits of being Betty White is that you get to work and become friends with show-biz royalty. Such was the case with her and the Tony Award–winning Broadway legend Carol Channing, whom Betty got a chance to perform with in four episodes of *The Love Boat* in the early to mid-'80s. Betty portrayed Betsy Boucher, a friend of Julie's (Lauren Tewes) Aunt Sylvia (played by Channing).

It was a lot of fluffy fun, and you could see just how much the ladies were enjoying bouncing off each other. This was especially true in their installment that premiered on December 11, 1982, titled "My Friend, the Executrix."

The segment finds Betty (er, uh, Betsy) having been appointed as the trustee to help widow Aunt Sylvia keep hold of the apparent millions left to her by her late husband. Let's just say that Betsy takes her new job a mite too seriously, driving Sylvia mad with her hovering and insistence on frugality.

On the boat, for instance, Betsy dissuades Sylvia from ordering a champagne cocktail.

"One should never spend money unless it's necessary!" insists Betsy. "Wouldn't a glass of water do just as well?"

Heavens to Betsy!

"But I like the bubbles," Sylvia reasons.

Betsy: "Soda water, then."

Meanwhile, Betsy orders a champagne cocktail for herself. Oh, the humanity.

Then Sylvia makes the mistake of mentioning she'd like to purchase a $50 scarf she'd had her eye on, inspiring Betsy to wag a finger and proclaim that were she to buy 20,000 scarves at $50 apiece, there goes a million bucks out the window.

Finally, Sylvia rebels and tells her new thriftiness monitor to screw off. She buys everyone on the ship a drink and decides to let the financial chips fall where they may.

Of course, we come to discover that in fact Sylvia is flat broke, that her husband didn't have a red cent to his name, and what was she going to do now? Answer: When life hands you sour lemons, make entertainment lemonade.

Cue the music. Betty and Carol, as Betsy and Sylvia, put on a song-and-dance cabaret with the tune "Two a Day," written in 1960 by Jerry Herman for *Parade: A Musical Revue*. Their routine comes complete with matching straw hats, white canes, checkered orange vests, and orange skirts, for the entertainment of the sailing audience. Rarely will you ever see two people having more of a ball than they do during this number.

How much did White and Channing enjoy working together? So much so that there was a plan with the production company owned by legendary talk show host and show-biz entrepreneur Merv Griffin to produce a comedy series starring the ladies titled *Friends Like Us*. Griffin even booked them onto his show earlier in 1983 in a stunt designed to promote the proposed show. But it was never to be.

No matter. Sometimes, you just want to put on your dancing shoes and croon alongside your pal, and that's what *The Love Boat* guest appearances provided for Betty and Carol. Let it never be said that this lady didn't love every moment of her career journey no matter how diligently she worked. ■

OPPOSITE: Actor Louis Nye and song-and-dance legend Carol Channing (center) join Betty on an installment of ABC's *The Love Boat*.

Just Men!

After years of having the long-stemmed mic dangled in front of her, Betty was finally given the chance to play host.

It's hardly a secret that Betty is the Empress of Television Gaming. No one else even comes close. By 1983, she'd appeared as a celebrity panelist on more shows than can easily be listed here. To name just a few: *Concentration, Celebrity Sweepstakes, Celebrity Bullseye, Call My Bluff, Chain Letter,* and *Chain Reaction.* And those are just the ones beginning with the letter "C."

What White had never managed to procure, however, was a gig as a game show *host.* Ridiculous as it now seems in hindsight, it was thought that women lacked the skills necessary to oversee a show, points out game show producer, historian, and author Adam Nedeff.

"Betty was actually first considered as host for *Make the Connection* way back in 1955," Nedeff emphasizes. "She wound up being passed over and given the consolation prize as a regular on that contestant panel instead. The wide-ranging view was a woman couldn't possibly carry the necessary air of authority."

That fallacy continued forth into the '60s, when Goodson-Todman Productions crafted a show in 1964 titled *Get the Message* for ABC. Originally, Betty was penciled in as host and offered the show. Then someone stepped in to quash it. Ten years after that, CBS had a show going into production called *Hollywood's Talking.* Same thing happened. They had Betty White front a pilot but then decided, "Well, we don't think people are going to accept a woman as a game show host." This happened once in the '50s, once in the '60s, and once in the '70s.

Then came the '80s. Betty finally, definitively landed a game show hosting gig on January 3, 1983 with *Just Men!*, a new NBC daytime series that gave White ample opportunity to drive the humor via ad-libs. (In fact, Betty wasn't the first female game show host, or "femcee." That would have been Arlene Francis, who hosted a thing called *Blind Date* way back in '49—and the republic still managed to stand. She wasn't the second, either. Rose Marie hosted a game show called *Scoop the Writers* that launched in 1953.)

The object *of Just Men!* was to have two female contestants win keys by correctly predicting the answers to questions posed by a panel of seven celebrity males. One of the keys fit the ignition of a car. Six other keys did not.

Nedeff compared *Just Men!* to *Match Game* and Betty's role to that of Gene Rayburn on the latter. The laughs emerged from White's interaction with the celebs. Little was scripted, which is the way she likes things best. And she had plenty of experience with making up jokes as she went along, going all the way back to the late '40s.

There was admittedly more than a bit of sexism at work in *Just Men!*, as the title and concept itself make clear. In one installment, the keys keep getting stuck in a mechanism and Betty has to fish them out to start the show. She plays up the fact she's a helpless damsel in distress, urging the guys to get out of their chairs and come to her rescue.

> "Well, we don't think people are going to accept a woman as a game show host."

"That was the strength of the show," Nedeff adds. "Instead of stopping tape when things didn't go as planned, Betty would just run with it and poke fun out of the moment."

Those who vote at the Daytime Emmy Awards evidently agreed, making White the first daytime game show femcee to win such an award—in the process defeating Dick Clark for *The $10,000 Pyramid* and Richard Dawson for *Family Feud*. Meredith Vieira would win 22 years later for *Who Wants to Be a Millionaire*, becoming the second. But winning was big stuff for Betty in '83 and, after decades of rejection, gave her the last laugh,

"And she deserved it," Nedeff concludes.

The show would survive only 13 weeks and 65 episodes. But for Betty, it served its purpose as yet another showbiz door she managed to kick open. ◾

ABOVE: Betty holds the keys (literally and figuratively) to the future of contestants as femcee of the NBC game show *Just Men!*

Welcome to
Mama's Family

Hanging out with this dysfunctional clan permitted Betty
to create the ever-snobby Ellen Harper Jackson.

Long after *The Carol Burnett Show* was in the rearview mirror as a weekly variety series on CBS, it spawned *Mama's Family*, a spin-off that began life as a *Burnett Show* collection of sketches centered by the star's protégé, Vicki Lawrence. And as part of that, Betty was featured in 15 episodes scattered through a pair of incarnations of the show—first on NBC in 1983–84 and then in first-run syndication from 1986 to 1990.

Beginning on January 22, 1983, Betty sank her teeth into the wholly dreadful recurring character of Ellen Harper Jackson, the eldest child of the widow Thelma "Mama" Crowley Harper's (Lawrence) three children. The fact that White was in reality nearly three decades older than the woman playing her mother is what they call artistic license.

Ellen has accurately been described as a pretentious, snobbish social elitist chock-full of entitlement issues. She's too good for the family and knows it, so she tends to keep to herself—unless she needs something from one of them, of course. Her arrogance and condescension don't prevent the soon-to-be divorcée from being Thelma's favorite and a burr in the saddle of younger sister Eunice (Burnett). During the show's second season, Ellen—in advance of her divorce—set tongues wagging when she dated Glen (Gary Hudson), which did not please Thelma one tiny little bit. In fact, Mama Thelma was heard to comment, "She's old enough to have lived two of his lives."

After her divorce was mercifully final, Ellen stumbled into a relationship with Alvin Tutweiler (played by Alan Oppenheimer), the mayor of Raytown (where they all live). It wasn't actually Alvin that she liked. It was the lifestyle that dating him afforded her, being the user that she is.

Did we mention that no one in the family wanted to have much to do with Ellen? There was good reason for this. She didn't attend the funeral of her uptight spinster aunt Fran (Rue McClanahan), drawing the intense wrath of Thelma. And yet, Mama loved her best, which shows you just how dysfunctional this clan really was.

What her work on *Mama's Family* gave Betty was an opportunity to play a divertingly unlikable character, something that worked utterly counter to her singularly wholesome and lovable image (but in a different way than Sue Ann Nivens). In point of fact, there were few people to root for inside this storyline, but it provided a great performance bridge for White's career until a little thing called *The Golden Girls* entered her life in 1985. ∎

> What her work on *Mama's Family* gave Betty was an opportunity to play a divertingly unlikable character.

OPPOSITE: Vicki Lawrence (as Mama Thelma) and Betty (as her daughter Ellen Harper Jackson) during a 1983 scene on the NBC series *Mama's Family*.

Wave Goodbye

Remember that time Johnny Carson nearly killed Betty?

Betty always had a great time with Johnny Carson on *The Tonight Show*, and the feeling was mutual. But never was their shared trust put more to the test than during a September 7, 1983, appearance when Betty and Johnny were featured in a sketch involving a couple having a romantic dinner at a Malibu seaside restaurant.

If you watch the approximately seven-minute clip, you'll be shocked at the sheer extent of the gag. It's really one of the more astonishing routines ever created for TV. And it only came off the way it did because Betty appears incapable of saying no.

The joke is that they're a couple vacationing from Duluth dining in an establishment right on the ocean and the tide is clearly too high to sustain table dining. The strolling violinist is playing the tune "Ebb Tide."

We see the water first splash up against the windows and then through, knocking Johnny off his chair onto the floor—wreaking havoc with the violinist and the couple's vain attempts to have an actual meal. The splashes get bigger and wetter, the second knocking Betty to the ground and forcing Johnny to pick her up and begin applying CPR.

Then comes the final avalanche of water, which washes both Betty and Johnny off their seats and yards away while Johnnny is forced to wrestle with a giant octopus. We'll let Betty herself recall what it was like from a 2007 interview she did for a *Pioneers of Television* special on PBS.

"At one point, they let 500 gallons of water go from this tank to wash us away," she recalled. "And we couldn't rehearse it, of course. So, they said, 'Be careful, and when the water comes out, pretend it knocks you off your seats and play it like that.' Pretend? There was no staying on those seats. I just stayed face-down on the floor."

White remembered being legitimately disoriented from the wall of H_2O and unsure where the camera was. Johnny pulled himself together and thought, *My God, she's drowned!*

"He later told me, 'I really thought I'd lost you,'" she said. "The craziest thing was, we had to go right back to the couch and continue with the talk show two minutes after the sketch. They didn't stop tape. Well, you can imagine what I looked like. I had bad hair to begin with, and it was soaking wet. But that was the most fun. Thank God there was a wall there or it would have washed us right out of the building."

Raymond Siller, the *Tonight Show* head writer at the time, recalled in an interview, "The sketch was based on an incident in which an actual restaurant in Malibu got flooded. We had no idea what the power and volume of the water would be like. It was all performed in a tank backstage, and we had literally done a dry rehearsal beforehand because we didn't want to mess up the set. But once the water came, it was just complete insanity."

The thing was, nobody had ever attempted anything quite like that on television in front of a live audience before, NBC's *Tonight Show* publicist Charlie Barrett recalled. "They were dealing with something so unpredictable, and that wound up being the beauty of it. Johnny was thrilled with the way it came off."

Ergo, Johnny wasn't upset with the watery havoc that was wrought?

"Not at all," remembered Siller. "In fact, we reran the sketch a year later. It was great television."

Was Betty equally thrilled? Unbelievably, yes. And that says it all about her anything-goes enthusiasm. All the same, she would be much more careful around water in the future. ▪

OPPOSITE: Betty enjoying being dry—a nice change from nearly drowning on set during a skit with Carson.

Rosebud

A fateful decision based on blind faith leads to
television immortality.

Jay Sandrich, the primary director on *The Mary Tyler Moore Show*, had been directing television going back to *The Danny Thomas Show* in 1963. Few in his line of work (aside from perhaps the legendary James Burrows) can boast anything close to his 40-year career and 86 credits (as listed on the Internet Movie Database, or IMDb).

Consequently, Sandrich's word on a set or when discussing a script went a long way.

And so when he was hired in 1985 he was hired to helm the pilot episode for an NBC series that would be called *The Golden Girls*, Sandrich was given de facto power in casting as well. When he read the script from series creator-producer Susan Harris, he noted the role of the man-hungry Blanche and immediately thought of Betty White, given that she was, after all, only eight years removed from playing the similar personality of Sue Ann Nivens.

"Betty's was the first name that came to mind," Sandrich said during a lengthy interview for the *Archive of American Television*. "We had her in to be Blanche, she reads three lines, everyone says, 'Great. Fine. You've got the part, see you.'"

Over the next several weeks, a few dozen actresses came in to read for the part of Rose. But Sandrich and his associates couldn't find anyone who worked. One of those who auditioned was Rue McClanahan, who had performed with White just a few years before on *Mama's Family* but never previously crossed paths with Sandrich.

"I remember Rue reading for Rose and said to myself, 'Boy, she's really good. But I don't believe her for this part,'"

> "If we do this right, in ten minutes nobody is going to care. Like Tracy and Hepburn, if you're good, you're good."

Sandrich recalled. "So, I said, 'Would you mind coming back and looking at Blanche's part?' Rue came back with 'Well, can I do it with a Southern accent?' I said, 'Fine.'"

And so, McClanahan returned to audition as Blanche. She was so good that Sandrich got series creator Harris and executive producers Paul Junger Witt and Tony Thomas on the phone and said, "Guys, get down here." Once they saw and heard Rue, they agreed she was wonderful and signed off. But that caused a bit of an issue.

"Now we've got two Blanches and no Rose," he recalled. "I said, 'Don't worry, Betty can play Rose.'"

Of course, Sandrich had no idea if White really could pull off a convincing Rose. He was just trying to reassure everyone it would work out somehow. The problem was, people weren't comfortable with the thought of having Bea Arthur and Rue in the same show because they had both been on *Maude* together. But Sandrich reasoned, "If we do this right, in ten minutes nobody is going to care. Like Tracy and Hepburn, if you're good, you're good."

Cut to the first table read of the pilot script. Sandrich hadn't spoken to Betty about his plan to swap characters. At the reading, she called Sandrich over and asked him, "How can you do this to me?"

Sandrich's reply: "You'll be great."

While the director believed that to be true with all his heart, in fact he still wasn't positive it would actually work. And meanwhile, Betty was certain she was facing disaster, maintaining, "I don't know how to do this."

ABOVE: Betty and Rue McClanahan co-starred on NBC's *The Golden Girls* as Rose Nylund and Blanche Devereaux, respectively.

"Just understand," Sandrich told her, "that Rose takes everything literally. She's not dumb, just very naïve."

"Betty said, 'Fine,'" Sandrich recalled, "and that was that."

The rest is television history. It's unimaginable now to think it might ever have been Betty as Blanche and Rue as Rose. But had Sandrich not stepped in to change things up when he did, both actresses could have been wrong for their parts, and there would have been no seven seasons (or perhaps even seven episodes) of *The Golden Girls*. Ah, fate. Actually, Sandrich knows that White could have been a dynamite Blanche, too. It's just that she'd already traveled that road and would be in danger of being typecast forevermore as the hot-to-trot cougar.

"It was unfair to Betty, I admit, because she'd previously done that other part and it was much easier," Sandrich says. "But it was ultimately also clear to me how perfect she was as Rose, and of course Rue was great as Blanche. It was meant to be. And the pilot was a joy. They were just great together." ▪

Demographics Be Damned

Studio execs never imagined audiences would embrace a cast composed of ladies of a certain age, but boy were they ever wrong.

Before getting into the story of *The Golden Girls* and how fortuitous it was in the life of one Betty Marion White, let's travel back to a fateful moment in May 1984.

It happened during a promotional introduction to advertisers of NBC's impending 1984–85 prime-time TV season. Selma Diamond of *Night Court* and Doris Roberts of *Remington Steele* starred in a sketch satirizing the network's forthcoming hot new cop drama *Miami Vice* as *Miami Nice*, hyping instead a mythical comedy about old ladies residing in Florida.

It was a send-up because the idea that the network—*any* network—would take a chance on a series centered on the elderly was preposterous. The reason was simple. Advertisers exclusively targeted the audience demographic aged 18 to 49. The prevailing wisdom was that senior citizens couldn't be jolted out of their established buying patterns and were set in their ways. Wooing them was seen as an exercise in futility.

This brings us back to the idea of a sitcom about women entering their golden years. Who would watch it except fellow geezers? No one could envision what the storylines would be. How much material could you craft about acid indigestion and dentures getting caught in the drainpipe?

But the audience of advertisers and industry executives who witnessed the *Miami Nice* sketch that morning responded with gales of laughter. Among that group was Warren Littlefield, NBC's senior vice president for entertainment. And it got Littlefield thinking that maybe a show about women of a certain age finding their way while cohabitating in Miami wasn't so far-fetched after all.

The Golden Girls would finally premiere the following year on September 14, 1985, and proved an immediate hit in its Saturday-night time period, anchoring the network's lineup for what would turn out to be a seven-year run. And

working alongside Beatrice Arthur, Rue McClanahan, and Estelle Getty revitalized White's acting career eight years after *Mary Tyler Moore* left the air.

In the best-selling 2016 book *Golden Girls Forever: An Unauthorized Look Behind the Lanai* by Jim Colucci, Betty noted, "As an actor, you get so many bad scripts, but when I read the pilot script for *The Golden Girls*, I sat up and took notice. It was different from anything I'd gotten, and it was all because of the wonderful writing."

From the very first table read of the pilot, Betty maintained, the actresses knew they were on to something. "Everyone was so perfectly cast that the minute you heard the lines coming out of our mouths, it was exciting. I've never had a read-through like that. We all had the same reaction. We could feel the chemistry. We could taste it."

That pilot episode, written by series creator Susan Harris and titled "The Engagement," was different from all other installments of the series that followed in one key way: it featured the sole appearance in the show of the gay houseboy Coco (Charles Levin), but it was ultimately decided the show would be better off without the character.

As the series opens, however, all the other character building blocks are in place. Dorothy Zbornak (Arthur) hits the ground running as the snarky cynic. Blanche Devereaux (McClanahan) is in midseason form as the man-chasing Southern belle. Rose Nylund (White) is cemented as the good-hearted but naïve innocent. And Sophia Petrillo (Getty) embodies the wisecracking, unfiltered, disrespectful stroke survivor.

The show opens with Dorothy, Blanche, and Rose already roommates, joined early on by Sophia when her nursing home burns to the ground. But their arrangement is instantly threatened when Blanche falls for Harry (Frank Aletter) and plans to get married, which will mean the remaining three won't be able to afford to stay in their house together. But then fate intervenes after it's discovered that

Harry is a bigamist, leaving Blanche to submit to the love and support of her best pals.

It's a superb opening episode that does everything a good series pilot should—which is to say, remain light and entertaining while introducing the characters and establishing the way they orbit around one another.

At one point, Dorothy laments that she was just having a moment of fun with a group of younger ladies and briefly forgot she was her advanced age. "Then I saw this old woman in the mirror," she bemoans. "I didn't even recognize her."

"Who was it?" Rose inquires numbly.

No, as the producers would often remind Betty, her Rose was never too smart for the room. She was always a step or two slower than everyone else. The saving grace was that her heart was always in the right place.

As Betty described Rose in *Women Pioneers in Television*, "There's really nothing pretentious or conniving about her. To Rose, life is a romantic musical, and she's waiting around to see how it all turns out. Meanwhile, she's humming her way through life."

It was also left to Rose in the pilot to share the monologue that would stand as the defining idea of the series: "We were lonely, and then by a miracle we found each other. It's not fair. I mean, we get married, we have kids, the kids leave, and our husbands die. Is that some kind of a test? You don't work that hard, you don't go through everything you go through to be left alone. We *are* alone, Dorothy, we really are. Our families are gone and we're alone. And there are too many years left and I don't know what to do."

Viewers certainly knew what to do. They watched *The Golden Girls* in droves. The show snagged a mammoth 43 percent share of the viewing audience for its premiere and never looked back. It nearly always won its Saturday-8:00 p.m. time period (moving to 9:00 p.m. for its seventh and final season) and was rarely out of the weekly Top 10 for the entirety of its original run.

As for the presumption that only fellow elderly viewers would be interested in watching a show about four old

broads cohabitating in Florida, Betty maintained that from the start, 75 percent of the mail came from young people, particularly viewers in their teens and early 20s.

Equally important, Betty and the cast had as good a time starring in the show as it appeared that they were. This was confirmed in an interview for this book with Isabel Omero, a trans woman who was male and went by the name Robert Spina during a seven-year run as the show's script supervisor.

"The set was a very normal and happy one," Omero recalled. "There was no drama. That's what happens when three of your four stars—Betty, Bea, and Rue—were such veterans of the weekly TV process. By virtue of their maturity, their age, and their experience, it was always very relaxed. That made it great for all of us."

For Betty in particular, the show proved a rebirth. Moreover, the fact she was playing the innocent rather than the horndog permitted her to stretch her acting muscles beyond the comfort of *MTM*'s Sue Ann Nivens. In fact, the "four points on a compass" idea that White believed defined the characters permitted them to complement one another perfectly.

But back in '85, it was all just beginning. ■

ABOVE: The megastars of *The Golden Girls*, from bottom left: Estelle Getty, Rue McClanahan, Bea Arthur, and Betty White.

Funny Like a Heart Attack

Drawing on her own experiences with grief, Betty's performance in this classic episode of *The Golden Girls* was memorably authentic.

The tenth episode of *The Golden Girls* was titled "The Heart Attack," and it summoned up some very real emotion in Betty. At the time of the taping of the half hour that premiered on November 23, 1985, her own mother, Tess White, lay dying (she would pass on November 11), and the script from Susan Harris gave all the actresses much more dramatic leeway than a typical *Golden Girls* storyline.

In the episode, Sophia begins experiencing chest pains following a dinner party, and it's feared she's suffering a heart attack. The paramedics are summoned, but inclement weather prevents them from getting to the house in a timely

A Conversation with Lex Passaris

Having served at various times as an editorial assistant, assistant director, and director on *The Golden Girls*, Lex knows a thing or two about Betty.

Q: *Can you tell me your favorite Betty story from the set? Everyone must have one.*

LEX PASSARIS: Well, it turns out that I got married between the second and third seasons of the series—and I'm still married to the same woman, I'm proud to say. We eloped with a few friends in attendance and wound up having a party later on. Anyway, I got married in March of '87 and we came back to work in July of that year. Everybody came up and congratulated me, and the ladies pulled together and bought me a nice piece of cookware that my wife and I still use. But it was Betty who took me aside and said, "I want to tell you about me and Allen."

Q: *There's a lot to tell there.*

PASSARIS: Oh, no question. I knew about the circuit she'd done on the game shows, including *Password*. But she said, "Allen fell head over heels for me, but after my marital history, I just wasn't interested." But every time she went back to New York, they traveled in the same circles. She'd be out to dinner with a group of friends, and Allen was always there and would manage to sit next to Betty. He looked at her one day and said, "Betty White, I'm going to win you over." And she smiled and said, "Sure, you keep trying, son."

Q: *He knew long before she did that they were destined to be together.*

PASSARIS: Yep. And at this point in the conversation with me, Betty really choked up. With her, I'd found, there was always a little bit of a veneer. Not a fake veneer. It was just about keeping her guard up. And we all respected that. But during this conversation, it all dropped away. She paused and looked at me and said, "It took a year, but Allen didn't stop. And finally, he won me over." Her voice cracked and she teared up when she said, "I'd give anything to have that year back."

Q: *Betty loved Allen more than she's ever loved anyone.*

PASSARIS: You know it. And in the "Heart Attack" episode from the first season, where she discusses her late husband Charlie's death and her eyes are welling up, we knew she was basically talking about Allen. It was just so clear. She still carries that man in her heart. It affected all of us on the set that day, too.

manner. In the meantime, the ladies (including Sophia) worry that this might be it, and it focuses them on their own brushes with mortality.

Rose makes it clear that she isn't down with this death thing, not one little bit. She intones, "There shouldn't be heart attacks or cancer or anything like that. There should just be a certain age where you have to turn your life in—like a library book. You know, pack a bag, you go, and that's that."

When Blanche later asks Rose if she wants to be buried or cremated, Rose responds, "Neither!"

"What do you want," replies Blanche, "to be flushed down the toilet like a goldfish?"

Both Bea Arthur's and Betty's real-life mothers had passed away within four weeks of each other in the months

leading up to "The Heart Attack" taping, and it was still only a little more than four years since Betty's husband, Allen Ludden, had succumbed to cancer. Death surely sat on White's shoulder as she shared Rose's memory of dressing her late husband for his funeral. It made for a wrenching scene, one clearly suffused with genuine pathos.

"Charlie was very stubborn," Rose began, her eyes welling up, her voice cracking, "and very dapper. And he told me he loved me. And then it was over. And I put a pair of gray flannel pants on him. And a blue shirt. And a striped tie. And he was all dressed when the paramedics got there."

Anyone who doubted Betty White's ability to carry off a believable dramatic scene questioned it no longer.

As it turned out, Sophia wasn't having a coronary after all, but a gallbladder attack brought on by all the food she had consumed throughout the day. Everyone could relax. No one was going to die. After all, they still had nearly seven more years of blissful cohabitation in front of them. ∎

ABOVE: The charmingly naïve Rose (Betty) soothes herself with a puppy during an early episode of *Golden Girls*.

Looking for "A Little Romance"

There was no shortage of height humor in this
unforgettable episode of unfortunate phrasings
and subverted expectations.

When people are asked to name their most memorable episode of *The Golden Girls*, a lot of folks, including Betty, report that it's the one titled "A Little Romance," written by Barry Fanaro and Mort Nathan (earning them the 1986 comedy writing Emmy Award) and premiering on December 14, 1985.

As White told Jim Colucci, author of *Golden Girls Forever: An Unauthorized Look Behind the Lanai*, "This episode sticks with me maybe more than any of the others. They milked it for every short joke you could possibly have, but there was a sweetness about this episode, too."

Indeed. And near the end, it also features one of the great twists in sitcom history.

The episode focuses on Rose's budding romantic relationship with a little person, Dr. Jonathan Newman (played by Brent Collins). She really likes the guy (he's a psychiatrist at the grief center) but worries about the reaction of her housemates, so she keeps him away. Then comes the day when it's clear things are moving toward a serious stage and a dinner invite to the house becomes necessary.

The only thing Dorothy, Blanche, and Sophia know about the guy is that he's a shrink, of which Sophia observes, "It's about time! The woman gives names to her gingerbread men!"

But again, Rose fails to mention this one little (so to speak) thing about Dr. Newman: his height, or lack of it.

> "It's about time! The woman gives names to her gingerbread men!"

When he arrives for dinner, Blanche opens the door and briefly mistakes him for the newspaper delivery boy. A dinner packed with inadvertent short jokes follows. Blanche, for instance, offers "Shrimp?" as an appetizer. And what's for dinner? "Short ribs."

"Don't be self-conscious about my height," the good doctor announces. "I'm not."

Unfortunately, he's the only one who isn't.

Rose admits that when she and Jonathan are alone together, everything is wonderful. But when she's around other people, she's uncomfortable. "I know they're staring at him and they're talking about us and it bothers me," she adds. "I know it shouldn't, but it does. I mean, how big a man is shouldn't make or break a relationship."

"Not a word, Blanche," Dorothy warns.

The episode also offers up an uproarious dream sequence in which Rose finds herself at her wedding to Jonathan. It features a cameo from famed little person Billy Barty.

Then comes the twist after Dr. Newman invites Rose to dinner to talk about "us." She's positive he's going to pop the question and has already determined she's going to say yes. "I've had time to think this thing through and I can honestly say it doesn't bother me that you're small."

But Jonathan delivers the shocker: he can't see Rose anymore because she's not Jewish. This does not sit well with Rose, who is more than dumbfounded; she's flat-out

offended. It's a great turnabout that no one could see coming and defies any and all expectations.

"A Little Romance" certainly relies too heavily on little person stereotypes and cheap jokes in its humor, but it's nonetheless a highly entertaining piece of business that shows Rose Nylund coming into her own as a fully realized character. And to think the show is only halfway through season one.

ABOVE: Dorothy (Bea Arthur) and celebrity psychic Jeane Dixon help Rose (Betty) sort out her feelings about marrying a little person in a surreal dream sequence.

Omero, née Spina, during her run as the *Golden Girls* script supervisor, recalls the episode as a series high point. It was the second installment directed by Terry Hughes, who would go on to become the show's most dependable director.

"It was like a harmonic convergence," she believes, "the perfect script at the perfect moment. The ladies had all fallen in love with Terry. The crew was on point. Everyone was just feeling it. And of course, Betty was magnificent. The script was like someone tossing a big softball at her and saying, 'Claim it.' And man, did she ever." ∎

It's a Bed to Die For

Things get thorny in Rose's love life as *The Golden Girls* hops over yet more boundaries.

As the first season of *The Golden Girls* rolled past the halfway mark, Rose (Betty) became the focus of attention in the half hour titled "In a Bed of Rose's" (original airdate: January 11, 1986), from the writing-directing team of series creator Susan Harris and Terry Hughes. And it seems that our favorite golden gal has a growing reputation as someone who goes to sleep with men who fail to wake up. It began with Rose's husband, Charlie, and now it's happened to Al (guest star Richard Roat). "I'm the kiss of death!" Rose admits in horror. "It's the second time a man has died in my bed."

Goodness gracious!

As the episode opens, Rose and Al have been dating for a while, and Al finally convinces her that it's time to take their budding relationship to the next level by doing the deed. But only one of them lives to see the following morning, and

A Conversation with Isabel Omero

Script supervisor Isabel Omero (a trans woman who was known by her birth name, Robert Spina, at the time) worked on *Golden Girls* throughout its run loved getting to know Betty.

Q: *As the show's script supervisor, how much interaction did you have with Betty and her co-stars?*

ISABEL OMERO: A lot. I was there on the set nearly every single day for the entirety of the run. I missed maybe ten days total. The producers certainly played a much bigger role in the series than I did, but in terms of proximity and hanging out with Betty, Bea, Rue, and Estelle, I was there as much as anyone. In fact, on tape days starting at 12:30, I would have them all to myself for a couple of hours. We would have lunch, just the five of us, and run through the script a few times—just the words. If there were questions about anything, I could get their detailed input and walk it over to the writers myself.

Q: *You're basically describing a Golden Girls fan's dream, every week.*

OMERO: Yes. And as part of those lunches, I might throw 25 or 30 photos at them to sign for various charities. It was a very relaxed atmosphere.

Q: *So, if anyone had a clue about the difference between the Betty White we see on camera and the one behind the scenes, you would.*

OMERO: Absolutely. And there was zero difference. When you see her on *Golden Girls* or on a talk show or interviewed, that's pretty much who she is. There is only one Betty. She would arrive on the set ready to work in a nice colorful outfit, her hair perfect, her makeup great, everything always on point.

Q: *And she didn't treat you any differently than she did her co-stars or the show producers or director?*

OMERO: Never. No attitude. It didn't matter who you were, big or small. Betty understood the importance of what people wanted from her, and if she could possibly give it, she did. Not only would she pose for a picture with your uncle; she'd invite the uncle's daughter into the shot, too, and make sure her hand was on her shoulder. Her grace was and is boundless.

Q: *Did you ever see Betty lose her composure?*

OMERO: Not really. But I did have occasion to visit with her on the set in the early days of *Hot in Cleveland* on the day Rue McClanahan died, in June 2010. She was clearly deeply shaken by Rue's passing. But even that day, when I asked her, 'How do you feel?' she replied, 'I just want to keep working.' She was still finding a way to look ahead.

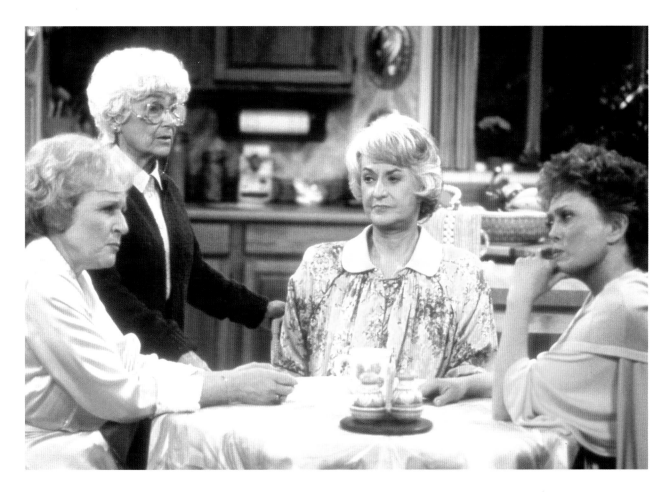

ABOVE: The ladies of *The Golden Girls* sit around the table as they often did, perplexed by something Rose (Betty) has said, as they often were. From left: Betty, Estelle Getty, Bea Arthur, Rue McClanahan.

it isn't Al. Sophia (Estelle Getty) goes into Rose's bedroom and finds him quite dead.

"He bought the farm," Sophia announces.

When Rose inquires which farm Al may have purchased, Dorothy (Bea Arthur) assures her he's gone.

Rose laments, "Oh my God. The poor man. And with a new farm and everything!"

When Rose comes to the realization that she'd slept with a dead man the night before, Blanche (Rue McClanahan) tries to console her that it's no big deal—she sleeps with dead guys all the time. But this somehow fails to quell Rose's considerable anxiety.

The ladies find a number for Al's purported live-in sister to break her the terrible news. But it's worse than that.

The sister is instead actually Al's wife, Lucille (Priscilla Morrill), and it's up to Rose to drive to Boca Raton and explain everything to her. But she finds a much more understanding widow than she expected. Seems Al was a big-time womanizer and Rose was just the latest.

It also appears that Al had a bad ticker, and it wasn't Rose's amorous attentions that killed him but clogged arteries, according to the coroner's report. At least, that's what Lucille tells Rose to ease her mind. But just to make sure that she herself isn't the problem, a few months later Rose heads off with male friend Arnie for a romantic weekend—and he doesn't buy any farms (with cash or otherwise).

The episode would become an early test for the *Golden Girls* producers in that NBC's higher-ups were reluctant to allow references to older women having sex and especially making noises of orgasmic pleasure, given their (mercy!) advanced age. But great success fortunately breeds creative freedom, and the show—and Betty—would be granted more and more of it as time went on. ∎

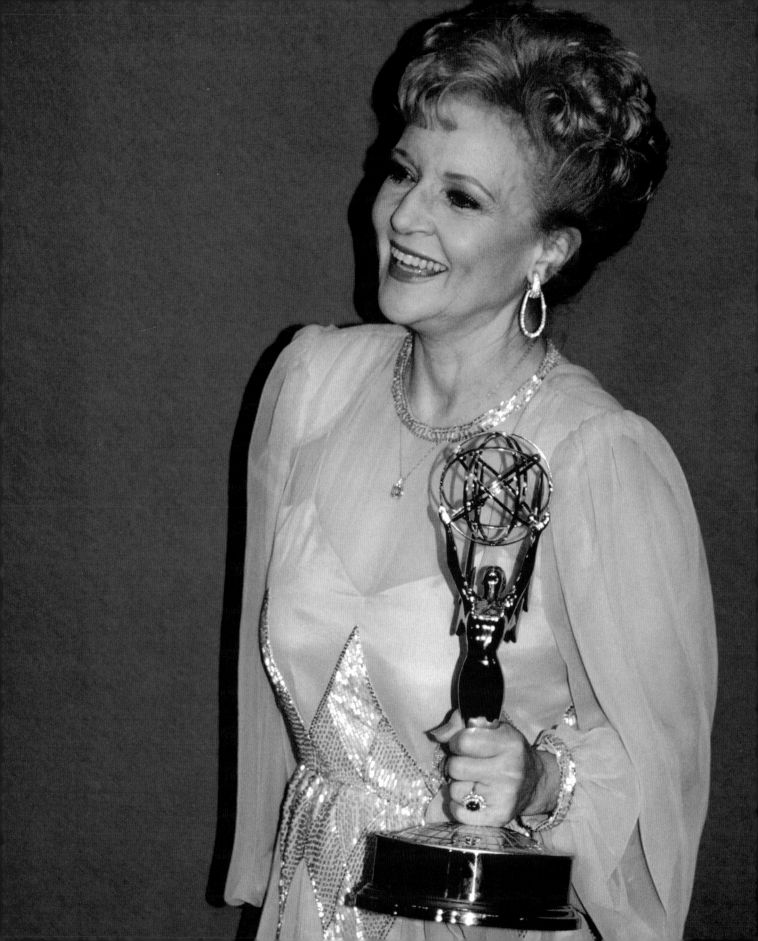

Betty Goes Fourth into Emmyland

The country was head over heels for *The Golden Girls*, but would the industry's golden girls show them love, too?

It wasn't as if Betty hadn't been to the Primetime Emmys before. She'd already been nominated five times and won three of the things, not to mention a Daytime Emmy. But the excitement in advance of the Emmy ceremony on September 21, 1986, was nonetheless palpable.

Why? Well, all three of the *Golden Girls* principals (Betty, Rue, and Bea) were nominated in the same Lead Comedy Actress category competing against one another, as was Estelle Getty for Supporting Comedy Actress. For lead, the question was whether any of the three gals would emerge victorious or they'd cancel one another out. Their competition was Shelley Long for *Cheers* and Phylicia Rashad for *The Cosby Show*. Long had already won once in the category, in '83, and the expectation was she could well repeat.

Bea Arthur, too, had some triumphant Emmy history on her side, having won for Lead Actress in a Comedy for *Maude* in 1977. She was also considered an actresses's actress, carrying a Broadway-stage pedigree that both White and McClanahan lacked.

But when it came time for presenter David Letterman to open the envelope, the name he read was "Betty White." And by the sound of the enthusiastic applause that followed, she seemed quite the popular winner with the audience of her peers.

Dressed elegantly in a sheer blue gown, White began her acceptance speech by expressing her excitement and how honored she was to be nominated with Long, Rashad, and her co-stars.

"But to get to this point, ya can't narrow it down any more than three," White continued. "I mean, there ain't no way. I am the lucky one who gets to come up and pick up this beautiful golden girl. But . . . Estelle and Rue and Bea all thank you. We're a matched set. You can't split us up."

She also thanked NBC "for taking a chance on four old broa-er-ladies" as well as all the people on the show, whom she felt so privileged to work with. It simply isn't possible for a winner to give a more gracious and inclusive speech than Betty delivered that night.

But when three equals share top billing and only one can take home the trophy, the opportunity for residual distress is vast. Rumors swirled that Arthur was privately hurt by the loss, despite White's utter sensitivity to the situation.

But in 1988, Arthur herself carted off the statuette, as did Getty for supporting actress. And McClanahan won in the category the year after White. That gave each of the Golden Girls her very own golden girl, making it one of only three comedies in television history to earn Emmys for each of its principal stars. *All in the Family* and *Will & Grace* are the others.

But in that first year of the show's eligibility, it was Betty who thrillingly got the Emmy call—and deservedly so. ∎

OPPOSITE: Betty beams backstage after winning the Primetime Emmy Award for Lead Comedy Actress over castmates Bea Arthur and Rue McClanahan at the 1986 ceremony.

Don't Say "Drop Dead" Unless You Mean It

The Grim Reaper's got nothing on Rose, as one nasty lady discovers the hard way.

Rose Nylund's activist bent comes to the fore in this early second-season *Golden Girls* installment that shows her power to inadvertently kill isn't restricted to men she has just made love to.

It happens in the November 1, 1986, episode titled "It's a Miserable Life" (written by Barry Fanaro) when a 200-year-old historical landmark tree is threatened with demolition and removal, and the owner upon whose property it sits—the mean and nasty Frieda Claxton (Nan Martin)—has no desire to help save it. In fact, quite the opposite; she seems determined to make it disappear.

Rose tries to bribe Mrs. Claxton into listening to reason. She bakes her homemade Danish. The apricot doesn't sway her, but the prune seems to do the trick. ("Always does for me," Sophia [Estelle Getty] agrees.) But it's soon discovered that the woman has no intention of agreeing to anything, and at the same time proves incredibly nasty and judgmental, going so far as to call Blanche (Rue McClanahan) "The Human Slinky."

Things come to a head when Rose and Mrs. Claxton lock horns during a city hall meeting. Rose asks her how she can hate such an innocuous living thing as a tree, and the woman venomously replies, "I hate *you*!"

That sends Rose over the edge. She goes on a tear, informing Mrs. Claxton she's not going to "waste my time kissing your fanny" and the lady can just put a sock in it while the people speak their mind, concluding, "And if you don't like that, just drop dead!"

It is at this point that Mrs. Claxton collapses to the ground. She has indeed taken Rose's advice literally and instantly dies.

Now, of course, Rose fears she has actually killed Frieda Claxton. And since the woman appears to have no friends or relatives, it's left to Dorothy (Bea Arthur), Blanche, and Rose to plan a cheap funeral that will at least provide her with a respectful farewell. Only the four ladies are at the memorial until another woman (Amzie Strickland) shows up to honor her with a eulogy—until realizing she's at the wrong service.

The irony arrives when Mrs. Claxton is cremated by mistake, her ashes are spread around the tree, and city hall is dissuaded from uprooting the tree as it would disturb a gravesite.

What's great about "It's a Miserable Life" is that while Rose remains her simpleminded self, she is at the same time granted a certain crusader bent that infuses her with a greater range. And White is more than up to the task, even if her alter ego is still most comfortable asking questions without an answer.

"Why do people die, Dorothy?" Rose asks her friend.

"Oh Rose, please," Dorothy replies, "I don't even know why fools fall in love."

The episode also demonstrates that despite her kind and loving nature, Rose is disinclined to get pushed around. When a bully shoves her, she shoves back, and we love her for it. ∎

OPPOSITE: Blanche (Rue McClanahan), Rose (Betty), and Dorothy (Bea Arthur) often put their heads together to solve problems that ranged from romantic misunderstandings to deadly curses.

Rose Discovers the "L" Word

And thank you, Betty, for being a friend to the LGBTQ community.

The quality of the *Golden Girls* episode "Isn't It Romantic?" (premiering on November 8, 1986) is underscored by the fact that it earned writer Jeffrey Duteil an Emmy nomination and director Terry Hughes wins for the Emmy and Directors Guild of America honors. It was also a tour de force for Betty as Rose, showcasing yet another aspect of her oft-stunning level of naïveté.

In the storyline, Dorothy (Bea Arthur) is paid a visit by her college pal Jean (Lois Nettleton), a lesbian who recently lost her partner and remains in mourning. Dorothy naturally knows Jean is gay but decides it's nobody's business and initially neglects to reveal this fact about her. Blanche (Rue McClanahan) keeps trying to convince Jean to go with her to pick up guys, since she's newly single.

It's left to Dorothy to break the news to Blanche. But when she does, Blanche confuses the words "lesbian" and

Betty & the LGBTQ+ Community

Pick pretty much any area of life and the odds are Betty White has been ahead of her time in it. That goes double for her support of LGBTQ rights long before it was trendy. It extends back at least to her entry into television in the early 1950s and her close friendship with fellow fledgling personality Liberace. Later also came her acceptance of stepdaughter Sarah Ludden, an out and proud gay woman who is now married to her longtime partner.

Back in 2010, when same-sex marriage was a growing and divisive issue, White made her views on the matter clear in an interview with *Parade* magazine. "I don't care who anybody sleeps with," she said. "If a couple has been together all that time—and there are gay relationships that are more solid than some

heterosexual ones—I think it's fine if they want to get married. I don't know how people can get so anti-something. Mind your own business, take care of your affairs, and don't worry about other people so much."

A few years later, in 2012, Betty took to the stage at the GLAAD Media Awards with her *Hot in Cleveland* co-stars Wendie Malick and Jane Leeves to exult in the popularity of older ladies with the gay community.

"On Saturday nights during our time on *The Golden Girls*, all the gay bars shut the music off, stopped the dancing, and watched our show. Then it would end, and they'd turn the music back on and start dancing again."

And in 2013, Betty centered a promotional video to help bring awareness to Spirit Day, GLAAD's anti-bullying initiative that asked

people to wear purple in support of LGBTQ+ youth. She joked about changing her name to "Betty Purple" as a way to stand up for a cause she believes in with all her heart.

Just to make sure everyone knew she meant it, she appeared again at the 2013 GLAAD Media Awards to emphasize, "Look, I'm 91 years old, I've been around the block, okay? I've seen a lot of things and done one or two and I know a few things. Not much, but some . . . I just want to say to all the judgmental people out there: If two people want to get married, let 'em get married!"

The Supreme Court was listening. By 2015, same-sex marriage would become the law of the land in all 50 states. Not even a justice dared defy Betty White.

"Lebanese." It's hilarious because Blanche thinks herself so sexually sophisticated and aware, yet a concept that's so simple eludes her.

Meanwhile, Rose and Jean become fast friends, as apparently they have a profound amount in common. For one, they both are farm girls. Rose asks Dorothy why she didn't mention Jean, like Rose, grew up on a dairy farm. To which Dorothy replies, "I was afraid it might be too much excitement for you."

Rose: "I remember when we first got our milking machine. I hooked Molly up to it and she dropped like a rock."

Jean: "Oh no."

Rose: "Oh, lucky she wasn't electrocuted. After that, she was no good for milking. But she certainly became the most popular cow during mating season."

ABOVE: Rose (Betty) pretends to be asleep while having a conversation with Jean (Lois Nettleton) in the *Golden Girls* episode "Isn't It Romantic?"

It soon becomes clear that Jean is attracted to Rose and admits she's falling for her. Through a series of circumstances, the two wind up in the same bed late one night, and Jean tries vainly to share her feelings with Rose. This inspires the mortified Rose to pretend she's asleep in the middle of their conversation.

The episode comes to a poignant and stirring conclusion when Rose and Jean talk it out in the morning, and Rose acknowledges that while she isn't gay, she certainly understands the grief of losing a partner and all it entails. Jean, who was going to depart in embarrassment, opts to stay for a while longer instead.

A wonderfully funny side story to all this is the way that Blanche reacts to the situation. Once she gets what's going on, she grows jealous that she isn't the one Jean fancies. "To think Jean would prefer Rose over me? That's ridiculous."

All in all, this is a sitcom episode that works exceptionally well while telling a very real and human story. And no one ultimately proves more accepting of the situation than Rose. She comes out smelling like one. ▪

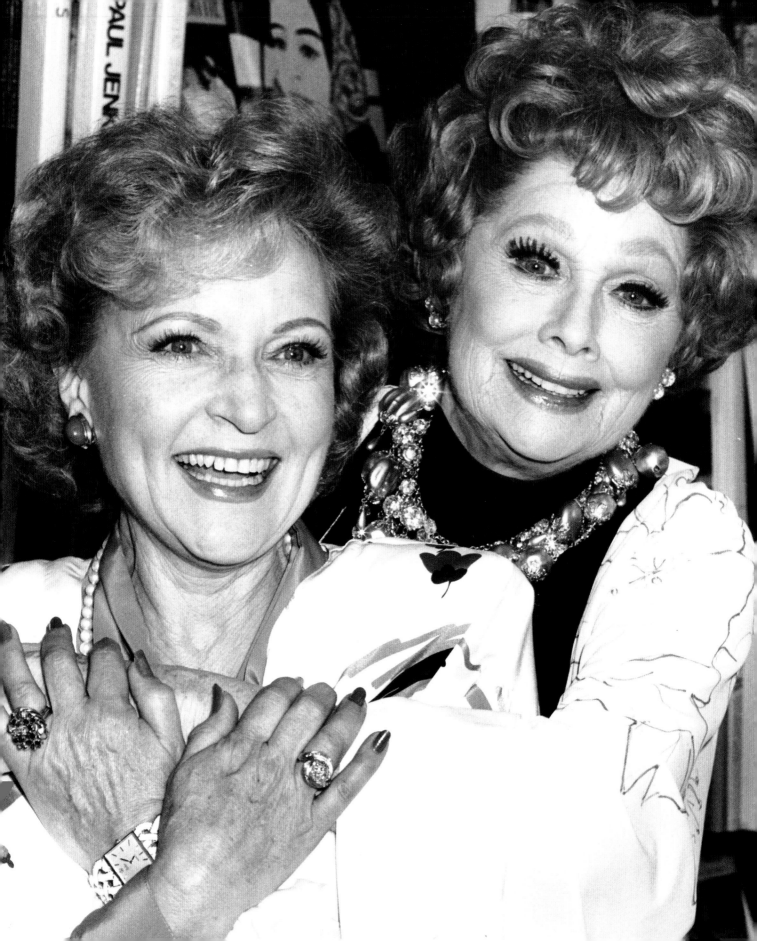

Lucy and Betty Mourn Desi Together

Is there anyone you'd rather have with you on a hard day than Betty White?

On December 2, 1986, Betty White was well into the second season of *The Golden Girls* when she took a familiar detour—appearing as a celebrity panelist on a game show. She could do it with her eyes closed and her ears clogged. But in this case, the show was *Super Password* (fronted by Bert Convy, its former host and Betty's beloved husband, Allen Ludden, having passed some six and a half years before), and she was facing no ordinary competitor: her pal of nearly 30 years, Lucille Ball.

But it was almost as if fate had placed Betty there for the taping, as it was the same day that Lucy's famed ex-husband, Desi Arnaz, died of lung cancer at 69.

You might think that Lucy's having been divorced from Desi for better than a quarter century at the time of his death would have cushioned the blow and quelled her grief, particularly since Ball was long since remarried to comedian Gary Morton. But that didn't prove entirely to be the case.

As Betty recalled in the book *Desilu: The Story of Lucille Ball and Desi Arnaz*, "The day Desi died, Lucy and I were doing *Password* together. She was being really funny on the show, but during a break she said, 'You know, it's the damnedest thing, Goddamn it, I didn't think I'd get this upset. There he goes.' It was a funny feeling, kind of a lovely, private moment."

> ## "The day Desi died, Lucy and I were doing *Password* together."

The rest of their day together would prove difficult for Lucy but was made significantly less so because she had a good friend to walk her through the feelings of grief that had welled up so unexpectedly.

Betty and Lucy originally met in 1957, right around the time *I Love Lucy* was wrapping its triumphant run and Betty was starring in the comedy *Date with the Angels* (which filmed at Lucy and Desi's studio, Desilu Productions).

The two women became fast friends, as they had much in common. Both had worked in the radio business before moving to television. They also were both broadcast pioneers who ran their own production companies. It's no surprise that Lucy and her second husband, Gary, became close with Betty and Allen.

Betty told *Closer Weekly* that a friendship had also developed between their mothers, Tess White and Dede Ball. And when Allen was dying, Lucy came through to bring Betty meals and supply regular comfort. Lucy also tried to teach Betty backgammon, but Betty recalls that Lucy mostly played by herself while Betty watched.

Lucy died in 1989 at 77 of an aortic rupture, leaving a deep void in Betty's life. But she remembers, "We had such fun!" And on the day Desi passed, they shared a special moment of connection—the right friend at the right time. ■

OPPOSITE: Betty and Lucille Ball embrace at a book-signing event in October 1987.

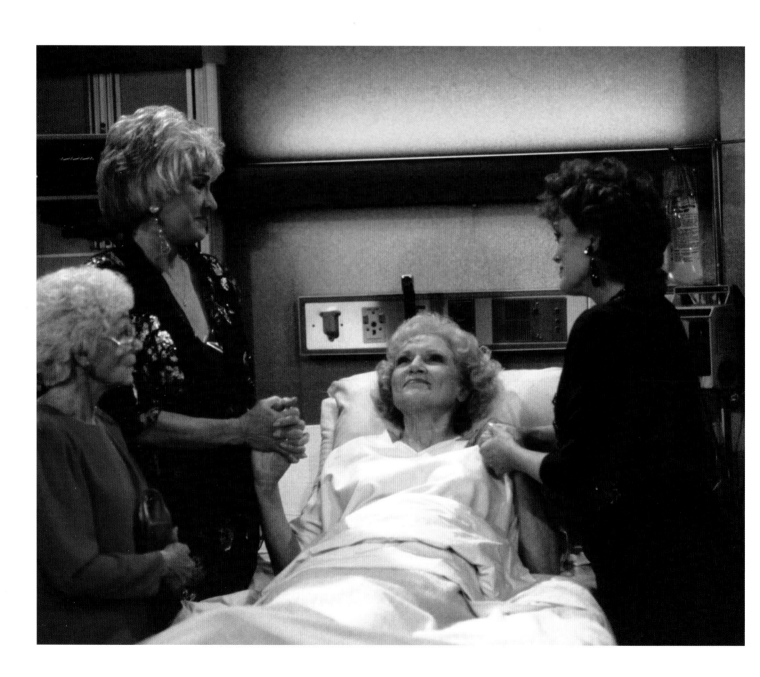

Striking Out on Her Own

There's nothing like a near-death experience to make you realize who your real friends are.

Rose Nylund (Betty) had certainly endured a lot of death and trauma in a little more than a year and a half of television. About the only thing she'd been able to count on was the love and loyalty of her housemates. But even that was no longer a given in the *Golden Girls* installment titled "Before and After" that had its broadcast premiere on January 24, 1987.

Written by Bob Rosenfarb and directed, as usual, by the ever-reliable Terry Hughes, the half hour finds Rose suffering a near-death experience from a throat spasm while in the hospital, moving her to reassess her priorities.

The new lease on life that Rose is given causes a rift in the household. It isn't really Dorothy (Bea Arthur), Blanche (Rue McClanahan), and Sophia (Estelle Getty) who have changed, but her. Sophia thinks it's pretty cool that Rose died and went briefly to heaven, and she requests a doggie bag filled with whatever pills the hospital was supplying Rose. But there was nothing amusing about the ordeal to Rose.

Dorothy struggles to reassure Rose that she passed out or hallucinated. She reminds Rose of the time she downed three margaritas and imagined she was an animated broom in *Fantasia*. But, no, this was different.

"Look, I know it sounds crazy," Rose says. "That's why I wouldn't tell anybody but my two closest friends. But it's true, it really is. I died and went to heaven. Well, it wasn't actually heaven proper. It was somewhere on the outskirts."

Her friends are incredulous about her visit to a "suburb of heaven."

Rose explains that no, it was like an enormous train station, like Grand Central, only cleaner. And once there, she met her uncle Johannsen, who spoke with a pronounced lisp as a result of a steam shovel having struck him in the mouth.

It all sounds insane, but to Rose it's deadly serious. She feels she's died and come back, given a second chance to live. But if her best friends can't accept that, maybe it's time to find some new friends who can appreciate the new Rose Nylund, "The girl who's gonna eat life."

Her first course in this new life banquet is moving out of the house and into a beach apartment with strangers who ignore her. It's very un-Rose-like to reject friends who poke fun at her hourly in the best of times, but it gives actress Betty an opportunity to mine even more new facets of her character, challenging her to appreciate what's right in front of her.

It's also fun to watch our favorite naïve farm girl let down her hair and get slightly more wild than we're accustomed to. You can tell that White is having the time of her life performing in this storyline, which drives home the moral that friends are more than just people you hang out with. They're the ones who will stick with you through thick and thin—and even a death scare or three. ▪

OPPOSITE: Rose (Betty) endures a near-death experience, surrounded here by (left to right) Estelle Getty, Bea Arthur, and Rue McClanahan in the episode "Before and After."

A Surprise Visit from Ralph Edwards

"Betty White, this is your life!"

You simply will never see a more emotional Betty White than you do during her surprise participation (it's nearly always a surprise) in the legendary television franchise *This Is Your Life* with host Ralph Edwards. The tears of joy and occasional sorrow streaming down Betty's face are real, and her gratitude is evident and equally genuine.

Say what you will about the concept—whose creation, like Betty, predates television—being an orgy of sentimentality. This special edition that aired on April 19, 1987, is the actual deal. And let it also be noted that for a program that aims to embrace and chronicle the whole of a person's existence, White was 65 when this half hour was taped. It turned out she still had more than a third of her life (and a very active one at that) yet to come. But calling it *This Is Two-Thirds of Your Life* doesn't have quite the same ring.

The special opens with Betty involved in a *Golden Girls* promotional shoot alongside her three co-stars, whereupon Edwards approaches and Betty's jaw drops permanently open. She instantly knows what's up. Edwards intones the famous words, "Betty White, this is your life," and the featured guest's priceless reply is "Oh no, it isn't!"

But of course, it is. We get to meet White's drama instructor from Beverly Hills High and, very briefly, the leading man in her 1938 high school production of *Pride and Prejudice*. ("I was Pride," Betty proudly insists.) Frank De Vol, the musical director of her 1950s variety program *The Betty White Show*, stands in the audience to take a bow, followed by a visit with White's good pal, late-night talk show host Jack Paar.

It's Paar who takes the proceedings up a notch, relating a story involving a heart Betty broke in order to marry Allen (not his) that causes his own voice to crack and Betty's steely reserve to give way. Next up is game show megaproducer Mark Goodson, who shares an anecdote about how *Password* host and Betty's future husband, Allen Ludden, would wear a gold chain around his neck holding the engagement ring that Betty had yet to accept.

Game show host extraordinaire Gene Rayburn swings by for a funny and loving couple of minutes before the *Mary Tyler Moore Show* gang enters en masse: Ed Asner, Cloris Leachman, Gavin MacLeod, Valerie Harper, and Georgia Engel. Asner insists, "Betty and I never slept together," while Leachman—ever bizarre—adopts her Phyllis Lindstrom alter ego to shoot down an Engel anecdote as "not an interesting story." Oh dear.

Mary Tyler Moore herself also materializes between a pair of dogs to pay homage live via satellite from New York. The grand finale has Johnny Grant, the Honorary Mayor of Hollywood at the time, showing up with a mock-up of a brand-new Hollywood Walk of Fame star for Betty's late husband, Ludden. That opens up the tear ducts full force.

If you check out the episode, you'll be surprised at how affecting an experience watching such a prefab piece of sappiness proves to be—both for us and for White. It's clear that she was caught so off guard by the whole thing, making for an honor that plays like few others she's ever received. ∎

OPPOSITE: Clockwise from the top: Carl Reiner, Ralph Edwards, Betty, and George Fenneman promote a game show special in 1984. Three years later, Edwards would give Betty the surprise of her life.

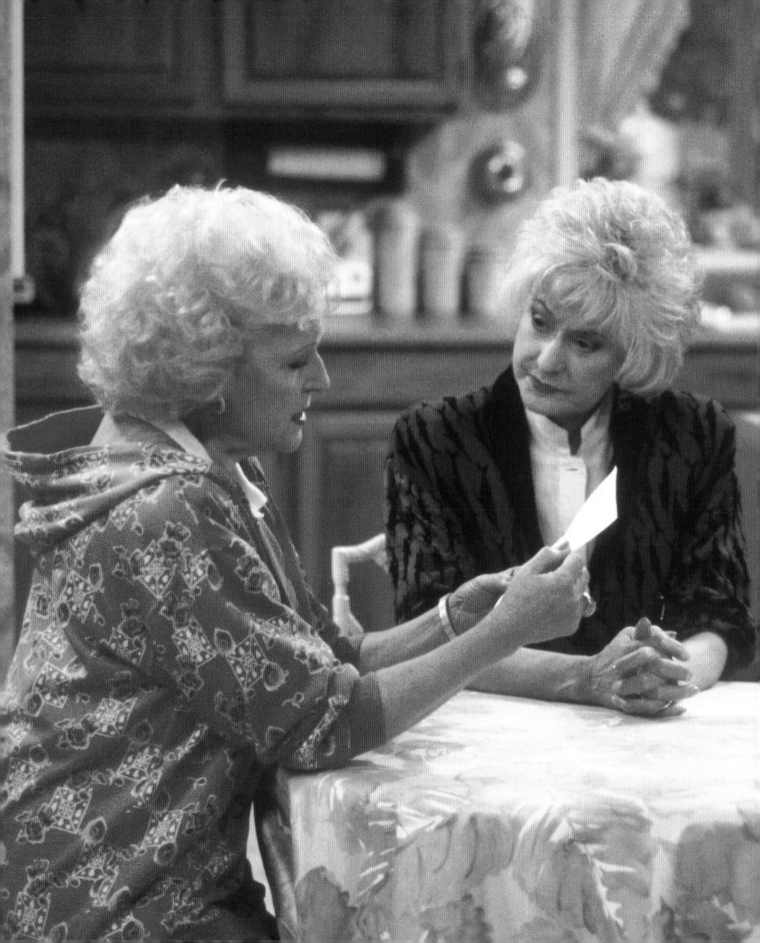

Where's Fernando?

Teddy bears are serious business when you're Rose Nylund.

While the *Golden Girls* episode "Old Friends" (the September 17, 1987, opener of the show's third season) is ostensibly about Sophia's (Estelle Getty) friendship with her new acquaintance Alvin Newcastle (Joe Seneca), who has Alzheimer's disease, it provides a terrific "B-story" opportunity for Betty (as Rose) to flex her comedy muscles in a different way.

Written by Kathy Speer and Terry Grossman and directed by Terry Hughes, the installment finds Sophia befriending grumpy old man Alvin on the boardwalk. It turns out that his outbursts are related to his deteriorating mental condition and the fact that his caregiver daughter has taken a leave of absence during a critical time.

But the Rose storyline here is simply delicious. It involves Blanche (Rue McClanahan) having donated a bunch of stuff to the Sunshine Cadets (think Girl Scouts), including—accidentally—Rose's prize teddy bear, Fernando. She'd had the stuffed animal since childhood, and it had long been the talisman she turned to when she was upset or scared.

Rose is not accepting of the fact that her childhood pal no longer belongs to her and demands his return. "Get him back! I want my teddy!" she orders. When Blanche reasons that the teddy was given to a young girl and therefore can't be returned, Rose is unmoved: "Just cut the crap and get the damn teddy bear!"

But when Blanche gently inquires about the teddy's return from the cadet, Daisy (Jenny Lewis), she discovers that Daisy is holding the stuffed animal prisoner while angling for something more substantial.

"In Sunshine Cadets," Daisy points out, "we learn you have to pay for your mistakes. This one's gonna cost you a ten-speed Schwinn."

Now, clearly, it's game on! This is every ounce a hostage negotiation, and Daisy actually sends Blanche a stuffed, amputated Fernando ear to show she's playing for keeps. Indeed, as the bargaining continues, the stakes rise. Daisy comes to realize she was "wrong" to ask for gifts in exchange for a donated toy bear and concludes that cash would be far better so she can buy whatever she wants.

Blanche just wants the whole mess to go away and offers to get her purse to pay the ransom. But Rose will have none of it. She gives a heartrending speech about life sometimes dealing us an unfriendly hand and isn't always fair, guides Daisy to the front door of their house, grabs Fernando, and shoves the greedy brat out the door before slamming it shut.

It's refreshing to see Rose's dark side in action. And we're all left cheering that an older woman has snatched a stuffed toy from the hands of a child. Such is the magic of this show, and of White's performance inside it. She's already so childlike herself that no tot stands a chance in trying to play her for a patsy as far as audience sentiment is concerned. That's what great writing and acting will do for a show.

Betty would later admit to author Jim Colucci in the book *Golden Girls Forever* that she particularly loved the moment when she pushed Daisy out of the house "because Rose, the one you'd least expect, got the chance to stand up for herself. She didn't often get the chance to come out on top." ∎

OPPOSITE: A concerned Rose (Betty) reads a note at the kitchen table with an equally concerned Dorothy (Bea Arthur) on *The Golden Girls*.

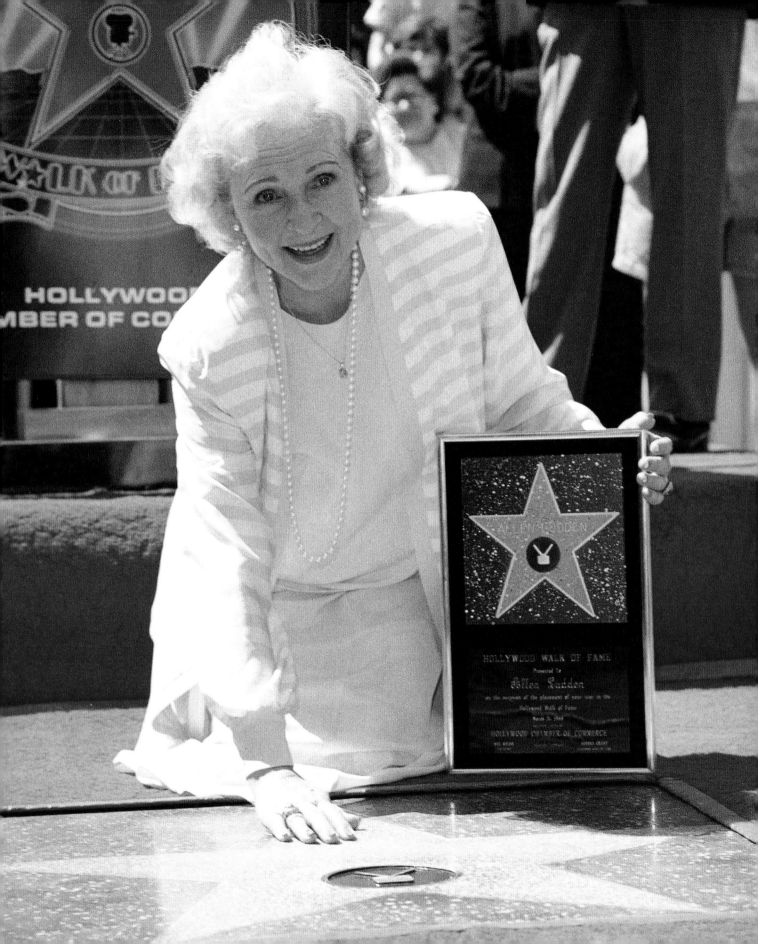

A Star Is Cemented

Betty was among the original stars commemorated on the Hollywood Walk of Fame in 1960—but it's Allen's star in '88 that meant the most to her.

The world-famous Hollywood Walk of Fame along Hollywood Boulevard and Vine Street is one of the top tourist draws in Southern California and an internationally recognized landmark of the showbiz capital.

While it seems as if it's been around for centuries, the Walk of Fame actually has been in existence for only about 60 years.

Ground was broken on the walk in 1958 but was delayed by a pair of lawsuits. The first was filed by local property owners, who challenged the legality of Hollywood's assessing a tax to pay for the walk along with new lighting and trees. Lawsuit number two was filed by silent film star Charlie Chaplin's son, who demanded $400,000 because his father wasn't chosen as an honoree.

Construction finally began in earnest on February 8, 1960, when 1,558 original stars were honored with planned designs on the proposed walk. One of those stars would be inscribed with the name "BETTY WHITE."

In her book *Here We Go Again: My Life in Television*, Betty explained that the Walk of Fame star was a particular honor. Whereas today the star and ceremony can set a celebrity or a studio back $50,000 or more, when White got hers, it cost her nothing.

> "I could hear his voice saying, 'I can't believe it.'"

However, an even bigger thrill would come to Betty on March 31, 1988, when her late husband, Allen Ludden, was given a posthumous star on the walk, the 1,868th celebrity to be so honored. Ludden's design was placed directly beside Betty's.

"I could hear his voice saying, 'I can't believe it,'" Betty said that day. "I cannot express what this means to me. Don't be surprised if in the wee hours of the morning, our stars are fooling around."

At one point during the ceremony, a tour bus drove past that bore a sign reading, "WE MISS ALLEN."

Today, there are more than 2,700 five-pointed, terrazzo-and-brass stars embedded in the sidewalks along the 1.3-mile route—15 blocks of Hollywood Boulevard and three blocks of intersecting Vine Street. They honor the accomplishments of professionals representing motion pictures, television, radio, music, and theater/live performance (the latter added in 1984).

What Betty is said to especially love about being a part of the Walk of Fame is its sheer permanence. Even after she's gone (gasp), her name will remain for succeeding generations to walk all over. She has, after all, never minded getting a little scuffed up. ▪

OPPOSITE: Betty places her hand on the Hollywood Walk of Fame star of her late husband, Allen Ludden, during a ceremony on March 31, 1988.

A Royal Performance

You know you're good when the queen mother asks for you personally.

It sounds like an urban legend, but it happens to be true. *The Golden Girls* really *did* perform live for Elizabeth the Queen Mother of England at the annual *Royal Variety Performance* at the London Palladium on November 24, 1988.

At age 88, the queen mum was said to be a huge fan of the show and specifically requested the presence of *Golden Girls* stars Betty White, Bea Arthur, Rue McClanahan, and Estelle Getty in character at the televised variety show.

So it was that the ladies came and staged reenactments of two of their kitchen table scenes from the show, albeit with a tad of censoring so as not to offend any of the royals present (including the queen mother and Princess Margaret).

What's striking about the eight-minute performance is that the four ladies evoke not an ounce of nervousness despite working for the first time in front of actual monarchs. It was like they did it every day. They'd already been involved in the show for three years at this point, so their ease with portraying Rose and Dorothy and Blanche and Sophia was understandable but impressive nonetheless.

It's also interesting to note that they chose material (some of which was original) that was particularly risqué, dealing with sex and losing their virginity and handling the male organ properly. They could have picked a thousand different routines, but they decided to give Her Majesty a more lewd 'n' crude time than she might have been expecting—and that was even after the aforementioned censorship.

In the routines, discussing her wedding night and first sexual experience with husband Charlie, Rose asked, "I mean, didn't you think it was a ridiculous thing to do at first?" She later admitted that Charlie mixed up the marriage manual with the cow milking machine manual, further complicating matters.

And when Dorothy asked Blanche how long she'd waited to have sex again after her husband died, Sophia quipped, "Until the paramedics came." The queen mother was seen in her royal box chuckling at the line with lusty glee and found to be thoroughly enjoying herself throughout the routine, confirming that she liked her comedy on the naughty side even at her advanced age.

In an interview with Reddit, White recalled, "It was very exciting. The queen [mother] was lovely. We were told not to address her unless we were (first) addressed. She was up in a box and she came down onstage after."

Thrills simply don't get much bigger than having the queen mother in your audience and then, just afterward, spending a few precious minutes *with* her. For Betty, it was one of those pinch-me moments that demonstrated the kind of charmed life she's led. ■

Thrills simply don't get much bigger than having the queen mother in your audience . . .

OPPOSITE: (From left) Bea Arthur, Betty, and Rue McClanahan dreamed of performing in front of Britain's queen mother. And it came true!

Magic Rose

In another banger of an episode, Betty tackles a *hard* issue TV had so far shied away from.

We should be grateful that the *Golden Girls* episode titled "The Impotence of Being Ernest" doesn't again find Rose (Betty) inadvertently killing off a lover. This time, he only suffers from erectile dysfunction. The half hour had its broadcast premiere on February 4, 1989, and came from writers Rick Copp, David A. Goodman, and Kevin Abbott and director Steve Zuckerman, breaking new sitcom ground in dealing with performance issues.

It's important to note right up front that Viagra wouldn't hit the market for another nine years, which helps explain why corporate lawyer Ernie Faber (Richard Herd) seems reluctant to put moves on Rose even though they've been dating for some time.

As Rose shares with Dorothy (Bea Arthur), "I think I love him. But I still can't understand why he hasn't even approached the subject of . . . you know . . . sex." But Rose confides to Blanche (Rue McClanahan) that she can't ask

Another Conversation with Lex Passaris

Being an editorial assistant, assistant director, and director on *The Golden Girls* showed Lex what Betty's strengths were and what she was passionate about.

Q: *Is there anything in particular that stood out about Betty while working with her on* Golden Girls*?*

LEX PASSARIS: Do you mean besides everything? Yes. It speaks to her professionalism. The training she got early on in television—you know, working live six days a week, five and a half hours a day, gave her an uncanny almost sixth sense about how to perform. Her instincts were just spot-on. Her internal clock was the most amazing thing.

Q: *Really? Tell me about that.*

PASSARIS: Well, after every show, Betty and the other ladies would cut promos. Half the time, it was for their pet projects. In Betty's case, it may have been about animals, or AIDS awareness, or shelters. Whatever. She would do a promo and all of us would pitch in and do our part. But she also

did show promotions for NBC, and they had to be precise. Sometimes it was 23 and a half seconds. Sometimes it was 22 seconds. Betty's deal was "Let me have the copy early." And she was such a quick study, she would absorb everything instantly.

Q: *How did that manifest itself?*

PASSARIS: She'd read through the copy and [script supervisor] Isabel Omero would time it. Her first read-through might be 28 seconds, but it had to be 23. You'd see her eyes roll around and make a mental change in her pacing and say, "Okay, I'm ready." And that second time, she'd do it perfectly. Right on the dot. Dead on. No mistakes. Go home. Have a nice weekend. It was just uncanny.

Q: *And I guess word would get around and all of your associates knew not to mess with Betty.*

PASSARIS: Oh, once or twice someone would start to argue and we'd go, "No. She's right. You're wrong. Fix it."

Q: *What else stands out about her during your time working together?*

PASSARIS: Just that she never, ever arrived at work without her public face on. She came from the era where you didn't show up unless you were fully made up and your hair was done, your outfit was immaculate, you looked perfect. That was her presentation. It wasn't phony. It was just her.

Q: *So, she was always a lady, and a star.*

PASSARIS: Yes, a lady, but one who could hold her own with any cadre of truck drivers or soldiers in the field. She's a saucy gal when the time calls for it.

ABOVE: Betty White strikes a Rose pose during her years on *The Golden Girls*, where she wasn't afraid to tackle taboo issues.

Ernie to go away with her because she's never learned to be aggressive when it comes to men. Blanche assures her that it's as easy as riding a bicycle. But Rose admits she never learned how to ride one. Bad analogy. Once Ernie takes Rose out of town for a romantic weekend, she assumes they finally will consummate their relationship. But when Ernie still treats her with kid gloves, the truth finally comes out.

> **Ernie:** "It's not easy for a man to say,
> Rose. I'm impotent."
> **Rose:** "I see. Well, in that case, why don't
> we see what's playing at the movies?"

Rose reassures him that people rely on sex too much anyway. That somehow inspires a naughty exchange in a restaurant that leads to Ernie's finally taking her to bed with both of their engines suddenly overheating. They do the deed. It recharges his dormant libido. He's good as new! Better even! Ernie is more than ready to make up for lost bedroom time after years of being incapable of performing. Unfortunately, it inspires him to want to mend fences with his ex-wife rather than hop in the sack again with Rose. We think he's going to propose marriage to Rose. Instead, he tells her he's returning home. Whoops.

There are some wonderful dialogue and intriguing situations in the half hour. And the conversations between Rose and Ernie are memorable, as are Rose's glorious non sequiturs. That would include her description of going to the movies every Saturday as a kid in St. Olaf in a theater without a sound system. It worked fine most of the time, but "through most of Citizen Kane, we all thought everybody was looking for a rowboat."

That, ladies and gentlemen, is what you call writing. ∎

The 1990s

Sharpening Those Comedy Chops

"I can claim one thing I don't know anyone else can claim, and I do it wholeheartedly. Nobody—nobody has had more fun in this world doing what they do for a living than I have in television."

—Betty White on being inducted into the Television Academy Hall of Fame

OPPOSITE: Betty's role as the beloved, albeit naïve, Rose Nylund earned her awards and acclaim, as well as opened new doors.

From Cuddly Senior to Gleeful Murderer, Betty Does It All

Betty White and *The Golden Girls* crossed from the '80s to the '90s without missing a beat, continuing to take on serious topics without sacrificing anything in terms of character and wit. One of Betty's greatest moments on the show came in February 1990, as the sitcom tackled HIV and AIDS when Rose suffered her own scare after a blood transfusion. Rose has to wait 72 hours to find out the test results. White was right at the center of what turned out to be an important half hour of television, bringing AIDS awareness and empathy to the mainstream. And Betty was proud to be such a crucial part of it.

While the girls weren't afraid of serious topics, that didn't mean they weren't downright silly a lot of the time. Case in point, the May 1991 episode "Henny Penny—Straight, No Chaser," which aspired only to be lighthearted and entertaining. The half hour found Blanche (Rue McClanahan), Dorothy (Bea Arthur), and Rose recruited to star as Goosey Loosey, Turkey Lurkey, and Henny Penny, respectively, in a grade school play.

The success of *Golden Girls* brought many gifts to White's life, including offers to branch out and try genres outside situation comedy. Mind you, Betty had already done pretty much everything in a career that was nearly a half century along—everything, that is, except for starring as the lead in a romantic comedy. It was one of the few boxes she had yet to check off. Fortunately, NBC swooped in at the right time to rectify that minor deficiency with a made-for-TV movie called *Chance of a Lifetime*. The film starred White as an uptight, workaholic widow who is diagnosed with a terminal illness and given just months to live. She decides to go live it up during whatever time she has left, hightailing it to Mexico and a chance meeting with a charming widower, cue the great Leslie Nielsen. Everything goes swell until she finds out she's been misdiagnosed and isn't dying after all.

Betty was enjoying a heck of a run at an age when many actors are already retired. But of course, all good things must come to an end, even *The Golden Girls*. Once it did, in May 1992, a plan was hatched to keep some aspect of the series going without Bea Arthur (who had tired of the grind and wanted out). Co-creator Susan Harris pitched an idea that found Rose, Blanche, and Sophia (Estelle Getty) investing in a Miami hotel—and CBS bit. The spin-off *The Golden Palace* premiered in September 1992, with the ladies joined by Don Cheadle as the hotel manager and Cheech Marin as its chef. It kept the concept going, as the *Golden Girls* women all were playing their previous personas. Dorothy even agreed to drop by a few times.

While *Golden Palace* would survive for just 24 episodes, it was nonetheless a valuable experience for White and the other ladies. It allowed them all a soft landing from the high that had been

their previous show. That's often the problem with iconic shows when the curtain comes down. The audience is left bereft, and the actors are left unemployed. *The Golden Palace* permitted everyone a cushion from which to bounce back.

Now, a normal performer coming off a seven-year run on a series, followed by another single season on a spin-off, would take some time to relax, kick their feet up, travel the world, enjoy the fruits of their labor. But that performer is not named Betty White, an unapologetic workaholic who knows only a single direction: forward. Never sideways. Certainly never backward.

When the opportunity came in 1995 for Betty to be part of the regular cast in a new ABC comedy series, she jumped. It was called *Maybe This Time*, and it starred Betty and Marie Osmond (portraying her daughter). Together, they operated a family bakery with help from a Scottish immigrant played by Craig Ferguson in his first acting role on American shores. While the show failed to catch on, it wasn't due to White's lack of commitment. It never is. It was just one of those things. And when that happens, Betty tends to shrug her shoulders and move on.

Betty White, an unapologetic workaholic who knows only a single direction: forward.

Shortly after the premiere of *Maybe This Time*, it was decided by the powers at the Television Academy Hall of Fame that Betty should be inducted into its Hall of Fame, the 11th woman to be so honored. What took them so long? An excellent question. But class act that she is, Betty didn't ask. She instead took her bow with typical grace.

Four years later, another image-altering professional experience would transpire for White. Mega-producer David E. Kelley discovered that magical things happen when you use her as the conduit for dark behavior and ghastly dialogue. Kelley's first inkling of this came when he cast Betty as a bloodthirsty widow in his 1999 horror-satire feature *Lake Placid*. She was a hostile, angry, vicious old bag who liked to feed cows to crocodiles. She also liked to swear. A lot. In other words, she was everything the woman portraying her is not.

Similarly eccentric and disturbing character turns would follow for Betty in Kelley's shows *Ally McBeal*, *The Practice*, and *Boston Legal*. Other producers picked up on the Bawdy Betty trend, giving the actress a whole new career turn. Why would Betty risk tarnishing her clean 'n' shiny reputation with such nastiness and vulgarity? If you need to ask the question, then you don't know her. She adores upending perceptions, well understanding the comedic benefit of shock value. Besides, she loves trying new things, particularly if those things inspire jaws to drop.

With the coming of the new millennium, White would repeatedly demonstrate that Kelley hadn't come close to cornering the market on her potty mouth. At the same time, the world would recognize that Betty had no intention of slowing down or acting her age. She was having way too much fun for that.

Seventy-Two Hours
to Sweat Through

The Golden Girls wasn't afraid to take on a serious topic like
the AIDS epidemic to help people see it for what it really was.

In yet another example of *The Golden Girls* tackling an issue that was generally considered too hot for prime time (at the time), "72 Hours" provided an opportunity to address HIV and AIDS when everyone else was shying away from the subject. And Betty White (through her lovably loopy alter ego of Rose) was right at the center of it.

The episode had its broadcast premiere on February 17, 1990, and was written by Richard Vaczy and Tracy Gamble, with directing duties handled by Terry Hughes. It kicks off with Rose receiving a letter from the hospital where she'd had her gallbladder removed three years before, warning her that she may have received an HIV-tainted blood transfusion.

The ladies accompany Rose to the hospital, and Blanche (Rue McClanahan) tries to assure her that she had the same thing happen and tested out negative. But then Rose is told she's got to wait 72 hours for the test results, which promises to make it the longest three days of her life.

Rose, in the meantime, loses her mind, lashing out at everyone's well-meaning words of comfort. "I don't feel like taking it easy!" she fumes. "I might have AIDS, and it scares the hell out of me. . . . Dammit, why is this happening to me? [To Blanche] You must have gone to bed with hundreds of men. All I had was one innocent operation."

Blanche takes offense and pushes back that AIDS isn't "a bad person's disease" and is not a matter of God punishing people for their sins. This drove home the point back in 1990 that AIDS wasn't "a gay plague" and could in fact

A Conversation with Jim Colucci

Author of the 2016 book *Golden Girls Forever: An Unauthorized Look Behind the Lanai* shares what made Rose so magical.

Q: *Looking back at 1990, it's hard to believe it was still controversial for a situation comedy to be addressing the AIDS epidemic.*

JIM COLUCCI: Absolutely it was. Only two other comedies had really dealt with it to that point. They were also able to discuss impotence. When you're *The Golden Girls*, this 800-pound gorilla in the Saturday night lineup, you have some leeway. You can push back and say, "This is what we want to talk about." It wasn't just a matter of the show being a hit. The audience was also much more open to accepting outrageous things coming out of the mouths of older women.

Q: *A few years into the show, Betty could also seemingly get away with anything as Rose. She was such an icon with viewers. She gave this character such depth and humanity.*

COLUCCI: And the interesting thing is that Rose was the hardest of the four characters to play. I'm sure all the ladies must have felt that way, too. Even drag queens who play the Golden Girls will tell you that.

Q: *Why do you believe that is?*

COLUCCI: Well, think about it. Dorothy has the witty, sarcastic, sharp lines. And Blanche, well, being the slut is inherently funny. And Sophia has her outrageous quips. But while Betty has some great lines written for her, she has to take a character who isn't deliberately making a joke and make her funny. The other three know they're supposed to be funny while delivering their lines. But Rose's lines are generally delivered for us to laugh at her. It's much tougher to do.

Q: *I've never thought of it that way.*

COLUCCI: And why would you? It's not something the audience is consciously aware of. Rue McClanahan marveled at how Betty, being so brilliant, could play such a naïve, dumb character. It's even more impressive when you watch Betty's facial expressions. It's all in the eyes. The minute they yell "Action!" all the light drains from those eyes and she has to turn off whatever part of her brain registers there. It's like Betty has to be thinking like Betty White but acting like Rose Nylund at the same time—performing all the technical machinations one must perform as a sitcom actress while evoking cluelessness in the eyes.

Q: *So, you're saying the woman seems to have mastered this acting thing pretty well.*

COLUCCI: No one has a greater work ethic than Betty White does. And if I can extrapolate, that's why she's continued to be active and sharp well into her 90s. Experts will tell you that it's having a passion and keeping your blood pumping that helps you to live a long and fruitful life. Betty's passion is performing. She loves the work. It's everything to her. That helps explain her amazing longevity.

impact the heterosexual community just as easily, including those who hadn't engaged in intercourse at all.

As Betty said in the book *Golden Girls Forever*, "Not only were people understandably afraid of AIDS, but a lot of people wouldn't even admit it existed. So, this was a daring episode to do, and the writers went straight for it."

But back to Rose. While in the process of coming unglued emotionally, she stresses that she hasn't been this scared since 1952, when her native St. Olaf's most active volcano was poised to erupt. "Some Druid priests said they could stop it if they could sacrifice the town's dumbest virgin. I don't know why I raised my hand." Ah, Rose. Some things never change.

It turns out of course that once her three-day torture of being in the dark is over, Rose is given a clean bill of health. No HIV after all. But the point was more than made in what stood then, and continues to play today, as an important half hour of television. Even sitcoms can be essential viewing, and "72 Hours" proved an exceptionally relevant installment given the social and political climate of the time.

If you're wondering why *Golden Girls* was and remains wildly popular in the gay community, this episode supplies ample evidence. The fact that it was Rose who has the AIDS scare and not Blanche serves to inflate the point without sacrificing any realism. It represents one of its—and Betty's—greatest contributions to American culture. ∎

OPPOSITE: Dorothy (Bea Arthur), Rose (Betty White), and Blanche (Rue McClanahan) sweat out Rose's HIV scare in the February 1990 *Golden Girls* episode "72 Hours."

A Henny Penny for Your Thoughts?

All the world's finally a stage for our favorite gals.

After all of the hard-hitting, socially relevant episodes of *The Golden Girls*, it was nice to see one like "Henny Penny—Straight, No Chaser," which had its premiere on May 4, 1991, and aspired only to be playful, silly, and joyous. Written by Tom Whedon and directed by Judy Pioli (notably the only episode of the show to be directed by a woman), it's a theatrical romp that demonstrates just how much freedom this comedy had as it raced toward the end of its sixth season.

Never will you see Betty White having more pure fun than she does here in a story that finds Dorothy (Bea Arthur) producing a grade school spring break production of Henny Penny as part of a get-interested-in-reading campaign. The kids who were to star in the play come down with the measles, of all things, and are forced into quarantine.

Dorothy doesn't want to lose the chance to get young minds interested in reading, so she refuses to cancel the show, asking, "Why can't we recast it with adults?" Her director, Frank (George Hearn), wonders where they'll find an adult with sufficient childlike naïveté to play a paranoid hen. Just then, Rose (Betty) ambles up and says, "Oh, you're not gonna believe it. I just saw a cloud that looked exactly like a cotton ball."

"My God," Frank marvels, "she is Henny Penny."

Pretty soon, Dorothy and Blanche (Rue McClanahan) have joined Rose in the replacement cast as Turkey Lurkey, Goosey Loosey, and Henny Penny, respectively. Rose initially balks when she finds out that the three characters are destined to be eaten by the wicked Foxy Loxy (Frank) at the end of the show. But she ultimately gives in as a way to give back to the chicken community, since she claims one once saved her life.

Cue Dorothy in a turkey outfit, Blanche in a goose costume, and Rose in a hen getup, with Sophia (Estelle Getty) narrating. Talk about ruffled feathers. Soon, they're crooning together on an elementary school stage.

> **Blanche (singing):** "Oh, dear! A piece of up there just landed down here. You better beware, the message is clear."
> **Rose and Blanche (singing):** "Though millions may find the prospect galling, it's run for your life, the sky is falling!"

It all goes relatively smoothly until Rose tries to convince the audience of kids that they can stop this concluding tragedy from occurring. "Clap now if you want to see the goose and the chicken and the turkey live. Come on, put your little hands together. Save us, and you won't have bad dreams. Clap, you miserable . . ."

When the kids refuse to comply with applause, Rose assures them there are monsters living under all their beds.

The episode proved exuberant and hilarious, sweet without sacrificing the acerbic edge that was the *Golden Girls* hallmark. Leading the way was Betty vigorously embracing a storyline that allowed Rose to break character—and in front of an audience of little kids, no less. If believability went off on holiday, it was okay. After more than 150 episodes, they had all earned the right.

We can almost imagine Betty's reaction upon first seeing this script. Gales of laughter, followed by jumping up and down, followed by squeals of delight, followed by an excitedly sleepless night. ■

OPPOSITE: (From left) Blanche is Goosey Loosey, Dorothy is Turkey Lurkey, and Rose is Henny Penny in the May 1991 *Golden Girls* installment "Henny Penny—Straight, No Chaser."

A Last Chance at Love

For the woman who'd pretty much done it all,
there was still one role she longed to play.

For years, Betty had told anyone who would listen that the only thing she'd never done in television that she still hoped to pull off was to star in a romantic comedy/love story. She had always been the best friend or the mom or the crazy neighbor in a supporting role, but never really the primary love interest. Always the bridesmaid, never the bride.

She finally got her opportunity when she was cast opposite Leslie Nielsen in *Chance of a Lifetime*, an NBC made-for-TV movie that White worked on during her *Golden Girls* hiatus between seasons six and seven. It premiered on November 18, 1991, and proved to be the thrilling fulfillment of a dream. Not only did she get to do her romance film but also starred with Nielsen, who had been her first choice. She wrote him a note asking, and he said yes.

The movie follows an uptight widow, Evelyn Eglin (Betty), who takes over her husband's business after he passes on. A decade of type A workaholism ensues, until Evelyn is shockingly diagnosed with a terminal illness and given just six months to live. She keeps the news under tight wraps while planning to live it up during her last days on earth, setting off for an extended getaway to Mexico.

It's there that she meets Lloyd Dixon (Nielsen), a debonair widower. He and Evelyn fall in love. They go bungee jumping—which proved challenging to Betty, since in reality it involved hot-air balloons and falling 15 feet onto a mattress. Everything goes just swell . . . until Evelyn finds out that she's been misdiagnosed and isn't going to die. That's the good news and bad news.

The fact that she's now going to make it (after all) forces Evelyn to reassess whether a more extended relationship can be just as exciting and fulfilling as her final fling. She suddenly backpedals on this whole love and happily-ever-after thing. But Lloyd isn't going to give up so easily and pursues his gal even after she demonstrates reluctance and ambivalence.

Chance of a Lifetime features a terrific cast that also includes Ed Begley Jr. as White's son and such veteran supporting players as Michael Tucci, William Windom, Elaine Stritch, Orson Bean, and Annabelle Gurwitch. It also afforded Betty the long-delayed opportunity to stretch her performance muscles beyond Sue Ann Nivens and Rose Nylund.

The players all were met with solid reviews for their sharply delivered dialogue and warm chemistry. And Betty and Leslie were simply adorable together—two pros delivering the goods with no muss or fuss. A splendid time was had by all, particularly Betty as she ticked off one more box on a long checklist of accomplishments. ■

> Betty and Leslie were simply adorable together—two pros delivering the goods with no muss or fuss.

OPPOSITE: Widow Evelyn Eglin (Betty) meets debonair widower Lloyd Dixon (Leslie Nielsen) while on a Mexican holiday in the NBC made-for-TV movie *Chance of a Lifetime*.

Continuing to Pan for Gold

The ladies try their hand at running a hotel in
The Golden Palace.

It was an open secret at NBC and among the *Golden Girls* cast that Bea Arthur wasn't altogether fulfilled during the last two years of the show and looked to move on. It invariably spelled the end of the series.

But this is where the show's creator, Susan Harris, had a brainstorm: What if Dorothy (Arthur) were to get married at the end of *The Golden Girls*, and the three remaining ladies sold their house and invested the pooled proceeds in a Miami hotel—where the trio would live?

Harris wound up selling the concept to CBS, giving rise to the spin-off *The Golden Palace*, which premiered on September 14, 1992. Betty (as Rose), Rue McClanahan (as the still promiscuous and vain Blanche), and Estelle Getty (Sophia) continued to play their *Golden Girls* characters, with a pair of talented regulars added to the cast. Don Cheadle portrayed Roland Wilson, the hotel's manager, while Cheech Marin was cast as Chuy Castillos, the facility's chef.

In the storyline, all of the employees of the hotel aside from the pair mentioned above had been fired to make it appear more profitable. Blanche became the main operator of the hotel, which is in financial trouble from the start due to mismanagement by the previous owners. Sophia and Rose were upset with Blanche for roping them into this mess in the first place.

Rose was given plenty to do in the *Golden Palace* milieu. She befriended a disoriented elderly woman, tried to set manager Roland up on dates, broke up with her cheating boyfriend Miles (Harold Gould), and in general stayed involved in everyone's business. She even spent time with visitor Dorothy when Arthur guest starred.

While the show missed the wise and caustic regular presence of Arthur, Lex Passaris—who directed 13 of the show's 24 episodes—recalled that Cheadle and Marin added a lot of comedic charm to the festivities. "They're both just incredibly funny guys," he said, "and that helped to fill the void caused by Bea's absence."

Landing yet another series on the heels of *Golden Girls* was a triumph for White. As she maintained in an interview with the *Archive of American Television*, "It sounded like a marvelous idea. These cloistered women sell their house and buy a modern art deco hotel to face life as it comes in off the street, through the lobby of a hotel. It's a whole new world for them."

But airing on Friday nights against ABC's powerful "TGIF" lineup, *The Golden Palace* never completely connected with audiences and stumbled in the ratings. Viewers didn't want to see Rose, Blanche, and Sophia hanging out in a hotel. They wanted the gals back in their house, and there simply was no going home again.

"Problem was, we had the same writers," White recalled. "If a script began to not fall together, they'd give one or the other of us a monologue. And pretty soon, we were doing *Golden Girls* in the lobby."

Additionally, the lack of Arthur ultimately proved too steep a hurdle to traverse. "It was like taking a leg off a table," White assessed. "If you take one off without rebalancing it, it just doesn't click." ∎

OPPOSITE: The cast of NBC's *Golden Girls* spin-off *The Golden Palace*. Top from left: Cheech Marin, Don Cheadle, Billy L. Sullivan. Bottom: Rue McClanahan, Betty, Estelle Getty.

Maybe You've Heard of Marie?

In the pantheon of series starring Betty, it's easy to overlook this sassy entry.

Let us take a moment here to examine an unprecedented phenomenon known as Betty White's television series life.

She has appeared as a regular or recurring player on more shows than any actress in prime-time history, dating back to her weekly *Life with Elizabeth*, *The Betty White Show*, and *Date with the Angels* in the 1950s; *The Mary Tyler Moore Show* and another *Betty White Show* in the 1970s; *Mama's Family*, *The Golden Girls*, *The Golden Palace*, *Maybe This Time*, and *Ladies Man* in the 1980s and '90s; and later *Boston Legal*, the soap opera *The Bold and the Beautiful*, and *Hot in Cleveland*.

Why is this such a big deal? Because a television actress is considered a success if she has even *one* regular or semi-regular role on a show throughout her lifetime. Betty has more than a dozen to her credit. She boasts hundreds of hours on TV, appearing in sitcoms, movies, and more game shows than anyone else.

One of Betty's series you probably never heard of was *Maybe This Time*, a multi-camera Disney TV comedy that had its ABC debut on September 15, 1995, and joined Betty with Marie Osmond in a multigenerational concept. Two ladies who embodied the very essence of Americana would play opposite each other, leaving people to wonder if a single screen could safely handle this much apple pie.

Marie starred in the show as Julia Wallace, a thirtysomething mother and recent divorcée running the family bakery in Haverford, Pennsylvania, alongside her own mother,

Shirley (White), while raising her 11-year-old daughter, Gracie (Ashley Johnson). Julia is looking for romance and sanity in equal measure, while Shirley is as man hungry as was Betty's onetime *Mary Tyler Moore* alter ego Sue Ann Nivens.

Helping the two women out in the bakery were the Scottish hunk Logan McDonough (Craig Ferguson a full decade before taking over CBS's *Late Late Show* franchise) and veteran actress-comic Amy Hill as frequent customer Kay Ohara. Comedian Dane Cook would be added as a bakery employee for the final nine episodes of its 18-installment run.

Betty's character here is a hoot. She's been married five times and widowed five times. She's the hottest of hot mamas on the prowl, providing a nice change of pace from Rose Nylund. But the show ultimately failed to catch on, as is the case with most new series. Essentially, White was carrying quite a load in holding up this ensemble, even though the performers all tried gamely to make it work.

Let's remember that the woman was already 73 years old when *Maybe This Time* premiered, 74 by the time it was canceled. Yet to look at the comedy today, Betty exhibited more pure energy than someone half her years despite being more than double the age of co-star Osmond. This lady puts even the Energizer Bunny to shame.

No matter how talented someone is, they're only as good as the writing. There are also factors beyond an actress's control, like time period and promotion.

But if you're Betty, it was well worth giving this a shot. She simply doesn't have it in her to turn down a job, demonstrating yet again how her dogged insistence on staying busy is a monumental thing to behold. It also helps explain why she has lived such a long life. She's always eager to welcome whatever is waiting around the corner. ∎

OPPOSITE: Betty leapt back into the weekly network sitcom fray in 1995 on ABC's *Maybe This Time*, featuring (from left) Betty, Ashley Johnson, and Marie Osmond.

The Hall of Fame Comes Calling

The question isn't why they inducted Betty White into the Television Academy Hall of Fame in October 1995, but why it took them so long.

The first inductees into the Television Academy Hall of Fame, in 1984, were Lucille Ball, Paddy Chayefsky, Norman Lear, Edward R. Murrow, and David Sarnoff. In year two, the list included Carol Burnett, Sid Caesar, Walter Cronkite, Joyce Hall, Rod Serling, Ed Sullivan, and Pat Weaver.

Betty White was the 11th woman to be so honored, during the 11th induction ceremony in 1995. The first ten were Ball, Burnett, Hall, Mary Tyler Moore, Gracie Allen, *Sesame Street* creator Joan Ganz Cooney, Barbara Walters, Dinah Shore, soap opera producer Agnes Nixon, and Oprah Winfrey. Not bad company to be in, to be sure, but frankly we're surprised she wasn't in the first group of five. The woman did, after all, help usher in the medium itself.

On the night that Betty entered the hall in October '95, she was accompanied by Michael Landon (posthumously), writer-producers Richard Levinson and William Link, sportscaster Jim McKay, journalist and political commentator Bill Moyers, and Dick Van Dyke.

Actress Michele Lee had the honors of introducing White with a stirring tribute, calling Betty a mentor and authentic role model throughout her career, spanning the beginning of black-and-white TV to modern color. She quoted writer Rip Rense as noting in *Emmy* magazine, "The only reason Betty was not on television for the first 24 years (or so) of her life is that it didn't exist." He's likely right.

Lee quipped—correctly—that White's first Emmy came well before Sputnik, and praised her work ethic, her philanthropy, her intelligence, her heart, her humor, and all the amazing qualities that make Betty the singular woman she is. She concluded by saying, "Who else but Betty has shown us that smart and tart and nice and spice are not only fun but perfectly compatible. Betty White, for helping pioneer a new medium, for your golden gift of comedy, and for your brilliant contribution to the art of ensemble acting, we warmly welcome you to the Television Academy Hall of Fame."

Betty's acceptance speech was, of course, typically gracious, modest, and heartwarming. "I can claim one thing I don't know anyone else can claim," she concluded, "and I do it wholeheartedly. Nobody—nobody has had more fun in this world doing what they do for a living than I have in television. Thank you so very, very much."

And if you happen to pay a visit to the Academy of Television Arts and Sciences Hall of Fame Plaza at Disney's Hollywood Studios in Walt Disney World of Lake Buena Vista, Florida, you will find the busts of a dozen Television Academy Hall of Famers. One of those is that of Betty. Deservedly so. ∎

OPPOSITE: Betty mockingly checks her makeup in her award with presenter Michele Lee backstage before being inducted into the Television Academy Hall of Fame in October 1995.

She's Got Some Mouth

Betty proves it's never too late to defy expectations—and that you're never too old to have a potty mouth.

The brilliant writer and producer David E. Kelley developed a mad crush on Betty. He looked deeply into her sweet, innocent, septuagenarian eyes and somehow saw hostility and evil. Beginning with his 1999 horror-satire feature *Lake Placid*, which he wrote and produced and was released on July 16, 1999, he implored Betty's characters to utter the most outrageous, awful things, seemingly corrupting the poor woman in the process.

And she appeared to love it.

Kelley would use White on *Ally McBeal*, *The Practice*, and *Boston Legal*. But first came *Lake Placid*, in which White portrayed the wacky widow Mrs. Delores Bickerman. Quarrelsome, cantankerous, vulgar, and ultimately homicidal, Mrs. Bickerman cares for the crocodiles of Maine's Black Lake, including a 30-foot one that's terrorizing the area's residents. She understands that the crocs devoured some folks as well as farm animals, her husband among them. And she's just fine with that. In fact, she may have even helped along the process.

What are we talking about here? Well, the dialogue speaks for itself and has to be seen and heard firsthand to be fully appreciated. For instance, there is the following exchange between Sheriff Hank Keough (Brendan Gleeson) and the bickersome Mrs. Bickerman:

Sheriff Keough: "Ma'am, your husband, Bernie, you didn't by chance lead him to the lake blindfolded?"
Mrs. Bickerman: "If I had a dick, this is where I'd tell you to suck it!"

And there was also this gem:

Mrs. Bickerman: "Murders and rapes in the city, people bomb planes, can the police stop 'em? No! But feed one little cow to a crocodile . . ."
Sheriff Keough: "You're gonna stay right here until the police show. You're under full house arrest."
Mrs. Bickerman: "Thank you, Officer Fuck-meat!"

There's plenty more where that came from. She blurts that she wishes a crocodile well in its attempts to devour law enforcement and refers to the police force collectively as "cocksuckers," later admitting without a bit of reticence that she killed her husband. It's announced with pride.

While few thought that *Lake Placid*—which starred Bill Pullman, Bridget Fonda, Oliver Platt, and Gleeson—was a great film, pretty much everyone agreed that White stole the picture. The filthy stuff that poured from her mouth left everyone in hysterics, even if it made Betty herself slightly nervous.

As she said in an interview with the *Los Angeles Times*, "I tried to sell David Kelley on the idea of using words that sound close. My question to him was 'How did this little old lady who lived way up in the woods all this time learn to talk like she was in the 'hood?'"

The film's director, Steve Miner, said in the same story, "[White is] the funniest comedic actress in the business. She could read the phone book and be funny." The critical consensus on Rotten Tomatoes was that "Betty White's delightful supporting turn may be worth the price of admission alone."

To be sure, the shock value of hearing words come out of Betty's mouth that would make the Golden Girls blush is wondrous. It opened up a whole new area for her as a Princess of Profanity that will repeatedly come in handy for Kelley—and Betty herself. ∎

OPPOSITE: Betty portrayed the evil, wicked, mean, and nasty Mrs. Delores Bickerman in David E. Kelley's 1999 horror satire feature *Lake Placid*, winning her rave notices.

The 2000s

Cementing a Legacy

"I've never met a more appealing, warm, witty person.
She had an edge but not too much of an edge.
You just wanted to eat her up with a spoon."

—Candice Bergen on working with Betty

OPPOSITE: The new millennium would belong to Betty White.

Is There Anything the Woman *Won't* Say?

A s a new century dawned, Betty's career and personal life would grow into a perfect blend of past and present, old friendships and new beginnings, places she's been and places she's headed. First, there would be a pair of strolls down memory lane honoring arguably her two most iconic roles: Sue Ann Nivens and Rose Nylund.

Twenty-five years after *The Mary Tyler Moore Show* ended its legendary run on CBS, the network got the old gang back together with an hour-long retrospective that aired on May 13, 2002. It joined White with co-stars Mary Tyler Moore (of course), Ed Asner, Valerie Harper, Gavin MacLeod, Georgia Engel, and Cloris Leachman, with Mary herself hosting. As the theme song alluded, love was indeed all around.

Then, the following year, came a 90-minute nostalgic look back at *The Golden Girls* on Lifetime, bringing together Bea Arthur, Rue McClanahan, and Betty (Estelle Getty was too frail to participate) in solo interviews augmented by abundant clips. It demonstrated the continued popularity of the show and its participants, becoming the highest-rated special in the cable network's 19-year history.

But if there is anything Betty would rather do than visit with old friends, it's hang out with animals. Few such opportunities proved more spectacular than her first-time meeting in 2004 with the incredible Koko the Gorilla. The female western lowland gorilla had a working vocabulary of more than 1,000 language signs and could understand some 2,000 spoken English words, but her bond with White was instant and defied conventional communication barriers. Koko gave White the name "Lipstick," and their gentle touch and obvious comfort level made for an intensely moving experience for Betty. Their invisible connection left both human and primate feeling no fear of one another.

Since mankind cannot live by gorilla visits alone, however, Betty went to work—because it's what she does. She loved being producer David E. Kelley's conduit of profanity, and he loved having a legendary actress who was willing to say and do almost anything. He cast her in 2004 in his quirky legal drama *The Practice* and in 2005 on its spin-off *Boston Legal* as the offbeat and self-destructive Catherine Piper, an old lady who seemed to lack both a moral compass and a censor button.

Catherine was the kind of woman who thought frying pans were best used to conk someone over the head rather than for cooking and committed armed robberies that her employer would have to defend her for. The actress portraying her reveled in playing such a lunatic, and it signaled to America that Betty White was available to shock with impunity. Have pun, will travel.

Even so, no one could ever have imagined what would come out of that woman's mouth when she consented to appear on the *Comedy Central Roast of William Shatner* in 2006. Sure, guests were expected to toss out insults at the guest of honor and others in attendance, but she was more than up to the task, proving surprisingly ribald and eager to detonate her image.

At the roast of her *Boston Legal* castmate, White joyously trashed everything that moved, including Farrah Fawcett, Patton Oswalt, George Takei, and, of course Shatner himself. The sheer rowdiness and political incorrectness flying all around didn't seem to much impact her, proving to the world once again that she understood comedy isn't always pretty (even if *she* is).

While Betty remained under the spell of "Let's try everything once," she figured she might as well do a daytime soap opera, because why not? She was cast in 2006 as the denial-driven Ann Douglas in the CBS serial *The Bold and the Beautiful*. Her character's specialty seemed to be dismissing the claims of her bipolar adult daughter that her ex-husband physically abused her. What surprised everyone around White on *B&B* was not that she could convincingly step into a soap and instantly fit in, but that she was able to come in as an outsider, perform 40 pages of dialogue, and never so much as stumble. Mind you, the woman was now 85 years old, but she was still delivering the goods.

Not that this was enough to keep her busy. White still sought out other cameo work, including a memorable turn on ABC's *Ugly Betty* in December 2007 in which she portrayed herself as, well, an ugly Betty. She has a grand time running afoul of diva Wilhelmina Slater (star Vanessa Williams), demonstrating to all that she could dish it out just as effectively as she could take it.

Even with her career poised to jet into orbit yet again, White was still pleased to take the occasional career bow. The latest happened in August 2008, when the Television Academy honored her with *Betty White: Celebrating 60 Years on Television,* an event attended by friends and colleagues (including the *MTM* cast once again). The reminiscences and loving feelings flowed freely on a night when people from every era of Betty's television past dropped over to pay tribute. Throughout, the monumental scope of her extraordinary career emerged, and the smile never left her face.

Betty remained under the spell of "Let's try everything once."

Then, after all her years on television, she again made her way onto the silver screen in the 2009 theatrical *The Proposal,* starring Sandra Bullock and Ryan Reynolds. As the adorable oddball Grandma Annie, White's supposed to be a supporting character, but she proves to be a scene stealer, particularly when she leads Bullock's character in a bizarre fertility song and dance. She would admit after the fact that it was probably the most fun she'd ever had on a project—this, at the tender age of 87.

But the woman didn't restrict her fun to the production set. In case it wasn't already clear, Betty loves to play games, and not just those as a celebrity panelist on game shows. She's been part of a traveling poker game with friends that's lasted more than 40 years, and a weekly Monday-night Scrabble date that's thrived for better than a decade. The latter takes place at the home of Betty's best friends actress Millicent Martin and Martin's husband, Marc Alexander, and it's proven to be one of the ongoing delights of her life. Mind you, they are not relaxed and friendly games but heavy competition, fueled by hot dogs and caviar.

It's at the Martin-Alexander home that Betty gathers her strength for whatever work lies ahead. That became particularly important in 2009, as 2010 promised against all odds to be the most eventful and wildly diverse single year of her professional life. It would presage a period of visibility and popularity that came to be known as The Betty White Decade.

It Seems
They Made It After All

Getting the WJM gang back together was a lovefest that
touched audiences and cast members alike.

It was on May 13, 2002—25 years after the final episode aired—that Mary Tyler Moore herself hosted an hour-long retrospective salute to her namesake show on CBS.

This was an intimate little affair that featured all of the principals save for Ted Knight, who had passed away in 1986. Everyone else was there: Ed Asner, Valerie Harper, Gavin MacLeod, Georgia Engel, Cloris Leachman, and of course Betty White. What, after all, would a *Mary Tyler Moore Show* reunion be without Sue Ann Nivens?

The format of the special found Mary sitting down individually with each castmate to reminisce about their time on the series and discuss their character, punctuated with favorite episodic clips. Opening things up was a hard-rocking 1996 cover of the theme song "Love Is All Around" by Joan Jett & The Blackhearts.

Betty is given a prime spot near the top of the hour, thinking back on the earliest days of Sue Ann: "They were looking for somebody sickeningly sweet, and they couldn't find anybody that sickening. They went through all these actors and then finally it got down to 'Why don't you just get Betty?' That was a turning point in my life."

In wondering aloud why Sue Ann worked as a character in the milieu of the series, White theorized, "Because she hit Mary funny. Mary could laugh at her and not be offended by her." To Moore: "I still remember being so nasty to you."

That idea of why Mary Richards would tolerate such callousness and insensitivity from Sue Ann was challenged again and again, as was her insult-laden relationship with Murray Slaughter (MacLeod) and her fruitless pursuit of Lou Grant (Asner), the latter of whom she consistently lusted after.

"With Lou," White reflected, "it was more of a passion than a relationship."

There is a special salute during the show to Knight (who portrayed charmingly narcissistic anchorman Ted Baxter) and, in general, a warm and sweet vibe to the hour.

It's clear how much participating in this show meant to all of the principal cast members, especially Moore herself, for whom it was the career zenith. It's certainly rare for a series to have an opportunity to take such a high-profile bow a quarter century after its conclusion, and none of the actors was taking a moment of this for granted.

Betty offered that her favorite moment/episode came in the half hour "Sue Ann's Sister," when a distraught Sue Ann took to her bed in grief over her sister's infringement on her professional territory. We get to see Ms. Nivens's seduction-ready bedroom complete with round bed, stereo surround sound, and vibrating mattress. It was indeed Sue Ann at her finest.

It's heartening to watch Betty share her genuine thanks with the woman who arguably played the most important role in taking her career to the next level—a lady who through it all remained a personal friend.

"You have been such a major part of my life, my dear friend," White tells Moore at the end. Mary is touched. So are we. ∎

OPPOSITE: Twenty-five years after *The Mary Tyler Moore Show* left the CBS airwaves, Mary and Betty were reunited in 2002 for a CBS retrospective.

Gold Doesn't Tarnish

More than a decade after the series ended, people were thrilled to see these girls get back together, even if only for a night.

Some 11 years after *The Golden Girls* completed its triumphant seven-season run on NBC, it spawned a special on Lifetime network that featured Betty, Bea Arthur, and Rue McClanahan, but sadly not Estelle Getty, whose health was too fragile to participate. But the 90-minute retrospective *The Golden Girls: Their Greatest Moments* that premiered on June 2, 2003, proved to be a creative grand slam.

It's Betty who was first out to welcome viewers with "Good evening, I'm Betty White. For seven wonderful years, I shared the screen with three unforgettable women: a wisecracking substitute schoolteacher, an oversexed egomaniac, and a feisty old lady who had a mouth like a sailor." She added that what we were about to see included favorite moments of cast members Bea (Dorothy), Rue (Blanche), and Betty (Rose) as well as, in absentia, Estelle (Sophia).

White added during the special that she loved Rose, describing her as "terminally naïve" but not dumb "and with a heart of gold." She also had a "Viking temper" and "her own private agenda to life."

The special featured Betty, Bea, and Rue each reflecting on the show in solo interviews, punctuated with clips galore and an entertaining collection of bloopers and outtakes never before seen.

What's perhaps most satisfying, however, is the context into which the extravaganza successfully put the show. *Golden Girls* writer/creator Susan Harris and executive producers Paul Junger Witt and Tony Thomas all checked in with interviews that fairly reveled in the show's uncanny, unprecedented success. Everyone was particularly proud to recall that the show was a favorite of England's queen mother, for whom a 1988 command performance was arranged.

White also recalled the time that Thomas had her ask Bob Hope if he might make an appearance on the

A Conversation with Lindsay Drewel

Handling the publicity for the 2003 special *The Golden Girls: Their Greatest Moments* for Lifetime gave Lindsay a surprising first.

Q: *Talk about your work on the* Golden Girls *special.*

LINDSAY DREWEL: Well, in 2003 I was just a 25-year-old pub cub doing publicity for the network when I got assigned to the *Golden Girls* reunion show.

Q: *So, you had to suffer through dealing with Betty White.*

DREWEL: Exactly. Oh my God, what torture! No, I mean, the woman truly is a national treasure. She put a mark on my career when I was very young that left me spoiled.

Q: *What was that like?*

DREWEL: Betty is just one of the kindest, most decent, most gracious, most authentic people I've ever met anywhere, much less in Hollywood. It was like dealing with my mother or grandmother. Based on the way she acted, you would never know she was a celebrity. She's just such a rare person. If they could clone it, Hollywood would be a very different place.

Q: *What did Betty do that made her so special?*

DREWEL: Two things. To this day—and I've now been in PR for 20 years—Betty is the only celebrity to thank me for doing my job. She sent me a handwritten note on her special stationery, cream-colored with her letterhead, along with an orchid. I mean, trust me, NOBODY does stuff like that for the publicist. And I don't expect it. I'm there to do a job. But that's just the way Betty is.

Q: *Not a huge surprise. What's the second thing?*

DREWEL: Again, I never ask for special favors because I'm really not supposed to bother the celebrity, just get the job done. But my grandparents were huge Betty White fans. So, I asked her to write them a personal note and took a photo with Betty especially for them. It made my grandfather's decade to receive that in the mail, you have no idea. And she was happy to do it.

Q: *People like that, you want to work with again and again.*

DREWEL: You do. And as a matter of fact, I got another chance in November 2011 when I reached out to her on behalf of the National Geographic Big Cats Initiative. She readily agreed to do a public service announcement. Again, she was just a joy to work with.

Q: *No problems? No issues?*

DREWEL: Oh God, no. The thing is, when you're with her, you're with her. She's 100 percent present. She recognizes you as a human being in the moment, not just a publicist. That really stuck with me. It's completely authentic. She sees you, she connects with you, she's completely there with you. It's real and very rare, and delightful.

show—and Hope agreed. That led to a segment showing some of the stars who did guest stints, including Sonny Bono, Julio Iglesias, talk show legend Merv Griffin, Dick Van Dyke, Debbie Reynolds, Mickey Rooney, *Jeopardy!* host Alex Trebek, Don Ameche, and a fellow named Burt Reynolds.

Reynolds's cameo was replayed as a clip here, and it remains one of the show's most uproarious moments.

Burt asks Sophia: "Are these the roommates you told me about?" Sophia says they are.

Burt than asks, "Which one's the slut?" To which all three of their hands shoot up, accompanied by "I am."

The trip down memory lane turned out to be a particularly smooth and beautifully produced affair that not surprisingly drew in viewers by the boatload. It became the highest-rated special in Lifetime's 19-year history. And wherever and whenever *The Golden Girls* plays today in reruns, it remains a rating draw even nearly three decades after leaving the air in originals.

As far as Betty's concerned, she's twice blessed to have been a part of a pair of comedy series classics portraying radically different characters. How lucky can one actress be? Only as fortunate as the shows were to have her as a part of them. ∎

OPPOSITE: (From left) Rue McClanahan, Betty, and Bea Arthur got back together to reminisce about *The Golden Girls* for a 2003 Lifetime network special.

Logging Quality Time with Koko the Gorilla

Betty has a way not only with people, but with our primate kin as well.

It's one of the most moving and tender things you will ever see: Koko, an amazing female western lowland gorilla who had learned more than 1,000 language signs and could understand some 2,000 spoken English words, welcomed Betty White into her world and demonstrated an instant and intense bond with the renowned animal lover. Their 2004 visit was a special experience for both of them.

White was at that time on the board of directors of The Gorilla Foundation, which worked with and cared for the 32-year-old Koko. Betty and the gorilla met at the foundation's headquarters in Woodside, California, along with Koko's longtime caretaker Dr. Penny Patterson, a psychologist specializing in animal behavior. Koko had been the subject of several documentaries that cited the primate's intelligence, tender nature, and tremendous capacity for empathy.

For Dr. Patterson, what was meant to be a four-year experiment at Stanford University turned into a lifelong mother-daughter relationship.

In her book *If You Ask Me (And of Course You Won't)*, Betty described the first time she and Koko met. Betty was sitting outside the gorilla's room when Koko arrived. Koko gently took Betty by the arm, leading her in through the gate and into her (Koko's) home. The gorilla then had a seat and gestured for Betty to do the same. Betty would later recall that she felt no fear, so caught up in the moment was she with this beautiful creature. It was easily apparent that they were completely enmeshed in and loving each other's company.

Koko's Fame

Twice a cover subject of *National Geographic*, Koko established friendships with Fred Rogers, Robin Williams (they tickled each other, and Williams called meeting Koko "a mind-altering experience"), Sting, Leonardo DiCaprio, Peter Gabriel, and many others. She also loved to hang out with house cats, kittens in particular.

Their 20-minute visit together betrayed an extraordinary comfort level between the animal and White. It was clear to both Dr. Patterson and Betty that Koko recognized her from television, particularly the *Golden Girls* reruns she watched on DVD. During subsequent visits, the gorilla would greet her by rubbing her fingers across her own mouth to indicate recognition of Betty as "Lipstick" (the name Koko gave her).

Koko's hands were on Betty repeatedly throughout their first time together, often as gentle touching—a hand on the shoulder, a finger on the cheek, clutching her arm. It's staggering and beautiful to imagine, and it proved one of the most profoundly moving experiences of Betty's life.

"To look into the eyes of a 300-pound gorilla and have her tell you what she's thinking is truly humbling," White recalled in an interview. "There was an invisible connection between (us). At that moment, nothing else around you exists."

Koko died in 2018 at 46, but not before changing how the world views her species and its capacity for an impressive range of emotional and cognitive abilities. And clearly, Betty's encounter with the gorilla left her a changed human being as well. ∎

OPPOSITE: Betty is never happier than when she's around animals, as her big smile in front of the L.A. Zoo gorilla enclosure demonstrates.

Homicidal Maniac

Gleefully causing trouble, legal and otherwise, was Betty's specialty in the role of Catherine Piper.

Technically, Betty's introduction as the character Catherine Piper began in 2004 on David E. Kelley's legal drama *The Practice*, when Catherine recalled that partner Alan Shore (James Spader) had put a burning bag of dog poop on her doorstep when he was nine years old. She didn't forget, shaking his hand with canine excrement all over hers.

It was at the dawn of her 16 guest appearances on the spin-off *Boston Legal* in January 2005, however, that Betty's alter ego Ms. Piper really began to reach full (wilted) flower. After enduring a host of travails and legal entanglements,

she was hired as Alan's new assistant and instantly made a nuisance of herself by crashing a law firm meeting as the "cookie lady" and commenting on the looks of lawyer Paul Lewiston (René Auberjonois), the weight of Tara Wilson (Rhona Mitra), and the bleached hair of Lori Colson (Monica Potter).

When Lori confronts her outside the meeting to mention she didn't appreciate the observations about her hair, Catherine apologizes. Sort of. "Oh, I'm sorry," she says. "I was just trying to make conversation. And I assumed you wouldn't want me to go anywhere near your eyebrows."

A Conversation with Bill D'Elia

The executive producer and director on *Boston Legal* talks about the joy of working with Betty.

Q: *What are your memories of Betty from her time on your show?*

BILL D'ELIA: Well, a lot of things. The first thing that struck me about Betty was this youthful exuberance she had despite being in her 80s. It was just amazing to everybody on the set. I mean, she was indefatigable. I've worked with a lot of actors, including a lot of elderly actors. Sometimes, you have to worry about how cognizant they are, how to shoot them, when to shoot them, what time of day is best. With Betty, it never mattered at all. It was like she was 17 years old.

Q: *So, you could even do late-night shoots with her if you needed to?*

D'ELIA: In fact, we did. A lot of times, it's guest stars who you're pulling in to shoot late into the night. But with Betty, it was like it was first thing in the morning. She was always enthusiastic and letter-perfect. Never groping for a line. She just totally knew her stuff. A lot of young actors don't deliver close to what she was able to in her 80s.

Q: *Did you ever ask David Kelley why he took such pleasure in corrupting such a sweet old lady with the dialogue he wrote for her?*

D'ELIA: It started when he cast her in the film *Lake Placid* in 1999. He would make that woman say the most horrible things. David loved the contrast of her image versus what her character was saying, and to pry into that side of her that didn't really exist.

Q: *Do you ever remember Betty having any qualms about what the script was forcing her to say and do on Boston Legal?*

D'ELIA: Not a one. She would happily say anything and do anything the story and script called for. She murdered a guy on our show, and it was hilarious. She took that frying pan to Leslie Jordan's head and killed him. It was arguably the only time Betty White has taken someone out on camera.

Q: *Did Betty take her character's nature to heart and start walking around the set acting like a cold-blooded killer?*

D'ELIA: (laughs) Not that I can recall. I mean, she was always just a joy to be around. That's why David kept coming back to cast her. You can never have too much Betty White.

Ouch.

Indeed, on *Boston Legal*, Catherine is every ounce a crazy old broad. She breaks the law as casually as others chew gum and offends everyone at the firm seemingly without trying very hard. The only one who will give her the time of day is Bernard Ferrion (Leslie Jordan), a client of Alan's who was charged with killing his mother by whacking her over the head with a cast-iron skillet.

When Bernard is acquitted due to a lack of evidence, he kills another neighbor with the same frying pan and again escapes conviction. Catherine, fearing that he will kill again, takes matter into her own hostile hands by using the same notorious iron pan to take out Bernard and then hide his body in a freezer. She is tried for murder and exonerated, but there are consequences. She is finally fired from the firm for being, you know, a murderess. As she's told by partner Shirley Schmidt (Candice Bergen), "We simply cannot have administrative staff killing clients."

"Everyone fell in love with Betty instantly," recalled Bergen in an interview for this book. "And I've never met a more appealing, warm, witty person. She had an edge but not too much of an edge. You just wanted to eat her up with a spoon. Every scene she was in was great, and her being in it is what made it wonderful.

"It was just really a treat for everyone to work with her, and every time she guested on an episode, we were sad to see her go."

Even after the firm of Crane, Poole & Schmidt gave her the heave-ho, Catherine's life of crime continued apace. She committed a pair of armed robberies at local convenience stores in a cry for attention. To be sure, there was never a dull moment when Catherine Piper was nearby. And we got the feeling that Betty loved every chaotic second of it. ∎

OPPOSITE: As the impertinent and erratic Catherine Piper on ABC's *Boston Legal*, Betty liked to fire off more than her mouth.

The Shat Hits the Fan

Betty turned up the heat at the roast of William Shatner,
making jaws drop left and right.

Of all the places you might expect Betty White to show up and perform, the least likely would probably be the *Comedy Central Roast of William Shatner* that premiered on August 20, 2006.

It isn't that she didn't know the guy. They worked on the same show (*Boston Legal*) for several years, after all. But all the foul-mouthed antics that go down at these specials make it less than a safe space for an 84-year-old living legend of such refinement, style, and grace.

Nah. That's just what she wants everyone to believe. Turns out Betty fit right in with this crowd, which included roastmaster Jason Alexander and celebrity roasters Fred Willard, Farrah Fawcett, Jeff Ross, Andy Dick, Lisa Lampanelli, Artie Lange, Patton Oswalt, Kevin Pollak, George Takei, Nichelle Nichols (from the original *Star Trek*), and Greg Giraldo.

And if you think that Betty provided a squeaky-clean alternative to all of the blistering profanity and raucous sexual innuendo during her five-minute routine, guess again. It turns out that White can be as blue as anybody—bluer even. She dons glasses to both better read the prompter and play up her old lady bona fides. But she sounds nothing like she looks.

The truth of the matter, of course, is that Betty doesn't really need anyone imploring her to be raunchy and risqué. It comes somewhat naturally. If there's anything she loves, it's turning expectations on their head as a jarring contrast to her sweet and kindhearted nature. She doesn't require a script to get saucy, just an opportunity. A roast, it turns out, is right in her wheelhouse.

Early on in her presentation, Betty proves that politically correct she ain't by making jokes about the race and

A Conversation with Rick Austin

A producer on the Comedy Central Roast of William Shatner *remembers Betty's willingness to say anything for a laugh.*

Q: *What was it like working with Betty on the Shatner roast?*

RICK AUSTIN: I'll always remember the first writers meeting we had with her during rehearsal. The writers were all just over the moon, excited to pitch jokes to Betty White because she was this comedy legend. Whenever we have a legend like her, the writers are all so jazzed about it that they try to up their game. It's like, if Betty accepts a joke that some 28-year-old guy wrote, it's the highlight of his career.

Q: *And I imagine it's a little intimidating for everyone initially.*

AUSTIN: Well, yes and no. The thing is, despite her reputation, she was just so un-intimidating. The nervousness comes in because the writers have such incredible respect for her.

Q: *And I would think they might be a little bit concerned about offending her in this case.*

AUSTIN: Yeah, probably. But I just remember this buzz when the writers all formed a kind of distant circle around Betty the first time they met with her to run jokes. What happens with people like her is, we kind of write the set in advance and see how it plays. So, the writers were standing around in awe, tossing out their jokes to see Betty's reaction, because she knows her brand better than anybody else. I remember a moment where one of our writers pitched her a joke that was especially dirty and out there. And Betty, in her inimitable way, listened to the joke and sort of laughed at it and said very sweetly, "Well, I won't say that."

Q: *She knows best how far she can step without crossing the Betty White line.*

AUSTIN: Well, exactly. Only she understands where she needs to draw it. There's a very solid line that she won't cross, because she gets so well how she's perceived.

Q: *It turns out she'll say more than anyone could have guessed.*

AUSTIN: Yep. I think probably her most famous joke on the Shatner roast had to do with us all knowing Shatner's nuts, but only George [Takei] has tasted them. That was the one she thought the hardest about before saying yes. She said it in rehearsal and it got a big laugh from the crew. That decided it for her.

Q: *Some would think it was off brand simply for her to do a Comedy Central roast in the first place.*

AUSTIN: For sure. But at the same time, she enjoys playing off the persona of sweet, old Betty and causing jaws to drop. It was a bit of a shock for people who had never seen her go there to hear this stuff come out of her mouth. We all got to see up close just how much she loves doing that.

sexuality of some of Shatner's original crew on *Star Trek*. But she's Betty, so she does it in a way that punches up at racist and homophobic culture.

That's not to say that she doesn't just get downright and hilariously mean. Betty describes Patton Oswalt as "a plump little troll" and notes to Farrah Fawcett, "I'm in my 80s, and that's the last decade you mattered." She notes the people who couldn't make it to the event and is moved to observe to Shatner that "you know, they make one percent milk now."

And then: "Darling, you were supposed to explore the galaxy, not fill it."

Yes, this is what qualifies as good-natured ribbing in the age of anything-goes. The roasts are considered safe zones for laser-targeted insults, and the well-meaning nastiness fairly coats the proceedings like a heavy fog. It also features Betty's boasting that she and Shatner "once had sex" and, in trying to hurry him along, she warned, "In two minutes, they're gonna start the roast!"

This wasn't even the dirtiest stuff to emerge from White's routine. The thing with these roasts is, even when you're being loving, you're popping out malicious smackdowns.

Perhaps the real miracle is that Betty can perform at these rowdy affairs and emerge with her classy image and dignity intact. The fact she can be so wicked and fly so gleefully in the face of her long-established image generates even greater admiration for her. Perpetual golden girl that she is, nothing can tarnish that pristine persona. ∎

OPPOSITE: Betty gets down and dirty as the roastess with the mostest at the August 2006 *Comedy Central Roast of William Shatner*.

Betty Gets Soapy

If you were going to cast Betty White on a soap opera,
wouldn't it be on something called
The Bold and the Beautiful?

Betty White is bold. Betty White is beautiful. Therefore, she's got the title *The Bold and the Beautiful* totally covered. It makes sense she'd embrace a role in it.

Moreover, if you're Betty and you have done literally everything in your career—from talk shows to variety shows to game shows to prime-time comedy to prime-time drama to stage plays to motion pictures to parade commentary—wouldn't you turn your gaze to the daytime soap world? After all, it was pretty much the only performance genre she had yet to pay a visit. And if you're a mistress of reinvention like Betty is, new challenges really go with the territory.

So it was that on December 1, 2006, White was cast in the role of Ann Douglas on *B&B*. She immediately became a key recurring element in the CBS series' storyline that continued for 23 episodes through 2009. And as is always the case in these convoluted dramas, there were many interlocking plots that she grew embroiled in.

As Ann, Betty was the overbearing mother of Pamela Douglas (Alley Mills), who is bipolar, and Stephanie Forrester (Susan Flannery). While Ann was mostly a sympathetic character, perhaps her greatest failing was her denial that Stephanie had long been physically abused by her father, John Douglas (whom we see only in flashback). Stephanie would finally confront this in therapy. But Ann denied it and denied it no matter the evidence.

Then one day, Stephanie and husband Eric (John McCook) invited Ann back to Los Angeles at Christmastime along with poor Pam, who was now Ann's caregiver. Ann finally began to resolve the past and admit what had been clear for years. She confessed to knowing all about the abuse but feeling terrified to confront her husband. So, she weaseled out of her motherly responsibility. But Stephanie forgave her. I mean, what are you gonna do, stay mad at Betty White forever?

Oh, and did we mention that the reason for Pam's bipolar diagnosis was a mass pressing on her brain that caused her erratic behavior (which included poisoning her husband)? My oh my, what a tangled web they all weave.

Finally, in 2009, it was revealed that Ann was dying of pancreatic cancer. She returned to L.A. under the pretext of seeing the Pacific Ocean one last time, and not wanting to die in the hospital. Her daughters took her to the beach, where she went gently into that good night.

As her time on *The Bold and the Beautiful* was wrapping, Betty gave an interview to *TV Guide* discussing Ann's motivation: "[Ann would] never admit she's been less than perfect as a mother. But she's losing her power. She's losing control. She wants to get rid of some of the old garbage, so it's nice for her to be with Stephanie and Pam and resolve some issues that have been sticky for a while.

"She must have looked in the mirror one morning and said, 'My God, Ann, you're getting older. We better get some things resolved.' Of course, *I* do that every morning!" And so, Ann Douglas was no more. But like everything else in

> "My God, Ann, you're getting older. We better get some things resolved."

White's life, she had a blast while it lasted. And her co-star McCook was, for one, greatly impressed with how Betty handled things from the get-go. As he noted while appearing at the 2008 Television Academy salute *Betty White: Celebrating 60 Years on Television*, "It's so different for even an experienced performer to come onto our show—which had been there for 20 years—and be the outsider. "Betty walked onto a soap opera set she had never been on before, with a company of people who had been there a very long time, having 40 pages of dialogue to deliver. It's pretty intimidating. But she rose to that occasion so well right from the start. No one could have done it better." ▪

ABOVE: Betty playing the stoic Ann Douglas on the CBS soap *The Bold and the Beautiful* in 2006. From left: Susan Flannery, Alley Mills, Betty, and John McCook.

Revenge Is a Dish Best Served Cold

No one would dare use "ugly" to describe our dear Betty,
but she was nonetheless wonderful on the show bearing that title.

Then there was the time that Betty showed up on the ABC series *Ugly Betty* in a cameo as herself that would continue to set the stage for the resurgent decade to follow. Producers were just starting to follow the David Kelley model of casting White in guest spots and instantly bringing magic into the mix. This appearance demonstrated just how sly and fearless she remained well into her 80s.

Ugly Betty was already far along in discovering the joys of big-name stunt casting, featuring appearances by Adele, Naomi Campbell, Martha Stewart, Victoria Beckham, Christie Brinkley, Shakira, Victor Garber, and others. But the show simply couldn't do better than trotting out someone literally named Betty behaving in an ugly fashion.

The story, part of the "Bananas for Betty" season two episode that had its broadcast premiere on December 6, 2007, finds villainous, self-absorbed diva Wilhelmina Slater (Vanessa Williams) confronting Betty (playing herself) on a rainy day when both were vying for the same taxicab. (These were the days before Uber and Lyft changed everything when it came to public transport.) She shoves the old lady out of the way, snatches the cab for herself, and slams the door on her fingers.

Unfortunately for Wilhelmina, the whole thing is captured on smartphone video by a couple of eyewitnesses and becomes a social media viral sensation—Facebook and Twitter were already around in '07—and now she has a PR snafu on her hands. Abusing Betty White in plain sight seems to be a poor career move. Who knew?

As Betty recovers in the hospital, she floats a call to Wilhelmina, who admits to her, "I just thought you were some old lady." The "some old lady" reasons that it was her own fault: "I stopped to sign a few autographs and almost bled out on the sidewalk." When Wilhelmina offers that it's heartening Betty is so loyal to her fans, Betty comes back with, "Well, I adore 'em. Except for the few sickos who write lesbian fan fiction about me and Bea Arthur."

And bingo. *There* is the reason White grew in such demand for a late-life rebirth as a living legend. Not only is she willing to poke fun at herself and her image; she's downright eager. If there is a laugh to be mined, she's all over it.

So it goes in this *Ugly Betty* episode. The incident continues forth with Wilhelmina asking Betty to personally forgive her on live television from Betty's hospital bed. But it's a trap. As soon as Wil touches her, she screams out in pain. "Now she's going after my other hand! Why do you hate me? Oh God, get the monster away from me!"

Officially betrayed, Wilhelmina shuts down the live shot to confront her tormentor, who maintains that this little feud is the best thing that's happened to her in years and she's going to milk it for all it's worth because "that *Golden Girls* money went right into the nickel slots."

It's a great gambit that Betty plays with perfect deadpan charm, and you can tell by the crafty way she works it that she's having the time of her life portraying such a devious version of herself. Playing against type like this demonstrates how sharp her acting chops remain all these decades later. ■

OPPOSITE: Betty portraying a hilarious version of herself (with Alec Mapa and Vanessa Williams) on the "Bananas for Betty" episode of the ABC comedy *Ugly Betty* in December 2007.

Sixty Years in the Rearview Mirror

When people call Betty White the First Lady of Television, they mean it in every sense of the term.

Yes, Betty was there at the dawn of the TV medium in 1949, featured on the local Los Angeles program *Hollywood on Television,* and has rarely been off camera since. One wonders, in fact, if television itself could survive her ever being off it.

It was with this in mind that Betty was honored with a special night at the Leonard H. Goldenson Theatre of the Television Academy in North Hollywood, California, on August 7, 2008. The tribute, *Betty White: Celebrating 60 Years on Television,* featured abundant clips and visits from a number of her longtime friends and colleagues.

Moderator Pete Hammond introduced a joyous procession of well-wishers trekking with Betty down memory lane, beginning with game show creator-producer Bob Stewart. Stewart recalled the first brief meeting on the set of *Password* between Betty and host Allen Ludden, the man she would marry two years later. Ludden took Stewart aside, looked out at Betty, pointed, and promised, "I'm going to marry that woman."

"I didn't want to upset Allen," Stewart recalled, "so I said, 'Of course you are. You've known her six minutes. How can she resist?' But it really happened."

The parade of guests who came to lovingly honor Betty continued with her unofficial son, singer-author Tom Sullivan. The two had met on Cape Cod while Sullivan was in college more than 50 years before and have remained close friends ever since, writing several books together about their mutual love of dogs.

"She was the master of elegant innuendo."

Also taking the stage was Mary Tyler Moore, who gave a gargantuan boost to White's sitcom career by casting her on her classic namesake 1970s comedy series. Recalling Betty's Emmy-winning turn as Sue Ann Nivens, Moore quipped, "She was such a slut!"

White reflected on the very early reception of her Happy Homemaker character and how "the Saturday morning after filming the first show, Mary was there with Grant Tinker [her then-husband]. They had a casserole with a chocolate soufflé full of flowers. Mary said, 'You're going to be back.' It was a very memorable morning."

After Mary got her alone time onstage with Betty, the other surviving castmates joined in the fun. Ed Asner, Cloris Leachman, Valerie Harper, Gavin MacLeod, and Georgia Engel all came out to greet Betty with warm hugs and words of adoring reminiscence. "She taught me things to do with a bald head that shouldn't even be mentioned," recalled MacLeod, who played news writer Murray Slaughter on the series.

Harper, who portrayed Rhoda Morgenstern on *The Mary Tyler Moore Show* before spinning off the character into her own long-running comedy, used her moment at the tribute to weave a verbal homage of uncommon affection and grace for both Betty and her embodiment of Sue Ann.

"When she hit that set, it's as if she'd been there forever," Harper recalled. "She was just so . . . to the manor born. And so dear. She was the master of elegant innuendo.

Always a lady, but naughty. Such a great person to act with. And I love that she's kept on keeping on. Betty's aliveness, her fearlessness, and when darling Allen left, the fact she didn't sink into widowhood but just kept going in Allen's name, in her own. And I love how she's always kept at it with such vigor, and independence, and flair."

Harper added, "John Denver said that Tina Turner showed women how to dance in heels, you know? I said, 'Betty White shows us how to be a star.'" More than a bit of well-deserved praise, this was the truth.

Golden Girls creator Susan Harris took to the stage and praised Betty for bringing "such depth and dimension" to Rose Nylund, "who could have been a cliché" in the hands of a less-skilled performer. And Craig Ferguson, then a late-night host on CBS, made a rare public appearance to commend White for her "genius." Taped tributes also came in from her *GG* co-star and beloved friend Rue McClanahan as well as from Vanessa Williams and Jay Leno.

And so it went on, a memorable, warm, and celebratory night that Betty would forever cherish. ■

ABOVE: Valerie Harper (left) and Betty (in greeting mode) arrive at the TV Academy for the salute *Betty White: Celebrating 60 Years on Television* in August 2008.

Grandma Gets Down

No matter the size of the screen,
Betty is pretty much all you see when she's on it.

Betty White didn't make her mark on humanity via the big screen; she made it on the small one. She's the First Lady of Television, not the Magnificent Matron of the Movies. But on a couple of occasions, she was featured in a cameo that showed the world her charm could slay the masses no matter the size of the display.

She proves this in her thoroughly enchanting turn as Grandma Annie (or "Gammy") in the rom-com feature *The Proposal* (written by Pete Chiarelli and directed by Anne Fletcher) that was released on June 19, 2009. Betty plays a spunky, loopy old lady who fakes a heart attack to stop the bickering between Andrew Paxton (Ryan Reynolds) and his dad and basically captivates everyone—not unlike the real-life woman who portrays her.

But it's a short scene with star Sandra Bullock (in the role of Margaret Tate) that brought Betty a huge new boost of popularity with the younger audience that flocked to the film. Dressed in Native American regalia, Annie is spotted by Margaret in the forest near Andrew's family home performing an odd tribal song-and-dance ritual.

"Call to me Margaret of New York!" she demands. "Come. See how I give thanks to Mother Earth. We must give thanks. And ask that your loins be abundantly fertile. Come. Dance with me in celebration."

Reluctant at first, Margaret really has no choice but to join in. Grandma Annie insists, you see.

"Follow and learn. . . . Feel the rhythm of the drums."

And so, the two women get down and funky together. Margaret starts slowly but finally dives headlong into the spirit of the moment, crooning and jiving to the tune inside her head ("Get Low" by Lil Jon & The East Side Boyz). It's at once amusing and affecting.

And what *was* the deal with that song and dance?

"It had been a long filming day," Betty told the *New York Daily News*. "So, when we wound up doing the scene,

it was 3:30 in the morning and pouring rain. They put a tarp over our heads to keep us as dry as possible, but it was an interesting experience."

As if all of that weren't enough, White had to chant in the Tlingit ("People of the Tides") language. "And if you think it's easy to memorize," she told the *Daily News*, "it's nothing that you can relate to. You almost have to memorize it syllable by syllable."

But when you're Betty White, chanting in Tlingit is all in a day's work. Even at 87. And while you might assume that since she is nearly 90, all this might be a bit too much for her, it's clear that Betty enjoyed herself immensely while shooting *The Proposal*, which became a blockbuster hit—raking in nearly $164 million at the US box office and a worldwide gross of $317 million.

Betty told the *Daily News*, "I've been in this silly business for 61 years, and it may be the most fun I've had on one particular production."

She wasn't the only one who had a great time shooting the movie. The principals didn't want the experience to end at the actual feature and decided to manufacture a faux feud pitting Betty and co-star Ryan Reynolds as mortal enemies in a short video for the comedy website FunnyOrDie.com. And it's appropriately uproarious, demonstrating how great White is at deadpan satire.

The video opens with Reynolds and co-star Sandra Bullock purportedly shooting a behind-the-scenes film promo, only to have Betty interrupt things. Reynolds displays open frustration and contempt for her, pushing Bullock to ask, "What's your problem with her?"

"She hates me, and I don't understand why," Reynolds, who is famed for his fake celebrity feuds, laments through gritted teeth.

Bullock walks up to give Betty a warm and reassuring hug as White calls her "America's Sweetheart" while

flipping Reynolds the bird behind Bullock's back. Reynolds looks on in irritation as Betty goes to sit beside him, asking "Brian" to get her a cup of coffee. Reynolds informs her that his name is "Ryan" and he doesn't get coffee, only to have White continue, "When Betty White says she wants a cup of coffee, you get her a f**king cup of coffee." She then mutters to him that he's an "ab-crunching jackass."

Now it's game on, with Reynolds likening her to a "seething demon." Profanities ensue and are mostly bleeped, but it's more than clear what's being said. A tearful Betty scampers over to Bullock for solace, and Bullock then stomps over to her co-star to read him the riot act. "She's a national treasure. You are not. She's a living legend. You are not."

ABOVE: Betty was joined by Ryan Reynolds and Mary Steenburgen (and Sandra Bullock, not pictured) in the rom-com hit *The Proposal* in June 2009.

It's great fun, all of it punctuated with a concluding ersatz promo that cuts Reynolds's head out of the picture. The tormenting and belittling of the man is complete. Betty told the *Daily News*, "We had a ball. I loved it because poor Ryan gets the short end of the stick through the whole thing."

She also added in an interview with the *San Jose Mercury News* that she initially didn't want to perform the spoof. "They sent me the script, with all of the swearing, and I said, 'I don't want to do that. What does that have to do with our nice little romantic comedy?'" But she ultimately gave in, unable to resist pushing the envelope of what little old ladies can do.

Indeed, the video supplies ample evidence that Betty is fully in on the joke, even if she sometimes grows weary of the whole bawdy Betty schtick. She certainly understands how to make light of her adorable and motherly image and poke savage fun at herself. We love every excruciating hard-core second of it. ∎

All Scrabbled Up

As anyone who knows Betty understands all too well,
the woman is a game player.

It happens that Betty's drive to play games isn't restricted to those on television, where she's served as a celebrity panelist more often than perhaps any other single human ever. It also extends way beyond playing beer pong with Jimmy Fallon, which she did on NBC's *Late Night* on June 11, 2009. The lady can't get enough of games with friends, with acquaintances, with everyone. If she were here right now, she would be likely to say, "Enough about me. Let's play some Pictionary."

Consider that until the COVID-19 pandemic drove everyone into isolation in 2020, Betty had a group she would get together with monthly to play poker. It's a game that lasted more than 40 years, involving dealer's choice. White's favorite poker game is called Screw Thy Neighbor, featuring the passing of discarded cards to adjacent players at the table. They had a brass cup engraved with Pico Poker Club, and it went home with whomever won at the end of the night.

The story goes that if the winner forgot to bring the cup to the next game, he or she would owe $2,000 or death—"whichever is more appropriate."

But as British actress Millicent Martin (whose work has included roles on the soap opera *Days of Our Lives* as well as recurring work on *Frasier* and the Netflix streaming comedy *Grace and Frankie*) can attest, poker isn't Betty's only game.

Until the pandemic struck, Betty would go to the home of Martin and her husband, Marc Alexander, for cutthroat games of Scrabble.

"Every Monday, at our house," Martin says. "We'd supply the caviar or hot dogs. Betty is equally happy with either."

White is evidently also pleased when she wins and not happy at all when she loses. These are not relaxed and friendly little games but intense tile-laying combat, Martin explains.

"We really have to fight her to win at Scrabble," she says. "She is simply ruthless! If Betty gets a score under 300, she's really upset. I hate to say it, but she does win most

of the time. Every now and again, one of us will beat her, almost by accident. And if we do, *that face* . . . my gosh, I can't even describe it. She's not a happy puppy. But all in all, she adores playing games. Games are her life. That, and of course animals."

Asked if she can ever recall a night when Betty put down, say, a 70-point or 80-point word that made the earth begin spinning the opposite way on its axis, Martin admits, "No. But she regularly comes up with word scenarios where she'll use all seven of her letters. She'll think of a word, and then she'll think of another word that's worth 50 points or more, and then she'll find a way to incorporate everything. The woman does crosswords every day. Words bring her joy. It really isn't a fair fight."

They enjoy their gameswomanship so much that Millicent guested on the *Hot in Cleveland* episode "Tazed and Confused" as Elka's bitter rival in a game tournament at Elka's favorite watering hole. Spoiler: the Queen of the Game Shows wins. In real life, though, it's all in good fun for women who have been friends for some 23 years and *best* friends for probably 20 of that. The first time they met, Martin was on a stage at the now-defunct Huntington Hartford Theatre in Hollywood. The year was 1978, and Martin was performing in the production of *Side by Side by Sondheim* featuring the original London cast.

"We'd heard that Betty White and her then-husband, Allen Ludden, were there at the show, and we saw them, fourth row center," Martin recalls. "They came around afterward and introduced themselves. About a week later, they were back again. Then once again, a week after that. Then a fourth time.

"When they greeted us backstage, I said, 'You again? What do you want?' But it was wonderful. They came to see the show six or seven times in all. It became almost their weekly ritual."

But that was that for the better part of a few decades, until Martin came to Los Angeles to appear in *Days of Our Lives* in 1998. She and Betty were reintroduced through game show producers Anne Marie Schmitt and her longtime companion, Bob Stewart.

"We started phoning each other all the time, then daily, then several times daily," Martin emphasizes. "We've been very close now for a long while, and it's such a thrill, because typically your best friends are the people who you've known most of your lifetime. To get a best friend in your 60s is kind of even more special, because you've succeeded in finding each other."

ABOVE: Agnes (Millicent Martin) has to be Elka's (Betty's) maid after Elka bests her in a game reminiscent of *Password* on an episode of *Hot in Cleveland*.

The two have managed to stay close even while their Scrabble game night was on hold for more than a year due to the pandemic. The telephone was their lifeline. "I tell her every day on the phone how much I love her," Martin says. What is it about Betty that Martin loves so much? Basically everything. It's the respect she has for every living thing, the dignity she carries herself with, the fact she treats every person and animal the same.

"It also just amazes me that Betty has such a multi-generational following," Martin says. "It seems every decade, there will be a new show or new commercial or new something that will introduce her to a whole new group of followers who absolutely adore her."

But only the very special get the chance to play Scrabble with her. ▪

The 2010s

The Best Is Yet to Come

"Seventy-one years ago . . . I sang on an experimental thing . . . called television . . . and you still can't get rid of me. I was only 88 last Sunday, so I've got lots more stuff to do."

—Betty White accepting the Screen Actors Guild Lifetime Achievement Award

OPPOSITE: A Golden Girl on her throne, where she belongs.

Near 90? So What!
Betty Is Built for Work

I t was just six days after her 88th birthday that the latest and perhaps greatest act of Betty's wonderful life kicked off in earnest. There is no greater honor for an actor than to be conferred the Life Achievement tribute from the Screen Actors Guild. Past winners include names like Frank Sinatra, Paul Newman, Audrey Hepburn, Elizabeth Taylor, Jack Lemmon, and Julie Andrews. And on January 23, 2010, Betty White joined those esteemed ranks.

Presented the award by Sandra Bullock, she received a roaring 90-second standing ovation that left White in not just a grateful mood, but a forward-thinking one. "I'm only 88, so I've still got lots more stuff to do," she declared. She had no idea how accurate that assessment would prove to be. Or then again, maybe she did.

Betty's Year of Living Rapturously was just leaving the launchpad. The true beginning of the Betty Rebirth can be pegged to the February 2010 premiere of her Snickers Super Bowl commercial in which she's seen getting smashed into a mud puddle while playing tackle football. The hilarious ad proved so popular that it served not only to power Betty's career profile to unprecedented heights but also to spark a grassroots Facebook campaign demanding that she host *Saturday Night Live* that May.

And guess what? She did.

More than half a million supporters later, Betty was commissioned to host a live 90-minute comedy show, a gig that neither its creator-producer Lorne Michaels nor she herself had sought. It didn't matter. White went about turning back the clock to 1953, the last time she had presided over a live telecast.

SNL old-timers were asked back to share the stage with Betty, and she nailed the night, of course. She knows no other way. And when all the smoke had cleared, it was a rousing success, sparking the show's highest ratings in a year and a half and yet another Emmy Award for White.

What could possibly be more exciting than that? Only one thing: having a hot dog named in her honor at the iconic Hollywood stand Pink's. That happened just weeks before the *SNL* gig, and the franks probably gave her the energy and stamina necessary to preside over a live comedy show at nearly 90. The Betty "Naked in the City" Dog (a plain dog and bun with no condiments) arrived on the scene on April 19, hyped in a personal appearance by the lady herself.

How could 2010 possibly get better for Betty from there? No one could imagine. And yet . . . On June 16 of that year, a new original comedy series premiered over cable's TV Land titled *Hot in Cleveland*, starring Valerie Bertinelli, Jane Leeves, Wendie Malick—and Betty White. For Betty, it was supposed to be a one-shot guest appearance in the pilot premiere. But then she had a great time, loved her co-stars, loved her character (the raunchy and feisty Elka Ostrovsky), had plenty of time on her hands, and she figured, she might as well stick around for a while. Indeed, while her 90s beckoned, Betty had no intention of kicking back and calling it a career. Retirement, after all, was never part of the plan.

In fact, while Betty continued to work every week on *Hot in Cleveland*, it somehow occurred to her that she wasn't quite busy enough. So, the ageless wonder took a job hosting the NBC reality

series *Betty White's Off Their Rockers*, because if her name was in the title, she couldn't very well leave it to anyone else to be in charge of the thing.

The hidden-camera show that featured elderly performers pranking younger adults, like *Candid Camera* but with seniors. The show survived for just three seasons, but it served to fill whatever free time Betty might have previously enjoyed while working on a single show. For her, after all, leisure is the enemy.

Not that her life was all work and no play. Betty felt like she was visiting with a couple of longtime friends when she dropped by the White House on June 11, 2012, for some quality time with President Obama and his Portuguese water dog, Bo. She got a kiss on the cheek from the chief executive and several meaningful moments of warm chat. Because she's Betty White, she was perhaps more interested in cuddles and smooches with Bo. They stretched out together on a White House couch and rejoiced in the snuggle time.

She was the First Lady of Television, and now she was Television's Grande Dame.

While she worked on *Hot in Cleveland*, the production staff annually wracked its collective brain to best honor Betty on her birthday. But as she prepared to turn 93 in 2015, they were fresh out of ideas. Then her personal assistant Annie Wetherbee had a brainstorm: a flash mob!

And so, on January 16, the day before White's big day, Wetherbee hatched a plan that found both cast and crew members on the production lot dancing, swaying, singing, and sashaying to a Hawaiian beat as the birthday lady bore witness from a golf cart. The ensuing two minutes proved to be glorious, viewed nearly 4.5 million times on *YouTube*. And Betty? Speechless and moved nearly to tears.

You see, once you hit a certain age in a brilliant career, it grows difficult to stop people from honoring you. They just can't help themselves, even when they've already presented you with every award there is to give. For example, there Betty was standing onstage at the 70th Primetime Emmy Awards on September 17, 2018. But she wasn't summoned to accept another lifetime recognition award. There was in fact no special Emmy forthcoming. The idea was simply to tell Betty how much they adored her at 96 years old and appreciated the role she played in creating the medium that brought such success to all in the room.

Everything had, in other words, come full circle for White. She was the First Lady of Television, and now she was Television's Grande Dame. As such, she deserved the extended standing ovation she received that night and throughout this book. Try to imagine a TV world that had never been graced by Betty White. It's actually impossible. She believes with all her heart that the business has blessed her, and it's true. But in the main, she has it backward. She has made all our lives better by sharing herself in our living rooms for more than 70 years.

Annoyingly Good

If you're an actor in the United States, there really is no bigger deal than to be presented the Life Achievement Award from the Screen Actors Guild.

Betty White received a Life Achievement honor from the Screen Actors Guild during the 16th Annual SAG Awards on January 23, 2010, when she was bestowed it by presenter Sandra Bullock (with whom she had appeared just the year before in *The Proposal*).

Bullock's introduction noted that her inspiring friend Betty was "talented, funny and beautiful. . . . I mean, she's been working as an actor in the industry for more than six decades in a business that doesn't exactly value getting older." She continued, "Me? I find Betty White annoying. I'm sorry, it's true. Betty, you make me feel bad about myself. You make me feel like a slacker." And as Bullock goes on to list all of Betty's achievements, we see what she means. The woman won an Emmy in 1952 for a local Los Angeles–area variety show (*Hollywood on Television*) over no less than Zsa Zsa Gabor and has continued to overachieve ever since.

Bullock, in mock exasperation, detailed how Betty was the star of not one, not two, not three, but *four* TV shows named after her. And that's not nearly all. She also created legendary characters on shows that didn't have "Betty White" in the title: Sue Ann Nivens on *The Mary Tyler Moore Show*. Rose Nylund on *The Golden Girls*. Both were Emmy-winning roles. But did she stop there? No, she went on for decades more, guest starring on television shows and in movies, earning Emmys again and again.

"And let's not forget," Bullock went on, "her nearly life-long fight to improve animal health and welfare. Well, it all adds up to one seriously annoying, some would say extraordinary, person. Her optimism and caring and kindness are legendary in our business, and to those who doubt that God has a sense of humor, there is irrefutable evidence to the contrary. He gave us an actor named Betty White."

Following a package of clips, Bullock finished with "Betty—my dear Betty White—for a career that continues to touch millions of fans and your generous ongoing humanitarian work, the Screen Actors Guild proudly presents you with this year's Life Achievement Award. Come on up!"

A boisterous 90-second standing ovation followed as White floated to the stage, opening her acceptance with "Thank you from the bottom of my heart and from the bottom of my bottom. Thank you for whatever! Oh, my dears!" And showing she could dish it out as well as take it and putting on her best roaster's voice, Betty gestured toward Bullock and said, "And this lovely lady. Isn't it heartening to see how far a girl as plain as she is can go?"

With the biggest laugh of the night in her pocket, Betty continued, "Seventy-one years ago when I sang on an experimental thing, and it was called television, who would have dreamed it would culminate in an evening like this? I should be presenting an award to *you* for the privilege of working in this wonderful business all this time. And you still can't get rid of me. I was only 88 last Sunday, so I've got lots more stuff to do." (How right she was.)

Betty went on to talk about the friends she made in the "small town" of Hollywood, and how lucky she feels to have two great passions in life: show business and animals, of course.

"Actually, I may have more than two passions," she quipped, "but it's none of your business." She finished by saying, "Back when I first started, it would never even have occurred to me to imagine such a thing as this moment. And I still can't believe I'm standing here. This is the highest point of my entire professional life." ∎

OPPOSITE: Oscar-winning actress Sandra Bullock embraces Betty while presenting her with the Screen Actors Guild's prestigious Life Achievement Award in January 2010.

Snickers All You Want

When 106.5 million people see you in an ad that would become instantly legendary, it tends to supply a rather valuable brand boost.

It wouldn't be stretching things to extrapolate that the 30-second Snickers candy bar commercial that Betty starred in for Super Bowl XLIV on February 8, 2010, set the stage for the spectacular career revival that followed over the ensuing decade. Suddenly, it was like "Did you see how funny Betty White could be, ladies and gentlemen?"

The answer was naturally, "Yes, in fact we've been noticing that for the better part of the past 60 years." But no matter.

There Betty is at 88, on the field with a group of dudes playing tackle football in the mud, dressed up in her powder blue old lady outfit as the hungry alter ego of a guy named Mike. As she goes out for a pass, one of the guys crunches her into a mud puddle just as the ball arrives. She rises and heads back to the huddle, covered in grime, including all over her face.

One teammate asks Betty-Mike what's going on with him, and another tells him he's been playing like Betty White out there.

"That's not what your girlfriend says!" she retorts.

Then Betty-Mike is handed a Snickers bar by his girlfriend and suddenly turns instantly back into himself. It's the chocolate, caramel, and peanuts that do the trick, doncha

Did you see how funny Betty White could be, ladies and gentlemen?

know. He goes out for a pass, but now the quarterback—still not Snicker-ed up—turns into actor Abe Vigoda, a year older than Betty at 89. He's sacked and observes deadpan as he lies on the ground, "That hurt."

The spot was the first in the company's mega-successful campaign "You're Not You When You're Hungry" that featured a number of famous faces. In 2020, *Business Insider* called the Betty ad one of the 15 most iconic Super Bowl commercials of all time.

But the Super Bowl was only the beginning of the Snickers ad's magical journey in raising White's profile. Suddenly, Betty and the commercial were everywhere, from *The Oprah Winfrey Show* to *The Tonight Show with Jay Leno*, *Larry King Live*, and *The Ellen DeGeneres Show*. As she told Ellen, "The strange part is, it's now showing all over the world. We're in Africa, we're in Central Europe, and a lot of the countries we're in don't have football!"

Yes, Betty White was suddenly more than just a showbiz survivor. She was now officially (and forevermore) cool. And all from getting manhandled (womanhandled?) on a football field in the interest of hawking a chocolate bar to sports fans. ▪

OPPOSITE: Betty gets her sports fan on as *Hot In Cleveland's* Elka in preparation for her Snickers commercial close-up at Super Bowl XLIV.

Getting Naked with a Hot Dog

It's no secret that Betty has a long-standing love of hot dogs, and now the weenie world is loving her back.

Not just anyone can get a hot dog named after them at Pink's, the iconic Hollywood hot dog stand that has been a staple of the famous and the ordinary since 1939 (when it began life as the pushcart of married couple Betty and Paul Pink). The stand would grow to become a landmark in the area, and this author used to live literally around the corner from the place in the 1960s when a chili dog cost just a quarter.

Times have surely changed. That same chili dog now sets you back $4.95, and Pink's has branched out to other locations, including Las Vegas. It's also named some of its menu items after celebs who love their hot dogs, including one Ms. Betty White.

On April 19, 2010, Betty—for being such a famous purveyor of haute (dog) cuisine—was honored with her own dog and made a personal appearance when a new Pink's stand was unveiled on the Universal CityWalk a few miles from the original location.

The grand opening event found White cutting the ribbon on the new location. A percentage of sales on that first day went to benefit L.A. Animal Services' East and West Valley Animal Shelters.

> "They said 'Well, it's a naked hot dog.' And I wish they had never thought of that."

And what goes on Betty's signature dog at Pink's? Nothing. That's right, she likes her dogs plain. No ketchup. No mustard. No onions. No relish. No toppings at all. Totally naked, the way the all-beef gods intended. Hence was born the Betty "Naked in the City" Dog.

Betty told the Associated Press, "I have loved Pink's hot dogs forever and ever. So, when they said they were going to name one after me, I asked, 'How can you? I don't put anything on it. The weenie is so good I just have the weenie and the bun.' They said, 'Well, it's a naked hot dog.' And I wish they had never thought of that."

White later went on the TV news to observe that it makes sense, as an animal lover, that her favorite food would be a hot dog and her favorite cocktail a Greyhound (vodka and grapefruit juice). And indeed, it's no stretch to observe that hot dogs are her preferred entrée whenever she has a choice. That, and vodka. Betty has admitted as much.

"Vodka and hot dogs, probably in that order," she told *Parade* magazine in 2018.

She also loves French fries with lots of ketchup, with Red Vines licorice for dessert.

Are you catching on yet that hot dogs may just have some sort of longevity characteristic inside them, a fountain of youth ingredient? Indeed, if the rest of her career ever crashes, White could easily land a job hawking franks for Oscar Mayer. And one gets the feeling she would be mighty proud to do it. ∎

OPPOSITE: Hot dog addict Betty enjoys her condiment-free namesake "Betty Naked in the City Dog" at Pink's Hot Dogs at Universal CityWalk.

Live from New York, It's Betty White!

The people demanded Betty White and she was more than happy to oblige in an unforgettable episode of *SNL*.

The Snickers commercial at the Super Bowl touched a nerve. Betty White was unexpectedly, almost inexplicably, everywhere you looked. It was as if a light went on and people realized, "Oh my God! This living legend is still with us. We'd best appreciate her while we can."

As soon as the Super Bowl was in the rearview mirror, a grassroots Facebook campaign was launched, titled "Betty White to Host SNL (Please)." More than 500,000 people signed on in support. *Saturday Night Live* creator-producer Lorne Michaels seemingly had no choice. He had to book Betty as a host—stat! This was only mildly complicated by the fact that the woman was 88, making her by far the show's oldest host in its history.

Didn't matter. The people had spoken, and they demanded Betty. So, now White had to get it together to do something she hadn't done in nearly 60 years—host a live television broadcast. She'd been offered the *SNL* host job once before and turned it down, concerned, as she told Katie Couric in 2011, that it was such a New York–centric show, and she was such a California girl, that she'd "stick out like an outhouse in a rainstorm."

Not a chance. Of course, Betty would nail it, as she does everything. But it helped that many of the show's veteran heavyweight performers returned to cameo in honor of Betty. The returning stars included Tina Fey, Amy Poehler,

Rachel Dratch, Maya Rudolph, and Molly Shannon. "Bless their hearts for doing that," Betty recalled in the PBS special *Betty White: First Lady of Television*. "They brought all those wonderful people back, surrounding me with all those pros."

This isn't to say White wasn't nervous. She later admitted to being scared to death, so out of her comfort zone was she. By this point in her life, her eyesight was so poor that she couldn't really read the cue cards, so it was fortunate that she could still memorize everything and therefore didn't need to see the cards. Having a mind like a steel trap helps.

All the stage fright melted away as soon as Betty was out there in front of the wildly cheering live audience on May 8, 2010, inside NBC's Studio 8H in New York.

"Many of you know that I'm 88 and a half years old, so it's . . . well, it's great to be here for a number of reasons," she began. She thanked the Facebook folks for being there, "and when I first heard about the campaign to get me to host *Saturday Night Live*, I didn't know what Facebook was. And now that I *do* know what it is, I have to say, it sounds like a huge waste of time."

Onward the monologue went for five minutes, during which Betty killed. Then came the rest of the show, the most memorable portion being a "Scared Straight" sketch in which White was tricked out in a giant frizzy white wig

> "Many of you know that I'm 88 and a half years old, so it's . . . well, it's great to be here for a number of reasons."

as Grandma Loretta, scaring inmates with tales of . . . *Willy Wonka & the Chocolate Factory* and *The Wizard of Oz*.

It all worked out perfectly despite Betty's considerable trepidation going in. She reportedly told her agent "Never again" once it was all done. She loved the experience, but it understandably took a lot out of someone entering her tenth decade of life. Especially since she went to not only the after-party but the *after* after-party, according to Allison Hagendorf, the head of rock music for Spotify, who had attended a number of these after-show extravaganzas herself.

"Keep in mind that the woman had just completed a week of grueling rehearsal days in preparation for hosting this live show—and she was still partying [at 3 a.m.]!" Hagendorf marveled. "There was Betty along with her cocktail, in all of her magnificent glory. I couldn't believe it."

Her late-night adventure certainly paid off. The episode of *SNL* fronted by Betty generated the show's highest ratings in 18 months and was nominated for seven Emmy Awards—and Betty won as Outstanding Guest Actress in a Comedy. ∎

ABOVE: Betty killing it during her opening monologue as host of NBC's *Saturday Night Live* on May 8, 2010.

It's White-Hot in Cleveland

Just as with Sue Ann in *Mary Tyler Moore*, Betty was only supposed to appear once as Elka in *Hot in Cleveland*. Six seasons later . . .

On June 16, 2010, the premiere of the comedy *Hot in Cleveland* hit the air on cable's TV Land. Filmed in front of a live audience, just the way Betty likes it, it was the network's first-ever original series. It would survive and thrive through five years and six seasons.

And while Betty White hadn't originally been scheduled to do more than appear in that original pilot, you know how it is with her. Everyone loves her. She can't get enough of the work. It's a blast. Suddenly, years have passed, and she's still there.

What was to be White's third long-running sitcom—premiering 18 years after the conclusion of *The Golden Girls*—starred Valerie Bertinelli (*One Day at a Time*), Jane Leeves (*Frasier*), and Wendie Malick (*Just Shoot Me!*) along with Betty as Melanie, Joy, Victoria, and Elka, respectively.

In the context of *Hot in Cleveland*, Melanie, Joy, and Victoria are entertainment industry icons (a writer, a beautician, and an actress, respectively) who are struggling with being middle-aged in youth-obsessed Hollywood. Their plane bound for Paris makes an emergency landing in Cleveland, and there they all stay, since the standards are purportedly lower. (The title *Hot in Cleveland* refers to the fact that the women are considered "hot" in Cleveland, but not so much in L.A.)

Elka Ostrovsky is the raunchy, sardonic, sexually astute, elderly Polish caretaker of the house that the ladies rent. She lives in the back guest cottage and remains one wild senior, having escaped the Nazis during WWII and standing tall as the ultimate survivor. She still likes her booze and her weed, as the scent often found wafting off her confirms.

It's a great, lusty character for White to inhabit, and she's given plenty to do from day one of the series. It was also a role she never really intended to take beyond that first pilot. As Bertinelli recalled in the PBS/Netflix documentary *Betty White: First Lady of Television*, "Luckily, after the pilot was done, Betty seemed to have had such an amazing time that she said, 'Oh yeah sure, I'll be in it.'"

It's a good thing, because by the third episode titled "Birthdates"—written by Vanessa McCarthy, directed by Andy Cadiff, and premiering on June 30, 2010—Betty was already a staple of the show, and her somehow not being a part of it was unthinkable.

Consider that in this installment, the late great Carl Reiner appears for the first time in what would become a recurring role. Reiner plays Max, Elka's blind date for the

A Conversation with Todd Milliner

The executive producer for *Hot in Cleveland* talks about being charmed by Betty.

Q: *So, as I understand it, Betty White didn't want to do any more series TV. Then she agreed to do the pilot and had a lot of fun. That turned into a few episodes, which turned into the whole first season, which turned into the entire series run.*

TODD MILLINER: You are well researched.

Q: *And pretty soon, it was impossible to imagine the show without her.*

MILLINER: Let me just say that I've worked on a lot of good shows and a lot of bad ones, and when it's working, it's just magic from the first moment. That was the case on *Hot in Cleveland*, and it was that vibe Betty was responding to.

Q: *At what point in the process do you know that it's working?*

MILLINER: You can hear it at the table read for the pilot [episode]. But it really isn't until you take in the actual reaction from the audience that you really fully know. We could tell we had something special in front of that audience, and we sat back and enjoyed it.

Q: *What did Betty bring to the set that contributed to the vibe?*

MILLINER: The first thing she gave us was that in all of the 128 episodes we did, nobody was ever mean or difficult to deal with. Our showrunner, Suzanne Martin, set a tone of collegiality from the start. But also, if Betty White is going to be as wonderful as she is, then everybody else had better get on board, too. If she's this gracious, we should all take a step back and think about how lucky we are to work in this business and work with her. That lasted our entire six-season run.

Q: *How did Betty's charm manifest itself during filming of the actual episodes?*

MILLINER: First off, she had such a rapport with our live audience. If she ever slipped up, she was the first one to be self-deprecating. She would jokingly lash out at the audience and involve everyone. People just enjoyed her so much. Her interaction with the audience on Friday nights was something I'll remember for the rest of my life.

Q: *What exactly would she say to the audience?*

MILLINER: Well, when she muffed a line and everyone would chuckle, she'd say, "It's not nice to make fun of old people." She had a million one-liners that she'd pull out, all of them on the spot. She'd playfully act angry. She really appreciated the live reactions, and she let everyone know she appreciated it. It isn't typically something actors do.

Q: *You can never tell for sure, but from their interaction on your show, it seemed Wendie Malick, Valerie Bertinelli, Jane Leeves, and Betty all genuinely liked each other.*

MILLINER: It was authentic, and yes, they did. That helps an awful lot when you're working together so closely and for a period of years. They're all truly nice people, and all of them previously had at least one hit show, so they'd been down this road before. But particularly in Betty's case, if you're super nice and super talented, it generally means a long and successful career. That's her in a nutshell.

evening. They hit it off so well that halfway through dinner, Max is proposing marriage and Elka is accepting. They yammer on about Glenn Miller versus Tommy Dorsey, about their favorite medications, about everything. They share a verbal marriage commitment and her "Yes" to his casual proposal is followed by her equally casual "Pass the salt."

Bertinelli sort of couldn't believe Betty was even along for this ride, as she admitted in the PBS special. "Working with Betty White is really like having a master class in comedic timing," she said. "The first time I was truly speechless was when Carl Reiner came on the show. During that first date as Max and Elka, they just riffed off each other like no one else was in the room—and they were brilliant."

Hot in Cleveland would be favorably compared to *The Golden Girls* by critics during its run. One writer saw Malick as the new Dorothy, Bertinelli as Rose, Leeves as Blanche, and Betty as the second coming of Sophia. All of this served to shine a spotlight on the fact that Betty was back in her element, riding the crest of an improbable but much deserved third act. ∎

OPPOSITE: *Hot in Cleveland* stars (from left) Valerie Bertinelli, Wendie Malick, Betty, and Jane Leeves drink a toast to their long-running TV Land comedy series.

A Legendary Love Triangle

Fighting for Betty's affections seems like a perfectly natural thing to do, even among the fellow elderly.

In the seventh episode of *Hot in Cleveland*—titled "It's Not That Complicated," written by Chuck Ranberg and Anne Flett-Giordano and directed by David Trainer—Elka's (White) love life becomes improbably active with not one but *two* suitors fighting over her: boyfriend Max (Carl Reiner) and new paramour Nick (Tim Conway).

It's awfully cute having a pair of television legends seeking Elka's affections. When their battle devolves into an actual fistfight, it looks more like patty-cake.

As the episode was having its premiere over TV Land on July 28, 2010, White and Reiner were both 88, Conway the kid at 76. That's 252 years of comedy greatness filling a single screen. They had won 23 Emmys between them (Reiner 11, Conway 6, Betty 6). And how did a fledgling little cable comedy in its first season land such entertainment royalty? One word: Betty. She was beloved, so much so that no one would think to turn down the request if she were involved.

"We had a few just amazing moments on that set," recalled Valerie Bertinelli in the documentary *Betty White: First Lady of Television*, "moments where everything stopped and we all just wanted to watch Betty work with Tim Conway."

In this half hour, Betty's alter ego Elka is a hoot, never more so than when she's not-so-silently judging her new housemates. For instance, when Melanie (Bertinelli) displays more cleavage than Elka is comfortable with, she observes, "Nice girls keep their cookies in a jar." She also maintains this is the first time she's landed herself in a love triangle, noting, "You girls are slutty. What would *you* do?"

It turns out that Elka's version of cheating on Max is to do a waltz and then a polka with Nick, the polka being the "Polish forbidden dance of love."

ABOVE: A pair of legendary friends got an opportunity to nuzzle together on *Hot in Cleveland* when the great Carl Reiner guest starred.

A Conversation with Wendie Malick

Wendie, who played Victoria Chase on *Hot in Cleveland*, talks about being on set—and off—with Betty.

Q: *What was it like suffering through six seasons with Betty White?*

WENDIE MALICK: Oh yeah, it was just torture. She was not only delightful to be around but an inspiration. And I always tell people that I felt so damn lucky to have joined *Hot in Cleveland* when I did because Jane [Leeves] and Valerie [Bertinelli] were about to turn 50, I was about to turn 60, and Betty was on the cusp of 90 when we got together to do the show. Knowing what Betty had done in her career and watching her have this major renaissance was truly extraordinary.

Q: *Not that she'd ever stopped working.*

MALICK: No. But she was introduced to an entire new generation of people, and boy, did she wear it well. I felt like Betty was this pioneer who showed me that not only was there life after 60, but that your third act could be the sweetest one yet. Instead of thinking, "Oh my God, maybe it's over, maybe I've stayed too long at the fair," it was quite the contrary. She just really opened up this whole idea of the last act being a big chunk of time if you're lucky and healthy.

Q: *And amazingly, you can stay healthy throughout your 90s while* subsisting on hot dogs and fries and licorice.

MALICK (laughs): Yeah, I can't believe the stuff that woman puts in her mouth. The one thing we share is a great love of cocktails, but I prefer gin and she's a vodka girl.

Q: *Is there any quintessential Betty moment you can recall from the set?*

MALICK: Well, two of them actually. Both set the tone for our time on the show. The first, which would be repeated regularly, was that whenever anyone came on to show Betty baby pictures, she'd run over and be disappointed if it was a real [human] baby rather than a puppy or kitten or foal. Also, early on, if someone came up to her and said, "You know what I hate?" she'd reply, "No, and I don't really care to." And I just thought, what a great way to avoid having people's negative energy come in and slime your day. She instead managed to find light in everyone and everything around her.

Q: *When did you initially see that positivity from Betty?*

MALICK: Oh God, at the first table read. You never really know if a cast is going to click until they're finally in the room together. Once we were, Betty said, "You know what? I can always tell if something feels like it's got legs. And this does."

Q: *Was there any feeling amongst you and Valerie and Jane of needing to protect Betty?*

MALICK: Well, I think we all looked out for each other, as good friends do, but Betty's a pretty independent woman. It was never a matter of having to prop up this older lady. The sweetest part of rehearsal days for us was just sitting around that living room set with coffee, checking in. It's funny, when you're around people and get to know them well, age sort of disappears. She was just one of us.

Q: *Any other Betty memories that come to mind?*

MALICK: One of my favorite days with her was the time she came out to my ranch and we had lunch. I think it was tuna sandwiches, French fries, and red licorice. We just spent the afternoon in rocking chairs on the veranda with my two dogs, four horses, and miniature donkey, and nothing makes Betty happier than hanging out with critters. For my money, any day that you can spend with Betty White is a special one.

The following week, Betty would experience what may be the single greatest piece of blooper-reel material in television annals, when she struggled to stress that she waited to sign up for a dating website until her alcoholic bender was over. "In fact, that was my screen name: Bender Over," Elka informs her incredulous friends. But the actress got such giggles while trying to say it that it stands tall as a gaffe par excellence.

The repeated screwups infected everyone with uncontrollable laughter, demonstrating how much fun everyone was having on a sitcom that grew quickly into appointment viewing. And Blooper Betty was a key reason why. ▪

Ranger Betty

To her, one of the most meaningful honors she could receive came not from her showbiz peers.

It's no secret that Betty has been in love with the great outdoors since she and her parents went on weeks-long camping and backpacking trips to the High Sierra of California when she was a little girl. She's a big-time nature gal, so much so that her first career dream was to become a forest ranger—that is, until finding out that women weren't allowed to work that particular position back then, in the 1930s and '40s.

But better late than never.

On November 9, 2010, the US Forest Service helped Betty to fulfill a lifelong dream by proclaiming her an honorary US forest ranger.

During the ceremony at the Kennedy Center for the Performing Arts in Washington, DC, the United States Forest Service chief Tom Tidwell told Betty that despite the gender challenges posed by the USFS in the era before gender equality, she had managed to make a difference in conservation and animal welfare by using her celebrity for the betterment of the land. "I am sorry you couldn't join us before," Tidwell told White while honoring her. "Judging from your illustrious career, you would have made marvelous contributions to our agency and to the cause of conservation across the United States. Betty, you are a role model for little girls—for all of us—to never give up on our dreams."

> "Betty, you are a role model for little girls—for all of us—to never give up on our dreams."

Make no mistake, this was a big, huge deal for Betty, even all these years later. She received a beautiful plaque, hugged Smokey Bear himself, and was given a forest ranger hat (just like the one her father, Horace White, used to wear) and badge that she donned proudly. She took the opportunity to emphasize the necessity of protecting our environment in the age of climate change.

"Wilderness is getting harder and harder to find these days on our beautiful planet, and we're abusing our planet almost to the point of no return," White said during the ceremony. "In my heart, I've been a forest ranger all my life, but now I'm official."

She added that one of her most cherished memories was riding a horse with her father through the High Sierra. "I cannot thank you enough," Betty said. "As excited as I am today, and as grateful as I am, I know two people who would be over the moon—my mom and dad."

The ranger hat, in fact, is what seemed to mean the most to White. "It always meant vacation to us in the summers," she said, "when I'd see that hat."

The US Forest Service sustains the health, diversity, and productivity of the nation's forests and grasslands, including some of the only remaining habitat for elk, grizzly bear, lynx, and many reptiles and amphibians. Or as Betty calls them all, her close personal friends. ■

OPPOSITE: It was a dream come true for Betty when she was named an honorary ranger by the US Forest Service.

Raise a Glass

Even a famous teetotaler like Letterman can't help but toast Betty on her birthday.

The rush of thrills that defined Betty White's 88th year proved rather overwhelming. It started off with a Screen Actors Guild Life Achievement Award and somehow got better from there with her much-heralded Snickers Super Bowl ad, a hot dog named after her, the *Saturday Night Live* hosting gig, a starring role in the new comedy series *Hot in Cleveland*, and being named an honorary forest ranger.

Talk about a heady 12 months. It would be more than a career's worth for anyone else. For Betty, it was just 2010. Nonetheless, the woman had earned a little relaxation. She found it in an odd place: the guest chair of CBS's *Late Show with David Letterman* on January 19, 2011.

Having just turned 89 two days before, White was ready to party. As her interview went on, the host appeared to grow a little short on words, asking Betty if she would be hosting *SNL* again. He already knew that was a big fat "No." And if he wasn't sure, she clarified, "I think you do a thing once and then you run like a thief."

Letterman then tried to get a bit more personal, wondering aloud what Betty liked to do in her free time. The answer came back that her interests included "most anything," but primarily playing with animals.

"And uh, vodka's kind of a hobby," she admitted to hearty audience laughter and applause.

> ## Having just turned 89 two days before, White was ready to party.

This was Letterman's cue to pull two glasses already filled with ice out from under his desk along with a bottle of Grey Goose Vodka, in honor of the birthday girl. He poured her a glassful but didn't bother with his own, chugging it straight from the bottle. After a few more seconds, Betty performed a perfectly timed spit take, the purported "vodka" winding up all over the surrounding stage.

The joke was that Letterman himself had stopped drinking booze entirely some 30 years before, having been an admitted alcoholic for many years. So, his taking the time even to down water in the guise of vodka demonstrated his love and affection for Betty.

Dave would honor White again the following year around her birthday when he invited her on to read "Betty White's Top 10 Tips for Living a Long and Happy Life." Number Four was the most fun: "Take some wheatgrass, soy paste, and carob, toss in the garbage, and cook yourself a big-ass piece of pork."

White has always had a great time with Letterman, Johnny Carson, Jay Leno, Jimmy Fallon, Craig Ferguson, Jimmy Kimmel, and all of the late-night hosts because she delivers the goods. She gives them and the audience what they want—self-deprecating, slightly naughty, perfectly timed repartee. But of all her brilliant appearances, it doesn't get much better than spitting vodka across the stage in front of an adoring nation. ▪

OPPOSITE: Betty pays a day-after-her-birthday visit to *Late Show with David Letterman.*

Elka Behind Bars

For Betty, it's clear that orange is the new White.

The first thing viewers see in the January 19, 2011, *Hot in Cleveland* season two premiere, titled "Free Elka," is Betty White, in the guise of Elka Ostrovsky, kicking back in a jail cell in an orange jumpsuit mournfully blowing into a harmonica.

"Nobody knows the trouble I've seen," she croons. "Nobody knows . . . what the next line is."

Written by series showrunner Suzanne Martin and directed by David Trainer, the half hour is one of the show's classics. White had just turned 89 two days before, yet her comedy chops remained as sharp as ever. We're treated right at the start to the most unlikely on-screen reunion with Mary Tyler Moore. It turns out that her cellmate in the joint (Diane) is in fact Mary, as we see when she lifts her head from her stone pillow.

Why was Elka in jail? For possession of a cellarful of stolen goods collected by her late husband while he worked for the mob. Diane was in the joint for "drunk and disorderly—or as I like to call it, Tuesday."

The art-imitating-life premise is that Elka and Diane are members of the same crime family, and it's now been 33 years since they'd seen each other—pretty much the precise number of years that had passed since the end of *The Mary Tyler Moore Show*.

As Diane is released, she lays eyes on Elka's roommates Melanie (Valerie Bertinelli), Joy (Jane Leeves), and Victoria (Wendie Malick) and quips, "You're right, they *do* look like hookers."

The ladies have arrived to bail Elka out. But first, Victoria has to freak out that her assets had been frozen due to her business manager getting indicted on tax fraud ("I've been Madoff-ed!") and crows to Elka while looking at her phone, "I've got bars—no offense."

But apparently their landlord has quickly taken to prison life despite having been there only three hours. She implores the ladies to get hold of themselves and stop the whining,

telling Victoria, "Oh, you've got to front up and bug down, bitch. [Beat] It's prison slang." She acknowledges that "the joint changes you" and that she already knows "how to kill somebody with a toothbrush."

Finally free, Elka enters a bar and wonders aloud who one has to "shag" to get a drink.

Anyone who worried that poor old Betty White wasn't going to have it in her to play the cheeky dame anymore needn't have been concerned. She had more than enough wisecracks left in the tank to carry her through this series and appeared at the same time to be savoring every moment of it. Can it possibly get better than to be incarcerated with Mary? And what would Mr. Grant have said?

News flash: Even at nearly 90, the woman remained funnier than pretty much everyone else. If you watch the *Hot in Cleveland* reruns, to say that she more than held her own would be like declaring water is wet and the sun is hot. A pair of Screen Actors Guild Award wins for the role underscored the point. ▪

ABOVE: Joy (Jane Leeves) and Elka (Betty) find themselves visiting bars (and not the good kind) on the season two premiere of *Hot in Cleveland* in January 2011.

A Conversation with Annie Wetherbee

Betty's stand-in and personal assistant on *Hot in Cleveland*
talks about being close to the living legend.

Q: *Tell us, Annie: What does a stand-in for Betty White do?*

ANNIE WETHERBEE: Well, I wasn't a body double or anything. I'm quite a few inches taller and several decades younger than Betty. I began as essentially an actress who would rehearse as Betty on Tuesdays, the day after the table read, when Betty wasn't there. And I'd handle the run-through in place of her because they needed someone who could get the jokes out to see if they worked or not.

Q: *What would you do when Betty was actually there?*

WETHERBEE: I didn't presume to tell her what to do or where the blocking was or anything, at least not at the beginning. I'd just kind of be there to assist Betty in any way she might need it. Then on Friday nights when we filmed, I was just told, "Sit near her. Be around her." After a short amount of time, we started hitting it off, and I'd run script lines with her. When they say she's the hardest-working person in the business, it's because it's true.

Q: *So, she didn't just put it on cruise control?*

WETHERBEE: Oh no way. She would work those lines and work them and work them some more.

Q: *You would just basically hang out and drill lines?*

WETHERBEE: Some of the time. But that grew into my being a full-on assistant at work, in her dressing room, on the set, wherever she was. And I also saw it as my job to kind of run interference for her on film nights, to make sure people weren't finding her to take pictures and break her concentration. A lot of times, I had to be a bodyguard. I'd have to say, "Listen, after this scene come and meet us at the couch and we'll get you a picture and an autograph. But not right now." The thing is, Betty loves meeting people and cared about her fans so much she could never say no. That's why she needed me to be the hard-ass.

Q: *Was Betty ever difficult to deal with when she was in work mode?*

WETHERBEE: Are you kidding? It was such a joy, every moment. It was just a treat. Really the absolute highlight of my life. I lived every day to go to work because I worshipped that woman. It was absolute heaven. During the entire five years she was on the show, I never left her side, never took my eyes off her. And I loved it.

Q: *What was it like hanging out with Betty in her dressing room?*

WETHERBEE: Every day was kind of an adventure. People would bring by dogs and tiger cubs to share. We'd eat junk food together or she'd have a tuna sandwich, and we'd watch animal videos. There was always a big tub of Red Vines in the room. We did a lot of laughing.

Q: *Was keeping tabs on Betty ever difficult?*

WETHERBEE: I wouldn't say difficult. But I'd sometimes guide her around the set. There were a few times when she might have fallen and I caught her.

Q: *So, Annie, you're saying you were personally responsible for this woman surviving* Hot in Cleveland.

WETHERBEE: I guess so, yeah.

Q: *Any other specific memories that really stand out?*

WETHERBEE: Actually, every Friday on show night, the emcee would perform a game with the audience where he'd play TV theme songs and everyone would try to guess them. Betty and I would be running lines backstage when they'd play the *Golden Girls* theme, and Betty came out to a standing ovation as the audience sang it. She would hold out her arms and cry. Oh my God, it was so sweet.

Lost and Found

Starring in a dramatic film at long last ticked off one of
the few boxes left on the list of things Betty *hadn't* done.

No one will ever mistake Betty White for a drama queen, in every sense of the term. By any measurable standard, she's an angel on any production set she steps onto. No crises. And if you look at the breadth of her extraordinary career in television, it's pretty much a nonstop collection of comedic roles, game show appearances, everything but a true full-on dramatic star turn.

But there is one notable exception to the dearth of high-profile drama on White's résumé. It happened on January 30, 2011, when Betty co-starred with Jennifer Love Hewitt in the Hallmark Hall of Fame production *The Lost Valentine* on CBS. And her performance blew everyone away.

In the made-for-TV movie based on the best-selling novel *The Last Valentine* by James Michael Pratt, a TV journalist named Susan Allison (Hewitt) puts together a story about a woman, Caroline Thomas (White), whose lieutenant husband disappeared 60 years before during World War II and was declared MIA.

A series of events leads to the information that Caroline's husband was last seen alive fighting in the Philippines. She finally receives his dog tags, watch, and wallet, which contains her valentine to him, now badly faded, that he carried close to his heart until he was killed in action. On Valentine's Day, his coffin finally is returned to Caroline by the US Navy with full military honors.

"It was a very sweet, sort of soft moment, and Betty was just brilliant."

The climax in the film is astoundingly raw and powerful. "My husband's coming home today," Caroline declares. Indeed, he is. And when his flag-draped casket finally arrives, his teary widow steels herself to greet it and him as taps is played.

White performs the scene with compelling emotional resonance. She bends down to gently touch and then kiss the coffin as the tears flow. To witness the moment, you would never know this actress is best known for making people laugh. She is fully there in a performance that would earn her a Screen Actors Guild Award nomination.

In an interview for the documentary *Betty White: First Lady of Television*, Hewitt referred to the film as "a generational love letter" and said that White "really had a connection to the piece.

"I think that Betty wanted to not only give to the audience watching the film, but I think also wanted to prove that, you know, she wasn't funny all the time. I also think she kind of went in her heart and her mind to [her late husband] Allen [Ludden], and it was very touching. At the end, it was a very sweet, sort of soft moment, and Betty was just brilliant."

Yes, Allen is never far from Betty's heart, not even some 30 years after his death. It wasn't difficult for her to summon those feelings and bring them out in a character. To be sure, White will always have a lost valentine of her own, and watching her during the pivotal culmination on-screen demonstrated just how visceral those feelings remain. It's an impressive piece of work that leaves viewers moved to tears themselves. And I mean, seriously, is there nothing this lady can't do? ∎

OPPOSITE: Jennifer Love Hewitt plays a TV journalist who does a story on a World War II widow (Betty) in the made-for-TV movie *The Lost Valentine*.

What Happened Last Night?

When Betty's Elka is getting married, legendary stars come out to shine on the event.

It's already crystal clear that Betty is much, much more than a sight gag on her new sitcom. Yet it's nonetheless a wonderful thing that she landed on a series (*Hot in Cleveland*) and a network (TV Land) that were able to attract some of the biggest names from comedy's past to lend her, and it, an assist (or several).

The second-season episode "Elka's Wedding" (written by Eric Zicklin and directed by David Trainer) that premiered on August 31, 2011, underscores this point rather nicely.

Ostensibly, it's the story of a bachelorette party gone off the rails due to the abundant flow of alcohol and the ingestion of what is thought to be aspirin but instead turns out to be consciousness-expanding worm medication. Melanie (Valerie Bertinelli), Joy (Jane Leeves), and Victoria (Wendie Malick) awaken the next morning unsure of exactly what they did, but with plenty of reminders that spur memories in a series of flashbacks.

But in terms of what the episode means for White—as Elka—well, it's an example of how anyone and everyone wants to work with Betty. Take the scene at the end in which Elka is just starting to walk down the aisle at her wedding to Fred, played by the late Buck Henry. Having a recurring performance by a legend like Henry is pretty

"She's not gonna marry any of you losers!"

great. The man co-created *Get Smart* with Mel Brooks and wrote the screenplay for *The Graduate*, for crying out loud.

However, in the climactic scene from this episode, we have Carl Reiner (as ex-boyfriend Max), Dick Van Patten of *Eight Is Enough* fame (as Lester), and longtime character actor Jack Axelrod (as Ernie) all standing up to oppose Elka's marriage to Fred.

The kicker is then having no less than insult king Don Rickles playing Elka's long-deceased mobster husband, Bobby. "She's not gonna marry any of you losers!" he declares. "She's already married to me. How about *that*?"

Holy moly. Are you kidding? This little sitcom draws legends by the gallon—and they're all entirely for Betty. Why? Because the lady delivers the goods—such as when she leads a hot young male stripper into the house and proclaims, "We're gonna go grate some cheese on his abs."

Just by accident, Betty has landed on a third long-running classic comedy. Or maybe she's made it classic by dint of her presence on it. All that's clear is, her character is a singular hoot, while her show is a magnet for old-time superstars who are perfectly happy to show up, deliver a line or two, and take a bow in Betty's glorious shadow. ∎

OPPOSITE: Elka (Betty) walks down the aisle and into an uncertain future in the star-studded "Elka's Wedding" episode of *Hot in Cleveland*.

Betty Is Still Hot (Duh)

And the music video she did with British electro-pop singer Luciana proves it.

We've said it before, but it bears repeating: Betty is perhaps the most adventurous soul showbiz has ever known. If it's different, if it's fun, if it's lively, if it's hilarious, if it's outrageous, if it'll somehow benefit animals, she's all over it.

This helps to explain why, in September 2011 at age 89, she would agree to partner up with musical artist Luciana on a camp video for the singer's hit "I'm Still Hot." Proceeds from the iTunes music downloads would go to benefit the Greater Los Angeles Zoo Association (GLAZA). There's the advocacy angle.

But the video truly has to be seen to be fully appreciated. It opens with Luciana pulling up outside the zoo in a limousine, shouting, "Oh, Betty! Come check out my hot wheels!"

"You think you're so hot?" Betty asks in reply. "Check out Betty's beat."

That leads into a song-and-dance rapping battle for the ages. And when we say "ages," we mean in every sense of the word.

There's Betty sitting on a golden throne grasping a scepter, flanked by beefcake-y shirtless guys on each side boasting six-packs. A live snake is languidly wrapped around her upper torso as she lists all the ways that she's still hot.

She and Luciana sing about "shaking it all the way" from Londontown to L.A. and rocking the world with their cheesecake. Cue the mass feeding of cheesecake to the musclemen as well as themselves. Who cares if they're consuming thousands of calories? If they declare "I'm still hot," we're powerless to doubt them.

Proving to the world that she's more limber and energetic than anyone who's pushing 90 could ever hope, Betty leaps around in purple sweats with "WHITE HOT" written on the back of the top. She dances on her hands, does the splits, cavorts gymnastically, and generally bops around in a decidedly un-seniorly fashion. Meanwhile, she's singing right in tune, letting us know that she's still hot while living life at the top.

Yes, she shakes it all the way and rocks our world with her cheesecake. Why? Because she's The Big Betty, that's why. Or so she claims. In fact, she will get us sweaty because she is in point of fact The Big Betty—that's all there is to it. She's still hot-hot-hot!

The whole thing is just incredibly adorable, punctuated after it's over with Betty sitting in the limo with Luciana chowing down on some of that cheesecake—or rather, Betty force-feeding her song mate. "But I'm on a diet, Betty," Luciana protests. "Oh, now open up, sweetie," Betty insists. "Yes, you keep eating you skinny little . . ."

We're all left asking the question "Was that really Betty dancing on her hands, or was it some kind of trick videography?" Betty is never going to tell, and no one would ever dare to ask. ■

"Oh, Betty! Come check out my hot wheels!"

OPPOSITE: The British singer Luciana (second from left) and Betty are surrounded by plenty of beefcakes while promoting their camp video for Luciana's tune "I'm Still Hot."

Leaving Her 80s Behind

When you're Betty White and you celebrate your 90th, a big-time network throws you a party on national television.

NBC was in a partying mood on January 16, 2012 (technically the day before Betty's birthday), when the stars came out to fete her with *Betty White's 90th Birthday: A Tribute to America's Golden Girl.*

It was a glorious, glamorous affair that found the birthday gal looking resplendent in powder blue and sequins on a special that would itself be nominated for a pair of Emmy Awards—naturally. The lady is, after all, an Emmy machine. Yes, even when she just marks a milestone, awards show attention follows.

The array of Hollywood heavyweights who showed up to honor Betty included Mary Tyler Moore, Carol Burnett, Tina Fey, Amy Poehler, William Shatner, Hugh Jackman, Doris Day, Morgan Freeman, Ray Romano, Ellen DeGeneres, Carl Reiner, and a few dozen others.

Even President Barack Obama joined in the festivities, sending good wishes in a pretaped greeting that poked fun at both himself and the guest of honor. In the video, the president is seen writing a letter and dictating it to himself: "Dear Betty: You look so fantastic and full of energy, I can't believe you're 90 years old. In fact, I *don't* believe it. That's why I'm writing to ask if you will be willing to produce a copy of your long-form birth certificate. Thanks, Happy Birthday no matter how old you are."

Gentle, loving gibes were indeed on the menu at the semiformal event.

Gentle, loving gibes were indeed on the menu at the semiformal event. Burnett emerged to say, "Like many of you, I first heard about Betty from the wonderful stories told to me by my grandmother." Poehler teased, "Betty, you're going to hear a lot of jokes tonight about your age. But take comfort in the fact that come tomorrow, you won't remember any of them."

What had to be the evening's highlight came from an unlikely source: Zachary Levi, star of the NBC series *Chuck*. Levi approached Betty in the audience. "I would like to be the mother of your children," he gushed. He then proposed marriage and even produced a prenuptial agreement he'd crafted. Finally, Levi laid a big kiss on White's lips, which she enthusiastically reciprocated.

"Forget about those other girls," she cooed.

The night proved to be a memorable one for Betty as she took all of the aging jokes and abundant praise in gracious stride. It's one thing they don't teach you in acting school or probably even charm school: how to properly accept a compliment. She'd be getting plenty of practice as the ensuing decade wore on.

During a press interview promoting the 90th birthday gala, Betty said, "I'm the luckiest old broad on two feet. It's such a privilege to be at this age and still be working. That doesn't happen often, and I'm deeply grateful. I love being 90—and I'll see you again in 10 years." ∎

OPPOSITE: When you're Betty White, your 90th birthday celebration is cause for a national TV event.

Who You Calling Old?

You'd have to be off your rocker to take on a *second* TV series at any age, let alone in your 90s.

To people's amazement—and befuddlement—Betty decided that co-starring in a weekly sitcom just wasn't quite challenging enough. Annie Wetherbee, White's stand-in and assistant on the series *Hot in Cleveland*, who would rehearse Betty's lines on the show in her stead to allow her rest during the week, imagined she herself was hallucinating.

Just when it looked like Betty may not have the energy or stamina at 90 to keep such an exhaustive schedule, she undertook to book a *second* series commitment at the same time.

Huh?

"Yeah, that was what I said," Wetherbee recalls.

So it was that Betty agreed to host the NBC reality series *Betty White's Off Their Rockers*, a hidden camera show that found elderly performers playing pranks on younger adults à la *Candid Camera* and *Punk'd*. It had its sneak-preview premiere on January 16, 2012, in the time slot following Betty's 90th birthday special.

"She was doing *Off Their Rockers* on Sunday, Monday, and Tuesday, and then she'd come and do *Hot in Cleveland* on Wednesday, Thursday, and Friday," Wetherbee observes. "I guess she had Saturdays off. I asked her, 'Are you out of your mind?'"

Apparently, she was. Or perhaps it's just that Betty can't form the word "no" with her mouth. To be sure, she didn't leave that legendary work ethic behind after turning 90.

Off Their Rockers was evidently just a concept Betty couldn't resist. Based on the Belgian TV series *Benidorm Bastards*, it followed a fearless group of seniors who took to the streets to play hoaxes on the younger generation, which in this case meant anyone below middle age. As Betty herself said at the top of the premiere in describing the premise, "All our senior moments are funny and on purpose."

We see a purportedly blind old man get behind the wheel of a Ford Mustang to drive off while an incredulous young guy looks on. In another sketch, an elderly lady approaches a young gal, holds up her phone, and inquires, "My boyfriend just sent me a text about things he wants to do in bed, and I don't know what any of it means. Do you know what a *Boston Tea Party* is?"

Indeed, shock value is a big part of the gambit. A codger sitting on a park bench boasts to a pair of young women, "My old lady got a hotel room. We're gonna really party. She's still hot after all these years. We can still boom-boom-boom, know what I mean?" As they're guffawing, expecting a wrinkled old lady, a hot young blonde greets him.

Other skits show a white-haired woman requesting assistance in dumping her no-good late husband's ashes, while still another claims to have a "date with Jesus" and asks if her covered breasts appear even.

It's all quite the hoot, with Betty showing up to make observations and say things like "If they're gray, get out of their way!" White couldn't very well do the pranks herself, being so recognizable, but she revels in the naughtiness and table-turning practical jokiness of it all.

Off Their Rockers would survive for two seasons on NBC and a third on Lifetime—46 episodes in all. Once it was gone, the world was again left to ponder, "How will poor Betty White keep busy now?" Somehow, she's always found a way. ∎

OPPOSITE: Betty makes like a paratrooper on her hidden camera series *Betty White's Off Their Rockers*, on which seniors pranked the young 'uns.

The *Other* Proposal

"Craig Gaylord Fanny Ferguson, will you marry me?"

Betty White has never been shy about going on late-night talk shows. And it hasn't just been to promote something. She became actual friends with the likes of Jack Paar, Johnny Carson, and Jay Leno.

But it was always clear that her heart really belonged to Craig Ferguson throughout the run of his CBS *The Late Late Show* (2005–2014). This was due in part to their history of having appeared together in the regular cast of the short-lived 1995 sitcom *Maybe This Time* (the Scottish-born Ferguson's first acting job in America).

Throughout Betty's 24 appearances with Ferguson, there was a special bond. It was on his show in 2012 that she announced her candidacy for president of the United States. And it was on Valentine's Day 2012 that White took the momentous step of proposing marriage—on the air—to the man who had become her valentine (at least in her mind).

Sure, there was that 40-year age gap between them. But when has age stopped Betty in the past?

Looking ravishing in red, Betty carries a single long-stem red rose and a heart-shaped box of chocolates over to the guest chair. She announces her plan is to "marry into money" because she'd purportedly lost everything betting on the Super Bowl—or at least, that's what her bookie told her.

Until the bookie comes clean, White decides she's going to "put the 'old' in 'gold-digger.'" Mind you, the lady had turned 90 less than a month before. You'd think she might

have better things to do than seek a sugar daddy. As it happens, she has a specific sugar daddy in mind.

"Who's the lucky guy?" Ferguson asks, as if he doesn't already know.

Sounding completely sincere, Betty says she's looking at him. "Craig Gaylord Fanny Ferguson, will you do me the honor of being my husband?" A legitimately perplexed look crosses Ferguson's face, as he's been happily married for three years and tells Betty so. Undeterred, she observes, "Oh Craig, we've all got weird baggage. You know we're compatible in the bedroom."

This inspires Ferguson to respond that the thing that supposedly happened between them once upon a time in Cancun in fact never occurred. He suggests she ask Jimmy Fallon for his hand instead. Turns out she already had. White notes that she also asked Jay Leno, and Conan O'Brien, and Ellen DeGeneres "and that weather guy on Telemundo." All to no avail.

"Did you really think you were my first choice?" she asks.

The mock proposal concludes with Betty spilling the chocolates from the Valentine's box all over Ferguson's desk, calling him a "candy-ass," and stalking off in faux outrage.

Long after he left the air, Ferguson was asked by *People* magazine his fondest memory of hosting *The Late Late Show*, and he didn't hesitate to say, "Anything involving Betty White, because she's such a lovely person." Clearly, the feeling was mutual—even if he turned her down flat on national television.

We're also left believing that they really *would* be compatible in the bedroom. ∎

> Throughout Betty's 24 appearances with Ferguson, there was a special bond.

OPPOSITE: Betty tosses out quips to the late-night host of her dreams on *The Late Late Show with Craig Ferguson*.

The Lorax Is Back in Town

Betty jumps at an opportunity to get her Seuss on.

Betty White was never a big Dr. Seuss fan. It isn't that she wasn't in admiration of his talent. No, it was more about the fact that by the time Theodore Geisel (his given name) authored his first books under the pen name "Seuss," Betty was already a teenager. And since she didn't have small children to buy the books for and read to them in adulthood, she never really had a need or opportunity to fully appreciate the Dr. Seuss genius.

Yet when the opportunity came for Betty to appear as a voice in the computer-animated feature film *The Lorax* adapted from the Dr. Seuss book of the same name, she jumped at it.

Released by Universal Pictures on March 2, 2012, *The Lorax* tells the story of a 12-year-old boy named Ted Wiggins (voiced by Zac Efron) who lives in the town of Thneedville, a walled city in which there is no actual live vegetation. All the plant life is artificial.

Young Ted falls for a young girl named Audrey (Taylor Swift). But to win her heart, he needs to find a real "Truffula" tree. To do that, he must embark on a journey involving the guardian of the forest, the orange furry Lorax (Danny DeVito), and the Once-ler (Ed Helms), whose greed once upon a time destroyed the forest. Betty, meanwhile, portrays Grammy Norma, the silly, sassy, wisecracking,

"Dr. Seuss was so far ahead of his time."

fearless, and altogether nutty mother of the neurotic Mrs. Wiggins (Jenny Slate) and Ted's beloved grandma. Boasting an impossibly curly gray Afro, round granny specs, and twirly cane, the nature-loving Norma is as wise and spirited as she is old. She is the sagely elder who guides her grandson in how to interact with the Once-ler.

It was the film's pro-environmental message along with its Seuss connection that drew White to the film, as she told NBC's *Today* show in an interview.

"I'm a big environmentalist," Betty said, "and I hurt when we abuse our planet. So I think [*The Lorax*] sends a delightful message that gets through that, to protect this environment while we have it because it doesn't come back once it goes away."

Betty went on, "Dr. Seuss was so far ahead of his time. He saw what we're living through now. I think this film gets the message across in an entertaining way and certainly a visually beautiful one."

The film was certainly a hit with audiences, grossing some $214 million in North American box office and taking in nearly $350 million total in worldwide gross despite receiving mixed reviews from critics. Oh, and the review of Betty's performance? Not mixed at all. The consensus was unanimous that she nailed it. ∎

OPPOSITE: Betty arrives for the premiere of her film *The Lorax* accompanied by her date, the Lorax himself.

A Love Interest Renewed

Thanks largely to Betty, *Hot in Cleveland* welcomed one veteran star after another.

Even if she's not the official casting director, it's a safe bet that a lot of the amazing stunt casting that *Hot in Cleveland* enjoyed was Betty's doing.

Take the episode titled "Rubber Ball" that premiered on TV Land on March 21, 2012, from writer Sebastian Jones and director Andy Cadiff. It featured White's former *Mary Tyler Moore Show* castmate Ed Asner, onetime *Saturday Night Live* regular Jon Lovitz (as Artie Firestone, a mentally unstable billionaire and heir to the Firestone Tire fortune), and *Family Guy* voice Alex Borstein (playing rich heiress Preshi Van Der Bosch, a country club member known for strange behavior).

Every time the producers snapped their fingers, stars appeared, like magic!

In the storyline, Asner portrays Jameson Lyons, Elka's (Betty) onetime boss. He's a rubber magnate and the president of a prestigious country club who once fired Elka supposedly because she wouldn't sleep with him. This becomes a thing when Melanie (Valerie Bertinelli), Joy (Jane Leeves), and Victoria (Wendie Malick) are hell-bent on joining the country club. They buy tickets at $5,000 apiece to attend the Rubber Ball at the club in hopes it will help them get in the door.

No sooner do the ladies make it inside the event than they spot Elka in attendance as well. What? Huh? How? Why?

Every time the producers snapped their fingers, stars appeared, like magic!

"I'm here to humiliate Jameson for what he did to me," she explains. She adds that she's going to make him fall in love with her, reveal her true identity, then toss a drink in his face. It's a deliciously diabolical plan, if only it could work. But early indications are that it just might, particularly when he asks her to go for a moonlight walk with him on the neighboring golf course.

Once the walk is done, Jameson continues his seduction of Elka. He points out that she's not like the other women at the club—not just some "happy homemaker" (a clever allusion to Betty's *Mary Tyler Moore* character). He could swear he knows her from somewhere and tells her so, but Elka is keeping her identity a secret. For now.

When it finally comes time to toss the drink in Jameson's face, however, poor Elka is empty-handed. But he assures her that she wasn't fired because she wouldn't date him but because she was the world's worst waitress. It was, alas, a charge that she couldn't dispute.

The interaction between Asner and White is as adorable as anyone had a right to expect. It's lent extra poignance by the fact that it's been 35 years since the two were last seen performing together—and that throughout their time on *Mary Tyler Moore*, Sue Ann constantly hit on Asner's alter ego, Lou. Now, here they are together again on a thing called cable that didn't exist the last time they shared a screen.

Clearly, if you're Betty White and Ed Asner and you live long enough, all things are possible. ∎

OPPOSITE: Ed Asner and Betty pose for a portrait on the set of *Hot in Cleveland*, where Asner was guest starring in an episode entitled "Rubber Ball."

Betty, Barack, and Bo

President Obama couldn't resist wielding the full power of the office of the presidency as a way to meet Betty, and who can blame him?

After President Barack Obama checked in with a surprise 90th birthday message for Betty back in January, the president extended her an invitation to come to the White House in person the next time she was in Washington, DC. She made sure to piggyback an excursion to the Smithsonian Institution and the National Zoo with a visit to America's headquarters on June 11, 2012.

The photograph of the two together is as effortlessly captivating as it is heartwarming. There is Betty in the Oval Office, dressed simply in a blue button-down blouse and black pants, her hands clasped as if almost in prayer, looking up at President Obama adoringly while he assesses her with a mischievous grin, as if she's said something that charmed the pants off him.

What did Betty and the president discuss? Well, that's private. But she did describe her White House visit during an interview with CNN in 2012. "I was with my secretary and my agent," she recalled. "We were all out in a waiting room and then they called me into another inner room. So, I sat there for about five minutes and then I was called into yet another room as the president came out of the Oval Office and he said, 'You—you get a kiss.' And he came over and kissed me on the cheek."

Betty called President Obama "a real charmer."

She continued, "I was very impressed. He made me feel so comfortable and not awkward or anything like that, and I tend to feel awkward."

Did she plan to vote for the president for reelection that November? In fact, while White typically steers away from any political discussion so as not to risk upsetting any of her fans, she admitted to the Associated Press, "I very,

Betty Blue

Betty's record as an old-school Democrat was well established even before her moment with President Obama. She supported Franklin Roosevelt, Adlai Stevenson, John F. Kennedy, Lyndon Johnson, Jimmy Carter, and Bill Clinton prior to Obama. But it's likely that if dogs had been eligible for presidential nomination instead of humans, she would have preferred it.

very much favor Barack Obama in the election. I like what Obama has done and how he represents us."

Was it mere coincidence that after receiving such a ringing endorsement from Betty White, Obama went on to a resounding victory later that year over Republican nominee Mitt Romney? We think not.

But back to her White House visit. It happened that the president could meet with Betty for only a short time before getting back to work. So, she was led around the grounds and finally had a chance to spend some quality time with Bo, the First Dog (a Portuguese water dog by breed). It's clear that Betty was at least as thrilled to meet Bo as she was the president.

White told CNN, "Of course, I was dying to meet Bo. I walked into this room and he greeted me like an old friend, jumping to meet me on the couch. So, I sat down on the couch and he stretched across my lap, and I spent a half hour with the First Dog stretched there, smooching on the couch. He's adorable! Such a smoocher."

Betty's *Hot in Cleveland* stand-in and assistant Annie Wetherbee said that Betty has met every president since Roosevelt (Franklin, not Teddy) save for Richard Nixon, Donald Trump, and Joe Biden. But it's clear that her moment with Obama and Bo was the most special of all. ∎

OPPOSITE: Betty relishing the honor of visiting with President Barack Obama in the Oval Office of the White House.

Once More, with Feeling

Getting the original girl gang back together was a memorably special experience for the actor and audiences alike.

It happened on April 5, 2013.

The producers of Betty White's TV Land comedy *Hot in Cleveland* had decided to craft an episode that generated a pretext to reunite the female castmates of *The Mary Tyler Moore Show* on camera together for the first time since that legendary series left the air in 1977. Nearly 36 years later, Mary Tyler Moore, Valerie Harper, Georgia Engel, and Cloris Leachman were sharing quality screen time with Betty to film the episode titled "Love Is All Around."

The installment—written by Steve Joe, directed by Andy Cadiff, and premiering on September 4, 2013—finds the quintet reuniting their bowling team in the storyline. But it was their time together behind the scenes on the production lot in Studio City, California, that became an unmatched memory for White.

"We're grateful for the fact that we love each other," Betty told a media throng assembled for the occasion. "We've always gotten along. It would be different if it were one of those shows where we don't speak. That wouldn't have been any fun."

The ladies may have understood that this would be their last opportunity to appear on the same screen. Moore would be gone by 2017, Harper and Engel by 2019, Leachman early in 2021. But on the day they got back together, there would be more laughs than tears.

In the episode, Elka (White) and Mamie Sue (Engel) decide to reunite the bowling team they called GLOB (The Gorgeous Ladies of Bowling), which also included Diane (Moore), Angie (Harper), and Peg (Leachman). They had a falling-out originally, because after their championship season, the fame went to their heads.

As the story goes, the only thing they can agree on is that Mamie Sue was the ditz—and still is. Elka was the bombshell. And the legs. And the tramp. As Peg recalls, Elka was "always backing up into a hand dryer so it would blow her bowling skirt up."

Elka insists, "That was an accident. Every time."

The memories flow throughout the half hour, and it's clear just how overjoyed these actresses were to be in one another's company again. They were all eager to make fun of themselves and their characters' purported arguments back when they bowled together in 1962–63.

Why did the actresses agree to get back together? "It wasn't the money," Leachman assured the press.

Whatever the reason, the chemistry returned as if no time had passed. "Even though we are playing different people, we are still ourselves," Moore noted. "No matter where you put us, we will continue to interact as only you can when you've been together for a long, long time." ▪

LEFT: Left to right: Cloris Leachman, Mary Tyler Moore, Valerie Harper, Betty, and Georgia Engel drink a toast during their reunion episode of *Hot in Cleveland*.

A Conversation with Kari Hendler

The script supervisor for *Hot in Cleveland* talks about how Betty brought her A game every day.

Q: *Describe what it was like being the script supervisor for six seasons on a series like* Hot in Cleveland *featuring a regular cast of four such highly accomplished actresses in Betty, Valerie, Wendie, and Jane.*

KARI HENDLER: It was amazing. The chemistry they had. The respect they had for one another. Everything just clicked and made it a phenomenal experience for everyone on the crew.

Q: *But because there was such an age gap between Betty and the other women, you must have had to make allowances for her in terms of absences, additional rest, all of that.*

HENDLER: Yeah, you'd think so, wouldn't you? But that wasn't the case at all. It didn't feel like there was any age difference. Being in her late 80s, early 90s, you'd imagine it would give Betty a perfectly valid excuse to sit a lot, to show up late, to be off on her lines. But no. She was always right on time, often even a few minutes early. Always incredibly professional. Knew her lines perfectly. And when she would walk out on stage for rehearsal, it was almost like you felt someone had turned up the dimmer switch.

Q: *And if Betty White was bringing it every day, everyone else had to feel they needed to bring their A game, too.*

HENDLER: But it wasn't just her incredible work ethic. There was also a joy that she reflected onto the entire set. There was a concern and love for her fellow crew and castmates. It got to the point where if there were ever an issue in my own life, I'd ask myself, "Okay, how would Betty handle this?"

Q: *That sort of positive energy tends to be infectious.*

HENDLER: It really does. There were times when a bunch of us would be sitting around reading the paper, listening to the radio, getting depressed, and doing the whole "Oh, isn't it terrible?" routine. Betty would intervene with "If there is nothing you can do about it, why ruin an otherwise perfectly beautiful day? Don't let this tear you up and drag you down." Words to live by.

Q: *Did you ever see Betty get depressed or just even have a rough day physically?*

HENDLER: Only once. She cracked a rib in an accident at home and I think had to take two days off. Imagine that. She's 93. If it were anyone else, we'd have had to shut down production for three weeks. With her, she came in two days later and was like "Hi, everybody! How's it going? Let's get to work!" She was back, totally there, lines together, just moving a little slower.

Q: *It also probably didn't stop her from being with her animals.*

HENDLER: Oh, are you kidding? I'd have script revision pages for her to look at and dropped by her dressing room on a weekly basis. You'd walk in and there's Betty bottle-feeding a baby tiger. There she is holding a monkey. Now she's sitting in the middle of a roomful of puppies. It was like Doctor Dolittle's party room in there. Word got around, and actors from other soundstages would head over and guess which animal she was hanging with.

Q: *But Betty liked to hang with humans too, no?*

HENDLER: Oh sure. Like when we'd have famous guest stars, especially Carl Reiner. They were old friends. When he came, they'd sit together right there on the set during lunch eating their tuna sandwiches and catching up, talking about life. I'd always pretend to have something to talk about so I could eavesdrop. But it didn't matter who it was, Betty treated every guest star like they were personal friends attending a cocktail party at her home. Like a great host.

Q: *So, it's safe to say you have fond memories from your time working with Betty?*

HENDLER: Oh God, yes. The woman is a powerhouse. She knows how to work with people but also how to have fun. She became a role model for everyone in how best to conduct yourself and live your life. I remember asking her once, "Have you ever thought about retiring?" She replied, "No. I love waking up every morning and knowing that I'm needed somewhere." We should all be like that in our 90s.

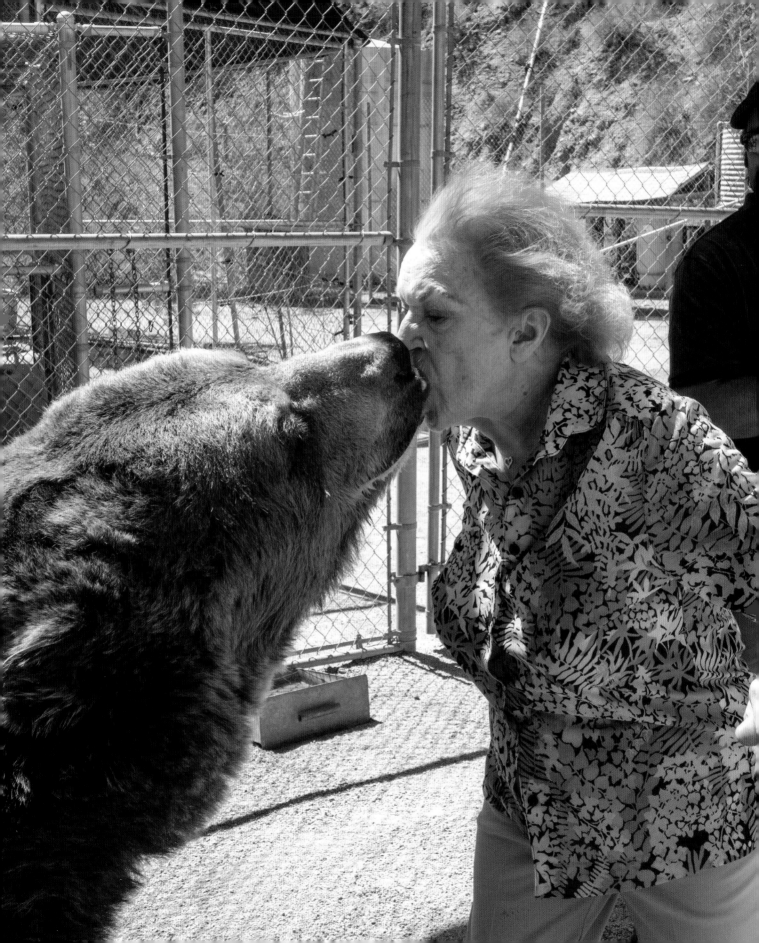

Pucker Up, Bam Bam

Fearless around all animals, Betty thought nothing of feeding a grizzly bear like it was a baby bird.

Betty has never once turned down an opportunity to spend time with animals. They, even more so than humans, are her priority. She generally prefers their nonjudgmental, loving company. And who can blame her?

Naturally, when White got an opportunity in April 2014 to hang with a lion, a tiger, and a bear at the Hollywood Animals ranch in Santa Clarita, California—which provides trained domestic and exotic critters for work in television and film—she leapt at the chance.

She wound up getting even more than she bargained for.

As Annie Wetherbee, Betty's *Hot in Cleveland* stand-in and assistant who accompanied Betty, remembered it, they were at the facility when the trainers started hinting that Betty had to "come and give the bear a kiss." The bear in this case was Bam Bam, a trained and docile brown grizzly.

Yes, a grizzly. No matter how gentle a bear may be, a grizzly is a grizzly.

"What they meant by 'give the bear a kiss' was to have Betty feed Bam Bam marshmallows," Wetherbee said, "out of her own mouth."

As crazy as that sounds, clearly Bam Bam had done this before, probably hundreds of times. "It was obviously a trick he'd learned and performed regularly from the time he was a cub," Wetherbee figured.

Yet it's one thing to consider feeding marshmallows to a grizzly. It's quite another to agree to allow the beast to take them from your mouth and not worry about him, say, accidentally biting off your nose at the same time. ("Oh, so sorry, I thought your nose was part of the marshmallow.")

Betty didn't even think twice, Wetherbee recalled. She just waltzed into the grizzly's enclosure, took the marshmallow, placed it into her mouth, and several times, without once flinching, encouraged the bear to eat it. When Bam Bam gently took it into his mouth from her lips, it did indeed appear that Betty and bear were smooching. It was way beyond cute.

"Bam Bam would take it and leave behind a little slime residue," Wetherbee remembered. "Betty would just laugh and laugh, wipe her mouth, and do it again. And then again."

As Betty recalled in an interview with producer Darren Wadyko, "We did about six marshmallows total like that, and I've been dreaming about him ever since."

Wetherbee assured that, as ominous as it appears to go snout to snout with a grizzly, it was perfectly safe—at least, as safe as being in the same space as a giant brown bear can be. The trainers were completely surrounding her, and as Betty fed Bam Bam, one of the trainers grasped her hand to steady her.

"We were well protected throughout," she said. "Bam Bam sat perfectly still in the same spot. There was nothing threatening about it. But we're still talking about a 92-year-old woman exhibiting zero fear while having a grizzly bear in her face. And honestly, I never saw her happier."

Betty also took the time to pose for photos with Bam Bam while his trainers were urging him to smile—which in the bear's case led to a roar. The two of them also waved goodbye in unison for another photo.

Just another day in the life of Betty White—Grizzly Mouth Feeder. ◾

OPPOSITE: Bam Bam, a resident of the Hollywood Animals ranch in Santa Clarita, California, gets all kissy-face while being fed a marshmallow via Betty's teeth.

Celebrating in a Flash (Mob)

Heartfelt affection and some hard work combined to make one of the best birthday surprises Betty ever received.

It was January 2015, and the production team over at *Hot in Cleveland* faced a dilemma. They had already celebrated Betty's 89th, 90th, 91st, and 92nd birthdays and were running low on ideas for something new with which to honor her as her 93rd birthday approached.

"We'd done all sorts of things for her birthday," recalled Annie Wetherbee, White's *Cleveland* stand-in and assistant. "We'd brought in boxes of puppies. We'd had cakes made in the shape of puppies. We were really wracking our brain to come up with something different."

Weeks before, Betty had taken a group of her friends (Wetherbee included) to a luncheon that included a concert complete with traditional Hawaiian music. For each day after that, it became a running gag that when people saw Betty coming on foot or in a golf cart on the set or production lot, they immediately went into a hula greeting. And Betty would laugh. It got to be that she started expecting it and would be disappointed if she didn't see it.

That's when it hit Wetherbee how they could best honor Betty for her latest birthday: a Hawaiian-themed flash mob. She approached the publicist for TV Land, who gave it her blessing.

Wetherbee set out to produce it for the day before Betty's birthday. She sought out crew members from both *Hot in Cleveland* as well as nearby soundstages on the lot. She begged people to come in two hours earlier than their call time on a shooting day for no extra pay. Many of them griped about it but promised they wouldn't miss it.

"Everyone had such love for her that they agreed," Wetherbee recalled. "Believe me, they wouldn't have done it for anyone else. Mind you, I had no giant expectations. I figured, well, if we get 12 people, this will be cute." Instead, they got more than a hundred people to commit, including White's co-stars Valerie Bertinelli, Jane Leeves, and Wendie Malick. And the resulting video would go viral, viewed on YouTube as of this writing nearly 4.5 million times. It's easy to see why it became a sensation. It's simply glorious—two minutes of pure, unadulterated joy.

After coaxing Betty into a golf cart when she'd really wanted to walk to the set, the cart—driven by *Cleveland* recurring player Dave Foley—navigates the lot and comes upon a lone hula dancer wearing a wrap and moving to a loud, languid Hawaiian beat. That person is Wetherbee. White sticks out her hands and sways in her golf cart seat, not yet comprehending that this was about to escalate in a spectacularly over-the-top way.

The beat suddenly intensifies, and people—many dressed in Hawaiian shirts and leis, grass hula skirts, and flowered wraps—seem to come out of nowhere and everywhere, by the dozen. They dance. They sway. They sashay. They raise their arms and move in a line. As soon as a group shuttles to the rear, they're replaced by others dancing in.

While this is all going down, the look on White's face is priceless. To say she is simply shocked is to greatly undersell her level of surprise. Her eyes are wide and mouth agape in hypnotic ecstasy throughout. After about 100 seconds, it all builds to a climax, with a group holding a HAPPY BIRTHDAY BETTY! banner and everyone shouting those same wishes at the top of their lungs.

"At 93, you shouldn't be doing this!" Betty finally scolds through her veneer of astonishment, her voice cracking, her breath coming in uneven gasps.

"I guess it worked," Wetherbee observed.

Only someone as beloved as this lady would be treated to this kind of affectionate and energetic display. She knew it. And it only meant everything to her. ∎

OPPOSITE: Betty, flanked by actor/comedian Dave Foley, gets the surprise of her life when she's greeted by a flash mob for her 93rd birthday on the studio lot for *Hot in Cleveland*.

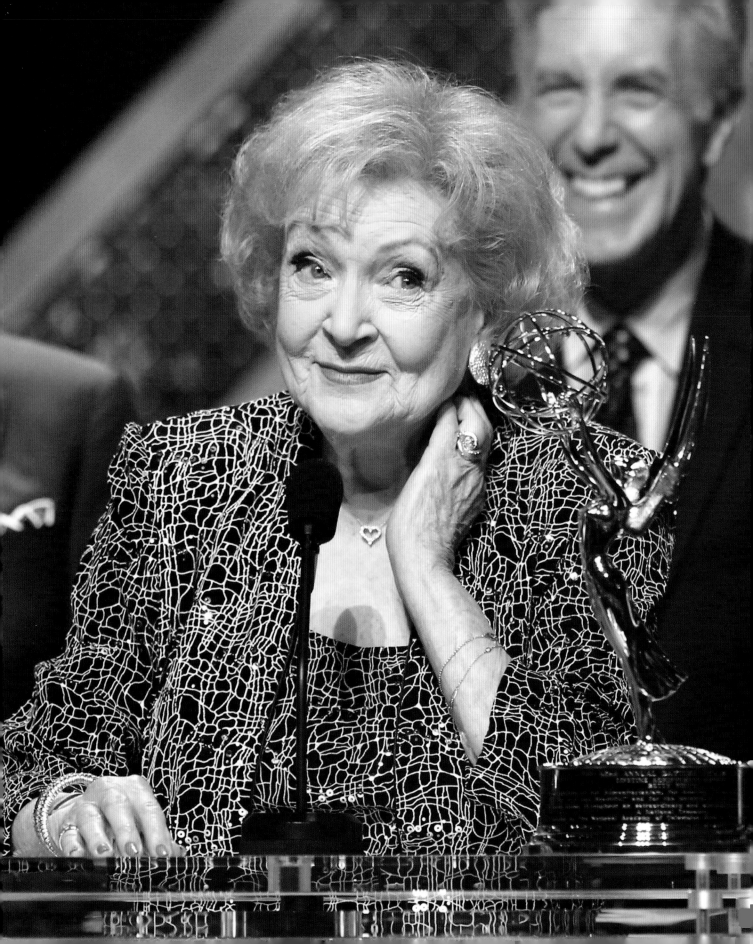

A Lifetime of Emmys

As "an American institution," Betty's received no small number of accolades, including a very special award from the Daytime Emmys.

Once you get to be 93 years old and such a revered and respected figure in your line of work, the career achievement tributes tend to pile up.

So it was with Betty White, whose accolades now included a Life Achievement Award from the Screen Actors Guild; a Career Achievement Award from the Television Critics Association; a Lifetime Achievement Award from the Jane Goodall Institute; a Lifetime Achievement Award from American Women in Radio and Television; and a Lifetime Achievement Award from the Broadcasting & Cable Hall of Fame.

Then, on April 26, 2015, came one more: the Lifetime Achievement honor at the Daytime Emmy Awards from the National Academy of Television Arts & Sciences, whose president, Bob Mauro, called Betty "an American institution."

That she is. And in honoring her, the Emmys were putting her in some great company. Previous winners of the lifetime tribute included Oprah Winfrey, Barbara Walters, Merv Griffin, Dick Clark, Bob Barker, Phil Donahue, Regis Philbin, and Alex Trebek.

The ceremony at which White was presented the award was an eccentric gambit in itself, treating the presentation as a special edition of *Celebrity Password Plus*. The passwords were "Epic," "Legend," and "Cleveland" and featured the participation of Philbin, Marie Osmond, Fred Willard, and Charo, along with "host" Tom Bergeron.

In accepting her plaque, Betty said, "Oh my goodness. I cannot tell you what this means. [Looking at the award] Hello, beautiful. I have been in this business for a long time. You may not have noticed that. But when I started—1949—I had no idea that I'd still be around at this point, for one thing, or that I'd still be privileged enough to be in this business. And it is *such* a privilege."

White went on to thank the many generations of viewers and showbiz colleagues in a heartfelt rush, and you could truly feel that she meant every word. Whether or not Betty was really surprised to receive this honor is a matter of conjecture. But she seemed both dumbfounded and flustered (as well as incredibly thrilled) upon taking the stage, and it felt genuine.

The truth is that if daytime game show celebrity panelist extraordinaire Betty White doesn't qualify to receive a Lifetime Emmy for her work during the daylight hours, honestly, who does? The woman practically invented daytime TV back in 1949, and she's still working 66 years later. It's the ultimate no-brainer. ∎

> "Oh my goodness.
> I cannot tell you
> what this means."

OPPOSITE: The icon, the legend, the national treasure Betty accepts a Lifetime Achievement honor at the Daytime Emmy Awards in April 2015.

"The Greatest of All Time"

Having already showered her with rewards,
showbiz really just wanted to say thank you, Betty,
for being a friend.

You want to know perhaps the greatest honor Betty has ever received? It may well be the one she got at the 70th Primetime Emmy Awards on September 17, 2018, when she was 96.

They didn't present her with any trophy or plaque. Instead, they gave her only love.

That's right. No award was bestowed. They just wanted to tell Betty how much they thought of and appreciated her as a living legend. It was basically "This woman is remarkably still with us, so let's just invite her up onstage and let her drink in our collective adoration."

That's homage in its purest form. Just a woman, a microphone, and a rapt, appreciative audience.

Alec Baldwin and *SNL*'s Kate McKinnon took to the stage, with McKinnon starting the introduction with "We are lucky to be joined by the greatest of all time: Betty White."

"Betty was nominated for the Emmy 24 times," Baldwin continued, "and she won eight."

McKinnon then quipped, "And at 96 years old, she still thinks about all those Emmys she didn't win. And she's still bitter."

Out came White, looking and sounding a tad bewildered—not because she wasn't lucid but simply that it felt so overwhelming to be honored by her television peers with solely a warm embrace rather than an award excuse.

"Oh my goodness-goodness-goodness," she uttered as an opening. "Thank you. I'm just going to quit while I'm ahead." McKinnon and Baldwin then took turns kissing her hand, inspiring her to say, "You think I'm gonna miss a chance when I get it?"

Betty then thanked Lorne Michaels, the Emmy producer and the creator-producer of *SNL*, for doing so many wonderful things *with* her, clarifying "no, *for* me." She then told a story about discovering that by "First Lady of Television" some people literally mean she was the first woman to *appear* on television. Which is in fact true! But what is even more Betty was her deep and earnest gratitude:

"All I can say is, it's such a blessed business to be in. How lucky can I be? And thank you to each and every one of you."

And with that, Betty was led offstage to a standing ovation for a career—and a life—like no other. ▪

> ## "How lucky can I be? And thank you to each and every one of you."

OPPOSITE: After being called onstage to take a bow and say a few words at the 70th Primetime Emmy Awards in September 2018, Betty was overcome with gratitude.

Just Shy of a Century

In passing on December 31, 2021, Betty
came within 17 days of her 100th birthday.
But she celebrated life to the very end.

From the time Betty White turned 98, she essentially dropped out of public view. This shouldn't have been a surprise for a woman who was closing in on the century mark. But because she had been so vital and popular and ubiquitous throughout her 90's up until that point, it proved jarring.

We were so accustomed to having Betty around that it seemed inconceivable she could just . . . disappear. But disappear she did. She was last photographed in public the day before her 98th birthday while running errands in Beverly Hills, accompanied by her driver (who also provided walking assistance) and looking joyous and stylish in a turquoise floral blouse, matching pants, and tiny black heels—all accented by a lovely red scarf.

And then, she fell out of sight, if certainly never out of mind.

Betty's vanishing act can mostly be ascribed to two factors: the fact it was recommended that she limit contact with people during the COVID-19 pandemic, and that she was in her late 90's and no longer possessed the same energy level.

White's people released a statement on the occasion of her 99th birthday that had Betty saying, "You probably didn't ask, but I'll tell you anyway. What am I doing for my birthday? Running a mile each morning has been curtailed by COVID, so I am working on getting *The Pet Set* re-released and feeding the two ducks who come to visit with me every day."

The Pet Set was of course the syndicated 1971 series that found host and co-producer Betty visiting with celebrities and their pets.

LEFT: Betty celebrates her 93rd birthday on the set of *Hot in Cleveland* in January 1995. The cake was baked by show stand-in Carol Pawlak.

Meanwhile, as the months piled up and Betty's magic 100th on January 17, 2022, drew close, the planning for the celebration began, with or without the birthday gal's active participation.

It was announced that a new documentary entitled *Betty White: 100 Years Young—A Birthday Celebration* (actually a slightly tweaked version of her 2018 PBS doc *Betty White: First Lady of Television*) would show in some 900 movie theaters coast to coast on January 17. Then, as December wound down, *People* magazine prematurely released a pair of issues (one commemorative) that hyped Betty turning 100.

And then came the only thing that could douse the momentous event: Betty died on December 31, and the world's heart was collectively broken.

The official cause of death on Betty's Los Angeles County death certificate was a "cerebrovascular accident," or a stroke, suffered on Christmas Day some six days before she passed. But an insider confirmed that Betty had been bright and lucid until nearly the very end, counter to any reports that she was frail and nearly bedridden for months.

Betty did not die as a result of a bad reaction to the COVID booster, as had been rumored, nor was her last word "Allen," a cry out to her beloved long-deceased husband Allen Ludden. "All she did was pass in her sleep, but that isn't dramatic enough somehow," the insider said.

Despite the painful timing of White's passing 17 days before her 100th, the documentary showed in theaters as planned on her birthday as a way to celebrate her life, albeit with the revised title, *Betty White: A Celebration*. And far from pulling its magazines off the stands and withholding them from subscribers, *People* printed more copies to meet exploding demand.

Yes, even in death, Betty's spirit was unstoppable.

Farewell to a Golden Girl

The heartfelt outpouring of love to Betty
in the immediate aftermath of her death proved
that we weren't yet ready to let her go.

The mourning of Betty Marion White began in earnest the moment her death was announced on the morning of December 31, dwarfing the flood of feelings that would typically even have greeted the passing of a head of state or a spiritual icon.

Sure, the woman lived to 99 years, 348 days. But it just wasn't enough.

Everyone from the President of the United States to the U.S. Army lamented Betty's having left us, as did a tweetstorm of grieving celebrities who clearly cherished the special time they had working with Betty and/or appreciating her genius.

"She was a lovely lady," President Joe Biden said during a press conference before expanding in a tweet, "Betty White brought a smile to the lips of generations of Americans. She's a cultural icon who will be sorely missed."

"We are saddened by the passing of Betty White," the Army said in a tweet, noting her service during World War II as a member of the American Women's Voluntary Service. "She was a true legend on and off the screen."

To be sure, White's impact on the showbiz community was vast.

Comedian Kathy Griffin recalled in a tweet the time that Betty guest starred on her comedy series *Suddenly Susan*, and Griffin accidentally parked her car in the spot reserved for White.

"She walks in and yells from the back of the soundstage for everyone to hear, 'Where's that redheaded bitch who stole my parking spot???' SWOON. A friendship was born."

Griffin also remembered the time Betty "was gracious enough" to guest star on an episode of her series *Kathy Griffin: My Life on the D-List* and agreed to let Griffin's mother Maggie have a "playdate" with her.

"We surprised Maggie," Griffin tweeted, "so when Betty shows up at the Sizzler Senior Early Bird Special, my mom about fell OUT! And I got to spend the day on film and off camera with my mom and Betty White.

"Betty legit treated my mom like a friend. They hung out like peers. And she treated me like an equal in the comedy gurrrl world. She was as sharp and funny as she was soft and wise."

"The world looks different now," tweeted Ryan Reynolds, who starred with Betty in the 2009 hit romcom *The Proposal*. "(Betty) was great at defying expectation. She managed to grow very old and somehow, not old enough. We'll miss you, Betty. Now you know the secret."

Tweeted Valerie Bertinelli, with whom Betty starred in the TV Land comedy series *Hot in Cleveland*: "Rest in peace, sweet Betty. My God, how bright heaven must be right now."

Late night host Seth Meyers recalled in his tweet the time in 2010 when Betty hosted *Saturday Night Live*, at age 88: "RIP Betty White, the only *SNL* host I ever saw get a standing ovation at the afterparty—a party at which she ordered a vodka and a hotdog and stayed till the bitter end."

Cher, meanwhile, posted on Twitter, "I watched her on her first TV show *Life with Elizabeth* when I was 7 years old. When she did (*Sonny & Cher*), I got a chance to tell her. I was embarrassed 'cause tears came to my eyes. She put her arms around me, and I felt 7 again."

"Our national treasure, Betty White, has passed just before her 100th birthday," tweeted George Takei of *Star*

ABOVE: The four Golden Girls strike an iconic pose during the height of the show's run. Left to right: Rue McClanahan, Bea Arthur, Betty, Estelle Getty.

Trek fame. "Our Sue Ann Nivens, our beloved Rose Nylund, has joined the heavens to delight the stars with her inimitable style, humor, and charm."

Indeed, the tone of the tweets from the Hollywood celebrity culture was an intensely personal one. All of them seemed to indicate that the tweeter had lost a personal friend, whether or not they had ever worked with or even met Betty before.

Ex-CBS News correspondent and anchor Dan Rather tweeted, "A spirit of goodness and hope, Betty White was much beloved because of who she was, and how she embraced a life well lived. Her smile. Her sense of humor. Her basic decency. Our world would be better if more followed her example. It is diminished with her passing."

Will & Grace star Debra Messing never worked with Betty but felt a kinship nonetheless. She tweeted, "Betty White. Oh noooooooo. I grew up watching and being delighted by her. She was playful and daring and smart. We all knew this day would come but it doesn't take away the feeling of loss. A national treasure, indeed."

Oscar-winning actress Viola Davis also didn't work with White but had an especially emotional response to her death, tweeting, "RIP Betty White. Man did I think you would live forever. You blew a huge hole in this world that will inspire generations. Rest in glorious peace . . . you've earned your wings."

Of course, if the dogs, cats, and other animals had their own Twitter feed, they would express similar love, admiration, and grief. That, at the end of the day, distinguishes the loss of Betty from nearly all who came before. Her passing cut across not just generations, but species.

In Honor of Betty

Animals continued to benefit following
White's passing as the hashtag #BettyWhiteChallenge
blew up, leading to millions in charitable contributions.

Lawmakers in Illinois declared January 17, 2022 as Betty White Day in honor of the late icon's 100th birthday, pointing to her birth in Oak Park, IL a century before. The latest plan was to make it an annual occurrence throughout the state, if not quite a federal legal holiday.

But it was the animal kingdom that perhaps wound up benefiting most from the tributes that poured in for Betty thanks to a social media-driven campaign to turn her birthday into a windfall for animal charities throughout the world.

The Betty White Challenge (punctuated with the hashtag #BettyWhiteChallenge) proved to be monumentally successful thanks to a viral push to donate $5 to any animal organization. At last count, more than 400,000 people had contributed to a host of rescues and shelters, with some $12.7 million raised in total. On Betty's birthday alone, $900,000 came in from 26,000 individual contributions.

Among those donations were some particularly special ones that would have particularly warmed Betty's heart. That included the Los Angeles Zoo (one of Betty's favorites) raising $70,389 from 1,731 donations on January 17 alone—the money coming in from 49 states, the District of Columbia, and 11 foreign countries. Donations continued to come in after her birthday to the tune of many thousands of dollars more, growing toward $100,000 overall.

The ride share service Uber made a $50,000 contribution in the name of the Betty White Challenge to the American Society for the Prevention of Cruelty to Animals (ASPCA). And the nonprofit Best Friends Animal Society that operates one of the world's largest sanctuaries for homeless animals raised $340,000 through its website and social media fundraisers via the Betty Challenge.

On the day after White's birthday, the Calgary Humane Society in Alberta, Canada posted on its website, "We're speechless! As of right now, we have raised $91,845.81 and counting toward the #BettyWhiteChallenge . . . We know Betty would be proud. What a legacy!"

What a legacy, indeed.

Donations poured in from all over the country on her 100th—from Nashville to Boston, from San Diego to Seattle, from Ashland, Kentucky to Kennesaw, Georgia, and everywhere in-between.

Some people sought out particularly creative means to meet the challenge. For instance, artist Corie Mattie created a distinctive yellow mural that was posted on the famed Melrose Avenue in West Hollywood, California that implored people to "BE MORE LIKE BETTY" and encrypting a QR code where they could scan and donate directly to Wagmor Pets, a Los Angeles-based dog rescue. Folks heeded the message, giving more than $17,000 to Wagmor on January 17 alone. It was enough money to spay and neuter at least 60 dogs.

Wagmor owner Melissa Bacelar told *The Wall Street Journal* that the amount donated was "just really shocking and overwhelming" for a small organization. "I woke up to hundreds of Venmo notifications on my phone," she added.

The conspiracy of gift-giving goodness extended to Mineral Point, Wisconsin, the hometown of Betty's beloved husband Allen Ludden, and a watering hole called the Commerce Street Brewery Hotel. Mike Zupke, who runs the Commerce, got the idea for her 97th birthday in 2019 to have patrons pre-purchase drinks for Betty at $5 a pop as a pay-it-forward gesture.

Within a few months, more than 40 beers had been bought for Betty, a special craft cream ale called The Blonde

Betty. The goal was actually to entice her to come in to claim her free beers. But it was not to be.

"I really thought she was going to come in here and drink those beers," Zupke told *The Washington Post*.

Instead, people just kept buying and buying for Betty. Had she come in, she could have drank free beers from Commerce Street Brewery for the rest of her days. By her 100th birthday, nearly 600 beers had been purchased for White in absentia in what turned into a "Beers for Betty" initiative. It raised almost $3,000 that was donated to various organizations to provide medical care and vaccines for rescued animals as well as the support of strays.

And so it goes for Betty, for whom supporting animals remained possible from beyond the grave. As if we ever had any doubt.

A Legacy Like No Other

A trailblazing feminist. A fighter of racism. A champion supporter of LGBTQ+ rights. A dogged advocate for animals. An all-time great comedic actress. Betty was all of these.

It's nearly impossible to sum up Betty's legacy in a single assessment, but let's give it a try.

She was a feminist who produced and delegated on pioneering television shows. She defended LGBTQ+ people and causes before there was even such a term. She advocated for animals with diligent gusto. She fought against racism when it reared its ugly head early on in her career. She also served by example as someone who knew how to age the right way—that is, by working tirelessly and never surrendering to any notions of how seniors were expected to behave.

Moreover, Betty practiced all of this without making it seem she was pushing an agenda, much of it during a time when opposing racism and battling homophobia were hardly in vogue. And her animal thing, well, she didn't do it because she thought it would be a good look to support God's most vulnerable creatures. She walked that walk because she felt it with every fiber of her being.

The legacy Betty White leaves in her prodigious wake is indeed a monumental and multi-pronged one. No one had a greater impact on more areas of humanity from a societal perspective than did she. And yet, she made it all look effortless.

But of course, it's in entertainment that Betty exerted her greatest influence on what turned out to be multiple generations of fans. Putting it into the proper context, however, proves somewhat challenging.

With her gigantic body of television work in so many areas—from sitcoms to drama series guest spots, from game shows to soaps, from parade commentary to talk show appearances—Betty's impact extended well beyond her breakout roles as Sue Ann Nivens in *The Mary Tyler Moore Show* and Rose Nylund on *The Golden Girls*.

However, given White's uniquely versatile set of skills, where does she rank among the all-time greats? Does she belong up there with the likes of Lucille Ball, Carol Burnett, Eve Arden, Mary Tyler Moore, Joan Rivers, Phyllis Diller, Rose Marie, and (more recently) Julia Louis-Dreyfus, Amy Poehler, Catherine O'Hara, Tracey Ullman, and Lily Tomlin (among numerous others)?

"I would put Betty in the same league with Lucy as a great comedic actress, but with a twist," stresses Jim Colucci, author of the 2016 book *Golden Girls Forever: An Unauthorized Look Behind the Lanai.*

"The difference between them was that Lucy would tell you she wasn't a comedian but a clown. She wasn't a funny person or a natural wit. Betty, by contrast, was funny off camera when there was no script as well as on. She had a naturally wicked sense of humor. She was this great combination of bawdy old broad and sweet grandmother that you could enjoy on so many levels."

It was that flexibility, believes Colucci, that elevated Betty into the pantheon of the greatest funny ladies in American entertainment history. "When you see her ad lib on talk shows with Johnny Carson and David Letterman and the others, it was just so clear," he says. "She was able to instantly flip into whatever the moment called for, including playing either with or against her type even as she aged."

Susan King, an entertainment journalist for more than 40 years and an ex-staffer for the *Los Angeles Times* who interviewed Betty some 10 times, believes that getting cast as Sue Ann on *Mary Tyler Moore* changed everything for White, moving her away from being known primarily up to that point as a great celebrity game show contestant.

"Sue Ann opened doors, windows, she opened it all," King observes, "and it didn't happen until Betty was halfway into her life, at 51. Her greatness was always there, but thanks to Sue Ann, it was able to really flower."

The fact that Betty was able to stick around through so many decades while continuously sharpening her abilities moved her "into the top five women in comedy all-time, maybe even top three," King believes.

Agreeing wholeheartedly with that assessment is Herbie J Pilato, the author of numerous books about classic television. He points out that Betty has "clocked more time on TV than anyone" and "really personified comedy as well as enormous likeability.

"What I also like to point out," Pilato continues, "is that Betty was equally funny when the camera was off. That's what everyone will tell you. This means she didn't need writers to be hilarious and charming."

But to Wesley Hyatt, author of the 2020 book *Betty White on TV: From Video Vanguard to Golden Girl*, the secret to Betty's success and long-term legacy had at least as much to do with who she was as what she accomplished.

"Her persona embodied intelligence, humor, happiness, friendliness, and a true love of animals," Hyatt says, "traits we'd all like to emulate. She represented the best of humanity."

Filmography

FILMS

1949 *The Daring Miss Jones*, Best Friend

1962 *Advise & Consent*, Senator Bessie Adams

1998 *Hard Rain*, Doreen Sears

1998 *Dennis the Menace Strikes Again*, Martha Wilson

1998 *Holy Man*, herself

1999 *Lake Placid*, Mrs. Delores Bickerman

1999 *The Story of Us*, Lillian Jordan

2000 *Whispers: An Elephant's Tale*, Round (voice)

2000 *Tom Sawyer*, Aunt Polly (voice)

2003 *Bringing Down the House*, Mrs. Kline

2005 *The Third Wish*, Lettie

2008 *Ponyo*, Noriko (voice, English version)

2009 *Love N' Dancing*, Irene

2009 *The Proposal*, Grandma Annie

2010 *You Again*, Grandma Bunny

2012 *The Lorax*, Grammy Norma (voice)

2019 *Toy Story 4*, Bitey White (voice)

2019 *Trouble*, Sarah Vanderwhoozie (voice)

TELEVISION

1949–53 *Hollywood on Television*, herself

1953–55 *Life with Elizabeth*, Elizabeth

1954 *The Betty White Show*, herself

1956 *The Millionaire*, Virginia Lennart

1957–58 *Date with the Angels*, Vickie Angel

1958 *The Betty White Show*, herself

1962 *The United States Steel Hour*, unknown

1964/1988 *Another World*, Brenda Barlowe

1968 *That's Life*, unknown

1969 *Petticoat Junction*, Adelle Colby

1971–72 *The Pet Set*, herself

1971 *Vanished* (miniseries), herself

1972 *O'Hara, U.S. Treasury*, herself

1972 *The Odd Couple*, herself

1973–77 *The Mary Tyler Moore Show*, Sue Ann Nivens

1975 *Lucas Tanner*, Lydia Merrick

1975 *Ellery Queen*, Louise Demery

1975–78 *The Carol Burnett Show*, various

1976 *The Sonny and Cher Show*, herself

1977–78 *The Betty White Show*, Joyce Whitman

1978 *With This Ring* (TV-movie), Evelyn Harris

1978 *Snavely* (TV-movie), Gladys Snavely

1979 *The Best Place to Be* (TV-movie), Sally Cantrell

1979 *Before and After* (TV-movie), Anita

1980–85 *The Love Boat*, Betsy Boucher/ Louise Willis

1981 *Stephanie* (TV-movie), Agnes Dewey

1981 *Best of the West*, Amanda Tremaine

1982 *Love, Sydney*, Charlotte

1982 *Eunice* (TV-movie), Ellen

1983 *Just Men!*, host/herself

1983 *Fame*, Catherine

1983–86 *Mama's Family*, Ellen Harper Jackson

1984 *Hotel*, Wilma Klein

1985 *St. Elsewhere*, Captain Gloria Neal

1985 *Who's the Boss?*, Macy's parade host (voice)/Bobbie Barnes

1985–92 *The Golden Girls*, Rose Nylund

1987 *Alf Loves a Mystery* (TV-movie), Aunt Harriet

1987 *D.C. Follies*, herself

1987 *Matlock*, herself

1988 *Santa Barbara*, waitress/lady in the theater

1989–92 *Empty Nest*, Rose Nylund

1990 *Carol & Company*, Trisha Durant

1991 *Nurses*, Rose Nylund

1991 *Chance of a Lifetime* (TV-movie), Evelyn Eglin

1992–93 *The Golden Palace*, Rose Nylund

1993 *Bob*, Sylvia Schmidt

1994 *Diagnosis Murder*, Dora Sloan

1995 *The Naked Truth*, herself

1995–96 *Maybe This Time*, Shirley Wallace

1996 *The John Larroquette Show*, herself

1996 *A Weekend in the Country* (TV-movie), Martha

1996 *Suddenly Susan*, Midge Haber

1996 *The Story of Santa Claus*, Gretchen Claus (voice)

1998 *The Lionhearts*, Dorothy (voice)

1998 *Noddy: Anything Can Happen at Christmas*, (TV-movie), Annabelle/ Mrs. Santa Claus

1998 *L.A. Doctors*, Mrs. Brooks

1999 *Hercules*, Hestia (voice)

1999–2001 *Ladies Man*, Mitzi Stiles

1999 *Ally McBeal*, Dr. Shirley Flott

1999–2002 *King of the Hill*, Dorothy/ Ellen/Delia (voices)

2000 *The Wild Thornberrys*, Sophie Hunter/Grandma Sophie (voice)

2000/07 *The Simpsons*, herself (voice)

2001 *The Retrievers* (TV-movie), Mrs. Krisper

2001 *The Wild Thornberrys: The Origin of Donnie* (TV-movie), Grandma Sophie (voice)

2001 *The Ellen Show*, Connie Gibson

2002 *Yes, Dear*, Sylvia

2002 *Providence*, Julianna

2002–03 *That '70s Show*, Bea Sigurdson

2003 *Return to the Batcave: The Misadventures of Adam and Burt* (TV-movie), herself

2003 *The Grim Adventures of Billy & Mandy*, Mrs. Doolin (voice)

2003 *Gary the Rat*, Gary's Mother (voice)

2003 *I'm with Her*, herself

2003 *Stealing Christmas* (TV-movie), Emily Sutton

2003–04 *Everwood*, Carol Roberts

2004 *The Practice*, Catherine Piper

2004 *My Wife and Kids*, Mrs. June Hopkins

2004 *Malcolm in the Middle*, Sylvia

2004 *Father of the Pride*, Grandma Wilson (voice)

2004–05 *Complete Savages*, Mrs. Riley

2004–07 *Higglytown Heroes*, Grandma (voice)

2005 *Joey*, Margaret Bly

2005 *Annie's Point* (TV-movie), Annie Eason

2005–08 *Boston Legal*, Catherine Piper

2006 *Family Guy*, herself (voice)

2006–09 *The Bold and the Beautiful*, Ann Douglas

2007 *Ugly Betty*, herself

2009 *30 Rock*, herself

2009 *My Name Is Earl*, Grizelda Weezmer

2009–10 *Glenn Martin, DDS*, Grandma Sheila Martin (voice)

2010 *The Middle*, Mrs. Nethercott

2010 *Saturday Night Live*, herself/host

2010 *Community*, Professor June Bauer

2010–13 *Pound Puppies*, Agatha McLeish (voice)

2010–15 *Hot in Cleveland*, Elka Ostrovsky

2011 *The Lost Valentine* (TV-movie), Caroline Thomas

2011 *Luciana Featuring Betty White: I'm Still Hot* (video short), herself

2012 *The Client List*, Ruth Hudson

2012–17 *Betty White's Off Their Rockers*, host/herself

2013 *Disney Mickey Mouse*, Aardvark Lady (voice)

2013 *Save Me*, God

2014 *WWE Raw*, herself

2014 *The Soul Man*, Elka

2015–18 *Fireside Chat with Esther*, Rose/Lady Bette

2015 *Betty White's Smartest Animals in America*, host/herself

2015–17 *Bones*, Dr. Beth Mayer

2016 *SpongeBob SquarePants*, Beatrice (voice)

2016 *Crowded*, Sandy

2017 *Young & Hungry*, Ms. Wilson

2017 *If You're Not in the Obit, Eat Breakfast*, herself

2018 *Betty White: First Lady of Television*, herself

A (Very Likely) Complete Game Show History

Here is every single (we hope) celebrity panel appearance of the Game Show Queen in her kingdom, as recorded by game show statistician Brendan McLaughlin.

1955 *What's My Line?*, at least four episodes, two as the Mystery Guest (CBS)

1955 *Make the Connection*, 13 weeks

1958, 1972 *I've Got a Secret*, 4 episodes, 4 weeks

1958–64 *To Tell the Truth*, 44 episodes (CBS nighttime)

1959 *Keep Talking*, 1 episode

1959 *Masquerade Party*, 1 episode

1961–67 *Password*, 20 weeks (CBS daytime)

1962 *Play Your Hunch*, 1 episode

1962–64 *Your First Impression*, 12 weeks

1963 *Missing Links*, 1 week

1963–65, 1967 *Password*, 5 episodes (CBS nighttime)

1963–69 *Match Game*, 25 weeks

1963, 1965–69 *You Don't Say!*, 15 weeks (NBC daytime)

1964 *Get the Message*, 5 weeks

1964 *The Price Is Right*, 2 episodes (nighttime)

1964, 1966 *To Tell the Truth*, at least 2 weeks (CBS daytime)

1965 *Call My Bluff*, 2 weeks, 1 day

1965 *Concentration*, 1 episode

1965 *The Price Is Right*, 1 week (daytime)

1965 *What's This Song?*, 2 weeks

1966 *Chain Letter*, 1 week

1967, 1968 *Snap Judgment*, 4 weeks, 2 days

1968, 1969 *Win with the Stars*, at least 2 episodes

1969 *Beat the Clock*, 1 week

1969 *It Takes Two*, 1 week

1969 *Liar's Club*, 17 weeks

1969–70 *He Said, She Said*, at least 2 weeks

1969, 1970, 1972 *It's Your Bet*, 4 weeks

1969, 1970, 1972 *What's My Line?*, 1 week panel, two days as the Mystery Guest (syndicated)

1971–75 *Password*, 13 weeks (ABC)

1972 *I've Got a Secret*, 4 weeks (syndicated)

1973 *Baffle*, 1 week

1973 *To Tell the Truth*, at least 1 week (syndicated)

1973–79 *Match Game*, 75 weeks

1974 *Masquerade Party* 1 episode (in disguise)

1974–76 *Celebrity Sweepstakes*, 2 weeks, 4 days

1974, 1976–78 *Tattletales*, 10 weeks (CBS daytime)

1975 *Password All-Stars*, 2 weeks

1975 *Showoffs*, 2 weeks

1975 *You Don't Say*, 4 weeks (ABC)

1975–76 *The Magnificent Marble Machine*, 2 weeks

1975–81 *Match Game PM*, 58 episodes

1976 *Cross-Wits*, 5 weeks

1976 *Stumpers!*, 2 weeks

1976–79 *Liar's Club*, at least 32 weeks

1976, 1978 *Hollywood Squares*, 2 weeks (NBC daytime)

1977–78 *Tattletales*, 2 episodes (syndicated)

1979 *Mindreaders*, 2 weeks

1979–82 *Match Game*, 22 weeks (syndicated)

1979–82 *Password Plus*, 17 weeks

1980 *Celebrity Whew!*, 1 week, 2 days

1980 *Chain Reaction*, 3 weeks

1981–82, 1983 *Battlestars*, 6 weeks, 2 weeks

1981–82 *Celebrity Bullseye*, 3 episodes

1982–88 *$25,000 Pyramid*, 14 weeks

1983–84 *Go*, 2 weeks

1983, 1985, 1994 *Family Feud*, 2 weeks, 1 week

1984 *Dream House*, 1 week

1984 *Trivia Trap*, 1 week

1984–85 *Body Language*, 3 weeks, 3 days

1984–89 *Super Password*, 13 weeks

1985 *All-Star Blitz*, 1 week

1985–87 *$100,000 Pyramid* (Clark) 3 weeks

1986 *Double Talk*, 1 week

1986–89 *Hollywood Squares*, 9 weeks (Davidson)

1987 *Wordplay*, 2 weeks

1987–89 *Animal Crack-Ups*, 10 episodes

1987–89 *Win, Lose or Draw*, at least 3 weeks (daytime)

1987–90 *Win, Lose or Draw*, at least 7 weeks (nighttime)

1988–89 *Sweethearts*, at least 2 weeks

1989–90 *3rd Degree!*, 3 weeks

1990–91 *Match Game*, 3 weeks (ABC)

1990–91 *To Tell the Truth*, 3 weeks (NBC)

1991 *$100,000 Pyramid*, 2 weeks (Davidson)

1993 *Scattergories*, at least 1 week

2002 *Pyramid*, 1 episode

2006 *Gameshow Marathon*, 1 episode

2008 *Million Dollar Password*, 2 episodes

Acknowledgments

Books are complex creations that require considerable assistance to come into being, and this one was no exception. I'm indebted to many people for lending their time, energy, and expertise toward bringing the project to fruition. I am, after all, only one man, even if I like to think I'm at least two or three.

Isabel Omero and Lex Passaris gave freely of themselves and made a point of educating me in the ways of *The Golden Girls* in general and Betty White in particular, and Omero opened up her contacts list to charitably assist a guy she'd never before met. They both were incredibly helpful.

In the lovely Gavin MacLeod and the impossibly gracious Millicent Martin and Marc Alexander, I was accorded rare access to Betty's inner sanctum, an act of trust I didn't take lightly. They are wonderful humans whom I am proud to know.

No author has ever received a better education in game shows and their history than I did from Adam Nedeff, Bob "TV Bob" Boden, game show statistician Brendan McLaughlin, and David Schwartz. Mitch Waldow provided me schooling in the early days of local television, even taking the time to meet me in a parking lot to supply me with reference materials and photos that felt like a high-class drug deal. I thank him sincerely.

The incomparable Annie Wetherbee supplied invaluable information about Betty and her years on *Hot in Cleveland* as well as Ms. White's side trips to feed a bear marshmallows mouth-to-mouth and sit on the receiving end of a birthday flash mob. She has my lasting appreciation. Ditto Kari Hendler for her anecdotes and enthusiasm and Todd Milliner for taking the time to discuss Betty's impact on *Cleveland*, as well as on making the set a safe zone for joy and optimism.

I was granted warm and engaging interviews by the incomparable Carol Burnett, Ed Asner, Wendie Malick, Candice Bergen, Ed. Weinberger, Bob Ellison, Rick Austin, Arthur Duncan, and Bill D'Elia, all of whom added essential color and insight to these pages.

My gratitude also goes out to Neil J. Weiner, Marsha Posner Williams, Ken Levine, Allison Hagendorf, Charlie Barrett, Heidi Schaeffer, Charles Sherman, Emily Benton, Jane McKnight, Marcia Hurwitz, Dan Pasternack, Rick Kuhlman, Brooke Jones, Richard Tanner, Susan King, Herbie J Pilato, Wesley Hyatt, Raymond Siller, Stacey Luchs, Darren Wadyko, Lindsay Drewel, Suzanne Stone, Burt Kearns, and Jim Colucci, a one-man Rolodex who proved incredibly generous with his time and energy.

Thank you also to Jeff McLaughlin for having the foresight to hire me to write this book; to designer Ashley Prine for making the book look like a million bucks (possibly as much as two million); to my meticulous and perceptive editor, Katherine Furman, for remaining a pillar of Zen calm amid the storm, talking me off numerous ledges and having my back at each step of the process; and to Nanette Bendyna for saving my butt on numerous occasions with her conscientious copyedits.

Finally, to Betty White, for having been perhaps the finest human the entertainment industry ever produced. The honor was all mine, Bets. I wished you could have lived forever. In our hearts, you surely will..

—Ray Richmond

Resources

..

INTERVIEW SUBJECTS

Ed Asner

Rick Austin

Charlie Barrett

Candice Bergen

Bob Boden

Carol Burnett

Jim Colucci

Bill D'Elia

Lindsay Drewel

Arthur Duncan

Bob Ellison

Kari Hendler

Wesley Hyatt

Susan King

Ken Levine

Gavin MacLeod

Wendie Malick

Millicent Martin

Todd Milliner

Adam Nedeff

Isabel Omero

Lex Passaris

Herbie J Pilato

Raymond Siller

Ed. Weinberger

Annie Wetherbee

BOOKS

Betty & Friends: My Life at the Zoo by Betty White (Berkley, 2012)

Golden Girls Forever: An Unauthorized Look Behind the Lanai by Jim Colucci (Harper Design, 2016)

Here We Go Again: My Life in Television by Betty White (Scribner, 2010 edition)

If You Ask Me (And of Course You Won't) by Betty White (Berkley, 2011)

When Women Invented Television: The Untold Stories of the Female

Powerhouses Who Pioneered the Way We Watch Today by Jennifer Keishin Armstrong (Harper, 2021)

Women Pioneers in Television: Biographies of Fifteen Industry Leaders by Cary O'Dell (McFarland & Company, 1997)

TELEVISION

13 @ 50: Our Golden Anniversary produced by Mitch Waldow

WEBSITES

AARP (www.aarp.org)

ABC News (www.abcnews.com)

AllMovie.com (www.allmovie.com)

Associated Press (apnews.com)

Boston Legal Wiki (bostonlegal.wikifoundry. com)

Britannica (www.britannica.com)

Broadway World (broadwayworld.com)

Buzzfeed (www.buzzfeed.com)

CBS News (www.cbsnews.com)

Chicago Tribune (www.chicagotribune.com)

Closer Weekly (www.closerweekly.com)

cnet (www.cnet.com)

CNN (www.cnn.com)

Complex.com (www.complex.com)

Deadline (www.deadline.com)

Emmys.com (www.emmys.com)

E.T. Online (www.etonline.com)

Fandom, The Golden Girls Wiki (goldengirls.fandom.com/wiki/ The_Golden_Girls_Wiki)

Fathom Events (www.fathomevents.com)

Forbes (forbes.com)

Genius.com (www.genius.com)

GLAAD (www.glaad.org)

Hollywood Chamber of Commerce (hollywoodchamber.net)

Hollywood Reporter (www. hollywoodreporter.com)

Hollywood Walk of Fame (walkoffame.com/ history/)

Huffington Post (www.huffpost.com)

IMDB Pro (pro.IMDb.com)

The Internet Movie Database (IMDb.com)

LGBTQ Nation (www.lgbtqnation.com)

The List (www.thelist.com)

Los Angeles Times (www.latimes.com)

Los Angeles Zoo (www.lazoo.org)

New York Daily News (www.nydailynews. com)

New York Times (www.nytimes.com)

Newsweek (www.newsweek.com)

Oh Shut Up Rose! (www.ohshutuprose.com)

OK! (www.okmagazine.com)

The Paley Center for Media (www. paleycenter.org)

Pastas World (pastasworld.com)

People (www.people.com)

Radar Online (www.radaronline.com)

Rotten Tomatoes (www.rottentomatoes. com)

San Jose Mercury News (www. mercurynews.com)

Screen Actors Guild Awards (www. sagawards.org)

Soaps in Depth (www.soapsindepth.com)

Thirteen.org (www.thirteen.org)

Today (www.today.com)

TV Quotes (tvquot.es)

Twitter (www.twitter.com)

United Press International (www.upi.com)

Variety (www.variety.com)

The Wall Street Journal (www.wsj.com)

The Washington Post (www.washingtonpost. com)

Wikipedia (www.wikipedia.com)

The Wrap (www.thewrap.com)

U.S. Veterans Magazine (www. usveteransmagazine.com) YouTube (www.youtube.com)

The U.S. Sun (www.the-sun.com)

ONLINE ARTICLES

Armstrong, Jennifer Keishin, "Best 'Mary Tyler Moore Show' Episodes: 'Love Is All Around,'" blog, jenniferkarmstrong.com/2019/04/02/best-mary-tyler-moore-show-episodes.

Bair, Lauren, "The Stunning Transformation of Betty White," The List, www.thelist.com/41245/stunning-transformation-betty-white/.

Barile, Louise A., "Betty White: The Actress Shares Her Hard-Earned Secrets about Love, Success and Her Golden Years," Closer Weekly, www.pressreader.com/usa/closer-weekly/20190701/281569472245167.

Beard, Lanford, "Betty White proposes to Craig Ferguson," Entertainment Weekly Online, ew.com/article/2012/02/15/betty-whites-valentines-day-proposal/.

Beresford, Trilby, "In honor of Betty White's birthday, here are some of her most iconic moments," Hello Giggles, hellogiggles.com/reviews-coverage/betty-whites-birthday-most-iconic-moments/.

Beveridge, Sydney, "Hear 8-Year-Old Betty White Playing a Crippled Orphan," Mental Floss, www.mentalfloss.com/article/29760/listen-8-year-old-betty-white-play-crippled-orphan-1930.

Beverly Press, "'Beastly Ball' raises over $1 million for animal conservation," beverlypress.com/2020/06/beastly-ball-raises-over-1-million-for-animal-conservation/.

Bilyeau, Nancy, "Betty White Celebrates 97th Birthday with Poker Game," The Vintage News, www.thevintagenews.com/2019/01/22/betty-white/.

Blair, "Betty White Reveals She Wanted a Very Different Career," Shared, www.shared.com/betty-white-career/.

Booth, Jessica, and Alex Aronson, "Betty White's Iconic Life In Photos," Redbook, www.redbookmag.com/life/g25714505/betty-white-life-in-photos.

Burke, Matthew, "Little Known Facts About Betty White," Factinate, www.factinate.com/people/32-things-didnt-know-betty-white/2/.

Chang, Rachel, "Betty White Was a Game Show Star Before 'Golden Girls,'" Biography, www.biography.com/news/betty-white-game-shows.

––– "Betty White's Love for Animals Began as a Child," Biography, www.biography.com/news/betty-white-animals-charity.

Closer staff, "Betty White and Lucille Ball Had Quite the Special Friendship: 'They Considered Each Other Family' (EXCLUSIVE)," closer Weekly, www.closerweekly.com/posts/betty-white-lucille-ball-friendship-145598/.

Cook, Meghan, "All of Betty White's movies, ranked by audiences," Insider, www.insider.com/best-and-worst-betty-white-movies-ranked-in-order.

The Copa Room website, "Celebrity Marriages in Las Vegas," www.angelfire.com/jazz/thecoparoom/vegas/marriages.html.

The Daily Beast Video, "Betty White's 15 Funniest Moments," www.thedailybeast.com/betty-whites-15-funniest-moments.

The Data Lounge website, "The greatest of all Sue Ann Nivens moments on 'The Mary Tyler Moore Show,'" www.datalounge.com/thread/11862485-the-greatest-of-all-sue-ann-nivens-moments-on-the-mary-tyler-moore-show.

Decades staff, "5 fast facts about 'Life with Elizabeth,'" Decades, www.decades.com/lists/5-fast-facts-about-life-with-elizabeth.

The Famous People website, "88 Top Betty White Quotes That Will Make You Love Her More," quotes.thefamouspeople.com/betty-white-6704.php.

––– "Betty White," www.thefamouspeople.com/profiles/betty-white-6704.php.

Furdyk, Brent, "The Untold Truth of Betty White," Nicki Swift, www.nickiswift.com/198614/the-untold-truth-of-betty-white/.

Gambino, Megan, "Betty White on Her Love for Animals," Smithsonian Magazine, www.smithsonianmag.com/science-nature/betty-white-on-her-love-for-animals-92610121/.

Gay, Verne, "'Betty White: First Lady of Television' celebrates a legend's career," Newsday, www.newsday.com/entertainment/tv/betty-white-pbs-special-1.20449588.

Golden, Lori, "Actress Betty White in 1928 with a childhood chow," The Pet Press, published on ChowTales, chowtales.com/actress-betty-white-in-1928-with-a-childhood-chow/.

Grab, Anna, "Betty White and Elephants," Bets' Pets–Betty White Fan Club, betspetsbettywhitefanclub.weebly.com/blog/betty-white-and-elephants.

Grossman, Lena, "Betty White Melted Everyone's Heart During Her 2018 Emmys Speech," E!, www.eonline.com/news/969204/betty-white-melted-everyone-s-heart-during-her-2018-emmys-speech.

Hazard, Mary Jo, "Rancho Palos Verdes resident Tom Sullivan, blind author and philanthropist, to moderate Peninsula Friends of Library fundraiser," PVNews.com, www.pvnews.com/news/rancho-palos-verdes-resident-tom-sullivan-blind-author-and-philanthropist-to-moderate-peninsula-friends-of/article_61a88bc0-c07a-11ea-b400-0bb6ef02fa5e.html.

Lawrence, Britt, "Betty White Was Terrified To Do Saturday Night Live," Cinema Blend, www.cinemablend.com/television/2456116/betty-white-was-terrified-to-do-saturday-night-live.

Lichtenbaum, Elisa, "Betty White: Golden Girl of Television," Inside Thirteen, www.thirteen.org/blog-post/betty-white-television-history/.

Littleton, Cynthia, "Betty White on Her 70 Years in TV: 'The Word "No" Did Not Exist,'" Variety, variety.com/2020/tv/news/emmy-winner-betty-white-1234772136/.

Luther, Claudia, "Betty White," Los Angeles Times bio, http://projects.latimes.com/hollywood/star-walk/betty-white/.

MeTV staff, "This cake scene from The Mary Tyler Moore Show proves Betty White has always been tough as nails," MeTV, www.metv.com/stories/this-cake-scene-from-the-mary-tyler-moore-show-proves-betty-white-has-always-been-tough-as-nails.

Meyers, Tom, and Greg Young, "Wacky, windy and weird: 1964 Macy's Thanksgiving Day Parade," The Bowery Boys, www.boweryboyshistory.com/2014/11/wacky-windy-and-weird-1964-macys.html.

Miller, Julie, "Betty White on Smooching Obama's Dog Bo, Her Summer Schedule, and the One Script She Wanted to Burn," Vanity Fair, www.vanityfair.com/hollywood/2012/06/betty-white-interview-barack-obama-hot-in-cleveland.

Nason, Jennifer, "The American Women's Voluntary Services," Museum Textile Service blog, www.museumtextiles.com/blog/theamerican-womens-voluntary-services.

Old Hollywood Films website, "Classic TV: Life with Elizabeth," www.oldhollywoodfilms.com/2019/01/life-with-elizabeth.html.

Paschal, Nick, "Betty White Reunited With Tap Dancer Whose Career She Launched in the '50s," yahoo!news, www.yahoo.com/news/betty-white-reunited-tap-dancer-whose-career-launched-50s-081652737.html.

Patterson, Adreon, "As Betty White Turns 99, Ryan Reynolds Shares That Time They Were In A Feud On The Proposal," Cinema Blend, www.cinemablend.com/news/2561646/as-betty-white-turns-99-ryan-reynolds-shares-that-time-they-were-in-a-feud-on-the-proposal.\

Pinak, Patrick, "Betty White Playing Tackle Football Never Stops Being Funny," FanBuzz.com, fanbuzz.com/nfl/betty-white-snickers-commercial/.

Popular Timelines website, "Betty White," populartimelines.com/timeline/Betty-White.

PowerPop blog, "Classic TV Episodes: The Odd Couple – Password," powerpop.blog/2019/12/08/classic-tv-episodes-the-odd-couple-password/.

PR Newswire, "Pink's Honors Betty White With Her Own 'Dog,'" Universal Studios press release, www.prnewswire.com/news-releases/pinks-honors-betty-white-with-her-own-dog-90927814.html.

Rich Samuels wbestite, "Live from Studio D," www.richsamuels.com/nbcmm/empirebuilders.

Roots, Kimberly, "Betty White to Turn 90 (Again) in New NBC Special," TV Line, www.tvline.com/2013/01/16/betty-white-birthday-special-nbc.

Smitek, Colleen, "Hot Shots: Betty White," Cleveland Magazine, clevelandmagazine.com/entertainment/film-tv/articles/hot-shots-betty-white.

Stanley, Gary, "When Koko Met Betty White," Koko.org: The Gorilla Foundation, www.koko.org/top-videos/4433/when-koko-met-betty-white-tgf-board-member/.

Thompson, Elise, "GLAZA Honors Betty White at Its Annual Beastly Ball with Creatures Both Great and Small," LAist, laist.com/2010/06/22/glaza_celebrates_its_annual_beastly.

US Department of Agriculture Press Office, "Forest Service makes actress Betty White honorary ranger," www.fs.usda.gov/news/releases/forest-service-makes-actress-betty-white-honorary-ranger#:~:text=Betty%20White's%20lifelong%20dedication%20to,allowed%20to%20do%20that%20then.

Us Weekly Staff, "Betty White's Best Moments through the Years," Us Weekly, www.usmagazine.com/entertainment/pictures/betty-whites-best-moments-2015131/.

Weigle, Lauren, "Why Betty White Never Had Children," heavy, heavy.com/entertainment/2018/08/betty-white-children-kids-step/.

Image Credits

Index

About the Author

Award-winning journalist and best-selling author Ray Richmond has worked as a chief television critic, columnist, and reporter for several publications, including *The Hollywood Reporter*, *Daily Variety*, the *Los Angeles Daily News*, the *Orange County Register*, and *Deadline Hollywood* (online). He has interviewed many of the most iconic celebrities in the world, including Elizabeth Taylor, Lucille Ball, Shirley MacLaine, George Burns, Chris Rock, Martin Scorsese, Ben Stiller, Amy Schumer, Steve Carell, and Jimmy Kimmel.

As an author, Richmond's books include memoir collaborations with the 98-year-old stage and screen legend Janis Paige (2020's *Reading Between the Lines*) and the famed character actor William Sanderson (2019's *Yes, I'm That Guy*). His earlier books include the *New York Times* best-seller *The Simpsons: A Complete Guide to Our Favorite Family* (1997), *This Is Jeopardy! Celebrating America's Favorite Quiz Show* (2004), *TV Moms: An Illustrated Guide* (2000), and *My Greatest Day in Show Business* (1999).

In 2017, Richmond fulfilled a lifelong dream by writing and producing a stage play. Titled *Transition*, it told the story of the November 2016 meeting in the Oval Office between President Barack Obama and President-Elect Donald Trump some 36 hours after the election. In 2017, the *Huffington Post* ranked it as one of Los Angeles's 10 best original plays of the year. He lives with his wife, Jill, and son, Dylan, in Los Angeles.